American Theology, Superhero Comics, and Cinema

Stan Lee, who was the head writer of Marvel Comics in the early 1960s, cocreated such popular heroes as Spider-Man, Hulk, the X-Men, the Fantastic Four, Iron Man, Thor, and Daredevil. This book traces the ways in which American theologians and comic books of the era were not only both saying things about what it means to be human, but, starting with Lee, largely saying the *same* things. Author Anthony R. Mills argues that the shift away from individualistic ideas of human personhood and toward relational conceptions occurring within both American theology and American superhero comics and films does not occur simply on the ontological level, but is also inherent to epistemology and ethics, reflecting the comprehensive nature of human life in terms of being, knowing, and acting.

This book explores the idea of the "American monomyth" that pervades American hero stories and examines its philosophical and theological origins and specific manifestations in early American superhero comics. Surveying the anthropologies of five American theologians who argue against many of the monomyth's assumptions, principally the staunch individualism taken to be the model of humanity, and who offer relationality as a more realistic and ethical alternative, this book offers a detailed argument for the intimate historical relationship between the now disparate fields of comic book/superhero film creation, on the one hand, and Christian theology, on the other, in the United States. An understanding of the early connections between theology and American conceptions of heroism helps to further make sense of their contemporary parallels, wherein superhero stories and theology are not strictly separate phenomena but have shared origins and concerns.

Anthony R. Mills received his PhD in theology and culture from Fuller Seminary. He contributes to poptheology.com and blogs at transgressivespaces. blogspot.com.

Routledge Studies in Religion and Film

Edited by Robert Johnston and Jolyon Mitchell

American Theology, Superhero Comics, and Cinema

The Marvel of Stan Lee and the Revolution of a Genre

Anthony R. Mills

Routledge
Taylor & Francis Group

NEW YORK AND LONDON

First published 2014
by Routledge
711 Third Avenue, New York, NY 10017

Simultaneously published in the UK
by Routledge
2 Park Square, Milton Park, Abingdon, Oxon OX14 4RN

*Routledge is an imprint of the Taylor & Francis Group,
an informa business*

Library of Congress Cataloging-in-Publication Data

Mills, Anthony R., 1978–
American Theology, Superhero Comics, and Cinema : The Marvel of Stan
 Lee and the Revolution of a Genre / By Anthony R. Mills.
 pages cm. — (Routledge studies in religion and film ; 2)
 1. Comic books, strips, etc.—Religious aspects. 2. Comic books,
strips, etc.—United States. 3. Comic books, strips, etc.—Moral
and ethical aspects—United States. 4. Motion pictures—Religious
aspects. 5. Motion pictures—United States. 6. Motion pictures—
Moral and ethical aspects—United States. 7. Superheroes—United
States. 8. Superhero films—United States. 9. Lee, Stan, 1922—
Criticism and interpretation. I. Title.
 PN6712.M55 2013
 741.5'973—dc23
 2013022303

ISBN: 978-0-415-84358-4 (hbk)
ISBN: 978-0-203-75404-7 (ebk)

Typeset in Sabon
by Apex CoVantage, LLC

Printed and bound in the United States of America by Publishers Graphics,
LLC on sustainably sourced paper.

For my father
Richard Craig Mills
1940–2004

Contents

Acknowledgements

Projects like this are always only possible because their creators depend on a vast network of people whose inspiration, commitment, comments, critiques, suggestions, and editorial work help bring them to life. Mine is no exception. My gratitude goes to Stan Lee, of course, for creating such endearing characters and for offering ways of being human and heroic that honor our fragile embodiment; to Robert K. Johnston, my doctoral advisor at Fuller Seminary, who made the case for turning an obscure dissertation project into a book; to Lauren Verity, the editorial assistant at Routledge, who has answered my endless queries with promptness and patience; to Veli-Matti Kärkkäinen, one of my dissertation readers, who has been wholly supportive of me and this project; to Kenneth Reynhout, my brilliant and amazing friend, who has offered numerous suggestions and stalwart encouragement throughout the sometimes long years of writing; to LeRon Shults, whose theological insights were nothing less than transformative for me and laid the foundation for this work; to Catherine Keller, not only for being such a creative and gracious theologian but also for telling me about her personal story; to Terrence Wandtke, for teaching me how to read comic books and providing helpful insights on those sections; to Luco van den Brom, for making the significant observation that this is an exercise in *public* theology; to Brian Schomburg, David Moyer, and David Haga, for hours of conversations and arguments about superheroes; to Don Delp and the crew at Office Depot #316, for letting me use vast amounts of down time to write this when, I suppose, I could have been cleaning; and, finally, to my late father, who was always a fan of all those heroes I criticize in this book, but who also read my early essay on Marvel movies and really wanted to see them because of it. I think he would have loved *Captain America*.

Introduction

This project was a long time in the making. It began nearly ten years ago while I was working on a master's degree at Bethel Seminary in Minnesota. The greatest influence on my thought during that time was LeRon Shults, professor of theology at Bethel (now at Agder University in Norway). His argument in books, articles, and lectures was that there has been a growing shift over the last few centuries from a preference for substance to a preference for relation in philosophical discussions of metaphysics and ontology. This "turn to relationality," as he calls it (which we will discuss in detail in chapter 3), can also be seen in conceptions of human personhood, not only in philosophy but also in theology and the natural and social sciences.

On my own, I began to see that the constructive proposals of Shults and others with regard to this relational anthropology parallel how many Marvel movies portray heroes and villains. I was given a chance to investigate this briefly in a term paper at Bethel, wherein I discovered that a similar shift to relationality had taken place in American superhero comics prior to the films. I argued that the major instigator of this change was Stan Lee, who was the head writer of Marvel Comics in the early 1960s and cocreated in that period such popular heroes as Spider-Man, Hulk, the X-Men, the Fantastic Four, Iron Man, Thor, and Daredevil. Although the relational turn in theological anthropology had been developing longer in both Europe and North America, the twentieth century brought new opportunities for voices that had been silenced historically, as well as a growing literature among white male theologians. Not only were both theologians and comic books saying things about what it means to be human in late-modern American culture, but, starting with Lee, they were largely saying the *same* things.

As I investigated even further, having taken up the topic as my Fuller Seminary dissertation, I discovered that the American hero mythology, of which comic books are a part, has its historical, philosophical, and theological origins in a variety of factors surrounding the founding and development of the United States, especially puritanism, liberal Protestantism, frontier expansion, Western literature, national independence from England, and cultural separation from Europe in general. Popular American ideas of what it means to be human likewise have their origins in the birth of the nation

and are, hence, theological in nature, in our day both explicitly and residually. Naturally, many American theologians still share the same categories and even formulations as the puritans, which in turn came to them from the Reformed theology of England and Holland. Ultimately, of course, this means that to a great extent both traditional comic book hero mythology and theological anthropology in the United States share the same philosophical roots via Western (primarily Reformed) Christian thought.

This fact is discussed chiefly in the first two chapters. Chapter 1 attends specifically to the historical, philosophical, and theological foundations of what John Shelton Lawrence and Robert Jewett refer to as the "American monomyth," the most prominent pattern of American portrayals of the hero in a variety of media, including literature, comics, and film. Here, I show in greater detail the historical connections between theological and mythological anthropological conceptions, especially as these were mediated by the early American western literature whose authors rebelled against the religion and mores of their New England forebears in a sort of secular Calvinism.

Chapter 2 specifically deals with superhero comics from the Golden Age, roughly 1938–1961, in which the various philosophical and theological assumptions of the American monomyth came to expression almost entirely uncritically. Specifically, heroes were idealized as individualistic, misogynistic, autonomous, staunchly independent, morally pure, and epistemically unambiguous. Villains were maligned as sociopathic, incurably evil, morally corrupt, unpatriotic, and, often, were minorities depicted as caricatured stereotypes.

While this may constitute the dominant paradigm of heroes, villains, and other persons in American thought and fiction, it is certainly not the only one. In chapter 3, I attend to five American Christian theologians who demonstrate a turn to relational categories in their own constructive anthropologies, and also criticize various aspects of the American monomyth on philosophical, theological, ethical, and social-scientific grounds: Thomas Merton, James Cone, Rosemary Radford Ruether, Catherine Keller, and LeRon Shults. Although several other thinkers could have been discussed, these imaginative voices represent not only a diversity of backgrounds and approaches, but also every significant era over the last 50 years, the same length of time that Stan Lee and Marvel have been challenging and changing the superhero genre. Moreover, it seems only natural to limit our conversation to American theologians, to highlight the prophetic voices of those who see both the various imperfections in their native land and the possibilities for overcoming them.

In chapter 4, I consider the transformations inaugurated by Stan Lee and his colleagues at Marvel Comics beginning in 1961. By simply wanting to make characters more believable and write stories that he himself would want to read, Lee brought about what I call a "turn to reality" in the superhero genre. On an ontological level, this entailed a shift from individualistic,

substance-metaphysical ideas of heroes and villains to more relational ones. It also brought with it epistemological and ethical changes, as the old heroic traits of certainty, autonomy, perfection, and absolute goodness began to be replaced by doubt, responsibility, psychological frailty and complexity, and moral ambiguity.

It would seem that as we move further into the twenty-first century, presentations of human personhood in American comic books and theology continue to share similar convictions and respond to mutual concerns. Advances in technology are enabling the classic Marvel Comics characters of Lee and others to reach wider audiences via adaptation to film, which we explore in chapter 5. These movies, like their printed source materials, are continuing to challenge traditional American conceptions of humanity, and offer alternatives. At the same time, the films offer unique expressions of the Marvel stories, due both to the distinct medium of the moving image and its role in American life, and to differences in cultural concerns since the 1960s.

Finally, in the conclusion, I draw on the insights of the last three chapters to offer four general anthropological proposals toward a constructive alternative to the American monomyth, comparing and contrasting some of the major points raised by both Marvel comics and films and our five theologians. To be real, and human, is to be in relation, and to need, and to be needed, and to need each other. Such is the wisdom of, and call from, both prophetic Christian theologians and Stan Lee's superhero stories.

1 The Historical and Theological Background of the Anthropology of the American Monomyth

INTRODUCTION

In his book *The Hero with a Thousand Faces,* Joseph Campbell defines the classical *monomyth,* or archetype for heroic action, found in traditional world mythologies. According to him, in the typical formula, a "hero ventures forth from the world of common day into a region of supernatural wonder: fabulous forces are there encountered and a decisive victory is won: the hero comes back from this mysterious adventure with the power to bestow boons on his fellow man."[1] Campbell saw this as a magnification of the rite of passage formula of separation–initiation–return, after which the hero is restored to his community.

In their book *The Myth of the American Superhero,* John Shelton Lawrence and Robert Jewett—observing the *lack* of community in American portrayals of the hero—adapt Campbell's formula and propose what they call the *American monomyth.* Although this archetype deals primarily with fictional stories, it was embryonic already in America's infancy, has evolved over the years, and comes to contemporary expression in sundry areas of American life. According to this formula, "A community in a harmonious paradise is threatened by evil; normal institutions fail to contend with this threat; a selfless superhero emerges to renounce temptations and carry out the redemptive task; aided by fate, his decisive victory restores the community to its paradisiacal condition; the superhero then recedes into obscurity."[2]

They further suggest that this plot was fully formulated by 1929 and spend most of their time articulating its various manifestations in American popular culture afterward.[3] Before we attend to contemporary concerns, however, it is helpful to explore more deeply the background of this pattern

1. Joseph Campbell, *The Hero with a Thousand Faces* (New York: Bollingen Foundation, 1949), 30.
2. John Shelton Lawrence and Robert Jewett, *The Myth of the American Superhero* (Grand Rapids: Eerdmans, 2002), 6.
3. Lawrence and Jewett, *Myth,* 36ff.

and the factors that gave rise to it. More specifically, we are concerned with the anthropological dimensions of this history, and the picture of humanity that then emerges in the monomyth. By *anthropological,* we are referring generally to that which has to do with human persons and groups—that is, the study or philosophy of human beings—and not directly to the field of anthropology as a proper social science. This focus on humanity is both narrow enough to limit a potentially endless discussion and broad enough to account for several (often seemingly disparate) phenomena. In order to describe a more comprehensive view of human personhood as presented in the monomyth, we will organize our investigation into three sections, corresponding to human being, human knowing, and human acting. This, in turn, parallels the classic philosophical categories of ontology (the study of being/s), epistemology (the study of knowledge), and ethics (the study of right and wrong actions), respectively.[4]

There are several major factors that contributed to the development of the American monomyth, philosophically and theologically. For one, there is the long history of Western thought, which was already engrained in the colonists' worldview before leaving for the New World. This included not only ancient and medieval philosophical categories, but also Reformed theological concepts of sin, salvation, and covenant, as well as ecclesiastical tensions in England, which were largely responsible for the puritan emigration.[5] There are also the unique challenges faced by the colonists in the New World, which include geographical separation from Europe, lack of ecclesial government, unfamiliarity with the land, differing attitudes toward the wilderness, and, most significantly, relation to the Native American peoples. Even after arrival in the New World, there continued to be strong influences from a rapidly changing Europe: the new science of Isaac Newton; the philosophical trends of evidentialism, common sense realism, and secularism; and the rise of republicanism and the dramatic political events in England that contributed greatly to the American Revolution. Finally, there are a number of changes that took place in America after independence was won, and which would determine the direction of the new nation. Particularly significant are slavery, the Civil War, expansion into the western frontier, and industrialization.

Since we are concerned here primarily with anthropology, in the following discussion, some of these aspects will not figure as prominently as others. Nevertheless, I will try to weave a common thread through the long history

4. This structure is meant merely as an organizational heuristic, not to imply separate parts of the person. I take the arrangement from F. LeRon Shults, but it is of course not new with him. See his *Reforming Theological Anthropology: After the Philosophical Turn to Relationality* (Grand Rapids: Eerdmans, 2003), 6–7.

5. On the use of *puritan* instead of *Puritan,* Michael P. Winship, "Reconsiderations: Were There Any Puritans in New England?" *The New England Quarterly* 74, no. 1 (March 2001): 118–138.

and myriad details as we discover more precisely the whither and whence of America's monomythic hero.

HUMAN BEING AS ISOLATING SUBSTANCE

The monomythic hero, as Lawrence and Jewett and many others recognize, is thoroughly individualistic. This is suggested already in the archetype itself in which the hero enters the community in solitude and then leaves in solitude when his mission is completed. In the context of human beings, then, I suggest that this phenomenon is expressive of an individualistic ontology, and any casual observer of the United States will notice that it figures prominently in our cultural life. To understand its place both in American society and in the monomyth, however, requires a look at its development in broader Western thought.

In his discussion of the nature of things, Aristotle made a distinction between the substance of a thing and its accidents.[6] Among what he considered accidents, he included the various relations among things. This came to mean the human person as well, such that, for instance, my being me has nothing to do with being my parents' son or my sister's brother. One's substance or essence, then, is entirely cut off not only from one's attributes, but also from one's relations to others.

Even before Aristotle, Plato located the self in the immaterial substance of the rational soul.[7] Not only is one determined in separation from others, then, but even also from one's own embodiment. These formulations were adopted by other philosophers and early Christian theologians fairly uncritically, such that by the sixth century the standard definition of the person could be offered by Boethius in his Christological argument against the Eutycheans: the person (divine or human) is "an individual substance of a rational nature."[8]

This understanding persisted throughout the Middle Ages and early modern period.[9] Despite John Calvin's attempt to understand the whole person in relation to God, he still held to ancient categories. and his followers in the seventeenth century hardened the idea of substance ontology,[10] especially in light of the popular new science of Newton, whose theories on mechanics were highly atomistic.[11] Among Calvin's followers were the English and

6. For this discussion see Shults, *Anthropology*, 12ff.
7. Shults, *Anthropology*, 165ff.; Colin Gunton, *The One, the Three, and the Many: God, Creation, and the Culture of Modernity* (Cambridge: Cambridge University Press, 1993), 46ff.
8. As quoted in Shults, *Anthropology*, 31, 168. See also Boethius, "A Treatise against Eutyches and Nestorius," section III.
9. Shults, *Anthropology*, 168; Thomas F. Torrance, *Calvin's Doctrine of Man* (London: Lutterworth, 1949), 122.
10. Shults, *Anthropology*, 169; Torrance, *Calvin's Doctrine*, 29, 56, 61, 122.

New England puritans,[12] who also adopted the individualistic ontology of Aristotle and Plato and continued to use substance language explicitly.[13]

English puritans also embraced the Reformed covenant theology of Heinrich Bullinger (successor to Ulrich Zwingli in Zurich) and William Tyndale, contributing to the notion of England as a chosen nation with whom God had a unique covenant.[14] Many have noticed that the English puritans even thought of themselves as God's New Israel and of their nation as the Promised Land,[15] but this notion was mitigated due to resistance by the monarchy and Anglican clerical prelacy.[16] As puritans struggled to reform these institutions, they met with great adversity and witnessed what they thought was England's fall into sin. This nullified God's obligation to the covenant, and, according to their interpretation, thus meant imminent destruction of the nation, such as had been the case with ancient Israel.[17] Hence, many puritans fled for both the Continent and the New World. This was intensified after Oliver Cromwell's puritan government collapsed in 1660 and the monarchy was restored; hopes for England as the New Israel were all but abolished.[18]

11. Shults, *Anthropology*, 17; E. A. Burtt, *The Metaphysical Foundations of Modern Physical Science* (Garden City: Doubleday, 1932), 230ff., 239, 245.

12. The puritan influence on American national identity is well documented and I will not argue it here. See Sacvan Bercovitch, *The Puritan Origins of the American Self* (New Haven and London: Yale University Press, 1975); E. Brooks Holifield, *Theology in America: Christian Thought from the Age of the Puritans to the Civil War* (New Haven and London: Yale University Press, 2003), 25–78; George McKenna, *The Puritan Origins of American Patriotism* (New Haven and London: Yale University Press, 2007); Mark Noll, *America's God: From Jonathan Edwards to Abraham Lincoln* (New York: Oxford University Press, 2002), 3–50.

13. As in, for example, William Perkins, *The Work of William Perkins*, ed. Ian Breward (Appleford: Sutton Courtenay, 1970), 184–5, 189, 191ff. See also Perry Miller, *The New England Mind: The Seventeenth Century* (New York: MacMillan, 1939), 122ff., 149–150, 177–178, 184.

14. Bercovitch, *American Self*, 79–80; J. Wayne Baker, "Faces of Federalism: From Bullinger to Jefferson," *Publius* 30, no. 4 (Fall 2004): 25–41; Richard T. Hughes, *Myths America Lives By* (Urbana and Chicago: University of Illinois Press, 2003), 20–26. The development of Reformed theology's eventual dominance in England is surveyed by Diarmaid MacCulloch, "Putting the English Reformation on the Map," *Transactions of the Royal Historical Society* 15 (2005): 75–95.

15. Robert W. Jenson, *Essays in Theology of Culture* (Grand Rapids: Eerdmans, 1995), 57; Steve Pointer, "Puritan Identity in the Late Elizabethan Church: William Perkins and 'A Powerfull Exhortation to Repentance,'" *Fides et Historia* 33, no. 2 (Summer 2001): 69ff.

16. Michael P. Winship, "Weak Christians, Backsliders, and Carnal Gospelers: Assurance of Salvation and the Pastoral Origins of Puritan Practical Divinity in the 1580s," *Church History* 70, no. 3 (September 2001): 463.

17. Hughes, *Myths*, 28–29; Pointer, "Puritan Identity," 70.

18. See William Dean, *The American Spiritual Culture: And the Invention of Jazz, Football, and the Movies* (New York and London: Continuum, 2003), 53.

In New England, however, the cultural capital of the colonies, a theology of covenant fit rather well with their circumstances. The world was "uncivilized" and eventually unfettered by European control;[19] Christians of the various Reformed stripes were able to carry on their traditions with official sanction and without Anglican interference; and the colonists were, for the most part, able to cultivate the land and prosper. America was considered blessed.

Like England, America as the New Israel saw itself as similar to biblical Israel and bound by a covenant.[20] Yet, whereas the early puritan theologians considered ancient Israel and creation in general to be under the covenant of works, the colonists were thought to be under the covenant of grace since the New Testament.[21] This new covenant was defined primarily in juridical terms as a transaction whose ordinances must be followed.[22] If the community obeyed, it would be rewarded; if it disobeyed, it would be punished. Since it was difficult in reality to discern God's precise precepts, puritans believed that the prosperity or misery of the community was an indicator of whether or not they actually were obeying God. The effect determined the cause.[23]

But identifying the human person primarily as a substantial soul enabled theological formulations that necessarily focused on the individual. The puritan role of community, then, was inherently tenuous. Although they saw themselves in communal terms as the New Israel, they understood human persons as isolated by nature,[24] which meant that puritan towns and churches were ultimately made up of autonomous individuals bound only by legal transactions.[25] The covenant, then, was ultimately an accidental, secondary utility for justifying and maintaining social order.

19. I use quotes around the word *uncivilized* to highlight the relative and, thus, contentious nature of the term, as are the related terms *civilized* and *savage*, etc. Hereafter, I discard the quotations so that they are not cumbersome for the reader, but bear in mind that I use these words only to betray the mindset of the puritans and their descendants, not to indicate the actual state of affairs.

20. Bercovitch, *American Self*, 72–108; Stanley Cohen, "Messianic Motifs, American Popular Culture and the Judaeo-Christian Tradition," *Journal of Religious Studies* 8, no. 1 (Spring 1980): 24; Hugh J. Dawson, "'Christian Charitie' as Colonial Discourse: Rereading Winthrop's Sermon in Its English Context," *Early American Literature* 33, no. 2 (1998): 120–122.

21. On this distinction in early modern European and then North American theologies, F. LeRon Shults and Steven J. Sandage, *The Faces of Forgiveness: Searching for Wholeness and Salvation* (Grand Rapids: Baker, 2003), 146–147.

22. As in, for significant instance, William Ames, *The Marrow of Theology*, trans. John Dykstra Eusden (Durham: Labyrinth, 1983 [Latin 1629]), 111 (1.X).

23. Dean, *Culture*, 67.

24. See Dawson, "Charitie," 122ff.; Miller, *Mind*, 297–298; Donald Frey, "Individualist Economic Values and Self-Interest: The Problem in the Puritan Ethic," *Journal of Business Ethics* 17, no. 14 (October 1998): 1573–1580.

25. See Dawson, "Charitie," 126–127; Dean, *Culture*, 26; Jenson, *Theology*, 57, 65; Ivy Schweitzer, "John Winthrop's 'Model' of American Affiliation," *Early American Literature* 40, no. 3 (2005): 451ff.

The practical dark side of America as the New Israel was to find its identity in opposition to both a history that it was losing and a wilderness that it did not know.[26] Hence, we are, as William Dean suggests, "a displaced people,"[27] and an extraordinary amount of energy was spent in New England forging this new identity and keeping external threats at bay. Since the settlers thought that the wilderness was a source of evil and must be avoided,[28] they were discouraged from exploring it too deeply, lest they be tempted and changed by the uncivilized natives, and the new community fall into disrepute in God's eyes.

Even in the seventeenth century, however, the notion of the wilderness as evil began to subside in the wake of forced engagement with it. This change of heart was facilitated by the growing distance between frontiers and towns, more realistic assessments of the wilderness, and the deterioration of Reformed theology among successive generations.[29] The result was a growing fascination with, and even respect for, native peoples and certain ways of their life.[30]

The seventeenth-century puritan captivity narratives, in which a white man or woman is kidnapped by savage natives and is then rescued by God in some manner, was the earliest American heroic formula, and prefigured the stories of rescue that are common in modern hero films and literature today.[31] Yet this early archetype did not itself enable the idea of the monomythic hero, because of its insistence on the depravity of humanity and the exclusive agency of God in stories of rescue and providence.[32] It did, however, lay the ground for venture into the wilderness, since at first only by being taken into the wild involuntarily was its exploration legitimated mythologically.[33]

By the eighteenth century, the disintegration of puritanism was paralleling the literary trend toward embrace of the wilderness.[34] The shift to the frontier began in 1716 and was developed by 1784 with the first publication of Daniel Boone's exploits.[35] During this time the idea of the hero as hunter was fully formed and became the standard through the nineteenth century. It was also here that the heroes broke with their communities, particularly as

26. Dean, *Culture*, 51ff.
27. Ibid., 44ff.
28. Richard Slotkin, *Regeneration through Violence: The Mythology of the American Frontier, 1600–1860* (Middletown: Wesleyan University Press, 1973), 9, 94ff.
29. Ibid., 153.
30. Ibid., 426–431.
31. Ibid., 94–115.
32. James D. Hartman, "Providence Tales and the Indian Captivity Narrative: Some Transatlantic Influences on Colonial Puritan Discourse," *Early American Literature* 32, no. 1 (1997): 66–68.
33. Slotkin, *Regeneration*, 99ff.
34. Noll, *America's God*, 31–50; Slotkin, *Regeneration*, 147ff.
35. Slotkin, *Regeneration*, 153ff., 268–312.

a response to organized religion. Their god would not be found in civilized establishments, but in the open air of nature.[36] The connection between organized religion and negative attitudes toward the wilderness was integral to maintaining the puritan establishment and had been expressed in New England preaching.[37] To reject the wilderness was to reject religion, which is precisely what happened as people moved into the western frontier and wrote the solitary hero that we know so well today.

Although this may seem like a significant break with New England thought, it was really just a logical conclusion to it.[38] If one is an individual substance, one has no genuine need for community beyond a system of transactional, utilitarian bargains. If, however, one can take care of oneself, even this system is superfluous. Since they indeed were growing accustomed to the wilderness, this was precisely what the frontiersmen thought, ironically legitimated by the theological categories of the time, even if contrary to official puritan teaching.

The rejection of established authority in the literary mythology of the eighteenth century coincided with the spread of republican political ideals, which repudiated most forms of human domination, especially monarchy, and led to the War of Independence.[39] This, in turn, was enabled by the adoption of Scottish Common Sense philosophy, according to which epistemic and ethical certainty were gained not through reference to an authority or tradition, but through the immediate, natural perception of each individual.[40]

Yet, communal consciousness of some sort is required for a nation to thrive, and even the republicanism that abandoned illegitimate authority acted to keep the individualistic tendencies of people in check by elevating concern for the body politic, as the theological covenant before it had done.[41] Hence, already by the late-eighteenth century, there was a tension between the new federal establishment and those on the frontier who rejected New England society.[42] For the latter, an ambivalent attitude toward Native Americans developed.[43] On the one hand, their dark skins and uncivilized ways were seen as dangerous and alien; on the other hand, they were appreciated for their natural and ancient ways of life.

36. Ibid., 147ff., 278ff.
37. Ibid., 57–93.
38. See Frey, "Economic Values," 1574.
39. Noll, *America's God*, 53–72. American federalism was itself a secularization of Reformed covenant theology, according to Baker, "Federalism," 25–41.
40. Holifield, *Theology*, 174–180; Noll, *America's God*, 93–113.
41. Noll, *America's God*, 49.
42. Slotkin, *Regeneration*, 181ff. See also Katherine E. Ledford, "'Singularly placed in scenes so cultivated': The Frontier, the Myth of Westward Progress, and a Backwoods in the Mountain South," *American Transcendental Quarterly* 18, no. 3 (September 2004): 207ff.
43. On the following, Slotkin, *Regeneration*, 19ff., 189, 205, 217, 558.

However, as Richard Slotkin suggests, it is one of the chief roles of myth to integrate and overcome the contradictions inherent in a culture, and America's monomyth is no exception.[44] This was done significantly in the nineteenth century by James Fenimore Cooper, whose stories combined the concerns of eastern civilization and western wilderness.[45] More specifically, he combined the genres of captivity myth (the old bulwark of New England puritan concerns) and hunter myth (the favored expression of frontier ideology), but his method for doing so is of chief concern for us here.[46]

In order to avoid acquiescing completely to either formula, Cooper decided that his hero must remain celibate.[47] Since marriage, family, and church were seen as aspects of the civilized east, he could not marry a white woman, since this would mean rejecting the wilderness.[48] However, he also could not marry a dark-skinned native woman, since this would mean rejecting his New England past and commitment to whiteness.[49] By avoiding marriage or sexual involvement of any kind, the hero was able to maintain both frontier and civilized ideologies and affirm the desired aspects of both; that is, the rugged individualism of the frontier and the honorable morality of the eastern cities.

While there is a shared denial of sexuality in both classic (Campbellian) and American monomyths, in the former, celibacy is a temporary condition to help the hero keep his focus on his task. The American version adds to this utilitarian denial a general and permanent repudiation of sexuality and community altogether, as aspects of femininity and enculturation which the lone hero must avoid. It is important to keep in mind that this shunning of sexuality did not come from the early puritans, for whom marriage and sex were sacred and meant to be enjoyed.[50] It is rather a mythological and literary device used by Cooper to combine contradictory ideologies.

Yet, why celibacy and not some other device, especially since it is not a universal aspect of world mythologies? I suggest that this owes more to the

44. Richard Slotkin, *Gunfighter Nation: The Myth of the Frontier in Twentieth-Century America* (New York: HarperCollins, 1992), 5ff.
45. Slotkin, *Regeneration*, 502, 512.
46. See Ledford, "Singularly placed," 217.
47. Slotkin, *Regeneration*, 502ff.; Joshua J. Masters, "'Smothered in Bookish Knowledge': Literacy and Epistemology in *The Leatherstocking Tales*," *The Arizona Quarterly* 61, no. 4 (Winter 2005): 4.
48. On the connection of religion and femininity, Belden C. Lane, "Two Schools of Desire: Nature and Marriage in Seventeenth-Century Puritanism," *Church History* 69, no. 2 (June 2000): 396–397; David R. Como, "Women, Prophecy, and Authority in Early Stuart Puritanism," *The Huntington Library Quarterly* 61, no. 2 (2000): 203–222; Martha Saxton, "Bearing the Burden? Puritan Wives," *History Today* 44, no. 10 (October 1994): 29ff.
49. Masters, "Knowledge," 12.
50. Lane, "Desire," 374, 379; Allen Carden, *Puritan Christianity in America: Religion and Life in Seventeenth-Century Massachusetts* (Grand Rapids: Baker, 1990), 172.

hero's autonomy. He cannot be intimate, because it would suggest an emptiness or need on his part that he cannot satisfy himself. Intimacy of any kind, especially sexual, would mean real vulnerability, and, hence, his worthiness to save the community would be challenged. Writ nationally, it would mean that America is weak and unable to forge its destiny in the face of great obstacles. From both angles, this autonomy is uniquely sanctioned by the individualistic substance ontology that was adopted and adapted throughout our political and theological history, and which has had unfortunate consequences for both epistemology and ethics.

HUMAN KNOWING AS OBJECTIFYING DISTANCE

As we saw above, Plato located the self primarily in the soul, which for him had a three-part structure of appetitive, spirited, and rational aspects, the last of which was primary.[51] This Platonic understanding led in the West to what is known as *faculty psychology:* the idea that human thought is separated into distinct modules or faculties assigned to different mental tasks. Throughout the Middle Ages, two faculties battled for supremacy—the intellect (having to do with rationality and understanding) and the will (having to do with intentionality and decision)—although the intellect won out during most of this time. In the early modern period, especially with the rise of the new science and the decline of traditional religious observance, the will began to dominate. Along with individualistic substance ontology, English and New England puritans also uncritically adopted faculty psychology.[52] This had significant impact on our anthropological considerations, especially by way of soteriology, the doctrine of salvation.

For Calvin, God was to be worshipped, not theorized.[53] He emphasized the mystery and incomprehensibility of God and his decisions, which is largely why predestination remained a relatively underdeveloped theme, even in later editions of his seminal *Institutes of the Christian Religion.*[54] Calvin's followers in the seventeenth century, however, felt that there were too many theoretical loopholes in his doctrine about which the Catholics and even other Protestants could ask problematic questions. For instance, if everything is predestined, what good are works and moral living? And how does one *know* whether or not one is chosen for salvation? Hence, Calvin's

51. Shults, *Anthropology*, 169ff.
52. Noll, *America's God*, 289–290. So prevalent was faculty psychology in early New England thought that it takes up almost the entire chapter called "The Nature of Man" in Miller, *Mind*, 239–279. See Perkins, *Work*, 191ff.
53. On the following, Perry Miller, *Errand into the Wilderness* (Cambridge: Harvard University Press, 1964), 50ff.
54. Jaroslav Pelikan, *The Christian Tradition: A History of the Development of Doctrine*, vol. 4, *Reformation of Church and Dogma (1300–1700)* (Chicago: University of Chicago Press, 1984), 218.

successors sought to bring a more comprehensive logic to his thought, concretizing many of the ideas that were only inchoate in Calvin himself.[55]

Puritan theologians in England and America also became consumed with these questions, especially that concerning assurance of election.[56] The anxiety was particularly prevalent among the laity, to whom the preachers and theologians responded with instructions on how to determine one's own state before God. However, mere passivity in regeneration did not sit well with Calvin's followers when the religious fervor of the Reformation began to die down among the people at the turn of the seventeenth century. There needed to be a way of affirming the necessity of works without denying the freedom of God to elect. The idea of the covenant solved both issues: God in his freedom creates the covenant, but humans must do certain things to maintain it.[57] This assured believers of their salvation by equating causes with their corresponding effects. If one is obedient, then one will be rewarded; if one is sinful, then one will be punished.[58]

This solution was facilitated by the evidential method of Francis Bacon, which was adopted from natural science and used by Christians in America to demonstrate their certainty of salvation[59] The manifestation of faith in one form or another has usually been important for Christians. With Bacon, however, evidential Christianity was not only concretized in Europe and America, but in a particular form in which it was now tantamount to scientific method.

Yet this became only secondarily about assurance as knowledge or intellect, and primarily about the will. For John Calvin and William Perkins (probably the most influential theologian in New England during the seventeenth century),[60] the will was crucial, but faith as knowledge still had the favorable place. William Ames, however (whose influential *Marrow of Theology* was the theological text at Harvard College),[61] went even further and asserted that faith was primarily based in the will.[62] Moreover, in the

55. Miller, *Errand*, 53.
56. Bercovitch, *American Self*, 8–25; Miller, *Errand*, 53ff. See also Perkins, *Work*, 256ff., 357–361, 392.
57. On Calvin's followers regarding covenant, see Miller, *Errand*, 60ff.
58. Camille Wells Slights discusses how one's conscience was analyzed to determine one's faith and the emotional turmoil that attended that connection in "The Conscience of the King: *Henry V* and the Reformed Conscience," *Philological Quarterly* 80, no. 1 (Winter 2001): 42ff. See also Timothy L. Wood, "Kingdom Expectations: The Native American in the Puritan Missiology of John Winthrop and Roger Williams," *Fides et Historia* 32, no. 1 (Winter 2000): 48–49.
59. On the significance of Bacon for American theology, see Miller, *Mind*, 217ff.; Noll, *America's God*, 94, 234ff. Holifield, *Theology*, has an entire section titled "The Baconian Style," 159–394; see especially 174ff.
60. Winship, "Weak Christians," 472.
61. On the significance of Ames, see Miller, *Mind*, 166–167.
62. John Dykstra Eusden, introduction to *Marrow of Theology*, 48–49. See also Burtt, *Foundations* (294) on this move in Newton also.

Conscience, he disagreed with Perkins that conscience is a faculty of the mind. Wanting to emphasize the pragmatic dimension of theology, he suggested that it is rather "an act of practical judgment."[63]

Logically, this situation gave individual believers, or doers, extraordinary control over their destinies. Newton's mechanics contributed to an *ordo salutis* (order of salvation) in which particular actions bump one to the next stage or step of salvation (e.g., justification, sanctification, regeneration, etc.);[64] and Bacon helped to determine how one *knew* in which state one was. Not only is such a theology impervious to critique,[65] but it also inevitably leads to atheism. The active "He will bless us if . . ." eventually becomes the passive "We will be blessed if. . . ." Invocation of God at all becomes superfluous at best, ignorant at worst, a conclusion that was not overlooked even in the seventeenth century, although it remained a minority view.[66]

In the growing secularization of American frontier ideology, this soteriological perspective on work was adapted without the theological hang-ups. It helps to make sense of the individualistic attitude of the early literary heroes, who were now free not only from the strictures of community, but also from divine decree, and thus able to manifest their preferred destiny.[67] This is also precisely where America at large found itself; the turn to salvation by works meant that it *could* create its own destiny, but the isolation from England meant that it *had to.*[68]

One of the features that enabled this self-creation was the particular approach through which Americans perceived natural and human others as they progressed westward, which has its roots in the epistemological shifts of the early modern period. Whereas in the Middle Ages human noetic pursuits were tempered by awareness of the infinite and of our relation to it,[69] in early modern thought the autonomous human subject became the measure of all things.[70] This was worked out in the well-known developments from René Descartes to John Locke, David Hume, and finally to Immanuel Kant, for whom even time and space are simply subjective noetic categories through which we organize our perception of the world.[71]

63. Eusden, introduction, 18. See also Miller, *Mind,* 173, 214; Slights, "Conscience," 43.
64. Shults and Sandage, *Faces,* 145–148.
65. Winship, "Weak Christians," 465ff.
66. See David Parnham, "The Humbling of 'High Presumption': Tobias Crisp Dismantles the Puritan Ordo Salutis," *Journal of Ecclesiastical History* 56, no. 1 (January 2005): 50–74.
67. Slotkin, *Regeneration,* 287, 430ff.
68. See Bercovitch, *American Self,* 13ff.
69. Barry Rasmussen, "Richard Hooker's Trinitarian Hermeneutic of Grace," *Anglican Theological Review* 84, no. 4 (Fall 2002): 930–931.
70. Gunton, *One,* 28ff.; Rasmussen, "Hermeneutic of Grace," 931–933.
71. See Gunton, *One,* 86ff., 114–119; Colin Gunton, *Enlightenment and Alienation* (Grand Rapids: Eerdmans, 1985), 11–26.

This epistemological turn is explicitly connected to substance ontology as well. Barry Rasmussen observes that Richard Hooker's relational (i.e., Trinitarian) presuppositions contrasted with "all cultural expressions that were based on the modern hardening of language that conceptualized substances as being self-contained and autonomous."[72] The point for us is not an excursus on Hooker, but to note that his (increasingly unpopular) epistemology was a reaction against the culture at large and especially against English puritans, who brought these individualistic ways of thinking to the New World.

The ossified separation of subject and object that attended these developments was also adopted by early American theologians, and has had negative consequences for the last few centuries, one of which was the early Americans' notion that their new identity had to be carved out in opposition to the natives. In this context, the covenant was used as an epistemic device to determine who was an external objectified other and who was an appropriate subject, in essence, to decide who was "in" and who was "out."[73] As many settlers moved into the western frontier and abandoned covenantal ideas, a modified epistemological approach was employed to discern subject and object.

William Meyer, Jr. refers to this noetic development as *hypervisualization*, by which he means the anti-intellectual and anti-verbal centralization of the eye in attitudes toward the wilderness.[74] It is characterized by immediate, self-reliant, and independent knowledge gained by one's own vision of the world. Meyer notices that this was deliberately preferred to the *hyperverbal past* of the civilized east and Europe, in which tradition and book-learning had priority.[75]

Here, then, the puritan shift away from the intellect and toward the determining power of the will comes to fruition on the frontier in the rejection of history, civilization, and religion, and in the embrace of individualism, autonomy, and immediate experience of the God of Nature, all characterized by a hypervisual epistemology that legitimates the creation of one's own destiny through rugged, practical know-how. It is with this in mind that we are able to understand the staunch ahistoricality of Ralph Waldo Emerson and Henry Ford;[76] the anti-verbal, anti-literary sentiments of James Fenimore Cooper and Herman Melville; and the pragmatism of Teddy Roosevelt, Buffalo Bill Cody, and John Wayne. They are all cut from the same cloth.

72. Rasmussen, "Hermeneutic of Grace," 931.
73. See Zubeda Jalalzai, "Race and the Puritan Body Politic," *MELUS* 29, nos. 3–4 (Fall/Winter 2004): 260–261, 266ff.
74. William E. H. Meyer, Jr., "The Hypervisual Meaning of the American West," *Philosophy Today* 33, no. 1 (Spring 1989): 30.
75. Meyer, "Hypervisual Meaning," 32. See also Masters, "Knowledge," 1–30.
76. Ford famously said that "History is more or less bunk," in an interview with Charles N. Wheeler, *Chicago Tribune*, May 25, 1916.

At the same time that hypervisuality was determining the western United States, Scottish Common Sense epistemology was taking a stronger hold in the east, as an alternative to established monarchical authority.[77] Yet the same substance ontology and separation of subject and object lie at the heart of both epistemic attitudes. For one, they are highly individualistic and, hence, lack any sort of accountability, save for acquiescence to majority opinion. More significant for our purposes is the metaphysics of distance entailed by hypervisuality.[78] The other can never be known on his or her own terms. She is always "over there" or "out there," located in a vista of one's own imagining, which necessarily excludes her because of one's "common sense" that she is culturally different and, therefore, ontologically inferior. After all, if one is an autonomous self-reliant substance, complete unto oneself, who perceives another strictly as an objectified other who is not like oneself, then the other must be inferior. To the extent that they interact, then, the other must either be assimilated or removed.

HUMAN ACTING AS HOMOGENIZING VIOLENCE

The English and New England puritans followed Calvin and his successors in adopting the Western Christian idea of inherited sin. This was formulaically introduced by Augustine, who drew upon other theologians and the substance philosophical categories of the time to suggest that infants inherit the stain of sin from their parents as they also had, going all the way back to Adam.[79] In the early modern period, the description of the mechanism through which we partake in Adam's sin shifted from biological to political language, such that by the seventeenth-century colonization of America the standard puritan conception was that the guilt of sin was imputed to every human being through the federal headship of Adam.[80]

Yet, what did not change was the notion of sin as located primarily at the individual level as a stain or blemish on the soul. In traditional churches, the accompanying isolation of this situation was partially mollified through confession and absolution. In English puritan theology, however, which became more individualistic in proportion to the level of ecclesial and monarchical censure it faced,[81] the feelings of isolation were exacerbated and combined with epistemic anxiety over one's salvation.

77. Miller, *Mind*, 111–153.
78. See Walter Ong, *Orality and Literacy* (London and New York: Routledge, 2002), 70–76.
79. Shults, *Anthropology*, 193ff. The primary source in Augustine is his "A Treatise on the Merits and Forgiveness of Sins, and on the Baptism of Infants."
80. Miller, *Errand*, 80ff. See also Ames, *Marrow*, 127 (1.XVII); Shults, *Anthropology*, 189ff.
81. William Haller, *The Rise of Puritanism* (New York: Harper, 1957), 6ff. See also Miller, *Mind*, 297.

In both England and New England, this resulted in a great increase in the keeping of diaries and personal spiritual writings,[82] which described the Christian life chiefly in terms of a battle with a sinful soul that must be purged of its evil blots.[83] Here, we can also see the connection of inherited sin to substance ontology. If that for which one strives is antithetically opposed to that which one is (an individual substance whose soul is stained by inherited sin), then the logical result is a metaphor and, ultimately, ontology of violence, since there is no room for these two impulses to coexist if one's eternal destiny is dependent on the displacement of one by the other. Even if this were the right way of formulating the situation, the puritan covenant and anxiety over salvation precluded the possibility of existential paradox (something more common in Lutheran piety).

It only made sense, then, that when devotion was transferred to ethics, warfare would likewise serve as the dominant motif.[84] Consider again the logic of the covenant, which was simply the social correlate of divine predestination.[85] God elects both one's soul and one's covenant community for eternal salvation. The life of both depends on one's hard work to be victorious over things that would threaten their salvation. As one works to purge one's soul of its evil stain, so one strives to expunge the villainy that threatens one's community. Since those who worship other gods and have other ways of life threaten the salvation of one's soul and culture, they must either become similar or be removed or destroyed.[86]

Hence, we can understand the burning of alleged witches and especially the rationale behind policies toward Native Americans. At first they were intended to be converted, which meant not only a religious change, but also a complete transformation to English mores and customs—total homogenization.[87] When this method met with significant problems already in the seventeenth century, the only other options were removal (thus, today's

82. See Ong, *Orality*, 149; Slights, "Conscience," 37; Matthew Peters, "Individual Development and the American Autobiography: Franklin, Thoreau, Adams," *Philological Quarterly* 84, no. 2 (Spring 2005): 241–243.
83. Slotkin, *Regeneration*, 149; Wood, "Expectations," 42. See also Perkins, *Work*, 237ff.
84. Slotkin, *Regeneration*, 148ff.
85. Pointer, "Puritan Identity," 66–67, 69; S. K. Baskerville, "Puritans, Revisionists, and the English Revolution," *The Huntington Library Quarterly* 61, no. 2 (2000): 157.
86. Slotkin, *Regeneration*, 37–56; Wood, "Expectations," 40–41. See also Thomas Jefferson's view in Peter S. Onuf, "'To Declare Them A Free and Independent People': Race, Slavery, and National Identity in Jefferson's Thought," *Journal of the Early Republic* 18, no. 1 (Spring 1998): 17–23, 38.
87. Jalalzai, "Puritan Body Politic," 262ff. See also Dawson, "Charitie," 137; Wood, "Expectations," 40ff., 45ff.; Tiffany Potter, "Writing Indigenous Femininity: Mary Rowlandson's Narrative of Captivity," *Eighteenth-Century Studies* 36, no. 2 (Winter 2003): 153ff.

reservations) or destruction.[88] Accordingly, Slotkin suggests that "tales of strife between native Americans and interlopers, between dark races and white, became the basis of our mythology."[89]

With subsequent generations, secularity spread and belief in inherited sin diminished. Instead, the concept of virtue became the locus of moral judgment. This turn was enabled by the adoption of republican forms of government in the eighteenth century, which Christian theologians welcomed because of the ethical values shared by Protestants and republicans.[90] This mutuality itself was based on a shared assumption of Common Sense moral reasoning, in which one could discern by nature the right virtues to extol and by which to live.[91]

Common Sense reasoning, however, is as problematic ethically as it is epistemologically. For one thing, its basis in Baconian inductive science and Newtonian physics means that ethical action takes the form of isolated atoms (that is, human persons) bumping into each other in an attempt to assert each one's "common sense" over against the other. It is, in other words, a perfect precondition for violence.

Moreover, it fails to consider the importance of social location and tradition in moral development. In the monomyth, this contributed to the moral certainty so characteristic of American heroes. If what is right can simply be read from nature by an enlightened mind whose faculties are functioning properly, then there is no doubt that what one *thinks* is ethical is *in fact* ethical. Hence, it was considered obvious to most wealthy white European men that dark-skinned natives, African slaves, women, and the poor were inferior and could legitimately be treated as such.[92]

This individualistic and immediate moral certainty was exacerbated after the Civil War, when it was combined with the Social Darwinism of Herbert Spencer and others, in which "survival of the fittest" was adapted from its biological roots and used prescriptively to justify the oppression of minorities.[93] Common Sense philosophy assumed others were inferior, and Social Darwinism justified it. This combination of thought figured prominently in

88. Kristina Bross, "Dying Saints, Vanishing Savages: 'Dying Indian Speeches' in Colonial New England Literature," *Early American Literature* 36, no. 3 (2001): 335ff.
89. Slotkin, *Regeneration,* 18.
90. Noll, *America's God,* 209–224.
91. Miller (*Mind,* 196) suggests that this self-evidentiality had its precedent in the puritan theologians.
92. See Como, "Women," 203–204, 208; Lane, "Desire," 385; Onuf, "Jefferson's Thought," 2, 17, 25–26, 34–35; Saxton, "Bearing the Burden," 28–33; Audrey Smedley, "'Race' and the Construction of Human Identity," *American Anthropologist* 100, no. 3 (September 1998): 694ff.
93. Hughes, *Myths,* 130–133; Slotkin, *Gunfighter,* 39–52; Jay Hatheway, "The Puritan Covenant II: Anti-Modernism and the 'Contract with America,'" *The Humanist* 55, no. 4 (July 1995): 24–26.

the revival of Manifest Destiny ideology in the 1890s and the interventionist policies of presidents Teddy Roosevelt, William McKinley, and Woodrow Wilson.[94]

This situation also had a significant economic dimension to it during the turn of the twentieth century.[95] It meant the legitimization of policies that oppressed those less financially successful, which in the growing urbanization and industrialization of commerce tended to be immigrants and racial minorities.[96] These causes were called *progressivist* at the time and were tempered by a *populist* movement that promoted economic responsibility and democratic equality.[97] America's national mythology alleviated the tension between the two by combining both ideologies into its expanding image of the hero. Similar to the way that the tensions between individualism and civilization were subsumed in Cooper's tales, the opposition between progressivism and populism were transcended in the pulp fiction genres of the western and hard-boiled detective.[98] Specifically, the populist trait of vigilante violence was employed to protect the community from conniving aristocrats who would oppress the poor in the community. The hero himself was a perfect moral exemplar who had created his quality by being the fittest (in the Social Darwinian sense), but who works to preserve the democratic egalitarian community from both outsiders and greedy insiders. This must be understood in relation to the works soteriology developed in puritan theology in the seventeenth and eighteenth centuries, since an aspect of Social Darwinism, even if unspoken, is the idea that one *makes* oneself the fittest.

It is against this backdrop that we are best able to understand the element of the American monomyth in which the hero restores the community to its original paradise.[99] Early puritan thought laid the groundwork for a notion of perfect community in its idea of the covenant. However, even they understood that the blessings of the covenant were dependent on the obedience of the community. As this theological dimension was lost contemporaneous with the growth of self-reliance on the frontier,[100] however, the idea of a potentially fallible community was replaced by the myth of the innocent community, which was concretized in public thought, especially by Woodrow Wilson

94. Hughes, *Myths*, 105–119, 163–166; Lawrence and Jewett, *Myth*, 58–59; Sally Frahm, "The Cross and the Compass: Manifest Destiny, Religious Aspects of the Mexican-American War," *Journal of Popular Culture* 35, no. 2 (Fall 2001): 83–99.
95. See Frey, "Economic Values," 1573–1580; Schweitzer, "Affiliation," 442, 446ff.; Max Weber, *The Protestant Ethic and the Spirit of Capitalism,* trans. Talcott Parsons (New York: Charles Scribner's Sons, 1958 [German 1904–1905]).
96. Hughes, *Myths*, 136–148; Slotkin, *Gunfighter*, 157ff.
97. Slotkin, *Gunfighter*, 29–122.
98. Ibid., 194–228.
99. See Lawrence and Jewett, *Myth*, 22ff.
100. Slotkin, *Regeneration*, 296.

on the eve of World War I.[101] By the time of Wilson, the project of native removal was complete, the frontier was closed, and all sociomythic resources could be spent bolstering white civilization against those who would undermine it from within (immigrants, labor unions, blacks) or without (Germans, eventually Communists). The contemporary monomythic hero—that is, after the syntheses of frontier–civilization and progressive–populist polarities—is, thus, one who simply restores the status quo.[102]

This means that when the town is restored to peace at the end of the story, there is no real change effected therein. Although this was prefigured already in seventeenth-century captivity narratives,[103] the complex question of whether or not people had sinned and thus deserved divine punishment at least made fallibility and repentance possible. Moreover, in captivity accounts, those who were rescued reflected deeply on their experiences and often expressed profound change and difficulty in returning to their earlier lives.[104] The cumulative effects of Common Sense ethics, frontier autonomy, Social Darwinism, and the myth of innocence, however, led to a monomythic formula by the early twentieth century in which there was no transformation as a result of the hero's deeds. Nothing is challenged, and at the end of the day the community goes about its business as usual until the next time it needs a savior. The town in peril is self-sufficient and perfect just as it is, with no ethical judgment on the conditions of its own institutions.[105] Correlatively, this means that evil and sin are limited to the perceived malignant agency of particular individuals who either threaten the community externally or have gone astray from within.[106]

Not only are the community's assumptions unchallenged at the end of the story, but the hero as well is left untouched, although with a few more kills added to his belt. This phase of the archetype fully reaffirms everything that has gone before, especially the hero's independence and refusal of sexuality, family, and communal life. It does this with a chilling consistency, for if the hero stayed, he would not only be tied to the institutions of society which he wants to avoid,[107] but also his self-subsistence would be called into question by exposing ethical doubt and imperfection and, thus, vulnerability.

In at least two ways, then, the idea of the hero as the defender of an Edenic status quo is problematic. First, it denies the genuine development of character that would certainly attend such traumatic events, both for the hero personally and the community socially, let alone the consequences related

101. Hughes, *Myths*, 153–189. See also Richard M. Gamble, "Savior Nation: Woodrow Wilson and the Gospel of Service," *Humanitas* 14, no. 1 (2001): 4–22.
102. See Slotkin, *Gunfighter*, 181ff.; Slotkin, *Regeneration*, 465.
103. Slotkin, *Regeneration*, 94ff.
104. Ibid., 110ff.
105. Lawrence and Jewett, *Myth*, 27, 358.
106. Cohen, "Motifs," 31.
107. See Slotkin, *Regeneration*, 464–465.

to the hero's place in that community. Second, it precludes the possibility that the community itself may be embracing structures that are inherently oppressive or exclusive. By being primarily concerned with the unquestioned restoration of the community and its conventions, the hero works to promote possibly unethical systems, implicitly if not intentionally.

SUMMARY

Here, then, is the background of the contemporary American monomyth. So prevalent in our present culture to the point of unconscious common expectation, it is actually a unique amalgamation of ancient and early modern philosophical and theological categories developed mythologically since the seventeenth century. Its assertions about what it means to be human are based on an ontology that sees persons as isolated, self-contained substances; an epistemology that presupposes a hardened distinction between autonomous subject and objectified other via a hypervisualizing metaphysics of distance; and an ethics in which a homogeneous community oblivious to its own wrongdoings guarantees its sameness and safety through the violent destruction or forced removal of perceived threats to its values and traditions. These are the anthropological assumptions that lie behind the development of the superhero comics of the Golden Age period up until 1961, to which we now turn.

2 The Anthropology of the American Monomyth in Golden Age Superhero Comics (1938–1961)

INTRODUCTION

My goal in this chapter is to show how the conceptions and assumptions of the American mythic system regarding human being, knowing, and acting came to expression in superhero comicbooks from 1938 (the introduction of Superman) to 1961 (the introduction of the Fantastic Four), a period generally known as the *Golden Age* of comics.[1] We will see how the ideas of independence, autonomy, certainty, supremacy, and cultural hegemony were recast in the particular medium of superhero comics in the unique context of mid-twentieth-century United States. We begin with a brief discourse on the transition from the nineteenth century to the twentieth, in order to better understand our subject.

THE CULTURAL AND HISTORICAL CONTEXT OF GOLDEN AGE SUPERHEROES

The Golden Age comicbook superheroes, beginning in 1938 with Superman, may be approached from a variety of perspectives. For our purposes here, in order to explore the anthropology of the American monomyth during

1. The Golden Age is typically dated from 1938 to 1954/55, and the Silver Age from 1956 with the revival of the DC hero Flash to about 1971/2. I suggest, however that the anthropology presented in the Golden Age never really changes until the debut of *Fantastic Four* #1 (November 1961). Therefore, my use of the term *Golden Age* refers to the years 1938–1961. Comics historians also tend to agree that the real shift in superheroes began after this time. See Jeffrey S. Lang and Patrick Trimble, "Whatever Happened to the Man of Tomorrow? An Examination of the American Monomyth and the Comic Book Superhero," *Journal of Popular Culture* 22, no. 3 (Winter 1988): 157–173; John M. Trushell, "American Dreams of Mutants: The X-Men—'Pulp' Fiction, Science Fiction, and Superheroes," *Journal of Popular Culture* 38, no. 1 (August 2004): 152. For more detailed discussion of comics eras in general, see Shirrel Rhoades, *A Complete History of American Comic Books* (New York: Peter Lang, 2008), 4–7. Also, the conjoined term *comicbook* is Stan Lee's preference as opposed to *comic book*. Stan Lee, introduction to *Marvel: Five Fabulous Decades of the World's Greatest Comics*, by Les Daniels (New York: Abradale, 1991), 10.

this time, we will focus on two: mytholiterary aspects and socioeconomic aspects.

Literarily, there is a connection between the frontier hero novels of James Fenimore Cooper and Golden Age superhero comics. This was mediated primarily by the late-nineteenth-century dime novels and the Wild West show of Buffalo Bill Cody, in which the complex circumstances of the frontier and the oppressive violence of white settlers were sanitized for audiences and distorted into a mythic picture of innocent whites taming dark savage peoples and lands.[2] As the real frontier closed and Native Americans were destroyed or removed to reservations, reality more easily gave way to fantasy, opening such mythic spaces and simplifying historical facts.

Buffalo Bill stories were the direct precursors to the western genre, whose most formulaic expression is Owen Wister's 1902 novel *The Virginian,* in which an aristocrat from Virginia moves to Wyoming and enters a dispute between ranchers and small farmers, taking the side of the former to dispense vigilante justice against cattle thieves.[3] Novelist Zane Grey, who was heavily influenced by Wister, proliferated and solidified the western formula in numerous books and short stories in the early twentieth century. His tales typically feature freedom-loving loners who defend honest people from oppression and manipulation by greedy men of power.[4]

As the growing industrialized cities of the east became the cultural center of the United States once again in the twentieth century, the literature expressing American mythology needed to accommodate those who knew nothing of the frontier. Richard Slotkin identifies the hard-boiled detective as a key mythic figure meeting this need. Like the heroes of Grey and Cooper, this urban counterpart is a man who knows the wilderness; in this case, not the native peoples but crime and criminals.[5] He is a combination of outlaw and detective: acting outside the law to enact his own definition of justice, which is usually congruent with eastern aristocratic values. Although his mission is often a private one of revenge, like the western hero this includes rescuing victims of criminal plots. At the end of the day, the hard-boiled detective is an incarnation of the frontier hero; "an agent of regenerative violence through whom we imaginatively recover the ideological values . . . of the mythic Frontier."[6]

Moreover, his world is one in which all money is big and dirty, the rich few dominate the poor, and systems of justice are corrupted by bribery. Accordingly, he is a champion of populist economics against those whose

2. On this transition, Danny Fingeroth, *Superman on the Couch: What Superheroes Really Tell Us about Ourselves and Our Society* (New York and London: Continuum, 2006), 39–45.
3. Lawrence and Jewett, *Myth,* 31–35; Slotkin, *Gunfighter,* 169–183.
4. Slotkin, *Gunfighter,* 216.
5. Ibid., 218–228.
6. Ibid., 228.

greed would be satisfied at the expense of the working lower classes. Considering that the pulp fiction in which the hard-boiled detective thrived was cheap, prolific, and popular among these masses, it is no surprise that pulp heroes in general had a bias against great wealth.[7] This was exacerbated after the stock market crash of 1929, when the divide between rich and poor was amplified. The story of the good badman, the sympathized criminal or outlaw detective, was the conventional device during this time for exploring the transition from frontier to civilization.[8]

It is in this overall context that we are best able to understand the mytho-literary dimensions of the Golden Age superhero. Like his hard-boiled pulp predecessor, Superman is an urban version of the western hero, an adaptation who resolves the unique tensions of life in the city.[9] Even more than Superman, Batman reflects the gritty noir underworld of urban crime; his explicit intent is to drive fear into the hearts of criminals.[10]

A fuller appreciation of the early superhero is possible only if we also consider the parallel socioeconomic aspects of its development. The rise of comics needs to be understood in the context of the Gilded Age, roughly 1873–1893, when immigrants surged into the northeastern cities and constituted a significant portion of the factory workers in growing industries that were dominated by a small number of wealthy tycoons. This situation demanded affordable forms of leisure and entertainment for the working masses, most of whom would never progress beyond their meager positions. Both newspaper comic strips and pulp literature originated in 1896 and were printed on cheap material that made them affordable to the urban lower class.[11] It was in these media that several genres, including the western and hard-boiled detective, first became popular.

Despite the proliferation of fictional protagonists during this time and the first few decades of the twentieth century, Americans also had real-life heroes. While the earliest of these in our history were politicians such as Benjamin Franklin and George Washington, there was a shift toward preferring practical intuition and instinct over theoretical reason, such that industrious men like Henry Ford and Thomas Edison were elevated to heroic status.[12] Before 1929, there was still the notion, even among the masses, that anyone with

7. Ibid., 195.
8. Ibid., 265.
9. Gary Engle, "What Makes Superman So Darned American?" in *Superman at Fifty! The Persistence of a Legend!* Ed. Dennis Dooley and Gary Engle (Cleveland: Octavia, 1987), 85; Wesley C. McNair, "The Secret Identity of Superman: Puritanism and the American Superhero," *American Baptist Quarterly* 2, no. 1 (March 1983): 6; Bradford Wright, *Comic Book Nation: The Transformation of Youth Culture in America* (Baltimore: Johns Hopkins University Press, 2001), 9–10.
10. *Detective Comics* #33 (November 1939).
11. Daniels, *Marvel*, 15.
12. Lang and Trimble, "Man of Tomorrow," 159.

enough determination and fortitude would be able to escape his destitution and take a seat with the rich and powerful. When the market crashed at the end of October 1929 and brought about the Great Depression, however, our optimism fell and our perspective of real-life heroes waned, as once-trusted people became corrupt, causing us to turn more to fictional heroes.[13]

Shirrel Rhoades suggests that this tragic situation was a major catalyst for the success of comics, as demands intensified for cheap escapist entertainment.[14] The first comicbooks appeared in 1933 as reprints of newspaper strips, followed in 1935 by the first comicbooks with original material.[15] In 1938, the fledgling Detective Comics company (better known as DC) launched a new series called *Action Comics,* whose first issue, dated June 1938, featured a new type of hero, Superman.

Socioeconomically, the early Superman exemplified conflicting aspects of American mass culture.[16] On the one hand, he was created to shore up the deficiencies brought by the Depression and those whose greed led to the economic ruin. Thomas Andrae discusses how Superman's public concerns paralleled the general climate of the common person in the 1930s.[17] In this era, the economic hardships of the masses created disillusionment with the government and the American Dream more broadly. The rich tycoons got richer at the expense of the workers, and the government structures at the time only served to legitimate this social irresponsibility.

For his first few years, consequently, Superman was dedicated primarily to helping the economically disenfranchised, reflecting an antiestablishmentarian ethos.[18] In these comics, he dealt with such issues as unjust execution, domestic abuse, political corruption, rights of the accused, prison brutality, hazardous working conditions, slum conditions, juvenile delinquency, and dishonest labor unions, to name a few.[19] "In these early issues," Andrae observes, "Superman is clearly the champion of the underdog, displaying a sense of class consciousness virtually absent from later comic book stories."[20]

13. Lang and Trimble, "Man of Tomorrow," 159; Thomas Andrae, "From Menace to Messiah: The History and Historicity of Superman," in *American Media and Mass Culture: Left Perspectives,* ed. Donald Lazere (Berkeley: University of California Press, 1987), 124–138.
14. Rhoades, *History,* 10.
15. For surveys of the early history of comicbooks, Bradford Wright, *Nation,* 1–29; Nicky Wright, *The Classic Era of American Comics* (London: Prion, 2000), 3ff.
16. For a survey, Neil Harris, "Who Own Our Myths? Heroism and Copyright in an Age of Mass Culture," *Social Research* 52, no. 2 (Summer 1985): 241–267.
17. Andrae, "Messiah," 124–138.
18. Lang and Trimble, "Man of Tomorrow," 161; Ben Saunders, *Do the Gods Wear Capes? Spirituality, Fantasy, and Superheroes* (London and New York: Continuum, 2011), 22ff.
19. See Bradford Wright, *Nation,* 11–13.
20. Andrae, "Messiah," 130. See also Jason Bainbridge, "'This Is *the Authority.* This Planet Is Under Our Protection'—An Exegesis of Superheroes' Interrogations of Law," *Law, Culture and the Humanities* 3 (2007): 455–456.

The need for inexpensive leisure led, on the other hand, to the serialization of fictional hero stories in the 1930s. Literary critic Irving Howe saw the close connection between industrial society and mass entertainment already in 1948,[21] but in the context of superheroes proper, the key text is Umberto Eco's 1961 essay "The Myth of Superman."[22] According to Eco, as Superman's popularity grew in the late 1930s, he and other heroes became commercialized and commoditized in the growing consumerist environment. It is in observing the tension between the need for dramatic development inherent in Western narrative, on the one hand, and the commercial demands for serialization and stasis, on the other, that Eco interprets comicbooks as characterized by an *oneiric climate*.[23]

This he defines as a tactic employed by comics writers to both connect each superhero story to previous ones in that character's mythos and to separate them by writing new and self-contained stories each issue. Thus, "what has happened before and what has happened after appear extremely hazy."[24] In this way, Superman was kept from maturing and growing toward death, allowing him to return in theoretically infinite subsequent issues.[25] Eco's main concern is the fact that, due to industrialization, our need for relaxation had become manifested in a loss of temporal progression, which was replaced by consumable and renewable products in an elongation of the present. Such *narratives of redundance*—constantly renewable stories that follow the same generic formulae—were becoming the norm instead of the exception.[26] Lang and Trimble suggest that this serialization was a key condition contributing to the full emergence of the American monomyth in the formative *axial decade* of the 1930s.[27]

It is no wonder, then, that they consider Superman to be the "purest example of the twentieth century American monomythic hero."[28] Not only is he tied mytholiterarily to the American hero heritage and socioeconomically to the immediate context in which he was created,[29] but his individualism and lack of temporality are also expressions of the philosophical and theological categories outlined in chapter 1. He personifies the puritan work ethic and embodies the American ideals of fair play, equal opportunity, and

21. Irving Howe, "Notes on Mass Culture," in *Arguing Comics: Literary Masters on a Popular Medium,* ed. Jeet Heer and Kent Worcester (Jackson: University Press of Mississippi, 2004 [original essay 1948]), 43–51.
22. Umberto Eco, "The Myth of Superman," in *The Role of the Reader: Explorations in the Semiotics of Texts* (Bloomington: Indiana University Press, 1979 [Italian 1961]), 107–124.
23. Eco, "Superman," 107–124. See also Andrae, "Messiah," 135ff.
24. Eco, "Superman," 114.
25. See Fingeroth, *Superman,* 34ff.
26. Eco, "Superman," 120ff.
27. Lang and Trimble, "Man of Tomorrow," 162.
28. Ibid., 160.
29. McNair, "Secret Identity," 5–12.

maximization of one's potential, even more so than does Captain America.[30] Gary Engle goes so far as to call Superman the "guardian of the American Way," symbolizing the right of each individual to pursue his or her own destiny.[31] Accordingly, Superman proceeds in an entirely autonomous manner, acting in alignment with frontier-style vigilante violence. He secularizes Judeo-Christian ideals, resulting in a dissonant combination of selfless, sacrificial individual on the one hand, and zealous destroyer of evil on the other,[32] echoing the earliest puritan captivity stories. This is only to be expected, considering our roots in an altered form of Calvinism, in which justification and success are based entirely on performance, manifested in the violent cleansing of ethnic and racial others.

We are to understand Eco's observation of the disintegration of temporality also within the theological and historical context previously outlined. Left alone to create their own future and destiny, Americans naturally lost sight of the past. By turning exclusively to the frontier, they abandoned historical consciousness. The subsequent turn to industrialization, where the masses lost even this frontier spirit of hope, meant the loss of a future. It is no wonder, then, that fictional heroes were restricted to a more-or-less immobile present, the irony being that they looked to them to free them from their own temporal anemia.

Between 1938 and 1941, however, the attitude shifted from a desire for external redeemers to a desire for heroes from within society. Franklin D. Roosevelt's New Deal explicitly rejected progressivist ideology, including the aspect of unchecked industrial growth.[33] The war effort simultaneously reinvigorated the economy and restored patriotism, a development that led to a remarkable shift from despair to confidence in less than five years.[34]

The unification of the country also meant a renewed optimism toward government institutions. Superman—formerly a champion of the oppressed whose first few years were drenched in social commentary and judgment—became a state-sponsored tool of the establishment. Even the grim and gritty Batman, who is usually associated with the dirty underbelly of the nation, fully endorsed American patriotism by urging readers to buy war bonds.[35] This shift was also manifested in an editorial decision by DC to cease the use of guns and killing by Superman and Batman,[36] thoroughly sanitizing the

30. Fingeroth, *Superman*, 73; Lang and Trimble, "Man of Tomorrow," 160. See also Brian Doherty, "Comics Tragedy: Is the Superhero Invulnerable?" *Reason* 33, no. 1 (May 2001): 54.
31. Engle, "Superman," 89.
32. Lang and Trimble, "Man of Tomorrow," 158.
33. Slotkin, *Gunfighter*, 256.
34. Lang and Trimble, "Man of Tomorrow," 163.
35. Nicky Wright, *Classic Era*, 37.
36. Les Daniels, *Batman: The Complete History* (San Francisco: Chronicle, 1999), 42; Gerard Jones, *Men of Tomorrow: Geeks, Gangsters and the Birth of the Comic Book* (New York: Basic, 2004), 174.

violence for less inhibited ingestion by America's youth. This second, establishmentarian phase would be the norm for the remainder of the Golden Age, at least with regard to the superhero genre.[37]

By the end of World War II, the felt need for superheroes drastically diminished, and eventually all but Batman, Superman, and Wonder Woman were cancelled. America was seen to be prosperous again and the cultural center moved from the complex urban scene to simple, affluent white suburbia. The introduction and use of the atomic bomb in 1945, however, had a schizophrenic effect on American culture of the 1950s. Les Daniels notes that, on the one hand, the bomb protected nuclear families and guaranteed the United States as a new superpower, while, on the other hand, there were underlying fear and guilt because of humanity's new power to destroy itself.[38]

This tension was fed back into the comicbooks of the period, and some timetables refer to the period from 1945 to the mid-1950s as the *Atomic Age* of comics.[39] While the 1950s superheroes were squarely on the side of America and the protection of the suburban nuclear family unit,[40] other genres and publishers called these dominant values and their perceived utopia into question. Entertaining Comics (better known as EC) was explicitly against war and the establishment during this time. Their crime and horror comics reflected a growing desire for realism in entertainment among readers during the early Cold War,[41] which included portraying the evils of abusive relationships, racism, and overzealous patriotism.[42]

Unfortunately for EC, however, these stories were presented in detailed images far too gruesome by contemporary standards. Psychologist Fredric Wertham famously led a public crusade against several genres of the time, including superheroes, but the lurid and grotesque pictures of EC's crime and horror comics were especially scrutinized. Wertham's efforts resulted in a congressional hearing, which itself led to the creation of the 1954 Comics Code, the first in a series of self-imposed content guidelines implemented and followed by several publishers, including DC and Marvel.[43] The public outcry did not affect superheroes as much as other genres, both because they were unpopular at the time anyway and because the 1941 editorial changes at DC helped to protect their flagship heroes from the witch hunt.[44]

By 1956, the hysteria had largely subsided, but not without leaving the industry in trouble. The demise of EC and crime and horror genres in

37. See Andrae, "Messiah," 132; Saunders, *Gods*, 24ff.
38. Daniels, *Marvel*, 64.
39. Rhoades, *History*, 45.
40. See McNair, "Secret Identity," 13.
41. Bradford Wright, *Nation*, 134–153.
42. Arie Kaplan, "Kings of Comics, How Jews Created the Comic Book Industry," part 1, *Arie Kaplan* (blog), accessed August 24, 2012, http://www.ariekaplan.com/reform-judaism/.
43. These events are detailed in Amy Kiste Nyberg, *Seal of Approval: The History of the Comics Code* (Jackson: University Press of Mississippi, 1998), esp. 53–103.
44. Daniels, *Batman*, 42.

general left a question mark about the future, particularly regarding what would take their place. In that year, DC's editor Julius Schwartz commissioned a one-shot story of the Flash, a relatively popular but second-tier superhero from the 1940s. Schwartz wanted a revised character, however, and the result was a new version, police scientist Barry Allen, who first appeared in *Showcase* #4 (October 1956).[45]

The new Flash turned out to be a hit and led to revamped versions of Green Lantern and other heroes. In 1960, DC published the first story of the superhero team Justice League of America (or JLA), a modernized take on the old Justice Society, this time with full membership by Superman, Batman, and Wonder Woman.[46] It was the success of the JLA that instigated Marvel publisher Martin Goodman to charge Stan Lee with creating their own superhero team in response. The Golden Age of comics ended, I suggest, with the publication of *Fantastic Four* #1 (November 1961).

With this historical and cultural context in mind, we now consider the specific anthropological views presented in the pages of Golden Age superhero comics. Notwithstanding the myriad social, cultural, economic, and religious changes in the United States between 1938 and 1961, it is evident that these stories are steeped in the American monomythic formula throughout, and, I propose, portray a relatively consistent idea of humanity,[47] one thoroughly congruent with the ontological, epistemological, and ethical contours described in chapter 1.

HUMAN BEING IN THE GOLDEN AGE

Just as the eighteenth- and nineteenth-century American literary heroes exemplified the substance ontology of the Western tradition, so, did the early comicbook protagonists. Like their imaginary counterparts, this was manifested primarily in the heroes' staunch independence and self-reliance. Richard Reynolds notices that the pop culture of the 1930s and 1940s in general was characterized by this kind of hero: an individualist who stands apart from society but operates on his own code of honor.[48] In the Golden Age superhero comics in particular, this also had a significant impact on several dimensions we will consider in this section, including superhero team-up stories, attitudes about sex and romance, treatment of women, and female hero myths.

Many have noticed the phenomenon of independence in comicbooks. Superman, for instance, is clearly "a rugged individual who does things on

45. Les Daniels, *DC Comics: Sixty Years of the World's Favorite Comic Book Heroes* (New York: Bulfinch, 1995), 116–117.

46. Daniels, *DC*, 126.

47. See Lang and Trimble, "Man of Tomorrow," 165.

48. Richard Reynolds, *Super Heroes: A Modern Mythology* (Jackson: University Press of Mississippi, 1992), 18.

his own"[49] and whose legacy is one of "assumed autonomy."[50] Lang and Trimble suggest that this was shaped by his adoptive parents, the Kents, and his Midwestern upbringing.[51] Even more than Superman, Batman fights a personal battle against the criminal element to avenge his parents' death.[52] His is an "utterly selfish vow" and the extent to which society benefits from his actions is only incidental.[53] His myth is that of the strong and healthy loner who makes his own destiny, leaving no room for prayer or helplessness.[54] In this sense, Batman and Superman perfectly express the secularized puritanism of the early American frontier discussed in the previous chapter, in which the epistemic anxiety over certainty of salvation is replaced by the definitive creation of one's own future.

It comes as no surprise, then, that so many comicbook superheroes are orphans. Some have noticed that this simply parallels American national identity as a people without a home and haunted by a "national sense of rootlessness."[55] Both the xenophobia of its dominant white citizenry and the rather extreme measures by which it burned its bridges with Europe meant that America would have to succeed on her own. American heroes, as personifications of her values, would be destined to orphanage, a logical correlate to her steadfast independence.

In his book *Superman on the Couch,* Danny Fingeroth makes some astute observations about the condition of orphans.[56] On the one hand, they are given incredible freedom to create their own destinies through choices that are unhindered by familial obligations. On the other hand, however, orphans have to suffer the negative consequences of loneliness and insecure identities, which, for better or worse, are often mitigated by relational commitments. In the Golden Age stories, notably, orphanage was treated more or less as a matter of fact, and the expected psychological repercussions were simply nonexistent.[57]

49. McNair, "Secret Identity," 6.
50. Julie D. O'Reilly, "The Wonder Woman Precedent: Female (Super)Heroism on Trial," *Journal of American Culture* 28, no. 3 (September 2005): 274
51. Lang and Trimble, "Man of Tomorrow," 161.
52. Will Brooker, *Batman Unmasked: Analyzing a Cultural Icon* (New York and London: Continuum, 2000), 44. See also Batman's introduction in *Detective Comics* #27 (May 1939).
53. Dick Giordano, "Introduction: Growing Up with the Greatest," in *The Greatest Batman Stories Ever Told,* by DC Comics (New York: Warner, 1988), 8. See also C. K. Robertson, "The True *Übermensch:* Batman as Humanistic Myth," in *The Gospel According to Superheroes: Religion and Popular Culture,* ed. B. J. Oropeza (New York: Peter Lang, 2005), 56.
54. Robertson, "*Übermensch,*" 61.
55. Engle, "Superman," 81.
56. Fingeroth, *Superman,* 67ff.
57. The closest we have to an exception is Batman, but still his traumatic childhood had no real effect on his personality during this time. See Fingeroth, *Superman,* 63ff; Bradford Wright, *Nation,* 185.

In terms of the formula of the American monomyth, the chief result of this independence was that heroes did not become part of a community at the end of the story. Instead, they ran off alone to help other people in need. Such a routine obviously works well for serialization, but considering the long history of isolationism and orphan mentality that has come to expression in American popular culture, it seems that serialization is more a symptom, rather than a cause, of refusing community. This can be seen even in the fact that it does not logically require nomadism. Heroic adventures could just as easily focus on the daily events of persons in a consistent setting.[58] Instead, heroic aloneness and itinerancy are best understood as an expression of our national identity. Gary Engle says it well: "Upward mobility, westward migration, Sunbelt relocation—the wisdom in America is that people don't, can't, mustn't end up where they begin."[59]

Accordingly, even the various recurring characters that fill out the casts of different Golden Age mythoi have little or no effect on the heroes' natures, save only for the intensification of concern with which the hero regards them relative to common citizens, and this typically only as a plot device. If one is a self-reliant substance, one's relations to others are merely accidental and, therefore, cannot have a real impact on the essence of who one is. The extent to which loner heroes care for others, then, it is primarily out of their sense of duty, not from genuine need.

The closest we have to an exception was the relationship between Batman and Robin that developed in the 1950s. Writing in detail on this topic, Will Brooker notes that the care and trust between them was rather unconventional.[60] Superhero relations at the time were strictly professional, not domestic or personal, such as that between Bruce Wayne and his young ward, Dick Grayson. The fact that Fredric Wertham famously described their relationship as a "wish dream of two homosexuals living together" only highlights its uniqueness in the context of superhero comics of the time.[61]

The standard professionalism to which Brooker refers, however, is depicted most clearly in the various superhero team-up stories that occurred occasionally throughout this period. In these crossover tales, especially in DC's Justice Society and the later JLA, the vast majority of the time, all the heroes got along fine without a hitch.[62] Daniels notes that the JLA heroes were "cheerfully cooperative" and often too crowded

58. That Marvel Comics actually made innovations in this area will be discussed in the next chapter.
59. Engle, "Superman," 81.
60. Brooker, *Batman*, 133–135.
61. Fredric Wertham, *Seduction of the Innocent* (New York: Rinehart, 1954), 190.
62. Fingeroth, *Superman*, 104; Jordan Raphael and Tom Spurgeon, *Stan Lee and the Rise and Fall of the American Comic Book* (Chicago: Chicago Review Press, 2003), 117.

for the development of unique personalities.[63] With them, DC was simply more concerned with plot than with characterization.[64] Moreover, in a chapter on superhero teams, Fingeroth suggests that the JLA—notably the most elite and exclusive—is a meritocracy; one can join only if one has *earned* a place there.[65]

This is perfectly consistent with the ontology outlined in chapter 1. As autonomous substances with uniform personalities and a common purpose, there is no place for dissension or disagreement among these heroes. One can only join such a team if one has demonstrated proficient self-sufficiency and independence. Meritocracy is the only available polity. The teams themselves, of course, never resemble actual communities, and quite often each hero is followed through a separate storyline in which each can maintain their self-reliance. Even when they team up against a common villain, the most that is conceded is that the villain is too powerful for any of the heroes to defeat alone.

Individualism is also reflected in heroes' perennial refusal of sex and romantic involvement. This is a well-known convention, which in American literature goes all the way back to at least Cooper's stories, and has characterized comicbook superheroes from the beginning. Superman's constant rejection of Lois Lane (although as Clark Kent, pining for her) is legendary, so formulaic already from 1938 and throughout the years that no examples need be given.[66] Other heroes were similarly apprehensive about romance. The Spectre never married his girlfriend, preferring instead the company of the Justice Society.[67] A famous story from 1953 depicts a wide-eyed Captain Marvel at the wedding altar with beads of sweat on his face, clearly feeling trapped.[68] Wonder Woman was also not allowed to marry.[69] Even the very few romances that did bud at the time, either temporarily or in imaginary stories,[70] "stayed at the level of grade school crushes."[71]

63. Daniels, *DC*, 126; Les Daniels, *Wonder Woman: The Complete History* (San Francisco: Chronicle, 2000), 105.
64. David A. Zimmerman, *Comic Book Character: Unleashing the Hero in Us All* (Downers Grove: InterVarsity, 2004), 98.
65. Fingeroth, *Superman*, 103.
66. See Lawrence and Jewett, *Myth*, 42–43; Ted White, "The Spawn of M. C. Gaines," in *All in Color for a Dime*, ed. Dick Lupoff and Don Thompson (Iola: Krause, 1997), 28.
67. Jim Harmon, "A Swell Bunch of Guys," in *All in Color*, 178.
68. Mark Best, "Domesticity, Homosociality, and Male Power in Superhero Comics of the 1950s," *Iowa Journal of Cultural Studies* 6 (Spring 2005): 81–82. See also Dick Lupoff, "The Big Red Cheese," in *All in Color*, 72.
69. Daniels, *Wonder Woman*, 101–102.
70. That is, those stories which were intentionally outside of official continuity.
71. *Comic Book Superheroes Unmasked*, The History Channel (2003; A&E Television Networks, 2005), DVD.

Several reasons have been offered for Superman's celibacy, which, by association, we can extend to other heroes as well.[72] While they all have some merit, we will augment them by offering another not suggested elsewhere: that is, that the Aristotelian substance metaphysics which undergirds popular American conceptions of being has found expression in heroes' celibacy. They cannot be intimate, because it would suggest a need on their part, which they cannot satisfy by themselves. Real sexual intimacy would mean true vulnerability, as with the heroes of early American literature, potentially invalidating the heroes' worthiness to save the community.[73] After all, if a real human with flaws and weaknesses were to save us from danger, then why could we not have just done it ourselves?

This refusal of sexuality was accompanied by rank misogyny. Consider Batman, for instance. Like other heroes, Bruce Wayne prioritizes his crime-fighting above his personal life,[74] and his girlfriends—of course, unaware of his secret identity—have never lasted long.[75] It was largely the lack of attractive, successful women in Batman's life in the first place that led Wertham to conclude that he and Robin were gay.[76] Will Brooker makes a strong case that the intimacy normally present in heterosexual relationships characterized the love between Dick Grayson and Bruce Wayne.[77] It was this exception to Golden Age individualism that Wertham mistakenly interpreted as homoerotic. In the wake of the U.S. Senate hearings and the Comics Code, however, DC responded by introducing Batwoman and Batgirl to discourage the notion that Batman and Robin were lovers.[78]

Nevertheless, Brooker contends that these new romances were unconvincing and that the heroes saw them as traps.[79] Daniels discusses an issue of *Batman* in which Robin has a nightmare about Batman and Batwoman getting married.[80] Although this may have been the creators' way of dissuading homosexual readings, Daniels also suggests that "this story may have succeeded in creating anxieties about females being the enemies of friendship and loyalty."[81] This fear must be understood in light of 1950s

72. To diverse perspectives, Best, "Domesticity," 82, 84; Brooker, *Batman*, 153; Eco, "Superman," 115; Lawrence and Jewett, *Myth*, 36–37; Nyberg, *Seal*, 168; Reynolds, *Super Heroes*, 66; Bradford Wright, *Nation*, 9; Joanna Connors, "Female Meets Supermale," in *Superman at Fifty*, 111; Jules Feiffer, *The Great Comic Book Heroes* (Seattle: Fantagraphics, 2003), 15.
73. See Lang and Trimble, "Man of Tomorrow," 162.
74. Aaron Taylor, "'He's Gotta Be Strong, and He's Gotta Be Fast, and He's Gotta Be Larger Than Life': Investigating the Engendered Superhero Body," *Journal of Popular Culture* 40, no. 2 (April 2007): 356.
75. Brooker, *Batman*, 104–105; Daniels, *Batman*, 29.
76. Wertham, *Seduction*, 191.
77. Brooker, *Batman*, 153ff.
78. Best, "Domesticity," 89; Brooker, *Batman*, 145.
79. Brooker, *Batman*, 156–157.
80. *Batman* #122 (March 1959).
81. Daniels, *Batman*, 92.

United States in general, in which the heroic, homosocial masculinity of World War II was being replaced by heterosexual domesticity.[82]

Yet, this phenomenon suggests two things. First, that the ideal American hero is a superior male, and second, that women are not fully human.[83] The first is articulated to lead logically to the second. That the model American hero is male is evidenced by the vast outnumbering of male heroes to female heroes, and the outnumbering of male comicbook creators to their female counterparts. Yet, these facts do not in themselves constitute misogyny. The argument only becomes overwhelming when we consider both the ways in which female characters are portrayed in comicbook stories and how they are treated by male characters.

It is well known that female characters have always been consistently drawn in comics as male (hetero)sexual fantasies: thin, attractive, and buxom. This is exaggerated with female heroes and villains (as opposed to mere supporting characters), because their costumes are typically either extremely form-fitting or scarce altogether. William Millar suggests that this objectification characterizes the American monomythic treatment of women at large.[84]

In the comicbook stories of the Golden Age, male characters treated their female counterparts as subordinate. Aside from the few female heroes at the time, women had one of two roles in the Golden Age: the annoying and helpless damsel in distress who futilely pines for the hero, or the ruthless conniving bitch who wants to see him fall (the villainess). The best example is probably Lois Lane, introduced in 1938 in the same issue as Superman himself. In the 1930s and 1940s, she synthesized two opposing ideas about women: that of the strong independent woman and that of the subservient woman of traditional gender roles.[85] In this sense, she actually shares features of both the villainess and the damsel. This is why, repeatedly throughout the comics, she is incredibly assertive and resourceful, often deceiving Clark Kent to get her story, but also usually ending up in need of rescue by Superman. By the late 1940s and 1950s, when male soldiers were returning from war to their civilian jobs, women were being driven out of those jobs and back into the home.[86] DC explicitly reinforced these traditional gender roles, including

82. Gerard F. Beritela, "Super-Girls and Mild Mannered Men: Gender Trouble in Metropolis," in *The Amazing Transforming Superhero!* Ed. Terrence R. Wandtke (Jefferson: McFarland, 2007), 52.

83. To the latter, Lark Hall, "The Other Side of the Coin: Reflections on Women in American Myth and Culture," *American Baptist Quarterly* 2, no. 1 (March 1983): 57–58.

84. William R. Millar, "Ronald Reagan and an American Monomyth, or The Lone Ranger Rides Again," *American Baptist Quarterly* 2, no. 1 (March 1983): 40–41.

85. J. P. Williams, "All's Fair in Love and Journalism: Female Rivalry in *Superman*," *Journal of Popular Culture* 24, no. 2 (Fall 1990): 106–107.

86. Roz Kaveney, *Superheroes! Capes and Crusaders in Comics and Films* (London and New York: I. B. Tauris, 2008), 19.

writing female characters as subordinate.[87] This helps explain why in stories from the 1950s and early 1960s, men constantly humiliated women. Lois, in particular, not only often must be rescued, but is then berated by Superman for not being smart enough to avoid capture in the first place.[88] Even when Lois got her own comicbook in 1958, she "was a catalog of stereotypes— from hussy to helpmate to hag."[89] In one issue of *Superman's Girl Friend, Lois Lane* from 1959, Superman grants superpowers to Lois just to teach her a lesson and maintain his patriarchal power over her.[90]

Lana Lang, Superman's other love interest, fared no better. She was introduced in 1950, but was later brought to the Lois Lane comics to serve primarily as Lois's rival in the effort to win Superman's affection.[91] By November 1960, the sole motivation for Lois and Lana was to show which of them could be a better housewife for Superman.[92] Whatever friendship they may have had was subordinated to their romantic rivalry.

In 1954, Wertham first noticed the inferior place of women in the comics. They were either superheroes flying around scantily clad or else molls or prizes to be abused, he thought. "The activities which women share with men are mostly related to sex and violence."[93] Wertham himself was unable to clearly connect this misogyny to the male homosociality of the time, which he mistakenly took to be homo*sexuality*. Nevertheless, the close and exclusively male bonds that Wertham observed, Best argues, functioned primarily to reinforce the genre's fantasy of male power in two ways. First, women were shown as threatening to masculinity, especially through marriage and domesticity. This is why women during the Golden Age are depicted as, at best, a nuisance.[94] Second, the comics presented male camaraderie as a means of containing the feminine threats. Batman and Robin are merely a continuation of this misogynistic maleness that runs throughout pop culture. Jules Feiffer contends: "In our society it is not only homosexuals who don't like women. Almost no one does."[95]

Comicbook scholar Jeffrey Brown waxes more philosophical. In his estimation, since their inception superhero comics have been "one of our culture's clearest illustrations of hypermasculinity and male duality premised on the fear of the unmasculine other."[96] The nonsuperpowered alter

87. Bradford Wright, *Nation,* 184–185.
88. Best, "Domesticity," 85.
89. Les Daniels, *Superman: The Complete History* (San Francisco: Chronicle, 1998), 100.
90. Beritela, "Super-Girls," 59. For other examples, see Best, "Domesticity," 91.
91. Williams, "All's Fair," 109.
92. Beritela, "Super-Girls," 57.
93. Wertham, *Seduction,* 234.
94. Best, "Domesticity," 81–86; Zimmerman, *Character,* 70.
95. Feiffer, *Heroes,* 53.
96. Jeffrey A. Brown, *Black Superheroes, Milestone Comics, and Their Fans* (Jackson: University Press of Mississippi, 2001), 174.

ego is seen as soft, impotent, insecure, and feminized. The pairing of feminine and impotent on the same side of the duality implies, of course, that women are powerless and, hence, less desirable than the superpowered (i.e., superior) male hero figure. This is evident from merely observing the comics.

Yet, this by itself still does not necessarily lead to our second contention that women are not fully human in Golden Age comicbooks. This becomes clear only when we consider male duality in light of the philosophical category of substance ontology. If to be human is to be an independent, self-subsistent substance whose relations are merely accidental—and the only such persons are superior males—then it follows that women are not human, or at least not completely.

This conclusion is unavoidable, even when we consider female superhero myths of the time. The prime example is, of course, Wonder Woman, created in 1941 by psychologist William Moulton Marston and introduced in *All Star Comics* #8 (December 1941). Despite Marston's intentions for her as a beacon of women's liberation and an inspiration for girls, Wonder Woman was in appearance an object of straight male sexual fantasies.[97]

Moreover, as with damsels and villainesses, Wonder Woman was still inferior to her male colleagues. In an illuminating essay, Julie D. O'Reilly dissects the differences between male and female heroes, in the context of the trials they are made to face that grant or legitimate their heroic roles.[98] She observes that the contests that male heroes are made to undergo are only mock trials, with no real significance. Superman and Batman simply choose to be heroes, while others, such as Captain Marvel and Green Lantern, have their roles and powers bestowed on them. The trials they undergo are not genuine, because they have the ability on their own to affect the outcomes. Wonder Woman and other female heroes, on the other hand, must pass tests according to the standards of the institutions that authorize their power.

This phenomenon of trials and mock trials emphasizes a polarity between male and female heroes. For the former it shows autonomy, for the latter it emphasizes weakness, highlighting not only a clear disparity between male and female heroes, but also the ancient binary of subject–object. The male hero is the self-sufficient subject, and the female hero, in spite of her physical strength, is still the weak, sexual other (the object), whose agency must be controlled and legitimated by a committee. That Wonder Woman has to earn her heroic right "only underscores the notion that female superheroes operate according to a different code of heroism than their male counterparts, a code with built-in limitations."[99]

97. Millar, "Monomyth," 41; O'Reilly, "Wonder Woman," 274; Bradford Wright, *Nation*, 21.

98. O'Reilly, "Wonder Woman," 273–283.

99. O'Reilly, "Wonder Woman," 275.

Equally illustrative of this sexism is the constant bondage that figured prominently in Marston's Wonder Woman comics. This is noted by almost everyone who discusses the character at all, and it not only expresses Marston's own love of bondage and whips,[100] but also his stated belief that women enjoy submission.[101] Ironically, Marston thought that this actually reduced violence.[102] Perhaps even more disturbing than the bondage itself, however, is the implication of what women are like if they are not so restrained. In one issue in which her bracelets are removed, for example, Wonder Woman goes berserk and attacks a group of Nazis. When she is finally restrained at the end, now with even tighter bracelets, she is grateful.[103]

Aside from the troubling issue of bondage, however, it is commonly assumed that Wonder Woman is a positive role model for girls and women. Mitra Emad notices that during World War II, when Wonder Woman was created, she did indeed encourage females' physical and economic strength.[104] Unfortunately, though, Emad contends that this was really a patriotic call for women to join the WAAC or WAVES. After the war, not surprisingly, Wonder Woman moved into more domestic roles, paralleling the contemporary transition of women from outside jobs back into their homes. Daniels concurs by observing that at the end of the 1940s, when the romance genre became popular in comics, Wonder Woman became more in need of a man.[105]

Ultimately, then, even though Marston intended to empower women and offer an alternative to hypermasculinity, he did nothing to fundamentally challenge the dominant heroic archetype.[106] Instead, Wonder Woman simply acquiesced to the male hero myth of violence and individualism, and her stories were articulated primarily in terms of the male pattern.[107] Even her idea of strength was still primarily physical, tested by how well she could compete with men.[108] Her sexuality was also like that of male heroes. Not only did she never marry love interest Steve Trevor during this time, but the general lack of men in her life and within her female group during the 1940s also brought Wertham's accusations of lesbianism.[109] Perhaps not surprisingly, girls actually read Superman more than Wonder Woman during the Golden Age.[110]

100. Nicky Wright, *Classic Era*, 100.
101. Daniels, *Wonder Woman*, 63.
102. Ibid., 59.
103. *Sensation Comics* #19 (July 1943).
104. On the following, Mitra C. Emad, "Reading Wonder Woman's Body: Mythologies of Gender and Nation," *Journal of Popular Culture* 39, no. 6 (December 2006): 957–968.
105. Daniels, *Wonder Woman*, 93ff.
106. Emad, "Body," 957ff.
107. Hall, "Other Side," 53; Reynolds, *Super Heroes*, 79–80.
108. See *Sensation Comics* #26 (Feb 1944).
109. Wertham, *Seduction*, 192–193.
110. Jones, *Men of Tomorrow*, 211.

Yet, do women really need to conform to the dominant male pattern to be considered more than distractions? Lark Hall challenges this assumption by calling for an altogether new mythic paradigm. It will not work to simply put women in the traditional role of male heroes, because "it is the communal nature of women's experience that is fundamentally at odds with the individualism necessary to the idea of the heroic."[111] We should add that this loner ideology is equally problematic for men and male heroes, because it perverts the basic anthropological datum that all humans are social creatures who need interdependent and mutually respectful ways of being if they wish to live bountifully and peacefully in the world.

While we will later challenge her position that the heroic is *intrinsically* individualistic, Hall is certainly right that the traditional American myth system is suitable neither for women nor for anyone who faces normal problems.[112] Most of us know at least intuitively that the need for others is a human phenomenon, especially when crises hit. Quite ironically, then, the American monomyth actually works to preclude such humanness by suggesting that a hero who needs others is inadequate for the heroic task itself. This was exemplified in the Golden Age by heroic independence, refusal of community, shallow social partnerships, rejection of romantic commitment, and blatant misogyny.

It is significant that many comics scholars and writers themselves are concerned about the autonomy of traditional superheroic ways of being. Former Spider-Man editor Danny Fingeroth laments the disjunction between fact and fiction, observing that "while the inhabitants of the real world we live in become ever more interdependent, the cult of the individual becomes more and more important in our fantasies."[113] When it comes to the hero himself, Thomas Andrae suggests that although his "feeling of power is based on the renunciation of all pleasure, sexuality, and emotional involvement . . . his inner world, like that of the schizoid, becomes increasingly impoverished."[114] David Zimmerman is even more poignant: "We sympathize with Superman for trying to protect those he loves by keeping the truth from them, but if we are true to ourselves, we want more for him: a community of people who know him truly and are truly known by him. When we are honest with ourselves, we know only too well that a fortress of solitude is a cold, lonely place."[115]

HUMAN KNOWING IN THE GOLDEN AGE

In many ways, the epistemology of the Golden Age was simply a logical extension of its ontology and a mid-twentieth-century reflection of the ways of knowing of American monomythic anthropology. Just as human being

111. Hall, "Other Side," 57. See also Millar, "Monomyth," 40–41.
112. Hall, "Other Side," 53.
113. Fingeroth, *Superman*, 71.
114. Andrae, "Messiah," 134.
115. Zimmerman, *Character*, 57.

was characterized as self-sufficient, so, too, was human knowing marked by individualistic certitude.

One way in which this came to expression was through strong faith in human progress. As we noted earlier, Americans had developed a unique pragmatism based on the belief that their future needed to be created from scratch. With no recognition of either tradition or divine guidance, the belief arose that all of the nation's problems could be solved by practical know-how. In general, of course, hope in progress was a broader Western view held since the Enlightenment and manifested especially in the Industrial Revolutions. In America, though, it was uniquely combined with the ontology of rugged individualism, resulting in personalities such as Henry Ford and Teddy Roosevelt. Like these iconic figures, Golden Age superheroes were capable and self-reliant, intensifying the pragmatic rationality of the time. Batman, for instance, has hundreds of gadgets that he has invented or appropriated to fight crime.[116] His superior, nearly superhuman intelligence is often his greatest weapon against villains.

The chief marker of American epistemic progress is, not surprisingly, scientific advancement. We can note their process of industrialization as well as the space race as examples of not only ingenuity, but also of obsession with being the smartest. Similarly, the Golden Age superhero stories, especially those of DC, for the most part exalted scientific progress and viewed the unknown as something to be conquered.[117] After all, the cultural opinion of technology by 1938 was that science could solve all human problems,[118] which helps explain why many superheroes were the result of experiments.[119] Superman, of course, was an alien, but the original Human Torch, Flash, Captain America, and the Shield were the result of scientific innovation. The latter two, in particular, were subjects of experimental serums, which, Cord Scott suggests, harkens back to the "get fit quick" ads of the 1930s, and may even reflect the practice of eugenics in the United States and Europe at the time.[120]

After World War II, there was a fear of "the Bomb" lurking under the surface in American culture,[121] which was mirrored only briefly in Golden Age superhero comics. Daniels suggests, for instance, that Kryptonite might be symbolic of atomic energy, since it was introduced on the Superman radio show just a few weeks after the bombs were dropped in Japan.[122] Although

116. Daniels, *DC*, 78.
117. Bradford Wright, *Nation*, 202.
118. White, "M. C. Gaines," 24.
119. Daniels, *Marvel*, 15.
120. Cord Scott, "Written in Red, White, and Blue: A Comparison of Comic Book Propaganda from World War II and September 11," *Journal of Popular Culture* 40, no. 2 (April 2007): 331, 334.
121. *Comic Book Confidential*, directed by Ron Mann (1989; Sphinx Productions, 1988), DVD.
122. Daniels, *DC*, 81. He mentions, however, that Kryptonite was actually invented by Superman cocreator Jerry Siegel for an unpublished 1940 story.

at first the atomic bomb was seen as evidence that God was on our side in the war, anxieties soon arose over the possibility that nuclear energy would be used outside of responsible government control.[123] Of course, the Cold War and its attendant anti-Communist propaganda machine were largely fed in America by this fear.

Superhero comics of the time were more successful in propagating the fear of irresponsible (atomic) science in general than with specifically anti-Communist rhetoric. The "mad scientist" villain who schemed to take over the world or steal money through some technological marvel is an old trope in Western fiction, predating the superheroes.[124] Not surprisingly, then, the earliest Superman villains fit this mold, such as the Ultra-Humanite and Lex Luthor.[125] After World War II, however, use of this villain was intensified, such that during the 1950s Superman television show, the most common storyline involved scientists whose inventions were stolen and used for criminal activity.[126]

Yet, even here, scientific progress as such was rarely questioned, only the potential misuse of it by villains. For example, Lester Roebuck sees a polarity between Jor-El (Superman's biological Kryptonian father) and Lex Luthor in this regard. The former used his scientific genius to serve humanity; the latter used his intelligence for crime and destruction.[127] This underscores the fact that technology in the Golden Age was typically neutral in and of itself.[128] Heroes and their allies could use it for good, while villains used it for crime and evil. Naturally, then, science as used by the American government is never questioned. Even to the extent that atomic anxiety was reflected in the superhero comics, it was usually from fear of the Soviet Union, not from the irresponsible use of power by the United States, since America was considered good and the USSR evil.

More often than not, however, superhero stories till 1961 presented a favorable view of science and technology.[129] DC, even in the late 1950s and 1960s, hailed science "as a progressive force in the service to humankind" and "rarely hinted at any unforeseen or harmful consequences of scientific progress."[130] Instead, science would usher in an age of cooperation and equality. Under editor Julius Schwartz specifically, DC of the late 1950s was about the sleek, the new, and the modern, where fortitude and rationality could solve any problem. The revamped Flash and Green Lantern, as well

123. Bradford Wright, Nation, 71.
124. Peter Coogan, Superhero: The Secret Origin of a Genre (Austin: MonkeyBrain, 2006), 67.
125. Daniels, Superman, 63.
126. Daniels, DC, 109.
127. Lester Roebuck, "The Good, the Bad and the Oedipal," in Superman at Fifty, 150–151.
128. Reynolds, Super Heroes, 16.
129. See Reynolds, Super Heroes, 53; Bradford Wright, Nation, 186.
130. Bradford Wright, Nation, 186.

as the JLA, showed all that was hopeful about technology.[131] The assumption was that it brought out the best in humanity, even after Auschwitz and Hiroshima!

It is at just this point with regard to epistemology that we must depart from the majority opinion that the period beginning with the revamped Flash in 1956 marked a new era in superhero comics. It is quite demonstrable that superheroes regained popularity at this time. However, the common view that Silver Age superheroes differed in being products of superscience, as opposed to Golden Age heroes who came about through some sort of mysticism,[132] is a simplistic and not altogether accurate distinction, at least not from the period 1956 to 1961. We already cited several examples of Golden Age heroes who were results of science, whether accidentally or intentionally. The optimism toward progress and technology in 1938 was only temporarily dampened by atomic energy, and was not basically any different from the attitude in the late 1950s.[133] Our knowledge about the natural world was growing, but the fundamental faith in human progress as reflected in superhero comics did not change until the advent of Marvel's new heroes in 1961.

Jason Bainbridge agrees that many heroes in the Golden Age were creations of science, either through mutation or accident. However, he sees this as the superhero challenging "the rationality of modernity by presenting a world founded on irrationality";[134] an irrationality that he sees as culminating in the Silver Age. The very irrational powers of the hero necessary to stop certain villains, he posits, act as a subtle critique of conventional (rational) society and its laws. Although we can agree with Bainbridge that superheroes certainly challenge traditional science, what he refers to as *irrationality* is better termed *hyperrationality*. That is to say, it is not so much that superheroes through 1961 offer an outright alternative to scientific rationality, but rather an impossible extension of it, thus ultimately reinforcing it. If the villain is smart, the hero must be smarter; if he is fast, the hero must be faster. There is still no philosophical questioning of scientific advancement itself, merely the occasional recognition that it can be used for good or evil.

Anthropologically, then, this means that there was no real alternative offered to the monomythic notion of the inevitability of human progress, which, of course, leaves unchallenged the ontology of autonomy, patriarchy, and self-subsistent perfection in which the monomyth is steeped. Unquestioned scientific progress is best seen as the social correlate of the hero's

131. Danny Fingeroth, *Disguised as Clark Kent: Jews, Comics, and the Creation of the Superhero* (New York and London: Continuum, 2007), 87.
132. Lang and Trimble, "Man of Tomorrow," 165.
133. This is illustrated, for instance, by the attempt already in 1939 to explain Superman's powers from a scientific basis instead of leaving them as a mysterious result of magic. See "Scientific Explanation of Superman's Amazing Strength–!" in *Superman* #1 (Summer 1939), shown in Daniels, *Superman*, 42.
134. Bainbridge, "Superheroes' Interrogations of Law," 462.

(and villain's) self-reliant identity, since being a completely constituted individual substance includes epistemic certainty and faith in one's own rational abilities.

Accordingly, Golden Age characters demonstrated little or no doubt about their own identities or places in the world. This is expressed most noticeably in the common observation that they were unrealistically simple and psychologically uniform. There were occasional thought balloons, but their primary use was to tell the reader what the hero was planning to do next or else what the characters were thinking about the action at hand. They were really never used to suggest any sort of epistemic struggle or doubt on the part of the hero—as they were later in Stan Lee's stories—since that would call into question his heroic validity.

During the Golden Age, Superman was the quintessential, square-jawed hero in this regard. We would expect some complexity from Batman, considering the distress of seeing his parents murdered as a child. Although his creator Bob Kane thought that this was the most traumatic event a child could undergo,[135] even Batman remained a stable and simple character until Dennis O'Neil and Neal Adams took him back to his dark roots starting in 1969. According to Bradford Wright, DC heroes in general at this time were always in control, never irrational, had the same personalities, and were impossibly altruistic. Moreover, any divergence from this pattern was equated with criminal activity.[136]

Two of the earliest Marvel heroes were exceptions to this rule, which, to be fair, was not limited to DC's heroes at the time. The original Human Torch and Namor, the Sub-Mariner, were more rebels than role models, according to Daniels;[137] they were confused and unstable, often misunderstood, and fought against each other until they teamed up against the Axis powers during World War II. Eventually, though, Torch was written like other heroes and lost his unique personality. After the war, Namor also was domesticated and limited to fighting criminals.[138] It was not till the end of the 1950s and early 1960s that superheroes would again be written with some emotional complexity and character development, although even then it was still rather trite and simplistic.[139] Not until the Marvel Age would real psychological depth, including self-doubt, be accomplished within the genre.

In addition to these heroes' certainty about their places in the world, we must add their impeccable moral judgment.[140] There was never a doubt as

135. Daniels, *Batman*, 31.
136. Bradford Wright, *Nation*, 185. See also Michael Chabon's comments in *Comic Book Superheroes Unmasked*.
137. Daniels, *Marvel*, 26–31.
138. Ibid., 60.
139. See Jones, *Men of Tomorrow*, 278ff., on Siegel's Superman of the late 1950s and early 1960s; also Kaplan, "Kings of Comics," part 2, on Bob Kanigher's late 1950s Flash.
140. Bradford Wright, *Nation*, 224.

to who the innocents were and who the villains were. Similarly, there was rarely ever a doubt that the hero knew the right course of action to take in any given situation.[141] Again, if there were, the hero could not logically be the hero, according to the rules of the American monomyth. Thus, we can understand superheroic certainty as the secular version of the myth of chosenness. The gradual evolution from trust in God to self-determination of one's own destiny with successive generations of Americans is reflected in heroes' and villains' autonomy and (for the former) perfect knowledge of right and wrong. This leads us, then, to the matter of ethics proper.

HUMAN ACTING IN THE GOLDEN AGE

What, then, is the nature of the evil against which these autonomous heroes meted out justice? Or, to speak theologically, what is sin? Again, we can see two tendencies during this period. The earliest was to understand evil in social or communal terms. This was most glaring in the first Superman stories, where he was concerned more than anything with what we would categorize today as *social justice*: race and class divisions, urban poverty, juvenile delinquency, slum conditions, and so forth.[142] Several Green Lantern stories addressed similar problems.[143]

By the time these heroes joined the war effort and became partners of the establishment, however, social justice all but disappeared from the comics.[144] The idea was that World War II had brought the nation together and, since the New Deal was fixing those social issues anyway, the superheroes could now focus on other problems.[145] Moreover, after the war—which brought with it economic prosperity for many and escape from the Depression—popular culture helped to consolidate the dominant image of American happiness as white, middle-class capitalist affluence.[146] For by then, the assumption was that those whom Superman helped in 1938 were now comfortably living in the suburbs, the postwar public mood having become weary of reform.[147] This ideal was especially emphasized by DC, even through the 1950s and most of the 1960s.[148]

This is not to say that there was no social consciousness at the time, only that it became subordinate to other concerns and, thus, took on a particular form. During and after World War II, this meant the white East Coast

141. See Fingeroth, *Superman*, 17; Bradford Wright, *Nation*, 47–48.
142. Daniels, *Superman*, 35.
143. Bradford Wright, *Nation*, 22ff.
144. See Daniels, *Superman*, 63.
145. Bradford Wright, *Nation*, 24.
146. See ibid., 35, 75ff., 127, 184.
147. Bradford Wright, *Nation*, 59.
148. Jones, *Men of Tomorrow*, 260; Rhoades, *History*, 88; Bradford Wright, *Nation*, 184.

tolerant liberalism of the majority of superhero creators.[149] In a well-known 1946 radio broadcast, for instance, Superman takes a strong stance against racism and the Ku Klux Klan.[150] George Reeves, the actor who played Superman during the 1950s television show, commented that they tried to give a message of tolerance there also.[151] Most telling, though, is a single-page Superboy story from January 1955, which nicely portrays the inoffensive sentiments of Golden Age heroes, a story where some local kids refuse to go to the house of a blonde Scandinavian girl for dinner because they do not want to eat her strange foreign food. Superboy talks to them, gets them to join him at the girl's house, and delivers a little message to the reader at the end about tolerance. Daniels notes, however, that there was no mention of the real groups that were targets of bigotry at the time.[152] Superman also spoke against racism in one-page features, but strangely, as in Smallville, there were no dark skins to be found in Metropolis.[153]

Such bland messages of acceptance, while a step in the right direction, were especially pronounced for DC, one of whose considerable editorial changes in 1941 was to emphasize fantasy over social commentary,[154] effectively stripping the early Superman of any progressive political agenda thereafter.[155] The real point was simply not to rock the boat in an era where most from the dominant group were now living more comfortably than they had during the Depression. The attitude of social indifference was so strong in America at this time—and associated with it—that during the McCarthy era of the 1950s, Marc DiPaolo suggests, one could not even be both a patriot and a progressive.[156] For this reason, Wonder Woman also abandoned political issues such as feminism in exchange for patriotism and traditional female roles.[157]

Accordingly, the second and far more predominant definition of sin was to see it on a strictly personal, individualistic level; "*an attempt on private property*,"

149. Jesse T. Moore, "The Education of Green Lantern: Culture and Ideology," *Journal of American Culture* 26, no. 2 (June 2003): 271. See also Bradford Wright, *Nation*, 53; Zimmerman, *Character*, 14.

150. Discussed in Daniels, *Superman*, 57; Jones, *Men of Tomorrow*, 242.

151. Daniels, *Superman*, 97.

152. Daniels, *DC*, 93.

153. Wright, *Nation*, 65.

154. Ibid., 59.

155. Andrae, "Messiah," 131–132; Daniels, *Superman*, 63. See also Bradford Wright, *Nation*, 59; Sean Carney, "The Function of the Superhero at the Present Time," *Iowa Journal of Cultural Studies* 6 (Spring 2005): 103; Greg Garrett, *Holy Superheroes! Exploring Faith & Spirituality in Comic Books* (Colorado Springs: Piñon, 2005), 74.

156. Marc Edward DiPaolo, "Wonder Woman as World War II Veteran, Camp Feminist Icon, and Male Sex Fantasy," in *Amazing Transforming Superhero*, 161. By *progressive* I mean what we think of today as liberal and oriented toward social reform, in distinction from the Progressives around the turn of the twentieth century who had the opposite values.

157. DiPaolo, "Wonder Woman," 161.

according to Eco, where "the underworld is an endemic evil, like some kind of impure stream that pervades the course of human history, clearly divided into zones of Manichaean incontrovertibility—where each authority is fundamentally pure and good and where each wicked man is rotten to the core without hope of redemption."[158] Obversely, *"good is represented only as charity"*;[159] and, thus, Superman and others became merely police officers used in the restoration of stolen or lost private property, "rounding up criminals and delivering gigantic Christmas baskets to the poor."[160] Such is the prevalence of this phenomenon that one scholar even suggests that Manichaeism and capitalism are two sides of the same coin propagated by American popular culture.[161]

These understandings of evil and good are simply extensions of the puritan regard for private property and maintenance of the established order, advanced in the monomyth since the seventeenth century and constituting a "deeply rooted obsession" in American culture.[162] Although Superman gained popularity as a "champion of the oppressed,"[163] his social conscience was merely an aberration from the American hero tradition. Hence, the practice during the Golden Age—without exception, Jesse Moore suggests[164]—was for the hero to protect the American Way, which meant democracy, the nuclear family, upper- and middle-class values, and (arguably more implicitly) whiteness.[165]

It is within this context that we are to understand why the consensus among comicbook scholars and historians is that heroes are primarily reactive instead of proactive.[166] If the "primary narrative convention of the Golden Age is the defense of the normal,"[167] then there is no real place for heroes where "normal" flourishes. It is partially for this reason that they had no psychological depth, for they existed primarily to serve a mythic function, having "no real personality apart from [their] work."[168] They were mainly foils for the real protagonists, the villains.

158. Eco, "Superman," 123. Emphasis in original.
159. Ibid. Emphasis in original.
160. Patrick L. Eagan, "A Flag with a Human Face," in *Superman at Fifty*, 92.
161. Jean-Paul Gabilliet, "Cultural and Mythical Aspects of a Superhero: The Silver Surfer 1968–1970," *Journal of Popular Culture* 28, no. 2 (Fall 1994): 203.
162. Eagan, "Flag," 93.
163. So he is called in the first several issues of *Action Comics*.
164. Moore, "Green Lantern," 263.
165. See ibid., 265; Reynolds, *Super Heroes*, 74; Bill Boichel, "Batman: Commodity as Myth," in *The Many Lives of the Batman*, ed. Roberta E. Pearson and William Uricchio (New York: Routledge, 1991), 7, 12; Matthew Joseph Wolf-Meyer, "Batman and Robin in the Nude, Or Class and Its Exceptions," *Extrapolation* 47, no. 2 (Summer 2006): 192–193.
166. E.g., Coogan, *Superhero*, 113; Fingeroth, *Superman*, 161; Reynolds, *Super Heroes*, 51–52.
167. Coogan, *Superhero*, 202.
168. Cohen, "Motifs," 30. See also Patrick D. Anderson, "From John Wayne to E.T.: The Hero in Popular American Film," *American Baptist Quarterly* 2, no. 1 (March 1983): 16ff.

The notion of a perfect and peaceful community threatened by external forces is an integral part of the American monomyth, referred to by Lawrence and Jewett as the *Myth of Eden*.[169] This goes back to the puritan captivity narratives in which a local white citizen is kidnapped by vicious Native Americans and held until a hero comes to the rescue.[170] Early superhero comics similarly understood threats to come not from inside society, but from outside;[171] most prominently as extraterrestrials, ethnic minorities, American war enemies, criminal masterminds, and mad scientists. Regardless of their origins or abilities, what all supervillains have in common is their deviance from the status quo. It is precisely this deviance that makes one a villain in the first place,[172] which is why attempts by heroes to be proactive rather than simply reactive usually end up being unsuccessful or even destructive.[173]

Equally disturbing is the fact that these villains were typically irredeemable, as Eco observes. This phenomenon also originated in the puritan tales and especially in later westerns, in which the town needed to be cleansed of its threats in a decisive manner.[174] Already in 1949, culture critic Gershon Legman explicitly connected this theme in our history to Golden Age superheroes.[175] Because Americans killed off the original population of the land in which they live, our guilty conscience must be calmed by creating the myth of the evil native. Our self-perceived national innocence must be maintained at all costs, so when traditional villains disappear, new ones must be found or invented. "Into this well-manured soil of national guilt, fear, and renewed aggression . . . the Superman virus was sown."[176]

The clear and sharp distinctions between good and evil and hero and villain in the American monomyth, including in Golden Age superhero comics, are widely acknowledged.[177] Both the 1948 and 1954 Comics Codes demanded that good and bad be presented without confusion, presumably for the sake of young readers.[178] DC especially maintained this simplistic differentiation well into the 1960s.[179]

169. Lawrence and Jewett, *Myth,* 22ff.
170. Millar, "Monomyth," 37; Slotkin, *Regeneration,* 94ff.
171. Coogan, *Superhero,* 203–204.
172. Wolf-Meyer, "Batman," 192–193.
173. Coogan, *Superhero,* 113; Fingeroth, *Superman,* 161–162.
174. Lang and Trimble, "Man of Tomorrow," 166; Bernard Brandon Scott, *Hollywood Dreams and Biblical Stories* (Minneapolis: Fortress, 1994), 53.
175. Gershon Legman, "From *Love and Death: A Study in Censorship,*" in *Arguing Comics,* 118–120.
176. Legman, "*Love and Death,*" 119.
177. E.g., Lang and Trimble, "Man of Tomorrow," 164; Lawrence and Jewett, *Myth,* 358; Millar, "Monomyth," 37–38; Andrew and Virginia MacDonald, "Sold American: The Metamorphosis of Captain America," *Journal of Popular Culture* 10, no. 1 (Summer 1976): 250.
178. Nyberg, *Seal,* 107, 139; Bradford Wright, *Nation,* 224.
179. Bradford Wright, *Nation,* 224.

Moreover, these comics "forcefully set forth the United States as the embodiment of all that is right."[180] As a people who need constant mythic reminders of their own innocence and righteousness, Americans can have no ambiguity regarding their villains' wickedness. The perception of innocence is thus maintained only by the complete destruction of the enemy. This is achieved in monomythic fashion by a purified hero. Bernard Brandon Scott suggests that America's self-estimate as peaceful (i.e., Edenic) in combination with its violent history creates a schism in U.S. mythology. We value peace as part of the status quo, but peace must be defended with the gun. "This conflict is resolved by having a purified savior destroy the enemy. Our villains must be morally evil so that we may be morally pure and our violence justified."[181]

Like several other aspects we have discussed so far, this also serves to affirm the self-sufficiency of the hero. If he is other than perfectly moral (by the standards of the community), his authority and ability to cleanse the town from evil will be challenged. One of the chief ways in which this heroic purity is demonstrated is in the very willingness to solve problems through violence, for the illusion of peacefulness cannot be maintained by the people if a threat to it exists.

It is for this reason that many early critics of comics were sincerely concerned with the heroes and the messages their actions conveyed. Hilde Mosse, a colleague of Wertham, suggested in 1948 that comicbooks stimulate children to think that violence is *the only way out*."[182] Good overcomes evil by violence alone, and "no one ever lives happily ever after."[183] Wertham himself observed that in superhero comics, "brutality is supposed to be manliness."[184] When it comes to the portrayals of "violence . . . sadism . . . morbid sexual stimulation . . . race hatred . . . contempt for work and family and authority," Wertham suggested, "Superman, Bat Man and Wonder Woman are among the worst."[185] Perhaps most significant for our broader discussion is the sentiment that another of Wertham's contemporaries expressed. Wertham wrote, "As Kingsley Martin sums it up: 'Comic books teach that everything that Christ taught is "sissy."'"[186]

180. Max J. Skidmore and Joey Skidmore, "More Than Mere Fantasy: Political Themes in Contemporary Comic Books," *Journal of Popular Culture* 17, no. 1 (Summer 1983): 84.
181. Bernard Brandon Scott, *Hollywood Dreams*, 53.
182. Hilde L. Mosse, "Aggression and Violence in Fantasy and Fact," in Fredric Wertham et al., "The Psychopathology of Comic Books: A Symposium," *American Journal of Psychotherapy* 50, no. 4 (Fall 1996 [original 1948]): 424. Emphasis in original.
183. Mosse, "Aggression," 424.
184. Fredric Wertham, "The Curse of the Comic Books," *Religious Education* 46, no. 6 (November 1954): 399.
185. Wertham, "Curse," 406.
186. Ibid., 399.

The only notable exception to the dominion of violence at this time came in the earliest Wonder Woman comics. Her creator Marston believed that women were less susceptible than were men to negative traits such as aggression, and that women could learn to control men through their sexual allure. Women's political power, then, would be achieved through this domination, and men would willingly submit, eliminating hatred and violence.[187] Accordingly, many villains in Wonder Women comics were taken to Transformation Island, where they were forced into docility and indoctrinated into submission to loving authority until they reformed.[188] In order to have recurring villains, however, many escaped to commit more crimes, demonstrating that "Transformation Island was a flop."[189] Wonder Woman stories later in the 1950s, under new writer Robert Kanigher, tried to avoid violence as well, often with a peaceful demonstration of her powers, which discouraged opponents from engaging her.[190]

Marston seemed to be philosophically disposed toward pacifism, according to Daniels,[191] and we may see his appeal for an alternative to violent retribution as a noble intention. However, his assumptions about men and women were quite problematic and simplistic, not to mention the ubiquitous images of female bondage.[192] Ultimately, his notion that women could change the world by making men subservient to their sexual power is only a different manifestation of manipulation and supremacy.[193] In this way, Wonder Woman also—even when acting alternative to the physical violence of her male colleagues—participated in the American monomythic formula.[194]

In the male-dominated majority of early Golden Age comics, though, villains were occasionally killed, especially in the very early stories of Batman, where he sometimes used a gun.[195] One of the editorial changes DC made in 1941, however, was to lighten up the characters, due to both sensitivity to the youth market and a general shift of mood toward patriotic fervor, after which Batman, Superman, and even the Joker stopped killing.[196] Instead, heroes brought villains to the local authorities, who then put them in jail. Refusal to kill the bad guys was also necessitated by serialization, so that a popular villain could be seen roaming the streets again after escape or release from prison.

187. Daniels, *Wonder Woman*, 19; Jones, *Men of Tomorrow*, 208–209. See also Nick Gillespie, "William Marston's Secret Identity," *Reason* 33, no. 1 (May 2001): 52

188. Emad, "Body," 966; Rhoades, *History*, 60.

189. Daniels, *Wonder Woman*, 36.

190. Ibid., 102.

191. Ibid.

192. See Bradford Wright, *Nation*, 21.

193. Emad, "Body," 979ff.; Gillespie, "Identity," 53.

194. Lawrence and Jewett spend a chapter (*Myth*, 65–85) discussing predecessors and examples of the idea of "redemption through controlling love" (67).

195. Brooker, *Batman*, 62–63. See also Daniels, *Batman*, 31.

196. Brooker, *Batman*, 46–47, 62–66; Daniels, *Batman*, 41; Daniels, *Superman*, 41–42.

Yet, despite these changes, the fact remained that villains were rarely portrayed in a favorable or humanistic light. Like heroes, they were written as unrealistically simplistic, with no ambiguity or complexity regarding their status as moral degenerates. Likewise, any psychological motivations or personal histories were entirely lacking beyond either revenge or an unexamined desire to rule the world or to destroy the hero.

Remarkable as well is the fact that the innocence of the people from whom the villains steal is never questioned. After the early Superman stories in which people with money and power were often rightfully accused of illegal and immoral activities, the Golden Age stories quickly reverted to the monomythic belief in the perfect community. This was no doubt aided by the restoration of free enterprise and the rejuvenation of capitalism after the Depression. A man could do whatever he wanted with his resources, without any question as to how they were attained or who was passed over along the way. But if a villain threatened any of those resources, there would be hell to pay and the heroes would see to that.

These factors—World War II patriotism, the turn to personal evil, the affirmation of white suburbia, the Manichaean distinction between good and evil, and the unambiguous wickedness of villains—had radical implications for how different groups of human persons were portrayed in Golden Age comics. The standard by which all others were judged was, to be expected, the middle- to upperclass straight, white American male.[197] The vast majority of superheroes fit this description, and, accordingly, persons in this group were pure and good, as Eco suggests, almost without exception. What about those, though, who did not fit this hegemonic mold?

One of the most disturbing Golden Age stories—and one that acutely illustrates the attitude toward difference during this time—is the introduction of Bizarro in a Superboy story from 1958.[198] At a lab in Smallville, Superboy is accidentally hit with a duplicator ray, which results in the creation of a robot-like double of himself who is given the name Bizarro. Bizarro does not know his own strength, and he is also considered ugly, so he accidentally breaks several things in town and scares most of the people who see him. The only solution presented is that he must be destroyed, which is finally accomplished when Superboy finds a radioactive piece of material similar to Kryptonite and makes Bizarro collide with it.

The fact that we are meant to pity him is indicative of the transition toward complexity, which would culminate in the Marvel Age. However, the fact that the only option put forth is for him to be destroyed reflects America's general view toward nonconformity to cultural hegemony. Even Les Daniels, who as a former writer and editor of comicbooks is quite familiar with their conventions and violence, confesses that Superboy "callously destroying Bizarro was a shock."[199]

197. See Best, "Domesticity," 80.
198. *Superboy* #68 (October 1958).
199. Daniels, *Superman*, 110.

This raises the matter of others beside the villain who did not fit the standard of the rich, white (and, we might add, conventionally handsome) American male. Some of the most inhuman caricatures in this period were reserved for racial and ethnic minorities. It is widely acknowledged by fans and critics alike that minorities were portrayed stereotypically in Golden Age comics,[200] as they were in popular culture more generally at the time.

One such group consisted of foreigners with whom America was at war. The racist and xenophobic portraits of Germans and Japanese during World War II, and later North Koreans during the Korean War, were largely for propagandist reasons. Imaging the enemy in extreme negative terms no doubt helped to pacify much antiwar sentiment that may have arisen in the minds of readers—which included a large number of American soldiers—as well as to affirm the moral superiority of the Allies.[201] As such, tales of glorified violence against the enemy were the rule for superhero comics during the war,[202] and many heroes expressed "unashamed hatred" for racial others.[203]

Specifically, the Nazis were pictured as either "stiff, militaristic, and ruthless" or "fat, bumbling buffoon[s]."[204] Despite these negative images, however, in comics and pop culture on the whole they were still treated as human because they were white. Examples abound, however, to demonstrate that the Japanese were clearly subhuman;[205] shown as "yellow-skinned devils"[206] with animalistic traits such as claws and fangs, or else as "bucktoothed little monkeys."[207] These general Asian stereotypes had been associated with the Chinese prior to World War II and were again with the Koreans later.[208] Villains early in the *Detective Comics* series, for instance, were often stereotyped Asians as evil masterminds,[209] including in the stories of Siegel and Shuster's pre-Superman hero Slam Bradley.[210]

For the Japanese during the war, though, this dehumanization was intensified. Although the Batman comics generally lacked anti-Japanese sentiment,[211] the live-action Batman serial from 1943 had a Japanese spy for a villain, consistently promoted anti-Japanese views, and even praised the American internment of citizens of Japanese descent.[212] The original Human

200. E.g., Lupoff, "Cheese," 62; Wertham, *Seduction*, 15, 100–103, 381.
201. See Emad, "Body," 961; Rhoades, *History*, 37.
202. Brooker, *Batman*, 77.
203. Ibid., 91.
204. Bradford Wright, *Nation*, 47.
205. Brooker, *Batman*, 90.
206. Rhoades, *History*, 40.
207. Bradford Wright, *Nation*, 45. See also Feiffer, *Heroes*, 59–60; Don Thompson, "OK, Axis, Here We Come!" in *All in Color*, 112.
208. Bradford Wright, *Nation*, 49, 110ff.
209. Daniels, *DC*, 19.
210. Daniels, *Superman*, 24.
211. Brooker, *Batman*, 35.
212. Boichel, "Batman," 10; Daniels, *Batman*, 58.

Torch frequently burned limbs off of Japanese soldiers while cheered on by a pretty girl.[213] In *Sub-Mariner Comics #5* (1942), Namor watches as an American officer welcomes a Japanese landing party with machinegun fire, and then celebrates afterward.[214] Not to be outdone, *Captain America* covers often portrayed Japanese soldiers with fangs,[215] and one issue from August 1941 shows an evil Oriental villain who will torture anyone, including women.[216] The next issue introduced a villain named Fang: Arch-fiend of the Orient.[217] The underlying tone was that all Asian groups were bent on taking over the East, if not the world. As the war progressed and fighting in the Pacific got deadlier, the stereotypes only increased.[218]

Korean War books were more ironic and cynical, but still portrayed the North Korean and Chinese enemies as subhuman.[219] Many of these comics featured heroes that were "dreadful specimens of humanity who fostered thoughtless hate" in their killing of Communists, the new villains of the age.[220]

Peoples not at war with America were rendered only slightly better than this. The Chinese allies during World War II were shown as lazy, unprepared, and in need of America's help and leadership. Even America's white allies were sidelined, such that Bradford Wright observes that a "reader with no other point of reference would have concluded from wartime comic books that American heroes battled the Axis with only occasional assistance from the subordinate British, Chinese, and Russians."[221] Also troubling is the fact that no comics during World War II mentioned the Holocaust.[222]

Foreign peoples from developing nations were generally seen to be helpless, simple, and in great need of direction from America, which then swept in and saved them from their uncivilized and primitive lifestyles and beliefs. In the jungle comics, such as *Sheena*, Africans spoke with poor, childlike grammar and were seen as superstitious and unruly until their uppity spirits were tamed by strong white leaders who put them back in line.[223]

Back home, presentations of racial minorities were similar. Native Americans were urged to put aside their hostility for the sake of the national war effort.[224] African Americans were consistently shown with big lips, bulging white eyes, and, like their African counterparts, as rather stupid. Marvel's first black hero was Whitewash of the Young Allies, created in 1941.

213. Thompson, "Axis," 112.
214. Ibid., 117.
215. Daniels, *Marvel*, 48. See also Zimmerman, *Character*, 88.
216. *Captain America #5* (August 1941).
217. *Captain America #6* (September 1941).
218. Cord Scott, "Written," 327–328.
219. Bradford Wright, *Nation*, 114–115.
220. Nicky Wright, *Classic Era*, 171. On Harvey Kurtzman's Korean War comics as a welcome exception, see ibid., 194–195; Kaplan, "Kings of Comics," part 1.
221. Bradford Wright, *Nation*, 49.
222. *Comic Book Superheroes Unmasked.*
223. Bradford Wright, *Nation*, 73–74.
224. Ibid., 54.

Although a black character was quite progressive, Whitewash was nevertheless a "deplorable stereotype."[225] Billy Batson/Captain Marvel had a black valet named Steamboat Willie, who exemplified the racial stereotypes of the era: in addition to fat lips and huge eyes, he spoke an illiterate lingo and was easily scared.[226] Even in Wonder Woman comics, from which we might expect more charity, minority ethnic groups were "often reduced to stereotypes, and African Americans were subjected to degrading caricatures that should have been laid to rest by the 1940s."[227]

In light of 9/11, we might consider as well depictions of Arab characters in comics. Jack Shaheen, surveying a period of about 40 years and thus even beyond the Golden Age, did not find a single Arab hero or heroine.[228] He cites one 1955 story in which they are referred to as apes and indiscriminately shot at. A few Batman stories from the 1930s and 1940s have stereotypical Arab or generic Middle Eastern villains.[229] Shaheen also observes that Arab women are shown either as belly dancers or as docile housewives in the comics, and that white women should fear ever being captured by Arab men.[230] Although deep misogyny does exist in many Arab contexts, this portrayal is incredibly ironic and hypocritical given the objectification of women that has pervaded American comicbooks.

Arguably more noticeable than the negative portrayals of minorities in superhero comics is their sheer scarcity. Some critics have observed that during the Golden Age, not a single minority character had a meaningful role, whether as hero, villain, or anything else.[231] Although there were occasional exceptions to racism and xenophobia, they only proved the rule that in a monolithic cultural and mythic system totally oblivious to its own relativity, uniformity is the moral standard. Racial differences are for the most part ignored altogether, because the "generic ideology of the superhero" is to "preserve America's status quo," according to Marc Singer.[232] The Legion of Superheroes (which first appeared in 1958), for instance, was not genuinely racially diverse, since only one of its races existed in real life: the whites who made up most of the team. In this sense, the Legion "ultimately erases all racial and sexual differences."[233] This follows logically if the status quo is white male heterosexual dominance. Real racism and, in fact, all issues of cultural difference could remain untouched, because social justice was simply contrary to the establishment.[234]

225. Daniels, *Marvel*, 45.
226. Lupoff, "Cheese," 61.
227. Daniels, *Wonder Woman*, 39.
228. Jack Shaheen, "Arab Images in American Comic Books," *Journal of Popular Culture* 28, no. 1 (Summer 1994): 123.
229. E.g. *Detective Comics* #29 (July 1939) and #35 (January 1940).
230. Shaheen, "Arab Images," 129.
231. Bradford Wright, *Nation*, 54, 65; Zimmerman, *Character*, 74.
232. Marc Singer, "'Black Skins' and White Masks: Comic Books and the Secret of Race," *African American Review* 36, no. 1 (Spring 2002): 110.
233. Singer, "Skins," 112.
234. See Zimmerman, *Character*, 75.

SUMMARY

We have seen here that the Golden Age superhero comics present a problematic concept of the human person. Ontologically, the hero was an independent, individualistic substance who relied only and completely on himself. Relationships did not constitute the hero's essence in any meaningful way and, quite often, were perceived to hinder the hero from his or her task, especially relations of a romantic nature. Hence, sex and community had to be constantly shunned, lest the heroes be tainted and unworthy of their calling. Women were, thus, seen either as distractions or pests, constantly in need of correction by better, smarter men. Only by being like their male counterparts could female heroes hope to gain respect, and even then they had a hard time earning that respect.

Epistemologically, these superheroes demonstrated great confidence in human progress and scientific advancements, with little regard for the dehumanizing and destructive possibilities inherent in unchecked progress. Moreover, they had shallow and undeveloped personalities that evinced no doubt as to their identities or places in the world. Similarly, they were always certain about the right course of action in any given situation, betraying their felt intellectual and moral superiority over others.

Ethically, they were completely autonomous and had no authority outside of what they granted to themselves. After a time, they abandoned concerns with social justice in exchange for preoccupation with defending and restoring the private property of rich and middle-class white suburbanites. As such their treatment of others did nothing to amend the contemporary structures of society, which enabled racist, classist, and sexist stereotypes and the unbalanced distribution of resources. On the contrary, most people who did not fit the status quo of straight white American maleness—especially racial and ethnic minorities—were dehumanized or vilified through stereotypes, or else ignored altogether.

We can picture our discussion of these three areas in a way that gives us a broad idea of the logical relations between the various dimensions of American monomythic and Golden Age superheroic anthropology presented in this and the previous chapter. The double arrow (\leftrightarrow) is meant to denote the mutually constitutive reciprocity between these dimensions:

> Self-subsistence \leftrightarrow independence \leftrightarrow refusal of intimacy \leftrightarrow epistemic certainty \leftrightarrow psychological simplicity \leftrightarrow autonomy \leftrightarrow moral perfection \leftrightarrow intolerance of difference \leftrightarrow oppression of others

It is often recognized, though, that as American culture has evolved, so has its conception of the hero. At the dawn of the 1960s, many ideas previously taken for granted were about to be challenged and changed, in the culture at large and also in comicbooks. Lang and Trimble are thus right to point out that the "American monomythic character described by Lawrence and

Jewett is the prototype for many of our pop-culture heroes, particularly superheroes, but often it is only that: the prototype."[235] Before considering the ways in which the monomyth was challenged by Stan Lee and Marvel Comics beginning in the Silver Age, we turn to consider five American theologians who have explicitly responded to the positions and assumptions of the philosophical, religious, and ethical foundations of the monomyth, and who exemplify the "turn to relationality" in their proposals for human being, knowing, and acting. This discussion will also provide the dialogue partner with which to explore the anthropological innovations of the Marvel comics and films in chapters 4 and 5, respectively.

235. Lang and Trimble, "Man of Tomorrow," 170.

3 The "Turn to Relationality" in American Theological Anthropology

INTRODUCTION

In this chapter, I present five Christian theologians for whom anthropology is a key focus: Thomas Merton, James Cone, Rosemary Radford Ruether, Catherine Keller, and LeRon Shults. In keeping with my organizational structure, I will attend to their views in terms of human being, knowing, and acting. While there are many theologians as well as scholars in other fields who now hold many of the positions I will outline here, several factors were considered in the selection of the particular thinkers to be discussed. First, because I have limited my project to American history and comics, it seems most consistent to feature only American theologians. Second, because I analyzed the comics in basically chronological order, I will similarly portray theologians from different eras of the last 50 years or so, roughly simultaneous with the period of Lee's influence beginning in the Silver Age and, thus, paralleling the discussion in chapter 4. Third, I have tried to utilize thinkers from a variety of backgrounds and perspectives. Given the historical dominance of white men in theology in the United States, this group is perhaps not as diverse as we might desire. Nevertheless, the reader will hopefully find more voices represented than what our theologians' own personal contexts would suggest.

Finally, and perhaps most crucially, I am considering theologians who are expressly concerned with critically responding to the philosophical foundations and/or ethical manifestations of the American monomyth, especially those related to self-subsistence and staunch independence. Indeed, what all of these thinkers share is a concern for relational ways of being, knowing, and acting that recognizes the dynamic and holistic communality of human life. While these sentiments are not shared among all American theologians, the trend is growing, and this group represents a diverse and notable voice in that direction.

THOMAS MERTON

Ontological Considerations

We begin with Thomas Merton, who was Stan Lee's senior by less than eight years and who did most of his writing between the late 1950s and mid-1960s, the same time that comics was transitioning from the Golden to the Silver Age, and when Lee and Marvel were beginning to revolutionize the American superhero. Merton is overtly critical of the idea that humans are essentially individualistic. He approaches this not primarily in philosophical or scientific terms, but ethically and practically. To live selfishly "is doomed to frustration, centered as it is upon a lie. To live exclusively for myself, I must make all things bend themselves to my will as if I were a god. But this is impossible."[1] Hence alienation is inherently narcissistic for Merton, for therein relations become "regressive, undeveloped, infantile."[2]

Moreover, although he recognizes that such autonomy is often seen as the definition of freedom, the exact opposite actually results. If freedom were simply about one's personal choices, the mere making of decisions would perfect our freedom.[3] Instead, our egoistic attempts to secure freedom in this way only bring about our slavery "to *things*—money, machines, commodities, luxuries, fashions, and pseudoculture."[4] Merton can, thus, refer to the "sin of solipsism"[5] and the "heresy of individualism,"[6] which indicate that we are dealing here with a deeply theological issue. The separation from God, which comes as a result of seeing only oneself as of ultimate concern, tends to entail "the complete autonomy of the individual . . . who is no longer responsible to anyone."[7] Christian faith, in Merton's reckoning, understands that at the basis of this solipsism is despair and death.[8]

However, if we refuse others by denying that we have anything to do with them, Merton asks, "What is there left to affirm?"[9] We would not even have ourselves. On the contrary, "the more I am able to affirm others, to say 'yes' to them in myself . . . *the more real I am*."[10] Perhaps more profoundly: "I

1. Thomas Merton, *No Man Is an Island* (New York: Barnes & Noble, 2003 [original 1955]), 24.
2. Merton, *Love and Living* (Orlando: Harcourt, 1985 [original 1965]), 146.
3. Merton, *Island*, 24.
4. Merton, *Love and Living*, 147. Emphasis in original.
5. Merton, *Conjectures of a Guilty Bystander* (New York: Image, 1965), 210.
6. Ibid., 144.
7. Ibid., 144. See also Merton, *New Seeds of Contemplation* (New York: New Directions, 2007 [original 1961]), 21.
8. Merton, *Conjectures*, 115.
9. Ibid., 144.
10. Ibid. Emphasis mine.

am therefore *not completely human* until I have found myself in my . . . brother, because he has *the part of humanity which I lack*."[11] And again: "The man who lives in division *is not a person* but only an 'individual.'"[12] Once more: "To live in communion, in genuine dialogue with others is *absolutely necessary if man is to remain human*."[13] Notice not only the ontological claim, but also the explicit connection between reality and relationality. To be really and fully human is to be in communion with others.

We can map this theologically for Merton quite precisely. If "all being is from God,"[14] then any instantiation of being, any creature, "is a direct participation in the Being of God."[15] Further, if the nature of this being is the "infinite sharing" of the triune life, then God "has made the sharing of ourselves the law of our own being, so that it is in loving others that we best love ourselves."[16] This fact is not merely received, but requires participation in the life of God by becoming transformed in Christ through the power of the Holy Spirit.[17] Crucially, this "sanctity," as Merton calls it, "is not a matter of being less human, but more human than other men."[18]

Far from being a relation to God that takes us out of the world, as is sometimes thought, sharing in the life of God through conformation to Christ entails a turning to the world in love. Not only does the pursuit of true humanity in Christ engender "appreciation of the good and beautiful things of life,"[19] but it also liberates us from the "self-contradictory and self-defeating enterprise of establishing [ourselves] in unassailable security."[20] Only in Christ can we be ultimately free to pursue our common destiny, which is "to love one another as Christ has loved us."[21] In fact, Merton sees love as "the fundamental law of human existence,"[22] "not something extraneous and alien to our nature."[23] Rather, to just be human, to be made in the image of God, he insists, means "that love is the reason for my existence, for God is love. Love is my true identity. Selflessness is my true self. Love is my true character. Love is my name."[24]

11. Merton, *Seeds of Destruction* (New York: Farrar, Straus and Giroux, 1965), 305. Emphasis mine. See also Merton, *Island*, xxii.
12. Merton, *New Seeds*, 48. Emphasis mine.
13. Ibid., 55. Emphasis mine.
14. Merton, *Conjectures*, 220.
15. Ibid., 221.
16. Merton, *Island*, 3.
17. Ibid., 175; Merton, *Love and Living*, 226.
18. Merton, *Life and Holiness* (New York: Image, 1963), 24.
19. Ibid.
20. Merton, *Conjectures*, 225.
21. Merton, *Island*, 12; see also xii.
22. Ibid., xix.
23. Merton, *Conjectures*, 121. See also Merton, *New Seeds*, 53.
24. Merton, *New Seeds*, 60.

Epistemological Considerations

The idea of love as one's true identity suggests, of course, that love is fundamental to Merton's epistemology as well. He is critical of naïve optimism in scientific progress in a far more acerbic tone than were many of his contemporaries. He observes that the Enlightenment and Industrial Revolution led to a "new, aggressive secular faith in progress" which "took hold on everybody."[25] The assumption of this faith is, in fact, so unqualifiedly prevalent in our culture that, in addition to whatever concrete problems arise as a result of technology, the trust in it "is itself one of our greatest problems."[26]

This leads to Merton's chief concern with science itself. On their own, many technological developments are wonderful and can actually contribute to the improvement of human life.[27] However, when not pursued in balance with all aspects of life, the speed of technological growth becomes "a factor [in the] disintegration" of society.[28] What has happened over the last few centuries is that we have subjected human interest to technology instead of the other way around.[29] One expression of this is that we are now in possession of incredibly destructive atomic power, for whose use we are morally responsible but in reality unprepared.[30]

Another expression is that we have now created a culture with these advances that is "not yet livable for mankind as a whole," because of the stark contrast between the misery of the poor and "the absurd affluence of the rich."[31] If technological progress were really about reason, Merton suggests, we would not be in the situation we are in; genuine human needs would not be so neglected and resources so unevenly distributed. On the sad contrary, technology is the means by which humanity "becomes *quantified,* that is, becomes part of a mass."[32]

For Merton, the failure of the science-obsessed mind to acknowledge human dignity is due to a shift in fiduciary allegiance; it is "what comes of believing in science more than God."[33] Hence, Merton understands the human noetic enterprise in theological terms. The task of reason is to help us distinguish between temptation and grace, between emotional urges and instincts of supernatural love, between the fancies of imagination and the illumination of the Holy Spirit;[34] and the goal of intelligence is to develop our freedom and capacity for love and the discovery of truth.[35]

25. Merton, *Conjectures,* 52. See also Merton, *The Ascent to Truth* (San Diego: Harcourt, 1978 [original 1951]), 3.
26. Merton, *Conjectures,* 73.
27. Ibid., 72, 253.
28. Ibid., 72. See also Merton, *Love and Living,* 79.
29. Merton, *Conjectures,* 222–223, 253. See also Merton, *Destruction,* 265.
30. Merton, *Destruction,* 124.
31. Merton, *Conjectures,* 73.
32. Ibid., 76. See also Merton, *Love and Living,* 55.
33. Merton, *Destruction,* 266.
34. Merton, *Ascent,* 183. See also Merton, *Island,* 58.
35. Merton, *The New Man* (New York: Farrar, Straus and Giroux, 1961), 42. See also Merton, *Ascent,* 9.

This pursuit, though, is inherently incomplete because the truth is God himself, who cannot be known unless he is also loved. Human knowing as well as being, then, is relational, not a body of data collected from a supposedly objective stance over against the world, but a yearning to know the truth in the light of God, whose knowledge is the origin of all creaturely reality.[36] "Every truth, every being, is simply a reflection of Him. Truths are only true in Him, and because of Him."[37]

Thus, the way to genuine knowledge of even finite things is through the purgation of desire such that we come to desire God alone, who gives us a clear idea of the reality of things as they are, enabling us to really know, love, and enjoy them.[38] Only when we recognize the limitations of our reason and relinquish the attempt to control those we see as epistemic objects do we become truly capable of knowing, and in a far deeper way than that which is championed within unchecked scientific progress.

This purgation is crucial for the formation of identity, because it makes oneself more available for the relations that constitute self-consciousness. "Man does not fully know himself so long as he is isolated in his own individual self-hood. His identity comes to light only when it fully confronts the 'other.'"[39] This requires that we abandon ourselves and our falsely secured identities to be reborn in communion with those who mediate our self-knowing.[40] This is itself facilitated by the Spirit of God as we seek to identify with Christ and therein find ourselves.[41]

Moreover, just as knowledge of God depends on love, so does knowledge of others. "Love has its own wisdom, its own science, its own way of exploring the inner depths of life in the mystery of the loved person. . . . When people are truly in love . . . they are made over into new beings."[42] Significantly, this does not mean being blinded to the faults of the beloved, but rather seeing them more clearly. "Love, love only, love of our deluded fellow man as he actually is . . . this alone can open the door to truth."[43] It is not simply that our identities are mediated by others, but more poignantly that our real value is shown in how we are beheld by our beloved ones, who "must love me as I am, with my faults and limitations, revealing to me the truth that these faults and limitations cannot destroy my worth in *their* eyes; and that I am therefore valuable as a person, in spite of my shortcomings."[44]

This also is theological for Merton. Love awakens due to faith that one is already loved by God, not only in spite of being unworthy, but regardless of

36. Merton, *Ascent*, 106.
37. Ibid., 32.
38. Ibid., 57–58.
39. Merton, *New Man*, 67. See also Merton, *New Seeds*, 51.
40. Merton, *Island*, xv.
41. Merton, *New Man*, 67, 159, 170.
42. Merton, *Love and Living*, 34. See also Merton, *Island*, 165.
43. Merton, *Conjectures*, 69.
44. Merton, *Love and Living*, 35. Emphasis in original.

the matter of worth altogether.[45] "God is asking of me, the unworthy, to forget my unworthiness and that of all my brothers . . . and to laugh, after all, at all preposterous ideas of 'worthiness.'"[46] In other words, we must learn to see ourselves and others just as we are, as naturally unique and flawed and imperfect, if we are going to truly love ourselves and one another.[47] We "need to see that we are lovable after all, in spite of everything!"[48]

Ethical Considerations

The failure of humans to see and accept themselves as imperfect is not only epistemologically problematic, but ethically, as well. Just as the noetic problem can only be assuaged by faith in the love of God, so sin, for Merton, is the denial of God's love; a refusal, more to the point, "to be what we are, a rejection of our . . . reality hidden in the very mystery of God. Sin is our refusal to be what we were created to be."[49] This turning away from divine love leads quite naturally to the elevation of the self as the primary focus of human activity. The "basic sin" of "rejecting others in order to choose oneself"[50] inevitably means that all others, including the natural world, will be used and exploited for personal gain.[51] This fact has myriad manifestations.

One of them is related explicitly to American self-understanding. Merton sees "the conventionally accepted American myth" to be the view that it is "the earthly paradise,"[52] a notion that predates and clearly parallels Lawrence and Jewett's idea of the Myth of Eden.[53] He suggests that as a place with no history, America offered itself to immigrants as a place also without sin. The underside, however, is that the United States needs an idea of the frontier to convince itself of its innocence. When there were no more geographical frontiers, "America gradually became the prisoner of that curse, the historical memory, the total consciousness of an identity responsible for what had happened to the Indians, for instance."[54]

Merton thinks that humans seem to have a proclivity to violence, which is one of the most mysterious aspects of life.[55] However, he suggests that it is more in accord with human nature to be nonviolent.[56] Accordingly, Merton can insist that the idea of war as necessary to destroy those who threaten

45. Merton, *New Seeds*, 75.
46. Merton, *Conjectures*, 174. See also Merton, *Island*, 133.
47. Merton, *Island,* 128.
48. Ibid., 202.
49. Merton, *Life and Holiness*, 12.
50. Merton, *Conjectures*, 174.
51. Merton, *New Man*, 59–60. See also Merton, *Island*, 18.
52. Merton, *Conjectures*, 34.
53. Lawrence and Jewett, *Myth,* 22ff.
54. Merton, *Conjectures*, 35.
55. Merton, *Love and Living*, 132.
56. Merton, *Destruction*, 258.

our peace makes clear that war is totally irrational and "that it proceeds to its violent ritual with the chanting of perfect nonsense."[57]

More specifically, war is irrational because it is based on fear, not just of perceived enemies, but of everything. Because we have stopped believing in God, we do not trust anything or anyone, including ourselves. Fear of ourselves is made even worse by the fact that it "makes us see our own evil in others and unable to see it in ourselves."[58] As a consequence, we have as the objective of war "total victory, the unconditional surrender and annihilation of all opposition."[59] Since it has its root in unreasonable fear, Merton concludes that this is not a "sane objective," but rather "paranoia."[60] Thus, he can also note the incoherence of the assertion that military strength creates peace. "Power has nothing to do with peace. The more men build up military power, the more they violate peace and destroy it."[61] Here again, we see a parallel with our discussion from chapter 2. Whereas Bernard Brandon Scott and others highlight the *mythological* dimension of American innocence and destruction of the enemy,[62] Merton pinpoints the *psychological* one; namely, intense fear and mistrust of everything and everyone.

To no surprise, then, Merton vehemently opposes the assumption that our enemies are unqualifiedly evil, and, hence, less than human and worthy of destruction. Although Merton suspects that this may have roots in the pessimistic anthropology of both Catholic and Protestant thought,[63] it results more immediately from the illusion that we are perfectly innocent and that those with different ideals must be evil.[64] This Manichaean duality inevitably leads to violence,[65] for the violent person "wants to rest assured that his enemy is violent, and that he himself is peaceful. For then his violence is justified."[66] He cites the particular example of the Cold War, but then opines that after the death of John F. Kennedy, we are no longer able to put "all evil on the other side of the Iron Curtain!"[67]

On the contrary, we must honestly and squarely face our own faults and not project them onto others.[68] If we can accept ourselves not in black-and-white terms, "but in our mysterious, unaccountable mixture of good and evil,"[69] then we can see our opponents as equals, as brothers and sisters.[70]

57. Merton, *Love and Living*, 129; see also 131.
58. Merton, *New Seeds*, 112.
59. Merton, *Conjectures*, 259.
60. Ibid.
61. Ibid., 41.
62. Bernard Brandon Scott, *Hollywood Dreams*, 53.
63. Merton, *Destruction*, 107.
64. Merton, *New Seeds*, 116.
65. Merton, *Destruction*, 107.
66. Merton, *Conjectures*, 84–85.
67. Merton, *Destruction*, 315; see also 250.
68. Ibid., 254.
69. Merton, *New Seeds*, 117.
70. Merton, *Conjectures*, 218.

This does not mean that we deny any wrongdoing on the part of the enemy, but rather that we seek only the "salvation and redemption of the opponent, not his castigation, humiliation, and defeat."[71] Only by faith in God is this fully possible, for then we can love people "even in their sin, as God has loved them. . . . For only love—which means humility—can exorcise the fear which is at the root of all war."[72] Moreover, Merton urges, we need to be "so much the children of God that by loving others we can make them good and lovable, in spite of themselves."[73]

Another sin Merton condemns is racism. Writing during the height of the Civil Rights movement, he was acutely aware of this tension in the United States, particularly between blacks and whites. Although many of the world's underprivileged want reciprocity with whites, communion is precluded by the "white myth-dream," which needs others over whom to assert and maintain supremacy.[74] When we think it is threatened, we then create the opponent we fear.[75] This air of superiority is so ingrained that even when so-called liberals profess a desire for equality, it is still on white terms and, hence, unconsciously racist.[76]

This last point is spelled out with greatest clarity in Merton's "Letters to a White Liberal."[77] He recognizes that blacks could not simply enter into white society without the latter radically changing and sacrifices on the part of whites demanded. Significantly, he connects this to individualism by observing that this was not able to happen in a society "based on a philosophy of every man for himself."[78] Consequently, blacks realized that they had to take action themselves and could not depend on the sacrifice of whites who were unwilling to give it,[79] at least not until black demonstrations and boycotts began to negatively affect white money.[80] The only path to resolution, Merton suggests, is for whites to atone for their racist sins, which must consist of two dynamics: complete reform of the social system that fosters racism and recognition that the work of reconciliation must be led by blacks.[81] Until whites are able to "think black," to genuinely understand their own complicity in the present predicament, even liberals will continue to be unable to see blacks as human beings.[82]

71. Ibid., 86.
72. Merton, *New Seeds*, 119.
73. Merton, *Island*, 170; see also 215.
74. Merton, *Love and Living*, 89.
75. Ibid., 91–92. See also Merton, *Conjectures*, 32–33.
76. Merton, *Love and Living*, 90.
77. In Merton, *Destruction*, 3–71.
78. Ibid., 9. See also Merton, *Conjectures*, 56.
79. Merton, *Destruction*, 32. See also Merton, *Love and Living*, 88.
80. Merton, *Destruction*, 24.
81. Ibid., 67–68; see also 34.
82. Ibid., 60.

For Merton, this is not simply a political and practical necessity, but is a theological mandate, for God is the source of all morality,[83] and without God as their center, "men become little helpless gods, imprisoned within the four walls of their own weakness and fear."[84] In the same way that faith in the love of God releases us from selfishness and allows us to identify others as lovely, so the experience of being loved by God empowers us to act in love toward others,[85] since the universal basis for friendship among people is that we are all loved by God.[86]

Moreover, the urge to love is a call to be loved as well. We "cannot love unless we also consent to be loved in return."[87] Merton makes a rather noteworthy observation when he says "we have hated our need for compassion and have suppressed it as a 'weakness.'"[88] As we saw in the previous chapters, this has been the chief reason for the hero as self-sufficient; to need others implies imperfection and thus unworthiness of the heroic mantle. If Merton is right that to be indifferent toward being loved really means that we are indifferent toward others,[89] then it helps explain why the autonomous hero fails at true love.

Furthermore, Merton explicitly condemns the definition of goodness as charity that Umberto Eco puts forward as the limitation of the (Golden Age) superhero genre.[90] The "token acts of mercy" which are often considered charity, Merton observes, have "no real effect in helping the poor: all it does is tacitly to condone injustices and to help to keep conditions as they are—to help to keep people poor."[91] Since, quite to the contrary, there "is no charity without justice,"[92] Merton prefers instead that we proceed to transform the world by political action that elevates human beings to a level reflective of their dignity as children of God,[93] which suggests that power entails responsibility,[94] a key mantra of Marvel's ethics, which we will discuss in the next chapter. Hence, real self-sacrifice and giving of resources requires "an interior poverty of spirit" that identifies us with the dispossessed and outcast;[95] and this onus on a global level is chiefly upon "the citizens of the great power blocs which hold the fate of other nations in their hands."[96]

83. Merton, *Ascent*, 112.
84. Merton, *New Man*, 25.
85. Merton, *Conjectures*, 158.
86. Merton, *Island*, 11.
87. Merton, *New Man*, 91.
88. Merton, *Conjectures*, 69.
89. Merton, *New Man*, 91.
90. Eco, "Superman," 123.
91. Merton, *Life and Holiness*, 89. See also Merton, *Love and Living*, 138.
92. Merton, *Life and Holiness*, 88.
93. Merton, *Conjectures*, 82–83.
94. Merton, *New Man*, 190–191.
95. Merton, *Life and Holiness*, 89; see also 100.
96. Merton, *Destruction*, 97.

This, as well, is necessarily theological. Our communions have their basis in and ought to resemble the relations among persons of the Trinity, which is "the key to the understanding of Christian social action."[97] Consequently, Christian love cannot be content with the status quo, if that means constant threats to and deprivation of the full development of every person.[98] Since Christians believe that all people should be regarded as Christ, we are responsible for the wellbeing of all.[99] To put it simply, for one "to be acceptable to us, nothing more is required than that he need our mercy, whether he himself is aware of this or not."[100]

JAMES CONE

Ontological Considerations

A careful reading of Cone suggests that the foundational principle of his anthropology, resolutely ontological before anything else, is *black power*. This was formulated already in 1969 with his first book *Black Theology and Black Power,* in which he defines it as "black people taking the dominant role in determining the black–white relationship in American society."[101] Far from advocating a form of "reverse-racism" or white hatred,[102] as was often thought in early reviews of Cone,[103] black power is primarily about "black self-determination, wherein black people no longer view themselves as without human dignity but as men, human beings with the ability to carve out their own destiny."[104] It is primarily a constructive endeavor, "a humanizing force"[105] for black persons who have spent their time in this country as inferior beings, in fact as nonbeings, because of their treatment by whites, both during and after slavery.[106]

Black power is, quite contrary to stereotyped views, a *universally* dignifying pursuit, one that blesses and re-creates the oppressors just as much as the oppressed. Cone explicitly states that the black man does not want to "repudiate his master's human dignity, but only his status as master."[107] When they rise up in disobedience and refuse to participate any longer in the myriad humiliating practices and structures of a fractured society, oppressors

97. Merton, *Love and Living,* 154.
98. Ibid., 155.
99. Merton, *Destruction,* 96.
100. Merton, *Love and Living,* 212–213.
101. James H. Cone, *Black Theology and Black Power* (Minneapolis: Seabury, 1969), 1.
102. Ibid., 16.
103. See Cone, *God of the Oppressed,* rev. ed. (Maryknoll: Orbis, 1997), xiii.
104. Cone, *Black Power,* 6.
105. Ibid., 7.
106. Ibid., 134.
107. Ibid., 14.

are freed from their illusions of superiority and forced to face blacks as full human persons.[108]

A year later, in *A Black Theology of Liberation,* Cone made the universally applicable anthropological insights of black power more explicit. To know black power, one has "to know what it means to be a nonperson, a nothing, a person with no past."[109] It is crucial to bear in mind that this can be achieved not only by those under oppression, but also by all who are willing to identify with the oppressed; who are willing to share with them in the struggle for personhood and liberation; who are willing to participate in their infirmity and inferiority for the sake of rehumanization.[110]

Because of this concrete humanity, that is, the need for human personhood to be constituted and found in the real lives of the oppressed, Cone is skeptical of traditional white philosophical and theological appeals to an abstract definition of human nature, especially when white humanity is set as the ideal,[111] as it is in monomythic portrayals. Cone specifically attacks the traditional American coupling of individualism and freedom. He considers "white Western Christianity with its emphasis on individualism and capitalism" simply unrealistic for blacks, whose experience of life and faith has been far different.[112] Furthermore, "unrestricted freedom is a form of slavery. . . . Authentic freedom has nothing to do with the rugged individualism of laissez faire."[113] A large part of this resistance to individualism has to do with the forced orphanage of black persons as they were taken from their homes in Africa. Whereas white immigrants looking to abandon what they saw as restrictions on certain liberties embraced the condition of ahistoricality, black identity was stolen by slaveholders with force.[114]

Cone instead prefers relational ways of thinking over individualism. Community "provides the structure in which our being as persons is realized. It is not possible to transcend the community; it frames our being because being is always *being in relation to others*."[115] This is also true for relations between groups. "Human beings are made for each other and no people can realize their full humanity except as they participate in its realization for others."[116] This is the ontological basis even for white liberation. For if, as Cone contends, a change of community means a change of being, then "whites will be free only when they become new persons . . . [when] they are created anew in black being . . . no longer white but free."[117]

108. Ibid., 41–42.
109. Cone, *A Black Theology of Liberation*, 20th anniversary ed. (Maryknoll: Orbis, 1990), 12.
110. Ibid., 65.
111. Ibid., 83.
112. Cone, *Black Power*, 33.
113. Ibid., 41–42.
114. Cone, *Liberation*, 12.
115. Ibid., 97. Emphasis in original.
116. Cone, *Oppressed*, xiii.
117. Cone, *Liberation*, 97.

Yet, even this basic formative function of community is theological at root, which Cone articulated quite clearly already in 1969. Our love for God and others is grounded in God's prior love for humanity. There is no innate worth in human beings that makes God love us. Rather, the reverse is true: we are valuable and dignified *because* God loves us,[118] as Merton also wrote. It is in the person and transformative work of Jesus in particular that we come to know both God and ourselves, and through him we realize that true humanity is inseparable from fellowship with God and is, in fact, found only in God.[119] To love based on the dignity of one's humanity, though, first means recognizing and identifying one as dignified, which is, as Cone understands, an epistemological issue.

Epistemological Considerations

Like Merton, Cone is critical of the unchecked use of technological reason, but largely on racial grounds. Black intellectuals, he contends, know that when liberals spoke of scientific advance and upward movement, it was at the expense of blacks "who were enslaved and colonized to secure 'progress.'"[120] In a vein that strongly echoes our discussion so far, Cone observes that the nineteenth century was "known for its confidence in the rational person, who not only knew what was right but was capable of responding to it"; yet this was also the period of extermination, enslavement, and colonialism.[121]

It is largely for this reason that Cone is critical of the traditional Christian definition of human nature primarily in terms of rationality, and commends the fact that the Reformation deemphasized the capacity of reason to know God.[122] The search for truth, which is part of the phenomenon of human knowledge, is not to be understood objectively. To the contrary, truth "is subjective, a personal experience of the ultimate in the midst of degradation."[123] Abstract truth is of no worth to blacks and others under oppression.[124] Truth must be concrete, "what places a man in touch with the real."[125] It is, more specifically, theological: an encounter with the God of black existence.[126] For Cone, then, human reason is valuable but not absolute, because ethical decisions cannot be made with the abstract methods of science. Since no technological advancement or claim to epistemic certitude is in itself capable of seeing blacks as full human beings, the faith of progress

118. Cone, *Black Power*, 50.
119. Ibid., 149–150.
120. Cone, *Liberation*, 19.
121. Ibid., 91.
122. Ibid., 90.
123. Ibid., 19.
124. Ibid., 83.
125. Cone, *Black Power*, 29.
126. Cone, *Liberation*, 19.

turns out to be morally limited, which is one reason why blacks have such animosity toward whites who continue to propagate it.[127]

Cone observes that white America has taken two main approaches to blacks: the decree that they are "outside the realm of humanity" and the attempt to integrate them into white society.[128] Both options consist of a deprivation of humanity: the first by labeling blacks and other minorities as subhuman,[129] and the second—the logical correlate—by asserting that the only true form of humanity is whiteness. The problem, to be clear, is not being white as such, but an arrogant whiteness that denies others their God-given human dignity. Accordingly, Cone suggests that the oppressed must affirm their humanity by a reality that is anti-white, by "an unqualified identification with blackness."[130] In this regard, blackness and black power generally stand for all victims who realize that their humanity is bound up with freedom from whiteness.[131]

Blacks, consequently, do not need, nor should they welcome, integration into whiteness, because it amounts to the destruction of black identity.[132] Rather, they need a sense of worth in being black, which only blacks can teach. "Black consciousness is the key to the black man's emancipation from his distorted self-image."[133] Moreover, even this longing for selfhood is "the search for God, because God's identity is revealed in the black struggle for freedom."[134] In epistemological terms, then, Cone includes within the definition of *imago Dei* the position that "liberation is knowledge of self; it is a vocation to affirm who I am created to be."[135] Such vocation necessarily leads to certain ways of acting.

Ethical Considerations

In his earliest work, Cone suggests in accord with the dominant theological tradition that the essence of sin is the desire to become like God. Unlike some understandings of pride, though, Cone's articulation stems clearly from his relational ontology. Far from enabling our divinity, pride makes man "estranged from the source of his being, threatening and threatened by his neighbor, transforming a situation destined for intimate human fellowship into a spider web of conspiracy and violence."[136]

This was echoed a year later in Cone's more systematic treatment of sin, in which he also expounds on the biblical views. Sin is a thoroughly relational

127. Cone, *Black Power*, 13.
128. Cone, *Liberation*, 13.
129. See also ibid., 7.
130. Ibid., 15.
131. Ibid., 7.
132. Ibid., 13.
133. Cone, *Black Power*, 19.
134. Cone, *Liberation*, 14.
135. Cone, *Oppressed*, 134.
136. Cone, *Black Power*, 63.

concept, defined in the Hebrew Scriptures as separation from Israel's community, outside of which it has no real meaning. It is alienation from God's covenant, which is grounded in God's rescue of Israel at the Exodus. Sin, Cone thus summarizes, is "believing that liberation is not the definition of being in the world."[137] Likewise in the New Testament, sin is to deny God's liberating activity as revealed in Jesus.[138]

Based on this reading of Scripture and in relative congruence with the tradition, Cone concludes that sin is "a way of life in which we cease to be fully human and we make choices according to our private interests."[139] For Cone, sin is to accept things such as slavery as a condition of human life. For this reason, he is critical of the tendency in white American theology to discuss sin in the abstract as something external to concrete reality. On the contrary, sin is neither theoretical nor even primarily a religious impurity but rather "social, political, and economic oppression of the poor."[140]

In this context, Cone rails against what we might delineate as the dual sin of white society. The sin of *commission,* so to speak, is "the desire of whites to play God in the realm of human affairs," which itself results from the faulty belief of white America "that it is God's chosen people because of its privileges in the world."[141] If whites think that God is on their side, there is theoretically no limit to their violence. Hence the displacement and extermination of Native Americans is not an aberration but a logical conclusion to white self-understanding.[142] Cone cites, moreover, not only the practice of slaveholding among founders like Washington and Jefferson, but also the ghettoization of blacks traceable to them and symbolized in the policies of modern political leaders such as Ronald Reagan.[143]

The obverse of such explicit expressions of white supremacy is the sin of *omission* and its myriad manifestations. This is to take whiteness and its cultural priorities for granted as the ordinary way of life and behavior. For instance, to identify "the rise of nationalism with Christianity, capitalism with the gospel, or exploration of outer space with the advancement of the kingdom of God serves only to enhance the oppression of the weak."[144] Since capitalism and American nationalism are themselves inherently exclusive and exploitative,[145] sin in this context comes not strictly intentionally,

137. Cone, *Liberation,* 105.
138. Ibid., 106.
139. Ibid.
140. Cone, *Speaking the Truth: Ecumenism, Liberation, and Black Theology* (Grand Rapids: Eerdmans, 1986), 41.
141. Cone, *Liberation,* 108.
142. Cone, *Black Power,* 75.
143. Cone, "A Black Perspective on America," in *Proclaiming the Acceptable Year,* ed. Justo L. González (Valley Forge: Judson, 1982), 86.
144. Cone, *Liberation,* 133.
145. Ibid., xvii; Cone, *For My People: Black Theology and the Black Church* (Maryknoll: Orbis, 1984), 184.

but as collateral damage; as the natural result of focusing time, energy, and resources on the prerogatives of the privileged groups.

Cone speaks out vehemently against sexism, as well. This is especially true of his mature work, most notably his 1984 book *For My People,* wherein he observes that early black theology, including his own contributions, made the mistake of interpreting sexism as a white problem.[146] So blinded, the black community put its emphasis on dignifying the black male, whose role as father, husband, and provider had been denigrated by white society. In order to earn authority and respectability, the black man needed not only a job but also, it was felt, to express his masculinity and assertiveness by stressing the weakness and passivity of black women.[147] Hence, the glorification of the pimp and womanizer in blaxploitation films, plays, and, of course, comicbooks. Cone came to recognize, however, that the oppression of black men by whites did not make patriarchy acceptable. Instead, he saw that "sexism, like racism, encourages violence as a way to subjugate the other";[148] as something that "dehumanizes and kills."[149] Black women are especially prone to victimization, because they suffer from both racism and sexism, a predicament often referred to as *double jeopardy.*[150]

It is no surprise to find, then, that for Cone the constructive alternative to sin as oppression and violence is genuine freedom, which has both personal and communal aspects. With respect to the former, Cone is critical of freedom defined either as white middle-class individualism or, more generally, sheer caprice of personal will.[151] On the contrary, freedom means "becoming what I should. A man is free when he clearly sees the fulfillment of his being and is thus capable of making the envisioned self a reality."[152] Far from being an individual quest for self-actualization, however, what is at stake here is really "an inner recognition of self-respect, a knowledge that I was not put on this earth to be a nobody."[153]

Moreover, this is the work of Jesus, the one who meets us in our "wretched condition and transforms our nonbeing into being for God."[154] The cross expresses God's solidarity with victims of oppression, while the resurrection is God's victory over violence, sin, and death.[155] These redemptive events are the gift of the Holy Spirit, who is not an internal feeling but God's dynamic presence with and for us.[156] For blacks and other oppressed persons, this

146. Cone, *For My People,* 96–97.
147. Cone, *Martin & Malcolm & America: A Dream or a Nightmare* (Maryknoll: Orbis, 1991), 276–277.
148. Cone, *For My People,* 129.
149. Cone, *Liberation,* xvi.
150. Cone, *For My People,* 125.
151. Cone, *Liberation,* 94.
152. Cone, *Black Power,* 39.
153. Cone, *Martin,* 317. See also Cone, *Liberation,* 89; Cone, *Oppressed,* 144.
154. Cone, *Liberation,* 108.
155. Cone, *For My People,* 188.
156. Cone, "Black Perspective," 94; Cone, *Black Power,* 57–58.

means that freedom is not received from those in power, but, rather, is pri-mally granted by God.[157] As such, the will of God can only be found among the dispossessed.[158] Consequently, personal liberty is inevitably communal, since "those who are free will not be content until all members of society are treated as persons."[159] Such is the shared destiny of human existence pioneered by Christ that any freedom that is not universal in scope is not true freedom.[160] No one can be free unless and until all are free.

The other side of the coin to this solidarity is the pursuit of justice, for although we share in the sufferings of the oppressed, "passive acceptance of injustice is not the way of human beings."[161] In order for this to happen, though, "what we need is the destruction of whiteness . . . the source of human misery in the world."[162] Later on, Cone would clarify more precisely that indeed all human violence and oppression must be resisted, not just rac-ism.[163] However, it is evident even in his earliest writings that whiteness is not about coloration, but is rather the dominant category of power; that is, of those who control the plenteous resources of wellbeing in the world and who in turn keep others from them. He insightfully connects this to human worth as well: "The person in . . . power is a strange creature, and it is very easy for such a one to believe that human dignity has no real meaning."[164]

This summons brings us once again to the weight of responsibility. Cone agrees with Merton that the real onus for justice is on those with power to stop being violent toward those they oppress and to start recognizing them as human beings.[165] It is the love of God for us that both obligates and enables love for our neighbors, making it "impossible to tolerate eco-nomic structures that are destructive to their humanity."[166] More distinctly, because of the mode of Christ's love in the concrete lives of those to whom he ministered, love is not a sappy emotional state, but a truly dynamic force. From the very beginning, Cone has posited that "love without the power to guarantee justice in human relations is meaningless. . . . Love demands all, the whole of one's being."[167] He connects this explicitly to our present topic by declaring that "love without responsibility is unacceptable to blacks: this view of God is a product of the minds of enslavers."[168]

So we come full circle. As with Merton, Cone understands the intimate relation of power, justice, responsibility, and love to be expressed in their

157. Cone, *Oppressed*, 127.
158. Ibid., 190.
159. Cone, *Liberation*, 88. See also Cone, *Oppressed*, 135.
160. Cone, *Black Power*, 42, 52.
161. Ibid., 123.
162. Cone, *Liberation*, 107.
163. Cone, *Truth*, 77.
164. Cone, *Liberation*, 16.
165. Cone, *Truth*, 65.
166. Ibid., 47.
167. Cone, *Black Power*, 53.
168. Cone, *Liberation*, 71.

mutual fulfillment, for even true power is not its destructive shadow, but "the possibility of the reunion of self with self and with the other."[169] Accordingly, even the annihilation of whiteness is not achieved by a reversal of historic roles or a denial of the dignity of white people, but ultimately by reconciliation with them.[170] It is not only the responsibility of those with power to pursue genuine communion, but of all of us working together;[171] the formerly violent and violated coming to abandon the shackles of apathy and animosity in all its countless reifications. The palpable "creation of a new humanity" is the peace toward which we strive as we share the present labor of Jesus through the Holy Spirit.[172]

ROSEMARY RADFORD RUETHER

Ontological Considerations

Even more than the other theologians we have considered so far, Ruether is critical of the traditional idea that human essence is defined chiefly in terms of reason. This is largely due to the ancient association of rationality with men, and irrationality or nonrationality with women, which resulted in a twofold hierarchy: that of mind over body and of reason over emotions.[173] When reason was adopted by the early Church as the key marker of anthropology in discussions of the *imago Dei,* it naturally meant that full humanity was associated with men, at the expense of women.[174] The idea of a single human nature was exacerbated by the democratic theory of the Enlightenment, in which it was still articulated in terms of reason, along with moral conscience.[175] This implies, though, that we are really dealing in the first instance with an ontological issue. In traditional thought, in other words, it is not simply the case that men are in various manifestations controlling of women, but more fundamentally that they are considered to be *more human* than women, and thus of greater essential worth.

A key expression of this way of thinking was the dualism between home and work that developed in the nineteenth century during industrialization.

169. Cone, *Black Power,* 54.
170. Ibid., 149–150.
171. Cone, "In Search of a Definition of Violence," *Church & Society* 85, no. 3 (January/February 1995): 7.
172. Cone, *Oppressed,* 204.
173. Rosemary Radford Ruether, *Sexism and God-Talk: Toward a Feminist Theology* (Boston: Beacon, 1983), 93.
174. Ruether, *Liberation Theology: Human Hope Confronts Christian History and American Power* (New York: Paulist, 1972), 19.
175. Ruether, "Gender Equity and Christianity: Premodern Roots, Modern and Postmodern Perspectives," *Union Seminary Quarterly Review* 50, nos. 1–4 (1996): 54; Ruether, "*Imago Dei:* Christian Tradition and Feminist Hermeneutics," in *The Image of God: Gender Models in Judaeo-Christian Tradition,* ed. Kari Elisabeth Børresen (Minneapolis: Fortress, 1991), 280.

With the locus of manufacturing shifting to centralized urban complexes, the "home was refashioned from a producer to a consumer unit in society."[176] This separation meant that women, who stayed home, concentrated on interpersonal relations, childcare, and the physical support of the male.[177] Although this briefly changed during World War II when previously working men were fighting overseas, by the 1950s women were less welcome in the workforce and the suburban housewife/full-time mom was seen as the social standard,[178] which, as we observed in chapter 2, came to expression in Golden Age comics.

On the other side of the coin, Ruether notes that the urban revolution "created a new elite group of males whose power was . . . based on . . . an inherited monopoly of political power, land, and knowledge."[179] This external "real world" of masculine aggression was juxtaposed with the innocent and ignorant place of the private home, where dwelt the women and children.[180] To the extent that men internalized this distinction, it has only served to exacerbate the individualism of the male pattern. For Ruether, this masculine autonomy is not mere aloofness, but "a fundamental proneness to translate all relationships into aggressive, assaultive modes of behavior,"[181] and any resistance to this ideology is seen as "disobedient rebellion."[182]

Accordingly, Ruether rejects the two dominant anthropologies that came to reign by the modern period. The older view, mentioned above, is the androcentric perspective that sets men as the standard of humanity, given the philosophical preference for rationality and its pairing with masculinity. The Romanticism of the eighteenth and nineteenth centuries, however, asserted that there are natural differences between men and women. In this two-nature or *complementarist* anthropology, men are seen as rational and active, while women are considered emotional and passive.[183]

Yet, such conceptions hurt both women and men. A woman does not have to become some caricature of a man to be fully human, especially since this often entails a felt need to be more aggressive.[184] They also do injustice to males, for even given all the privilege men have acquired for themselves, "they have not thereby succeeded in actualizing a humanity that we should

176. Ruether, *New Woman/New Earth: Sexist Ideologies and Human Liberation* (New York: Seabury, 1975), 197.

177. Ruether, *New Woman*, 197. See also Ruether, "Home and Work: Women's Roles and the Transformation of Values," *Theological Studies* 36, no. 4 (December 1975): 647.

178. Ruether, *Christianity and the Making of the Modern Family* (Boston: Beacon, 2000), 136.

179. Ruether, "Home and Work," 649.

180. Ruether, "Gender Equity," 56; Ruether, "Home and Work," 654.

181. Ruether, *Sexism*, 179. See also Ruether, *New Woman*, 195.

182. Ruether, *New Woman*, 196.

183. Ruether, "*Imago Dei*," 280.

184. Ruether, "The Becoming of Women in Church and Society," *Cross Currents* 17, no. 4 (Fall 1967): 424.

generally want to emulate,"[185] the same critique Lark Hall leveled against Golden Age superheroes.[186]

Ruether approvingly observes that many feminists are now avoiding the traditional views in favor of a more holistic anthropology that sees "activity and passivity, reason and feeling in both men and women," and not as strictly masculine or feminine traits.[187] The older views, she concedes, were not necessarily evil, but only partial.[188] Hence, she can opine that both men and women should be thought of as having the "full range of human qualities from which each had been excluded."[189]

This endeavor, though, may look different for men than for women because each has been acculturated into a particular gender pattern.[190] The journey for women to true humanity means that they must "literally discover themselves as persons, as centers of being upon which they can stand and build their own identity."[191] Since they have been denied an authentic self in the patriarchal system, what they need is an identity not based on male authority.[192] On the other side, men need to move away from their staunch autonomy and learn to be more relational.[193] Like women, they have also had to ignore "whole dimensions of their being," in this case "their ability to cry, to feel, to relate, to be sensitive."[194] Hence, men must also overcome the fear of appearing weak or effeminate and, thus, losing male status.[195]

A specific area in need of this transformation is human sexuality. Ruether points out that the "essence of male ideology" is contained in the perennial cultural relationship of men and women in which women are always objects to be used, including sexually.[196] The resultant depersonalization of sex can be seen, for Ruether, in the view of Augustine that sex is either strictly pragmatic or carnal, wherein "the possibility of bodily relation as an interpersonal relationship or a vehicle of love is essentially eliminated."[197] Such became the dominant Western view of sex.[198]

185. Ruether, *Sexism*, 178.
186. Hall, "Other Side," 53, 57.
187. Ruether, *"Imago Dei,"* 286.
188. Ruether, *Sexism*, 110. See also Ruether, "Gender Equity," 56.
189. Ruether, "Gender Equity," 56.
190. Ibid. See also Ruether, "Feminist Metanoia and Soul-Making," *Women & Therapy* 16, nos. 2–3 (1995): 43.
191. Ruether, *Sexism*, 186.
192. Ruether, *Sexism*, 174; Ruether, "Sexism and the Theology of Liberation: Nature, Fall and Salvation as Seen from the Experience of Women," *The Christian Century*, December 12, 1973, 1226.
193. Ruether, "Gender Equity," 56; Ruether, *Sexism*, 112.
194. Ruether, *Sexism*, 190.
195. Ibid., 191–192.
196. Ruether, *Liberation Theology*, 102.
197. Ibid., 106.
198. Ruether, "The Personalization of Sexuality," in *From Machismo to Mutuality: Essays on Sexism and Woman-Man Liberation*, by Eugene C. Bianchi and Rosemary R. Ruether (New York: Paulist, 1976), 71.

Ruether insightfully posits that what males fear most "is not sexual experience but rather ego-vulnerability through communication of the inner self," something men are able to avoid in an objectified view of sex.[199] In other words, like the hero of the American monomyth, it allows them to shun the experience of self-surrender, and sexuality becomes something "debased to ward off the challenge of love."[200] Instead, the liberation of sexuality will come about only in the mutual development of persons through respect, friendship, and a commitment to holistic growth,[201] wherein both men and women grow away from the fears and roles associated with sex. She proposes the idea of a covenant between partners "who seek to integrate sex with . . . friendship and mutual support";[202] a union that must be characterized by "fidelity and commitment."[203] Only in this way can sex be ethical and, thus, truly humanized.[204]

Not only sexuality, but also the understanding of community as a whole must be reformed. She levels a substantial critique against the notion that the nuclear family should be the normative one, arguing that, even on a merely descriptive level, this creation of the Victorian period, glorified in 1950s Americana, is simply no longer the predominant type of household, if it ever was at all.[205] Moreover, the nuclear family is ethically problematic for women because of the work-home, male-female dualities in which it emerged and is steeped.[206]

Ruether commends instead the early Church, which understood itself as a new family that broke down separations and brought together men and women, slave and free, Jew and Greek, clean and unclean.[207] We must accordingly seek a community that wills the good of others and facilitates the growth and empowerment of those who have been excluded. Ruether rightly asserts that this sort of "redemptive community" means a redefinition of family in which the view of the nuclear model as normative gives way to a postmodern view which would actually support a variety of household patterns, yet with a few shared characteristics.[208]

For one, new communions would include "cohabiting partnerships" of people that may not necessarily include romantic pairs.[209] Such families would, in any case, take as fundamental the "full and equivalent humanity of women in

199. Ibid., 71.
200. Ibid., 72.
201. Ibid., 81, 85.
202. Ruether, *Modern Family*, 214.
203. Ibid., 219.
204. Ibid., 218–219.
205. Ibid., 181.
206. Ruether, *New Woman*, 207.
207. Ruether, *Modern Family*, 226. See also Ruether, "Feminism and Peace," *The Christian Century*, August 31–September 7, 1983, 776.
208. Ruether, *Modern Family*, 210, 229.
209. Ibid., 212.

partnership with men," such that various relations are reconfigured "to foster a more equitable sharing of wealth."[210] For another, such "socialized local communities" would share resources as well as the responsibilities of raising children among members, including those who are not related biologically.[211] This would facilitate "a richer pattern of friendship" among adults, such that any romantic relationships would not leave the two partners as "each other's sole personal nurturers," as is too often the case.[212]

At the backbone of Ruether's alternative vision of human being—the overcoming of patriarchy, the call for respective male and female journeys, the personalization of sexuality, the reimagining of family—is fellowship with God. She notes that the biblical understanding of relation to God is expressed precisely in the concrete interactions between human persons.[213] She even identifies the theological meaning of *imago Dei* as "our capacity for healthy and life-giving relations,"[214] which necessarily includes "egalitarian mutuality" as the "true meaning of original and redeemed creation and reconciliation with God."[215] This path implies not only a renewal of human being, but also of our ways of knowing and being known.

Epistemological Considerations

As we saw above, the preference for rationality in defining human being, in addition to the association of reason with maleness, meant that men became the ontological standard of humanity. This was exacerbated in the early modern period, Ruether observes, by the Cartesian epistemology of subject-object dualism, which made knowledge "a process whereby a non-material thinking subject reduced all around him, including his own body, to the status of an object to be mastered."[216] This, in turn, was based on a dualistic metaphysics, which split reality into immaterial thinking substance and material nonthinking substance, or matter, a phenomenon that eventuated in two chief and closely related consequences.

On one path, it contributed to the rise of modern science, wherein nature was understood to be orderly and rational and reclaimed "as the realm of human knowledge and use."[217] The Cartesian abstraction of man as knowing subject over against natural objects enabled the mastery of men over nature. This became aided by technology, which "raises up the dream of expanding manipulation of material nature," such that eventually "no

210. Ibid., 207–208.
211. Ruether, *New Woman*, 208.
212. Ibid., 210.
213. Ruether, *Liberation Theology*, 131.
214. Ruether, "Metanoia," 38; see also 39.
215. Ruether, "Gender and Redemption in Christian Theological History," *Feminist Theology*, no. 21 (May 1999): 105.
216. Ruether, *Liberation Theology*, 17.
217. Ruether, *Sexism*, 82.

corner of nature . . . will elude human control."[218] Ruether even implicates Francis Bacon in this development, as we did in chapter 1. While Bacon rightly saw the need to break the connection of science to a magical world-view, "covertly he also created a quite unchristian split between the moral redemption of the human soul and the restoration of nature."[219] By the nineteenth century, rationality had become disconnected from ethical concerns, and technology was used for the pillaging of natural resources and perceived human good "at the expense of the subjective, personalist dimension of salvation."[220]

On the other path, the system of conquering nature through material production, Ruether observes, is also "carried out under the conditions of social domination and exploitation."[221] Since women as well as the poor and nonwhite races are seen to be lacking rationality and leadership,[222] they logically fall among the targets of technological abuse, as Cone similarly argued. The dualisms of soul–body and subject–object have simply been writ large into systems of oppression to the extent that Western prosperity "is purchased at the expense of the impoverishment of the dominated peoples."[223] In short, Ruether concludes, there is no real hope for women, minorities, or the environment "within a society whose fundamental model of relationships continues to be one of domination."[224]

In such a context, of course, those persons used for the felt wellbeing of the rich and powerful are deprived of authentic selves; that is to say, they lack genuine identities. Ruether observes that the subordination of women in particular, because it takes place in every culture, denies women an alternative context from which to find and express their identities.[225] Unlike most other minority groups, women simply have no distinct heritage or tradition from which to draw a uniquely feminine sense of self. What all oppressed persons do have in common, however, is a tendency to internalize the negative images impressed upon them by the oppressor, resulting in both self-contempt and violence toward their peers. Liberation, then, is experienced "as a veritable resurrection of the self," in which the marginalized gain new autonomy and self-esteem as well as the possibility of communion with their brothers and sisters.[226] Significantly, the only ground for this

218. Ibid., 83.
219. Ruether, *New Woman*, 191.
220. Ruether, *The Radical Kingdom: The Western Experience of Messianic Hope* (New York: Harper & Row, 1970), 284. See also Ruether, "Home and Work," 654; Ruether, *New Woman*, 191.
221. Ruether, *Sexism*, 84.
222. Ruether, "The Development of My Theology," *Religious Studies Review* 15, no. 1 (January 1989): 3.
223. Ruether, *Sexism*, 84. See also Ruether, *Liberation Theology*, 18.
224. Ruether, *New Woman*, 204.
225. Ruether, "Re-contextualizing Theology," *Theology Today* 43, no. 1 (April 1986): 22.
226. Ruether, *Liberation Theology*, 12.

reidentification is a "universal humanity" against which both oppressed and oppressors gauge their identities and, hence, mutual responsibility.[227]

Here, Ruether comes full circle and offers a redefinition of intelligence itself, since it has all too often been seen as a privilege and justification to alienate and dominate without concern. This old "white Western male rationality" is problematically based upon "linear, dichotomized thought patterns," and tends to see only brute facts instead of the relational contexts in which facts are situated, often leading to destructive uses of nature. Ecological thinking, on the other hand, must integrate linearity and relationality.[228] Consequently, intelligence itself should be understood as "the responsibility to become the caretaker and cultivator of the welfare of the whole ecological community upon which our own existence depends."[229] In other words, for Ruether, as it is for Merton and Cone, human knowing is consciously and intrinsically tied to moral action.

Ethical Considerations

As we have done throughout, we turn again to the chief theological category pertaining to human action, the doctrine of sin. For Ruether, sin has to do with broken relatedness with both God and others.[230] Although sin occurs on personal and social levels, "there is no evil that is not relational. Sin exists precisely in the distortion of relationality, including relation to oneself."[231] An overemphasis in much Christian thought on individualistic ideas of sin has tended to blind us to the systemic evil that Paul refers to as the "powers and principalities."[232] Since social sin becomes embodied in the customs and institutions that we take to be normal,[233] merely focusing on personal sin serves to "evade the reality and responsibility for the history of distorted humanity."[234]

She suggests that our traditional idea of sin has been confused with natural finitude. Since we share the latter with other creatures, however, we must distinguish it from sin, which is a uniquely human phenomenon.[235] Genuine sin, then, has to do with misusing the freedom we have with regard to our relations; when we "violate the basic relations that sustain life . . . a fancy way of saying that life is sustained by love."[236] The conclusion, of course, is that, ultimately, sin is a violation of love.

227. Ibid., 16.
228. Ruether, *Sexism*, 89–90.
229. Ibid., 88.
230. Ruether, *Liberation Theology*, 8, 131–132.
231. Ruether, *Sexism*, 181.
232. Ruether, *Liberation Theology*, 8. See also Ephesians 6:12.
233. Ruether, *Disputed Questions: On Being a Christian* (Nashville: Abingdon, 1982), 100.
234. Ruether, *Sexism*, 181.
235. Ibid., 160; Ruether, *America, Amerikkka: Elect Nation and Imperial Violence* (London and Oakville: Equinox, 2007), 259.
236. Ruether, "Metanoia," 35.

Several phenomena either unique to or propagated by the United States stand as clear examples of such violation, in resonance with what we have thus far criticized in the American monomyth. Two of these are the closely connected sins of sexism and racism. Ruether asserts that for the puritans, a woman was to be a submissive helper to the male.[237] For them as well, as in much Western Christian thought, "unredeemed nature bears the face of death, sin, and the devil" in which wild and native persons are taken to be residents of a fallen place "inhabited by the powers of darkness."[238]

In the Revolutionary period, male liberals did not include women in the idea of basic rights because reason and sovereignty were still seen as unique to men.[239] Moreover it is well known that the writers of the Declaration of Independence did not include women, children, slaves, natives, or men without property among those divinely granted inalienable rights, but specifically white male landowning Anglo-Saxon Protestants.[240]

Such ostracism has persisted to the present. Like Cone, Ruether contends that contemporary racism has been built on dividing the black family, achieved by making black men incapable of being heads of families and of providing for their wives and children. The black man was considered to be "'body-object' pure . . . seen as dangerously sensual," and all the irrationality associated with women became tied to him, also.[241]

On the other side, the white man "lives enclosed in a racial myth" designed to exclude black people, and white institutions are created to keep from focusing on blacks, while gaining from the benefits.[242] All marginalized persons, Ruether suggests, suffer under America's "one complex system of exploitation which sets different groups in different relations of oppression."[243]

Such a system is historically inevitable in a nation whose identity is shaped from the beginning in terms of exceptionalism, divine election,[244] and manifest destiny,[245] and which entails the notion that its own way of life is superior to, and thus normative for, all others.[246] At the present moment, Ruether contends, American imperialism is built on three key foundations: neoliberal economic theory, neoconservative ideology, and Christian fundamentalism, which coalesce into a reality that bears a striking resemblance to, and is in point of fact the political face of, the American monomyth. In a statement that remarkably summarizes our critiques thus far, Ruether

237. Ruether, *Sexism*, 171.
238. Ibid., 81.
239. Ruether, "*Imago Dei*," 279.
240. Ruether, *America*, 41; Ruether, "Gender Equity," 54.
241. Ruether, *Liberation Theology*, 20. See also Ruether, *New Woman*, 118.
242. Ruether, *Liberation Theology*, 139.
243. Ibid., 175.
244. Ruether, *America*, 5.
245. Ruether, "Teaching Peace in a Time of War," *Dialog* 42, no. 2 (Summer 2003): 168.
246. See Ruether, *America*, 148.

observes: "In neo-liberal anthropology humans are viewed as autonomous rational subjects who act solely to maximize their individual self-interest, qua economic possessions."[247]

She notes that this is closely related not only to patriarchy, but also to war and violence in general, citing a longstanding connection between masculinity, violence, and the degradation of women, including in the military itself.[248] If violence is based on the repression of one's sense of vulnerability, it is no wonder that men, who are taught to be invulnerable, tend to be more prone to violence than women. Ruether contends that even among men, the most violent are those with the greatest fear of impotence.

Genuine peace, on the other hand, must be based on a secure sense of self and of one's value as a human being. Only in this way can we pursue nonviolence, defined as "a courageous resistance to violence and injustice that reaches out to affirm rather than to negate the humanity of the other person."[249] Like Cone, Ruether posits that "there is no liberation *from* the enemy that is not a liberation *of* the enemy."[250] She is referring principally to the oppressors, who need to be freed from the "pathology of mastery and self-absolutization."[251] This is not in any way to reject the humanity of those who dominate, but rather to exorcise "the false, demonic powers that *possess* them."[252] Indeed, the real goal of this stripping away of power is to build "a community which brings together oppressor and oppressed in a new relationship" of friendship.[253] This is only possible, though, if there is a "common human nature" against which the dominant and the marginalized recognize each other as dignified and worthwhile.[254]

For Ruether, to be sure, this redemptive dynamic is the work of God. It is, in fact, Jesus who "reveals God's critical judgment against the rich and the powerful, the religious and social elites."[255] By making himself a servant of the outcast, Jesus showed that their liberation is "the critical locus of God's action in history."[256] Although Ruether is not naïve about our ability to create a perfect world, she does recognize the possibility that some societies can reflect the Kingdom of God more than others.[257] It is by following Jesus, by doing what he did and making ourselves "servants of all," that we not only

247. Ibid., 195.
248. On the following, Ruether, "Feminism and Peace," 773–775.
249. Ibid., 775.
250. Ruether, "Male Chauvinist Theology and the Anger of Women," *Cross Currents* 21, no. 2 (Spring 1971): 183. Emphasis in original.
251. Ibid., 183.
252. Ruether, *Liberation Theology*, 137. Emphasis in original.
253. Ruether, "Theology of Liberation," 1228–1229.
254. Ruether, *Liberation Theology*, 130. See also Ruether, "Theology of Liberation," 1229.
255. Ruether, *Questions*, 93.
256. Ibid.
257. Ibid., 97.

realize such a society, but also that we express our faith that God will win in the end and bring the divine reign to full fruition.[258]

CATHERINE KELLER

Ontological Considerations

More than any of our thinkers thus far, Keller explicitly critiques the ancient philosophical categories that have undergirded the individualistic anthropology of the American monomyth. In her first book, the 1986 *From a Broken Web,* Keller observes that the idea of a separate self began with Aristotle's view of the individual being as a substance, "as what cannot be 'in' another or immanent to another, what is therefore self-subsistent and independent."[259] Substance metaphysics also means that relations, "like bodies, are merely accidental";[260] they have no bearing on the nature or essence of a thing.[261]

In Christian theology, Keller notes, it was not until Thomas Aquinas that Aristotle's ideas of substance combined with Augustine's Platonic notion of subjectivity as separate,[262] such that Thomas's vision "represents the triumph of substantialism."[263] With Descartes—whose definition of substance is "that which needs nothing but itself in order to exist"[264]—the unity of body and soul established by Aristotle and Thomas split into two substances: the material body and the rational soul or mind. In Descartes, then, we find "for the first time in conceptual history the fully substantial self—the self-objectified self, autonomous and so fundamentally separate from everything, beginning with its own body."[265] This isolationism was reinforced by the mechanistic theories of seventeenth-century science and its idea of absolute space and time.[266]

The British empiricists, especially David Hume, challenged this dominant ontology, the latter arguing that if the essence of a thing is a substance about which nothing can really be known or said, we are left only with skepticism.[267] Keller also approvingly summarizes the views of William James, for whom the relational dynamic of lived experience replaces the idea of individual subjects or substances;[268] and Alfred North Whitehead, for whom "actual entities are

258. Ibid., 98. See also Ruether, "Gender and Redemption," 104.
259. Catherine Keller, *From a Broken Web: Separation, Sexism, and Self* (Boston: Beacon, 1986), 163.
260. Ibid., 117.
261. Ibid., 173; Keller, "The Love of Postcolonialism: Theology in the Interstices of Empire," in *Postcolonial Theologies: Divinity and Empire,* ed. Catherine Keller, Michael Nausner, and Mayra Rivera (Atlanta: Chalice, 2004), 222.
262. Keller, *Broken Web,* 163–164.
263. Ibid., 172.
264. Ibid., 174.
265. Ibid.
266. Ibid., 241–242.
267. Ibid., 175–176.
268. Ibid., 178.

events, not substances,"[269] and whom she credits as the true pioneer of relationality for Christian philosophical theology.[270]

In spite of these promising philosophical developments, the majority of Western metaphysics and popular conceptions continue to be "weighed down by the presupposition that to be a single individual is to be an enduring, self-identical substance, essentially independent from others."[271] A chief expression of this conceptuality is the dual dynamic of sexism and the male pattern. Keller makes the thesis of *Broken Web* explicit: "separation and sexism have functioned together as the most fundamental self-shaping assumptions of our culture."[272] To be more precise, the understanding of the male subject as "complete in itself" has arrogated men as the primary determiners of human civilization, over against women who are taken to be passive and incomplete without males.[273]

What makes Keller even more important for our discussion is that she explicitly critiques the Western male hero structure. For one thing, she suggests that the "free-wandering warrior" has been the broadest and most influential of our cultural types.[274] She also connects the hero explicitly to anthropology by claiming that this myth "has dominated Western imagining of what it is to be a 'man,' that is, a full human being."[275] Such a one values above all the traits we have so far called into question throughout this book: separation, isolation, changelessness, "mobile autonomy," and "self-possession."[276] This lone figure, which has historically been the mantle of the male, shields itself from vulnerability through the repression of interconnectedness and denial of intimacy with others.[277]

The problematic manifestations of this situation are myriad, but not the least of which is strictly philosophical. Keller refers to the "substantialist-essentialist-autonomy complex of the normative, Western, male ego,"[278] whose "relations do not affect its essence."[279] The "autonomous self-assertion" that characterizes the nature and behavior of this figure becomes "implicated in a sort of ontological belligerence."[280] Practically speaking,

269. Ibid., 182. See also Keller, "Feminism and the Ethic of Inseparability," in *Weaving the Visions: New Patterns in Feminist Spirituality,* ed. Judith Plaskow and Carol P. Christ (San Francisco: Harper & Row, 1989), 262.
270. Keller, "Seeking and Sucking: On Relation and Essence in Feminist Theology," in *Horizons in Feminist Theology: Identity, Tradition, and Norms,* ed. Rebecca S. Chopp and Sheila Greeve Davaney (Minneapolis: Fortress, 1997), 71.
271. Keller, *Broken Web,* 162; see also 1.
272. Ibid., 2.
273. Ibid., 7; see also 2, 13.
274. Keller, "Ethic of Inseparability," 258.
275. Keller, *Broken Web,* 8.
276. Ibid., 9; see also 8.
277. Ibid., 8–9, 204. See also Keller, "'To Illuminate your Trace': Self in Late Modern Feminist Theology," *Listening* 25 (Fall 1990): 214.
278. Keller, "Trace," 220.
279. Keller, *Broken Web,* 8.
280. Ibid., 26.

this means principally the move to control the other instead of connection with the other.[281]

Keller posits that this refusal of intimacy is not a natural phenomenon, but, rather, stems from a primal urge to escape the relational matrix of the mother, who is, as a woman, culturally associated with fallenness, sex, flesh, unredeemed nature, "uncontrolled instinct," and "rebellious desire."[282] Such "defensive matricidal aggression" suggests, then, that the chief target of the domineering male ego is women. Hence, Keller concludes, "separatism is systemic to sexism."[283]

For Keller, the outright exploitation, objectification, and domination of women are symptoms of a deeper conceptual problem concerning the definition of the self. The aforementioned negative connotations of womanhood became the way in which it was understood in the dominant strand of Western theology and culture.[284] The idea of the self as "sinfully self-seeking and self-saving fleshiness" was only fully configured, however, in light of Augustine's views of original and inherited sin.[285]

The consequence for women has been the persistent cultural pressure to lose themselves, resulting in a "soluble self" in which they "forfeit the strength of an assertive subjectivity" within a web of private interpersonal relations and duties that have traditionally defined them.[286] Keller agrees with Hall and Ruether that women can only be freed when these relations themselves are transformed, which, notably, "does not, cannot, take the form of a mere inversion: that is, a somewhat late and undernourished attempt to emulate the male ego."[287]

What, then, is our alternative? Like the other theologians we have considered, Keller also posits relational ontology to replace the problematic substance view. Already in 1986, Keller commended Whitehead's perspective that "every entity in the universe can be described as a process of interconnection with every other being."[288] To cite her more creative language: "Our connections . . . constitute a metaphysical force-field."[289] Moreover, she argues that relationality is natural, noting as an example the early child's connection with its parents. "Disempathy and separation, not connection, are what must be explained."[290] It is, in fact, a mature and healthy sense of self in relation that offers the greatest challenge to the path of the autonomous loner.[291]

281. Ibid., 138, 201. See also Keller, "Power Lines," *Theology Today* 52, no. 2 (July 1995): 193–194.
282. Keller, "Trace," 212, 214. See also Keller, *Broken Web*, 201.
283. Keller, *Broken Web*, 209.
284. Keller, "Trace," 212.
285. Ibid., 215.
286. Ibid. See also Keller, "Ethic of Inseparability," 258.
287. Keller, "Trace," 215. See also Keller, *Broken Web*, 22.
288. Keller, *Broken Web*, 5.
289. Ibid., 156.
290. Ibid., 136.
291. Ibid., 140.

In a later essay, Keller highlights more poetically the breadth and frailty of this reality. Since there are no such things as static essences, and since "we are all already bound up together," our humanity must be created anew in and through our concrete physicality.[292] All bodies, just in that they are essentially interrelated, disclose "our planetary ecology,"[293] meaning not only that all creatures are connected, but also, just so, that we are all mutually vulnerable: "Human interrelatedness remains as terrible as it is loveable."[294]

This implies, of course, that we be accountable to both ourselves and each other in a balanced interconnectedness. To be overly concerned with oneself is to risk falling into the old pattern of separation and autonomy.[295] On the other hand, to focus immoderately on others is to risk the loss of one's own self through absorption.[296] The latter concern is sometimes associated with relationality in itself, no doubt one reason why it meets resistance in a culture that prefers, even quite pathologically, complete independence. Keller makes clear, though, that we are to find our differentiation precisely in relation, not in opposition, to it.[297] Moreover, relation itself implies something to be related: "Taking part in each other presupposes and creates differentiated selves in which to take part!"[298]

Nevertheless, the interconnection that Keller promotes indeed entails a real and difficult challenge to the fiercely independent, which is its true psychological horror. She is explicit that relationality is not about "living together side by side" in which we just respect each other's autonomy. Such thinking only "recapitulates the hollow dualism of selves and others, lifting up a solitude without interconnection—a sterile parody of relation."[299] Quite to the contrary, our mutual constitution "evokes an anti-establishment metaphysic" that calls into question the ignorant comforts of the status quo, not just ethically, but first epistemologically.[300]

Epistemological Considerations

As was briefly broached in the previous paragraphs, Keller observes that the Western dualism of subject and object is closely related to patriarchy.[301] More precisely, she notes that men have claimed subjectivity exclusively for themselves, which comes to expression most grievously in the "capacity of selves to turn themselves and the rest of the universe into objects of reflection . . . the

292. Keller, "Love of Postcolonialism," 240.
293. Ibid., 241.
294. Ibid., 242.
295. Keller, "Seeking and Sucking," 66.
296. Keller, *Broken Web*, 161.
297. Ibid.
298. Keller, "Ethic of Inseparability," 264. See also Keller, *Broken Web*, 206.
299. Keller, *Broken Web*, 230.
300. Keller, "Ethic of Inseparability," 256.
301. Keller, *Broken Web*, 199.

definition of the . . . rational soul."[302] This notion of epistemology treats the knower as "a separate and independent substance cut off from the world."[303] The ego therein must then seek to control the objectified other in order to construct a sense of self. However, if all creatures are ontologically constituted by their relations, the autonomous subject is disillusioned, simply making up for "a lack that it does not really have—for it is only the feeling, not the reality, of isolation that cuts it off from the in-flowing other."[304]

In the same way that others influence one's being, though, they also shape subjectivity. If our knowing is not the "product of some autonomous essence,"[305] but is rather constituted by the concrete interactions with and experiences of others, then even our own subjectivity, our own consciousness, is a "'knowing together,' an interaction not of subject with object but of subjects reciprocally."[306] Such knowledge frees us from the felt need to dominate others through our objectification of them, recognizing that our own self-knowing depends on how we are seen and known by those others.[307]

For the traditional male hero, this search for identity requires a male enemy or a female possession by which to secure a self against "the fundamental anxiety that he may be no one."[308] This act of self-enclosure leads to "the delusion of an identity detached from all that it excludes."[309] In this *"idolatry of identity . . . difference . . .* hardens into *an essential sameness"* in which one denies his connection to all other creatures; to deny, in short, that one is, in fact, a creature, "the ultimate idolatry."[310]

On the contrary, true identity is formed in mutual relations: "A subject takes place amidst a dense ecology of interdependence."[311] This implies that such deep connections are holistic, concrete, and physical, not abstractly rational. Hence, Keller commends the view of process thought, in resonance with the Hebrew idea of knowledge, "that the only immediacy of knowing the other is the feeling of its feelings as it passes into immanence within my own constitution."[312] In other words, to know any being, "one must know its universe";[313] it is to "participate" in and "act with and upon" the one known.[314] Just at this point, Keller observes, theory and discourse become limited: "To put it clearly, mutual recognition demands more than talk."[315]

302. Ibid., 28–29.
303. Ibid., 31.
304. Ibid., 27.
305. Keller, "Seeking and Sucking," 55.
306. Ibid., 74; see also 58.
307. Keller, *Broken Web*, 178; see also 198.
308. Ibid., 31.
309. Catherine Keller, Michael Nausner, and Mayra Rivera, "Introduction: Alien/Nation, Liberation, and the Postcolonial Underground," in *Postcolonial Theologies*, 12.
310. Ibid., 12. Emphasis in original.
311. Ibid., 14.
312. Keller, *Broken Web*, 199.
313. Ibid., 188.
314. Ibid., 218.
315. Keller, "Seeking and Sucking," 74.

Ethical Considerations

Although not an explicitly prominent theme for Keller, her idea of sin flows naturally from her relational ontology and epistemology. In her most recent book, *On the Mystery,* she rejects the traditional definition of sin only in terms of separation from God, because it tends to distract us from our interdependence with each other and the other creatures.[316] This is not in any way to deny God or the significance of rejecting God, but rather to emphasize that "it is in our delusional separation from each other that our separation from God *matters*—and matters to the God in whose image we share responsibility for each other."[317] To be more precise, then, for Keller, like Ruether, sin is the violence we do to others and that done to us, the brokenness we effect into the world in both our hardness of heart and our woundedness.[318]

Such distorted relatedness has universal expressions, but it is important to note here Keller's critique of the United States in this arena. One key factor is Calvin's theology of God as deterministic, preemptive, and proactive, which contributed to America's elitist self-understanding.[319] Manifest Destiny, for instance, "has always bristled with Christian power codes."[320] Although Calvin's idea of divine power is problematic, he certainly would not have endorsed any human pretense, including that of the United States, to domination and imperialism.[321]

Keller does not go into a nuanced history of the other factors that led to American grandiosity, but she makes many comments similar to those we suggested in the first chapter. She notes that for the puritans, the new land was seen as a waste, and the wilderness as the home of wild beasts and natives and, hence, the devil.[322] She also observes that America's problem is not a past loss of innocence, but "the persistent delusion of innocence,"[323] in which the United States identified itself as righteous over against the evil of various cultural others, as Merton also noticed. It is in fact this self-understanding that differentiates the American from the Roman Empire; for although both would see themselves as the superior power, only the former coupled this with a "messianic good vs. evil superheroism" of moral perfection.[324] American dominance is based on this idea that the rest of the

316. Keller, *On the Mystery: Discerning Divinity in Process* (Minneapolis: Fortress, 2008), 79–80.
317. Keller, *Mystery,* 80; see also 97–98. Emphasis in original.
318. Ibid., 97.
319. Keller, *God and Power: Counter-Apocalyptic Journeys* (Minneapolis: Fortress, 2005), 25.
320. Ibid., 19.
321. Ibid., 27.
322. Keller, "Postmodern 'Nature,' Feminism and Community," in *Theology for Earth Community: A Field Guide,* ed. Dieter T. Hessel (Maryknoll: Orbis, 1996), 98.
323. Keller, *God and Power,* 21.
324. Keller, "Territory, Terror and Torture: Dream-reading the Apocalypse," *Feminist Theology* 14, no. 1 (September 2005): 65–66. See also Keller, *God and Power,* 98.

world should be like it, an image it shares with the British, Keller suggests,[325] but accomplishes more than any other empire—especially in times of conservative political leadership—"through a virtual Wild West of diplomatic vulgarity . . . and maximum firepower."[326]

Yet the ontology of reducing otherness to sameness only comes to *expression* in American national identity and foreign policy. Its real *origin* is in Greek philosophy, which "conceives of 'being' as changeless self-identity over and against change and difference."[327] Christian theology adopted this ontology, and has since had an aversion to difference. For this reason, Keller insists that any truly counterimperial theology must overcome this problematic philosophical preference for sameness.

One manifestation of a new respect for difference would be a Christian view of the enemy that always bears in mind that God sends rain and sunshine on both good and evil ones, according to Matthew 5:45.[328] Thus, we must demand of Christians (including Americans who are willing to identify as such) "that *we treat all enemies as human beings, that is, as creatures capable of responsibility and only therefore culpable.*"[329]

Another consequence, flowing from the first, is that we redefine justice as "*acting in consciousness of the relationships that bind us together, relations of fragile, global interdependence.*"[330] In this way, Keller closely identifies justice with love, moving away not only from the perennial connotation of their opposition, but also from the idea of love as a socially powerless and individualistic emotional state.[331]

We should take note here of the significant difference between Keller's views of the enemy and justice, and those of Golden Age comicbooks as described by Umberto Eco in chapter 2. Eco rightly observes that enemies, in his example criminals, were considered entirely evil,[332] whereas Keller's relational ontology and respect for alterity drives her to consider the humanity of perceived enemies. Similarly, doing good in the Golden Age was limited to charity, according to Eco, while systemic injustices were ignored.[333] Again, Keller takes a relational approach here in her idea of justice as acting on behalf of each other in awareness of the complex matrices of interdependence in which we find ourselves; a definition that entails consideration of institutional inequities.

325. Keller, Nausner, and Rivera, "Introduction," 12.
326. Keller, "Love of Postcolonialism," 232. Here Keller has the George W. Bush administration chiefly in mind, although it is certainly not limited to his.
327. Keller, Nausner, and Rivera, "Introduction," 10. See also Keller, "Love of Postcolonialism," 222.
328. Keller, *God and Power*, xii.
329. Ibid., 14. Emphasis in original.
330. Ibid., 15. Emphasis in original. See also Keller, "Power Lines," 203.
331. Keller, *God and Power*, 110.
332. Eco, "Superman," 123.
333. Ibid.

This relational approach is exacerbated by a process view of God for Keller, in which divine power is understood not as dominance or control of creaturely events, but as influence, lure, and response to creative desire.[334] Such a theology intensifies mutual responsibility by becoming "recirculated to human agents using their relative freedom against the background of cosmic indeterminacy."[335] The openness of the future for both God and creature, Keller argues, enables a "novelty of response" that is not bound to the cynical and oppressive modes of predestined relational patterns, but depends rather on a "receptivity to the other" that engenders the true and uncontrollable beauty of mutual love.[336]

F. LERON SHULTS

Ontological Considerations

Like Keller, Shults also explicitly challenges the substance metaphysics that lies behind American monomythic ideas of the human. In his 2003 book *Reforming Theological Anthropology*, Shults outlines what he calls the "philosophical turn to relationality": a shift in ontological and metaphysical conceptions from the dominance of substance to the primacy of relation.[337] He begins by arguing that, although Plato assumed the distinction between the "unchanging substance of a thing and its changing accidental qualities,"[338] it was Aristotle who developed a full theory of this distinction. "Here we find the root of Western philosophical privileging of substance over relationality,"[339] in which relations are accidental traits that do not affect the essence of a thing and are, hence, less real. This became orthodox Western philosophy.[340] With regard to anthropology proper, it was Boethius who articulated "what is perhaps the best known theological definition of a human being" as "'an individual substance of a rational nature.'"[341] The diffusion of this conception throughout the history of Western philosophical and Christian thought was in fact so vast, Shults contends, that its influence is simply "difficult to exaggerate."[342]

334. Keller, *Mystery*, 80–81, 98ff.; Keller, "Power Lines," 198.
335. Keller, "Power Lines," 198.
336. Keller, *God and Power*, 151.
337. Shults, *Anthropology*, 11–32.
338. Ibid., 13.
339. Ibid.
340. Ibid., 14–15.
341. Ibid., 31, 168; Shults, "Imago Dei and the Emergence of Sapiential Life," in Coping with Evil: Perspectives from Science and Theology, ed. Niels Henrik Gregersen & Christina Hjøllund (Aarhus: University of Aarhus Press, 2003), 101. See also Boethius, "A Treatise against Eutyches and Nestorius," section III.
342. Shults, "Spirit and Spirituality: Philosophical Trends in Late Modern Pneumatology," *Pneuma* 30 (Fall 2008): 276.

The privileging of substance over relation thus continued through the Middle Ages and early modern period, not only evident in but constitutive of, for instance, Descarte's and Newton's systems.[343] Like Keller, Shults observes that the British empiricists John Locke and especially David Hume came to the logical conclusion that, given the distinction between substance and accident, we do not really know anything about things as they are.[344] Different from Keller, however, Shults argues for an earlier beginning to the relational shift. Immanuel Kant offered his own list of philosophical categories in which substance and accident are subsumed under relationality, but he maintained the permanence of substances and the changeability only of accidents.[345] It was Hegel who took the primacy of relationality more seriously, a trend that Shults then highlights in the writings of several other thinkers, especially Søren Kierkegaard, Charles Sanders Pierce, Whitehead, and Emmanuel Levinas.[346]

In other disciplines as well, Shults observes, conceptions of personhood are no longer formulated in terms of the "isolated individual. . . . To be a person is to be in relation."[347] Shults even explicitly connects this to realism, a theme that was formative for Stan Lee's new superhero stories in the 1960s, as we will see in chapter 4: "After the turn to relationality, the concepts of being real and being in relation are thought together in a fresh way."[348]

In Shults's constructive proposal for theological anthropology, he organizes his argument in the order of human knowing, acting, and being." This incorrect version contains verb confusion.[349] With regard to ontology, he sees human life as characterized by a desire "to *belong-to and be longed-for* in harmonious and pleasurable fellowship."[350] Our inability to secure this kind of existence, however, engenders *ontological anxiety:* a "fear of nonbeing" characterized by the realization that we are able neither to control the presence of others, oneself, or God, nor just therein to guarantee a future of peace with them.[351]

Thus, the question of being is for Shults intimately related to eschatology. When we cease to hope, we cease in a decisive way to be, and our personhood

343. Shults, *Anthropology*, 17.
344. Ibid., 18–19.
345. Ibid., 20–22.
346. Ibid., 22–30.
347. Shults, "Spirit and Spirituality," 277.
348. Shults, *Anthropology*, 12.
349. Ibid., 163–242. Here Shults is concerned with anthropology proper, but we will cite some other works as well in which he is, nevertheless, quite obviously still discussing human personhood.
350. F. LeRon Shults and Steven J. Sandage, *Transforming Spirituality: Integrating Theology and Psychology* (Grand Rapids: Baker, 2006), 123. Emphasis in original. See also Shults, *Anthropology*, 218; Shults and Sandage, *Faces*, 208. References to *Transforming Spirituality* and *Faces of Forgiveness* are to the sections authored by Shults alone.
351. Shults, *Anthropology*, 217; Shults and Sandage, *Transforming Spirituality*, 138.

is arrested. Shults suggests that this is also related to our longing for beauty by noting the human "passion for a transcendent reality," which is itself conditioned by the allure of the aesthetic to share in an infinitely delightful future.[352] Hence, human being cannot be made, but must be received as a gift, both as it is awakened by the presence of other creatures and as it "finds its origin, condition, and goal in the call of the triune Creator to an ever intensifying share in the relation of the Son to the Father in the Spirit."[353] It is just this uncontrollable intimacy with the God who grants us being that "frees us to know and be known, to love and be loved in community."[354]

This emphasis on hope and futurity leads, moreover, to Shults's understanding of our creation in the image of God. "The essence of human creatureliness is disclosed by its end" as we are becoming formed by the Spirit into the image who is Jesus Christ.[355] The *imago Dei* is not a quality that we have or something that lies in the past, but rather "the goal of personal and communal being, the telos of humanity" revealed in the resurrection of Jesus and the coming of the Spirit at Pentecost.[356] "What is most true about human nature is not its primordial past but its eschatological future, an arriving determination that addresses us and calls us to spiritual union with God in Christ."[357]

Epistemological Considerations

It is arguable that, methodologically speaking, Shults is more concerned with the ways of human knowing than with acting and being. In a late modern culture, in which claims to truth are met with derision, and over against the early modern period, which had a very limited range for what counted as knowledge, theology as a discipline, and especially one hoping for broader respectability, stands in a precarious position. Shults's existential and conceptual shift toward the need for genuine argumentation in theology came to fruition in his Princeton Seminary dissertation, published in 1999 as *The Postfoundationalist Task of Theology*.[358]

In it, his first concern was to point out the problems of the foundationalist epistemology of Descartes and the early modern period, on the one hand, and then the antifoundationalist extreme relativist approaches of much postmodern philosophy, on the other.[359] Both share the problematic assumption

352. Shults, *Anthropology*, 218–219.
353. Shults and Sandage, *Faces*, 210. See also Shults and Sandage, *Transforming Spirituality*, 137, 144.
354. Shults and Sandage, *Transforming Spirituality*, 139.
355. Shults, *Anthropology*, 241.
356. Ibid.
357. Ibid., 242.
358. Shults, *The Postfoundationalist Task of Theology: Wolfhart Pannenberg and the New Theological Rationality* (Grand Rapids: Eerdmans, 1999).
359. Ibid., 25–38. See also Shults, *Anthropology*, 187.

that knowledge is about absolute certitude, each falling on a different side of the question of whether such certitude is possible.

Our concern in this project has been with specific expressions of the foundationalist quest for certitude, such as its form of subjectivity and its assumption that technological progress can solve all the problems of humanity. Although Shults is only peripherally concerned with the latter issues, he is important for us for two reasons. First, he affirms a number of our own critiques: that foundationalist epistemology and its sharp distinction of subject and object are individualistic;[360] that the twentieth-century conflicts have challenged the naïve optimism of reason alone;[361] and that rationality is not an activity of a disembodied immaterial substance.[362]

Second, he proposes in a number of ways and places that human knowing is instead thoroughly relational. In the work just mentioned, Shults offers his version of postfoundationalist epistemology in search of a third way between foundationalism and relativism. He articulates this by examining four mutually constitutive couplets: experience and belief, truth and knowledge, individual and community, and explanation and understanding;[363] the point of which is to "hold onto the ideals of truth, objectivity, and rationality, while at the same time acknowledging the provisional, contextual, and fallible nature of human reason."[364] This means, for instance, that we must recognize that our explanations on the way to discovery are "transcommunal and intersubjective;"[365] that is, that our endeavor to understand creation does not depend on a single approach to it, or presupposition about it, but, rather, on a holistic attitude that affirms a variety of disciplines and methods.

In his anthropology proper, Shults again takes a psychological approach and suggests that "personhood is characterized by a yearning to render things intelligible."[366] Rationality, however, is not the process of a lone disinterested subject making claims about a thoroughly distinct object of study and agreeing to statements thereabout.[367] Shults credits liberation and feminist thinkers especially for the recognition that reason is rather to be understood "as conditioned and mediated by the embodied communal relations of the knower,"[368] such that all knowledge is "mediated through one's relation to the 'other.'"[369] Because of the contingent and tentative nature

360. Shults, *Anthropology*, 181; Shults, *Postfoundationalist Task*, 59.
361. Shults and Sandage, *Transforming Spirituality*, 105.
362. Shults, *Anthropology*, 180; Shults, *Christology and Science* (Grand Rapids: Eerdmans, 2008), 35.
363. Shults, *Postfoundationalist Task*, 43ff.
364. Ibid., 58.
365. Ibid., 64.
366. Shults, *Anthropology*, 164.
367. Shults, "Imago Dei," 116; Shults and Sandage, *Transforming Spirituality*, 80.
368. Shults, *Anthropology*, 183–184. See also Shults, *Postfoundationalist Task*, 61, 68; Shults and Sandage, *Transforming Spirituality*, 78.
369. Shults, *Christology*, 84.

of knowledge, in addition, there is no act of knowing in which trust is not involved.[370]

Theologically speaking, Shults defines rationality "as a grasping for intelligibility . . . inherently linked to the creative activity of the divine *Wisdom*."[371] He is influenced in this by the Hebrew understanding of knowledge, "which expresses a concern for faithfulness in face-to-face covenantal relations."[372] To truly know was to become wise, which meant learning to have committed and righteous relations with God and neighbor. Hence, truth in the Bible is also primarily about being faithful, such that true persons are known "by the way they manifest faithfulness, the way in which they identify with others."[373] Even cognitive assent to propositions, Shults suggests, only serves the more ultimate goal of developing "trustworthy relations of concrete, temporal communion."[374] This is a process in which our knowing and being known takes the form of sharing in the mutual epistemic intimacy of the Trinitarian persons, who themselves call human subjectivity into being.[375] If ontic desire is associated with hope, then, epistemic desire is connected to faith.

However, because we cannot secure the truth or guarantee that others will be faithful and trustworthy, we experience *epistemic anxiety*.[376] This threatens our very selves, because the relational issues of truth, trust, and faithfulness shape our identity.[377] Hence, not only our knowing but also our being-known and our self-knowing are formed in relation to others. Identity "is not grounded in the self; the self *finds* itself *already known* by others, already identified by those who are beyond the self."[378] The anxiety which this uncontrollable identification creates is only assuaged by finding one's self "in relation to an infinite Other" in whom we know the peace which will not leave us and only so secures our ego.[379] As we grow in this peace, in mutual wisdom and trust with ourselves and others, we are "drawn into a more intense sharing . . . in the eternal communal knowing and being known that is the divine life."[380] Such relational knowledge implies, of course, particular contours of moral action.

370. Shults and Sandage, *Faces*, 174.
371. Shults, "Imago Dei," 116–117. Emphasis in original.
372. Shults and Sandage, *Faces*, 174.
373. Shults and Sandage, *Transforming Spirituality*, 71.
374. Ibid., 80.
375. Ibid., 71; Shults, "That Than Which Nothing More Lovely Can Be Conceived," in *Visions of Agape: Problems and Possibilities in Human and Divine Love*, ed. Craig A. Boyd (Aldershot: Ashgate, 2008), 128.
376. Shults, *Anthropology*, 164–165; Shults and Sandage, *Faces*, 173.
377. Shults and Sandage, *Faces*, 172.
378. Ibid., 179. Emphasis in original. See also Shults, *Anthropology*, 31; Shults and Sandage, *Transforming Spirituality*, 82–83; Shults, "Tending to the Other in Late Modern Missions and Ecumenism," *Swedish Missiological Themes* 95, no. 4 (2007): 427.
379. Shults and Sandage, *Faces*, 179.
380. Shults, *Anthropology*, 188.

Ethical Considerations

Somewhat different from the theologians we have considered so far, Shults *explicitly* identifies sin as the key doctrine in his constructive anthropological proposal regarding ethics. While he discusses the beautiful under ontology and the true under epistemology, he turns to consider the good as the key transcendental here. "To be a person is to long for goodness, to desire to secure one's relations to objects that are loved."[381] Hence, to hope and faith we now also add love.

All of us want what is good, so we naturally seek to possess or be close to those which we identify as such, whether they are things, persons, circumstances, feelings, and so on. Since we cannot always secure our objects of desire, however, we experience *ethical anxiety*.[382] It is in this context that sin must be understood.[383] Although Shults rejects the Augustinian synthesis of inherited sin,[384] he does not thereby deny the basic truth on which Augustine and the tradition touched. Rather, like Ruether, he affirms that the "heart of the doctrine of original sin" is that "each and every person is bound by relations to self, others, and God that inhibit the goodness of loving fellowship."[385]

As we have discussed throughout, for Shults as well there are a few key ways in which this problematic mode of relatedness is manifested. Like Keller, Shults implicates Greek thought in the Western philosophical and theological preference for sameness over difference, especially Plato, Aristotle, and Plotinus.[386] Aristotle's idea of the human as a rational animal is static: "the rational substance of human nature does not differ over time."[387] This is because Aristotle predicated sameness and difference only of the relations between things (accidentally) and not of the reality of things (essentially).[388] As opposed to the preferential option for the same, however, Shults argues that it is actually "differentiation from the other . . . which is the basis of relationality."[389]

Shults is more explicit about the ethical problems associated with the philosophical distinction between "us" and "them."[390] He does not explore the historical roots of this dichotomy (which he hints may be simply too engrained to trace), but discusses instead its assumption by social sciences in the early twentieth century. For our purposes it is most important to note

381. Ibid., 191.
382. Ibid., 191, 215; Shults and Sandage, *Faces*, 188ff.
383. Shults, *Anthropology*, 190.
384. Ibid., 191–201.
385. Ibid., 209; see also 213.
386. Shults, *Christology*, 24–25.
387. Shults, "Tending to the Other," 422–423.
388. Ibid., 423.
389. Shults, *Christology*, 29.
390. Ibid., 81–88.

that, for Shults, this dualism has led in countless ways to the drawing of hard boundaries between different persons and groups, even between those who are "in" and "out" of the church.[391] Such walls are most often "coercively maintained and supported by those in power."[392] He connects this even more insidiously to violence; specifically that used to keep unwelcome others outside of the group. Most violence linked with the separations of race, class, and sex, for key instances, has been "authorized by those with a vested link in maintaining the hierarchy."[393]

On the contrary, if it is true that the presence of others mediates self-identification, then the sharp distinction between "us" and "them" is philosophically and existentially problematic. "This does not mean that there are no differentiations, but that the processes of differentiation do not leave such simple and identifiable boundaries."[394] If we realize this, then we are in a position to move beyond our self-interestedness manifested in trying to keep strangers at bay and heal the divisions created by such action.

Shults discusses this primarily in his constructive soteriological work, *The Faces of Forgiveness*. However, far from advocating a position that sees the experience of divine forgiveness as separate from that between human persons, Shults argues that "salvation occurs in real communal living—actually sharing God's forgiveness with the world."[395] To articulate forgiveness strictly in terms of a legal transaction is not only theologically narrow, but interpersonally stifling. It must rather work toward the concrete healing of brokenness, which occurs on both personal and communal levels. For this reason, forgiveness is closely aligned with justice. When the former is articulated in terms of a forensic exchange but does not really transform structures of power, "then this is 'good news' to the oppressor but not to the oppressed."[396] On the contrary, Shults argues, the link between salvation and forgiveness should be expressed in, for instance, "real liberation of blacks from white oppression."[397] Like our other theologians, then, Shults calls us to responsibility for others. He even connects this explicitly to power (his preferred term is *agency*) by affirming the liberationist and feminist "insight that responsibility, agency, and sinning inherently have to do with community and sociality."[398]

391. Ibid., 82.
392. Ibid., 83.
393. Ibid., 85.
394. Ibid., 83.
395. Shults and Sandage, *Faces*, 172. See also Shults, "Nothing More Lovely," 133.
396. Shults and Sandage, *Faces*, 158.
397. Ibid., 157. Here he cites James Cone as a positive example of this connection.
398. Shults, *Anthropology*, 214; see also 218.

Yet the pursuit of true justice involves great sacrifice because of our anxiety not only over the inability to secure objects of desire, but perhaps even more so over our unhealthy attachment to perceived or possessed finite goods.[399] At the heart of our urges for these various things, though, is "an intense longing for intimacy," in which our yearning to love and be loved is met in an infinite other whose love never fails or fades.[400]

Human acting, then, can only be "transformed as it participates in a righteousness that is not its own, but is infinitely secured by divine love. We are becoming good as we are drawn into fellowship with the trinitarian God who is love."[401] Sharing in these mutually loving relations is in fact "the goal of human moral desire,"[402] which becomes manifested among Christians "in the redemption of human relations."[403] As we come to find our agency "mediated by the reconciling power of divine love," we are able to adopt and follow the way of Jesus and abandon our attempts to control objects we perceive as good and instead embrace others in a "vulnerable self-giving love" that no longer needs to be concerned about the other's rejection.[404]

It also means that we need not be anxious over whether or not others will reciprocate, opening for us a truly altruistic way of acting in the world that transcends both selfishness and self-abnegation.[405] Shults's most common exhortation is that of 1 John 3:16, which implores readers that since Christ "laid down his life for us . . . we ought to lay down our lives for one another."[406] For Shults, this is neither an excuse for oppression nor a suggestion that lovers lose their identities in the process. Well aware of the criticisms raised by the traditionally marginalized concerning self-sacrifice, Shults notes that nowhere in all of Scripture is there ever a case where a weak person is told to forgive someone in power. It is always the other way around.[407] To the extent that the weak do forgive the strong, it is because they refuse to play the power games that often characterize human agential life. The oppressed are able to respond with love, not out of meekness or acceptance of abuse, but to the extent that in Christ they are not seduced "by finite goods, because these do not provide that for which we are truly longing: righteous relations within loving community."[408]

399. See Shults, "Nothing More Lovely," 123.
400. Shults and Sandage, *Faces*, 191.
401. Shults, *Anthropology*, 216. See also Shults, "Nothing More Lovely," 129.
402. Shults and Sandage, *Transforming Spirituality*, 110.
403. Ibid., 111.
404. Ibid., 117. See also ibid. 118–119; Shults, *Anthropology*, 189; Shults, "Nothing More Lovely," 132–133; Shults and Sandage, *Faces*, 192–197.
405. Shults, "Nothing More Lovely," 133.
406. Shults, *Anthropology*, 215, 241; Shults, "Nothing More Lovely," 129; Shults and Sandage, *Faces*, 196.
407. Shults and Sandage, *Faces*, 203–204.
408. Shults and Sandage, *Faces*, 205.

SUMMARY

What we have discovered in this chapter is only a sample of a growing trend in theology toward a relational ontology that is also transforming epistemological and ethical conceptions. That this has been the case across generational, racial, and gender lines opens the possibility that the contemporary convictions we have been highlighting disclose not the interests or biases of any one group, but, rather, the dynamic and complex contours of a common humanity. Each of these authors may come from different backgrounds and address the issues from different angles, but all of them affirm—against the dominant philosophical and theological heritage and against the assumptions of the American monomyth—that genuine human *being* is not static, individualistic, and agonistic, but dynamic, relational, and interdependent; that authentic human *knowing* is not dualistic, objectifying, and domineering, but holistic, intimate, and mutual; and that exemplary human *acting* is not presumptive, fearful, and aggressive, but understanding, vulnerable, and compassionate.

In the next chapter, we will consider the ways in which these more desirable traits were depicted in the Silver Age comics of Stan Lee and his colleagues and successors at Marvel. Whereas our theologians pursued the "turn to relationality" in a more direct way by critiquing individualistic anthropological conceptions, Stan Lee did so through what might best be called a "turn to reality." By creating characters who were more true to life, Lee ended up rejecting American monomythic values and promoting the ideals advocated here.

4 The "Turn to Reality" in Silver Age Superhero Comics and Beyond (1961–Present)

INTRODUCTION

In this chapter, we will consider the innovations to American superhero mythology inaugurated by Marvel Comics and its chief writer Stan Lee, beginning with *Fantastic Four* #1 (November 1961). As with our discussion of Golden Age comicbooks, we will limit ourselves here to the anthropological positions and implications of Marvel's Silver Age comics, organizing our investigation again in terms of human being, knowing, and acting, as we have throughout our discussion. In addition, both here and in chapter 5, on the Marvel movies, we will put Lee's insights in dialogue with our five theologians from chapter 3, in order to present a more robustly interdisciplinary theological and philosophical anthropology.

Two brief qualifications are in order before we proceed. First, many Silver Age heroes and stories, Marvel and otherwise, continued to be articulated in terms of the American monomythic formula.[1] Second, there have been considerable changes in focus, plot, writing, art, and characterization since the 1960s. Given that, we are not claiming in the following that Marvel's break with its successors was an altogether clean one. We are also not interested in a comprehensive survey of comicbook superhero history since 1961.[2] However, we will explore the evidence that suggests both that Marvel's Silver Age comics represent a genuine revolution in notions about what it means to be human, and that these changes continue to guide contemporary comicbook creators.[3] As with the previous chapter, it is helpful to get a better picture of the situation within which the Silver Age Marvel heroes emerged.

1. Lang and Trimble, "Man of Tomorrow," 165.
2. The closest we have to that project is Matthew J. Costello, *Secret Identity Crisis: Comic Books and the Unmasking of Cold War America* (New York and London: Continuum, 2009), to which we will frequently refer.
3. A position reinforced by exploration of the Marvel films in chapter 5.

THE CULTURAL AND HISTORICAL CONTEXT OF MARVEL'S SILVER AGE SUPERHEROES

The Golden Age comics, as we saw, were created in a time of great optimism about the American way of life, despite World War II and the conflict in Korea. The Cold War had created new international tensions, but most Americans into the early 1960s saw the threat to be entirely external and saw themselves as prosperous and morally superior to the alternative.[4]

The majority of comics creators, including Stan Lee, held liberal political ideals, which by 1961 were bolstered in hope by the election of John F. Kennedy. Lee himself refers to this time as an idyllic era for the introduction of new heroes, given the optimism and spirit of promise that supporters felt for the young president.[5]

Matthew Costello identifies four main beliefs of the American liberal consensus of the 1960s of which Lee and others were a part: that affluence was produced by free individuals; that individualist America produced virtuous leaders; that the opposite of free-market individualism was totalitarianism, which must be opposed; and that American prosperity should include the traditionally poor and oppressed (i.e., women and racial and ethnic minorities).[6]

As the decade progressed, Costello contends, this consensus began to break down in the culture at large around four main areas. First, with regard to technology, there was increased anxiety over the role of atomic weapons.[7] Les Daniels suggests that, in general, the fear of radiation had actually waned since the 1950s, but that Marvel had drawn on what was still a strong undercurrent.[8] What is nevertheless clear is that this fear now included doubts about the government's ethical use of this power. Thus, second, the virtue of American leadership was called into great question, especially by the end of the decade, and the hero was typically considered more honorable than the U.S. government. Third was the issue of identity, which emerged as a dominant theme in Marvel Comics and American culture more broadly as people began, especially by the turn of the 1970s, to seek the meaning and purpose of their own lives as individuals, since being part of something larger was felt to be less promising. Finally, with regard to the enemy, the older decisive distinction between good and evil became blurred, although Costello opines that a sense of American superiority still lingered.

Congruent with the breakdown of this liberal mindset was a greater focus on social justice. In the wider culture, the Civil Rights movement had started

4. Costello, *Crisis*, 27, 32, 58; Moore, "Green Lantern," 265.
5. Daniels, *Marvel*, 99.
6. Costello, *Crisis*, 47–48, 56.
7. On the following, Costello, *Crisis*, 73–80.
8. Daniels, *Marvel*, 89.

years earlier, but by the end of the 1960s even comics readers wanted realism and social relevance.[9] Topics such as feminism, racism, drug abuse, protests, and the immorality of war became presented in the comics with some regularity as Americans began to see that threats to their wellbeing were not only external, but came largely from within, and were perhaps even more dangerous than were the Soviets.[10]

One of the lasting results of this change for the comics industry was the modification of the Comics Code in 1971. The 1954 code, Amy Kiste Nyberg suggests, was not meant to handle the social unrest and moral ambiguity of the 1960s.[11] Marvel played a pivotal role in this, as well. In 1970, Lee was asked by the Department of Health, Education, and Welfare to do a story about the dangers of drug use.[12] He complied by writing a three-issue story in which Peter Parker's college roommate Harry Osborn becomes addicted to pills.[13] Ironically, the Comics Magazine Association of America (CMAA, the organization that created and enforced the code) did not approve it, even with the government's request and endorsement, but Lee got permission from his publisher to release it anyway. The end result was public praise and a modification of the code toward the end of 1971.

Perhaps even stranger is the fact that the social fervor which gave rise to these alterations died out not long after they were made.[14] DC's famous *Green Lantern/Green Arrow* team-up, which is hailed as one of the most socially conscious series in comics history, began in May 1970 and lasted only 13 issues.[15] Over at Marvel, the death of Peter Parker's girlfriend Gwen Stacy in 1973 signaled the end of his innocence and reflected the hopelessness of a generation that was both weary of war and beginning to hear about Watergate.[16] Salvatore Mondello even suggests that Spider-Man's social conscience ended when Vietnam did.[17]

By the mid-1970s, social justice had more or less run its course as a major theme in comicbooks, spurred not only by loss of faith in American institutions but also by economic problems such as inflation.[18] Instead, the times

9. Raphael and Spurgeon, *Stan Lee*, 129.
10. Costello, *Crisis*, 28, 88, 100, 107; Trushell, "American Dreams," 157; Bradford Wright, *Nation*, 251.
11. Nyberg, *Seal*, 137–139.
12. Ibid., 139–140. Lee himself recounts the story in several interviews.
13. *Amazing Spider-Man* #96–98 (May–July 1971).
14. Nyberg, *Seal*, 142.
15. Daniels, *DC*, 154–155. See also Moore, "Green Lantern."
16. Costello, *Crisis*, 84; Gerry Conway, "Introduction: Turning Point," in *Webslinger: Unauthorized Essays on Your Friendly Neighborhood Spider-Man*, ed. Gerry Conway (Dallas: Benbella, 2006), 4.
17. Salvatore Mondello, "Spider-Man: Superhero in the Liberal Tradition," *Journal of Popular Culture* X, no. 1 (Summer 1976): 237.
18. Costello, *Crisis*, 56, 125ff.

had given way to a politics of the personal as people retreated into their private lives and searched for answers within.[19] What Americans wanted, Nyberg observes, was escapist entertainment.[20]

In comics, this came to expression in the exacerbation of introspection, individuation, and characterization.[21] A clear example is the revamped *X-Men* series under writers Len Wein and Chris Claremont and artist Dave Cockrum, begun in 1975.[22] Trushell notices that these new X-Men were "international and multicultural . . . with greater individuality and maturity."[23] Interestingly, they actually became increasingly critical of liberal politics.[24]

This concern with the self continued into the 1980s, but was now augmented by an intensified distrust of government and a loss of national identity, which became manifested in two significant ways.[25] For one, the rise of violent crime in urban areas instigated a glorification of vigilantism, both real and fictional. For another, America was still reeling from its loss in Vietnam, and a variety of media in the 1980s tried to compensate by presenting rescue and revenge fantasies. All of this was facilitated by the presidency of Ronald Reagan, who brought with him conservative patriotic views, an attitude of American superiority, and an ethic of cowboy justice.[26]

In the comics, this meant the creation and presentation of grim and gritty heroes who were often barely discernible from villains.[27] By this time, Lee's concerns and values were considered obsolete and irrelevant.[28] Something had to be done *now*, whatever it takes. Accordingly, the acclaimed graphic novels *Watchmen* and *Batman: The Dark Knight Returns*, both released in 1986, feature this kind of violent, ambiguous hero, as well as incompetent authorities and unbridled street crime. Over at Marvel, the tough guys Wolverine and the Punisher, although created in the 1970s, surged in popularity in the 1980s because of their psychological darkness, autonomy, and vigilante code.[29] Even the Hulk became grimmer as Bruce Banner's condition was reconfigured as an internal product of mental illness instead of Lee's theme of technology gone awry.[30]

19. Costello, *Crisis,* 89, 126ff.; Trushell, "American Dreams," 157; Bradford Wright, *Nation,* 251.
20. Nyberg, *Seal,* 142.
21. Costello, *Crisis,* 28, 76–78, 131–133; Bradford Wright, *Nation,* 251.
22. Starting with *Giant-Size X-Men* #1 (May 1975).
23. Trushell, "American Dreams," 156.
24. Ibid., 157.
25. Costello, *Crisis,* 76–78, 185, 193.
26. Douglas Kellner, *Media Culture* (New York and London: Routledge, 1995), 62–75.
27. Costello, *Crisis,* 166.
28. Ronin Ro, *Tales to Astonish: Jack Kirby, Stan Lee, and the American Comic Book Revolution* (New York and London: Bloomsbury), 244.
29. Bradford Wright, *Nation,* 273–274.
30. Costello, *Crisis,* 169.

This trend continued into the early 1990s, but toward the end of the decade, according to Peter Coogan, many felt that these cynical heroes had gone too far and were now being replaced by more traditional heroes with a positive, hopeful stature.[31] However, the concern for the merely personal and introspective was still dominant, both in culture and comics.[32] It would take a significant national disaster to challenge this complacency.

Costello contends that after 9/11, comics became political in a way not seen since the early 1970s.[33] At first, in both culture and comics, there was a great outpouring of support and renewal of patriotism. However, the last few decades had done their damage, and even this catastrophe could not ultimately undo the lingering distrust of American leaders or alter the reality of an increasingly shrinking and interconnected world.

For instance, the Captain America stories of the early twenty-first century suggest that American militarism has itself played a role in the creation of terrorism.[34] The moral certainty of the nation is continually questioned and often portrayed as self-interested and imperialistic.[35] In Marvel's recent *Civil War* series (2006–2007), this doubt about the U.S. government comes to the fore when the Superhuman Registration Act requires heroes to disclose their identities and powers to the authorities. Notably, Captain America is against the act, a far cry from the Nazi-punching Commie-basher of his earliest incarnations. Former Marvel publisher Shirrel Rhoades is perhaps correct, then, that comicbooks are now more relevant than ever.[36] Whether or not one agrees with this assessment, we no doubt find ourselves confronted with many of the same issues that were a concern for Stan Lee 50 years ago. This is equally true of the films, which we will address in the next chapter.

STAN THE MAN

More than any other person in the field of comicbooks, Stan Lee influenced the shift in superhero mythology over the last half century. He was born Stanley Martin Lieber on December 28, 1922, in New York City.[37] After working various odd jobs to help support his family, Lee got hired as a writer by Marvel Comics (then Timely Comics) publisher Martin Goodman, also Lee's cousin, late in the year 1940. About a year later, Lee's bosses Joe Simon and Jack Kirby were fired from Marvel, apparently because of

31. Coogan, *Superhero*, 226, 230.
32. Trushell, "American Dreams," 157; Bradford Wright, *Nation*, 251.
33. Costello, *Crisis*, 212.
34. Ibid., 216.
35. Ibid., 217–219.
36. Rhoades, *History*, 198–199.
37. His pen name Stan Lee is not a shortening of his last name, but a separation of the two syllables of his first name.

moonlighting for a competing company.[38] Goodman promoted Lee to editor and art director on a temporary basis. After his return from stateside service in World War II in 1945, Lee was made editor and head writer for Marvel, creating comics in various genres, depending on what would sell at the time.

Having nearly faded out after the war, superheroes regained popularity when the anticomics scandal of the early 1950s, led by psychologist Fredric Wertham, subsided.[39] DC Comics (then National Comics) resurrected the Flash in 1956, inaugurating a new era for the genre.[40] A few years later, in 1960, DC published the first issue of the Justice League of America.

The success of JLA incited Goodman to do a superhero team for Marvel (by then renamed Atlas Comics) in order to compete, and enlisted Stan Lee for the task. Interestingly, the same day Goodman told Lee about his idea, Lee was planning to quit, primarily because he was not able to write anything creative or original under Goodman's constraints.[41] Hesitant in light of Goodman's new enthusiasm, though, Lee took some time to discuss the situation with his wife Joan. She suggested that he just write this new superhero comic the way he always wanted to do.[42] There was nothing to lose, she figured, since he was going to quit anyway.[43]

Lee was rejuvenated by this idea and stayed on to create the Fantastic Four (hereafter FF) with artist Jack Kirby, who had returned to Marvel in 1959. The first issue was dated November 1961 and garnered immediate success, Atlas was renamed Marvel, and so began what is often referred to as the *Marvel Age* of comics, with Lee leading the charge.[44] So influential were these shifts in the status quo that by 1965, Nyberg observes, all other superhero comic publishers were following Marvel's lead.[45]

EXCURSUS—LEE AND JUDAISM, AND LEE AND KIRBY

Before we proceed, two important issues need brief consideration, lest the reader be distracted by the proverbial elephant/s in the room. The first has to do with the fact that Lee, like most other early comicbook creators, is

38. Raphael and Spurgeon, *Stan Lee*, 23–24; Stan Lee and George Mair, *Excelsior! The Amazing Life of Stan Lee* (New York: Fireside, 2002), 30.
39. As discussed in chapter two. See also Nyberg, *Seal*, 53–103.
40. Commonly referred to as the Silver Age, as we saw. Lee himself, though, is not partial to these labels, because he sees his Marvel heroes as an improvement on the Golden Age heroes. *Stan Lee: Conversations*, ed. Jeff McLaughlin (Jackson: University Press of Mississippi, 2007), 214.
41. Lee and Mair, *Excelsior*, 112ff.
42. Stan Lee, *Origins of Marvel Comics* (New York: Simon and Schuster, 1974), 17.
43. Lee and Mair, *Excelsior*, 113.
44. The convention at the time was to cover-date in advance, sometimes by several months, such that a November issue may have actually been released in, say, August or September.
45. Nyberg, *Seal*, 137. See also Rhoades, *History*, 109.

ethnically Jewish. It does not escape me that some may take umbrage at the fact that our religious considerations, both historically (in chapter 1) and contemporarily (in chapter 3), have attended exclusively to Christianity and not directly to Judaism, and that here and in chapter 5 we will put Lee in dialogue with Christian, not Jewish, theologians. I am also aware that whatever offense may arise will be intensified by Christianity's monumental role in global anti-Semitism. However, several facts justify these decisions.

First, it can hardly be denied that Christianity has had the most significant *religious* impact on American myth, literature, national identity, anthropological conceptions, and political and economic decisions (that there have been numerous *nonreligious* factors is also true). Second, it has served as the most logical and, for the sake of space, convenient option, then, to discuss contemporary Christian theologians who have contested the misuse of certain theological and biblical categories to support the problematic American monomyth. This much, in any case, seems uncontroversial.

Third, we should not ignore the strong similarities between Jewish and Christian theological ideas about human being, knowing, and acting. All five of our theologians are aware of this, and we even noted several examples in which they approvingly cite different aspects of ancient Hebrew anthropology, especially those advocating relationality. In their proposals, moreover, there is nothing explicitly Christian that contradicts insights into the human found in the Hebrew Scriptures. They are quite aware, as we ought to be, that Jesus and his earliest followers were Jews.

Finally, most importantly, it is notoriously difficult to gauge the extent to which Judaism, as either a religion or ethnicity, has consciously influenced Stan Lee's philosophical ideas, or even his theological ones, for that matter. We know that it was important for Jack Kirby.[46] We also know that Kirby, Jerry Siegel, and Joe Shuster, among others, seemed to be aware of the ways in which anti-Semitism influenced their lives and careers. And we know that many commentators clearly see Jewish traits and viewpoints in Lee's works, even if they also express confusion about his explicit intentions.[47]

For Stan Lee himself, however, the weight of the evidence suggests that Judaism has played no significant role with regard to his explicit or intentional perspectives on theology, ethics, politics, or anthropology. Perhaps he has been more formed by his Jewish roots than he admits, but at the end of the day, when it comes to this issue, we can only go by what he tells us. He admits both that he has encountered very little anti-Semitism personally and that although Jewish attitudes "may have been at the backs of our minds [referring to himself and other Jewish comics creators] . . . in the front of our minds we were just trying to make the best action-adventure comics we

46. Brian Cronin, *Was Superman a Spy?* (New York: Plume, 2009), 99–100.
47. Tom DeFalco, ed., *Comics Creators on X-Men* (London: Titan, 2006), 139; Fingeroth, *Clark Kent*, 95–97, 111; Kaplan, "Kings of Comics," part 2; Brett Chandler Patterson, "Spider-Man No More," in *Webslinger*, 139, 141.

could."[48] He also tells us that he never tried to promote any one religion or political view, but rather the Golden Rule,[49] which he interestingly connects to Judaism: "'To me you can wrap all of Judaism up in one sentence, and that is, 'Do not do unto others'. . . . All I tried to do in my stories was show that there's some innate goodness in the human condition. And there's always going to be evil. We should always be fighting evil.'"[50] The Golden Rule is found in some form in every major world religion, but the version in which it is most often quoted by Lee is the familiar Christian one of "Do unto others as you would have others do unto you,"[51] which suggests that the *direct* source of this saying for him is not the Torah, but either Matthew 7:12, Luke 6:31, a personal acquaintance, or any of the countless places in American media from which he could have taken it.

In the end, we will not be led astray if we follow Brett Patterson, who in his essay on Spider-Man tries to determine if Peter Parker is Jewish or Christian. "In both theological contexts, there is . . . the suggestion that we meet God in our relationships with others—that we bear responsibilities to God, to others, and to ourselves—that we are most truly ourselves when we are giving to others."[52] Stan Lee would not contest this, and neither would our Christian theologians.

The second issue we need to address is the maelstrom surrounding the question of the individual contributions of Lee and Kirby (and, to a lesser extent, other artists) to the creation of the 1960s Marvel heroes. Several minor points should be made about why Lee is, *practically* speaking, the best point of focus for our discussion of Marvel, in general. Because of both his personality and his role as editor at the time, he was and continues to be the public face of Marvel and the one most responsible for its image;[53] he has discussed these heroes publically more than has any other Marvel figure; and he "was the one common element between the various notable creations."[54]

The last fact hints at a more important reason, *theoretically* speaking, for focusing on Lee: that the themes we will outline in this chapter—and which are, thus, the most congruent with the relational anthropology we are proposing in this project overall—are more reflective of Lee's views than those of any artist with whom he worked. Several points suggest such a conclusion. First, Brian Cronin tells us that although Kirby co-plotted the first several years of the FF comics with Lee, Lee still made the final decision

48. Stan Lee, foreword to Fingeroth, *Clark Kent,* 10–11.
49. Lee and Mair, *Excelsior,* 150.
50. Quoted in both Kaplan, "Kings of Comics," part 2 and Patterson, "Spider-Man," 138–139.
51. E.g., Lee, *Conversations,* 193.
52. Patterson, "Spider-Man," 141; see also 138–139.
53. Daniels, *Marvel,* 145.
54. Cronin, *Spy,* 108. See also Ro, *Tales,* 292.

about the scripts, which often meant ignoring Kirby's margin notes and, thus, intentions for a story. This contradicts the notion among many Kirby fans that Lee merely became a transcriber of Kirby's scripts. In reality, Lee was writing the dialogue until the tail end of their work together on the series.[55]

Second, Louise Simonson, former writer and editor of X-Men comics, opines that the themes of that series are more aligned with Lee's convictions than with Kirby's. More specifically, she means "the alienation thing: being someone who's different to the rest of the world. . . . The urge to eradicate those who are different—and the utter *wrongness* of this urge—is one of the central themes of *X-Men*."[56]

Third, Cronin surmises that Spider-Man artist and cowriter Steve Ditko eventually left Marvel at least in part because of strong disagreements with Lee regarding the personality of Peter Parker.[57] As an Objectivist and follower of Ayn Rand, Ditko believed that people were either good or evil—an example of the Manichaean view of the world characteristic of Golden Age comics—and, therefore, wanted Peter to be completely good. Lee, however, did not share this view, and instead saw Peter as someone with both good and evil tendencies, a perspective that happens to cohere with a realistic, holistic view of human personhood advocated by our theologians.

Finally, comics scholar Matthew Pustz suggests, "Lee was the central figure in the creation of the Marvel philosophy,"[58] which includes several, sometimes contrasting, aspects: heroes with angst and self-doubt but with a duty to fight evil in the world;[59] the lesson that "the powerful have an obligation to help the powerless and battle those who would take advantage of them";[60] the heroes' concern with self-actualization and brute determination; Marvel's attempt to remain hip and relevant during the 1960s; and the turn toward realism,[61] which we will clarify throughout the rest of the chapter.

To be sure, none of this is to say that Kirby and other artists did not contribute significantly to the new heroes and stories that Marvel was creating. They did, both in their art and writing, and dozens of other talented people at Marvel have continued in their footsteps. It is to say, however, that without Stan Lee there would be no important difference between DC and Marvel, no major distinction between the Golden Age and the 1960s, and certainly no revolution of the superhero.

55. Cronin, *Spy*, 90–92.
56. DeFalco, *X-Men*, 139. Emphasis in original.
57. On this, see Cronin, *Spy*, 108–109; Ro, *Tales*, 105.
58. Matthew J. Pustz, *Comic Book Culture: Fanboys and True Believers* (Jackson: University Press of Mississippi, 1999), 49.
59. See also Ro, *Tales*, 292.
60. Pustz, *Culture*, 50.
61. Ibid., 51–53.

MARVEL MADNESS

In several places, Lee asserts that above all else the change he wanted to make in superhero stories was to make them more realistic or true to life, notwithstanding, of course, the fictional nature of the genre.[62] What we are calling this "turn to reality" became manifested in a variety of ways. For one, Marvel storylines were the first to take place over several issues, as opposed to the isolated single-issue stories of previous superhero comics.[63] This allowed greater narrative development as well as the introduction of subplots.[64]

For another, the elongation of story arcs allowed characters to develop and mature in ways akin to real persons. This was virtually absent in superhero comics before the FF, as we saw with Umberto Eco's critique of the oneiric climate in chapter 2. Although Eco briefly credits a few of the Marvel heroes with adding an element of irony to the genre,[65] he was not yet able to observe the way in which Marvel worked to overcome timelessness and offer a more robust concept of temporality with a definitive past, present, and future.[66]

For instance, Bruce Banner/Hulk eventually married his love interest Betty Ross. Reed Richards/Mr. Fantastic married Sue Storm/Invisible Girl (later Invisible Woman). Peter Parker/Spider-Man finished high school, went to college and eventually graduate school, and married Mary Jane Watson.[67] He also experienced the permanent deaths of significant people in his life. Eventually, DC followed Marvel's lead and even Superman finally revealed himself to and married Lois Lane.[68]

In addition to the general innovation of temporal progression, Lee had several specific concerns that enabled deeper characterization of the heroes. As a writer and overall lover of words, he was intent on making sure that the uniqueness of each hero was represented in his or her manner of speech.[69] As such, the realism of his characters is reflected largely in their dialogue, which Lee sees as the chief feature of great stories in any genre.[70] You could not have a God of Thunder such as Thor speak in the lingo a 1960s teenager, for instance, but this works for Johnny Storm/Human Torch because he *was*

62. For instance, Lee, *Origins*, 17; Stan Lee, *Son of Origins of Marvel Comics* (New York: Simon and Schuster, 1975), 9. See also Pustz, *Culture*, 51.
63. Coogan, *Superhero*, 92; Costello, *Crisis*, 17; Pustz, *Culture*, 52.
64. Lee, *Conversations*, 62, 88.
65. Eco, "Superman," 122.
66. Pustz, *Culture*, 52, 130.
67. Bradford Wright, *Nation*, 212.
68. Reynolds, *Super Heroes*, 123–124.
69. Tom DeFalco, ed., *Comics Creators on Spider-Man* (London: Titan, 2004), 20–21.
70. Lee, *Origins*, 72, 224.

a 1960s teen. Such realistic attention to detail makes the fantasy aspect more believable for Lee.[71]

Another feature was Lee's desire that heroes have no secret identities or costumes. These two are, of course, intertwined in superhero mythology,[72] but Lee wanted neither for the sake of making heroes more like us.[73] Thus, the public learns the real names of the FF right away, and they also did not wear costumes for the first two issues. Yet the fans, to Lee's dismay, insisted that the latter convention remain, so the FF were clad in costumes by the third issue.[74]

Along the same lines, Lee also wanted the focus to be on the heroes' personal lives rather than repeat what he had seen as the standard formula up till then: "hero sees a crime being committed, hero goes after the criminal, hero fights him and catches him in the end."[75] Lee preferred instead to see the narrative as "a *soap opera* story that just happens to be about a superhero who has to defeat villains."[76] Such mixture of genres was in fact new with Marvel,[77] since previously and even contemporaneously at DC, plot was the primary driver of stories. Instead, Marvel focused on character.[78] As such, in Lee's view, there is a fundamental difference between DC and Marvel. In DC comics, the hero is primary and the human person is the alter-ego; in Marvel stories, the person is primary and the costumed hero is the alter-ego.[79]

As real persons, then, Marvel heroes had to deal with all sorts of mundane concerns, such as bill and rent payments and other financial burdens, costume malfunctions, and car problems. Some had more serious physical disabilities, such as Tony Stark/Iron Man's failing heart and Matt Murdock/Daredevil's blindness.[80] These situations were virtually unknown in the Golden Age, a fact that is even occasionally referenced in Marvel stories.[81]

Another major way in which the Marvel stories were more realistic than before was in the creation of a unified world in which all the heroes and villains lived. This is commonly referred to as the *Marvel Universe,* which consists of numerous fictional and mythic places but parallels the real world

71. Lee and Mair, *Excelsior,* 161.
72. See Fingeroth, *Superman,* 47–61; Reynolds, *Super Hero,* 26–52.
73. See Fingeroth, *Superman,* 59.
74. Daniels, *Marvel,* 87.
75. Lee, *Conversations,* 88.
76. Lee, *Conversations,* 128. Emphasis in original. See also Lee and Mair, *Excelsior,* 115.
77. Raphael and Spurgeon, *Stan Lee,* 96.
78. Daniels, *Marvel,* 84–85; DeFalco, *Spider-Man,* 44.
79. Nyberg, *Seal,* 137; Pustz, *Culture,* 135; James Poniewozik, "Superhero Nation," *Time,* May 20, 2002, 77. Lee himself mentioned this difference explicitly at a symposium at the University of California, Los Angeles, December 2006.
80. See Pustz, *Culture,* 46, 112.
81. E.g., *Fantastic Four* #9 (December 1962). See also Daniels, *Marvel,* 88.

in that many characters live in real-life cities. For instance, the FF, Daredevil, and Spider-Man all live in New York City, one that includes its actual neighborhoods. Lee did this deliberately different than DC, whose stories are set in fictional places such as Gotham City and Metropolis.[82] More importantly, this enabled the various Marvel heroes to cross over into each other's plotlines and still maintain a single historical continuity.[83] Lee admits not only that he thinks such stories are better,[84] but also that "these types of meetings made the reader feel that these were real characters that you might bump into on the streets, and it made me feel that way, too."[85]

While these important innovations helped to add an unprecedented tone of realism to the superhero genre, the major thrust of Lee's turn to reality came in the precise ways in which the heroes' and villains' personalities were developed. In so doing, he and his successors at Marvel made both implicit and explicit anthropological claims, which we will discuss according to human being, knowing, and acting.

I FAIL, THEREFORE I AM: MARVEL ONTOLOGY

We could approach the changes Marvel brought to comicbook superhero conceptions of human being in a number of ways. In Lee's own words, however, the feature that stands out again and again in his interviews, writings, and commentaries is that he wanted his heroes to have flaws. He saw this as simply a manifestation of the turn to realism, since real people are imperfect. Unlike the incorruptible, "all noble"[86] heroes of the Golden Age,[87] Marvel characters maintained their weaknesses. Lee wanted them to be, as he puts it, "the kind of characters I could personally relate to; they'd be flesh and blood, they'd have their faults and foibles, they'd be fallible and feisty, and—most important of all—inside their colorful, costumed booties they'd still have feet of clay."[88] In short, he wanted "heroes plagued with the problems that torment us all."[89]

Not only was the idea of flawed heroes new in comics, but Lee made it a point to make their flaws somehow welcome, even lovable, for the reader, even if they often remained a thorn to the characters themselves. This is a

82. Lee at UCLA.
83. Daniels, *Marvel*, 100.
84. Stan Lee, *Bring on the Bad Guys* (New York: Simon and Schuster, 1976), 159.
85. Lee, *Conversations*, 171.
86. Ibid., 131.
87. Rhoades, *History*, 78; Scott Rosen, "Gods and Fantastic Mortals: The Superheroes of Jack Kirby," in *Gospel According to Superheroes*, 116.
88. Lee, *Origins*, 17.
89. Lee, *Son of Origins*, 9. See also Arthur Berger, "Comics and Culture," *Journal of Popular Culture* 5, no. 1 (Summer 1971): 171.

point pushed home by Thomas Merton, as we discussed previously. For Merton and Lee, it is not simply that we should be loved in spite of our weaknesses, but that our weaknesses constitute us, make us persons, make us worthwhile, throwing out "all preposterous ideas of 'worthiness'" altogether, as Merton says.[90]

The way in which Lee went about this is equally significant. The self-subsistent perfectionism that characterized Golden Age heroes and the American monomythic heroes long before them came to expression in a fairly uniform construction of their personalities. Not only were they alike in sharing the attribute of flawlessness, but they were also physically identical: brawny, square-jawed, confident, tall, white, handsome, and male.[91] The exceptions, like the original Human Torch and Plastic Man, only proved the rule.

What Lee, Kirby, Ditko, and others did in the 1960s, however, was to make each character unique by giving them their very own quirks, faults, and struggles. Ben Grimm/Thing is short-tempered, self-deprecatory, and pessimistic, especially after his transformation; Peter Parker is guilt-ridden and unconfident, but rather cocky as Spider-Man; Stephen Strange was a brilliant surgeon but greedy misanthrope before becoming Dr. Strange, Master of the Mystic Arts;[92] Thor was punished for his arrogance by his father Odin and condemned to live on earth in the mortal, impaired body of Dr. Donald Blake; and the Watcher, a powerful but benevolent extraterrestrial, is forbidden from engaging in human affairs, because of his brash and naïve interference with a primitive race earlier in life.[93]

Logically, then, when we introduce such mistakes, we must admit vulnerability. This is one of the things Lee explicitly wanted to do, in distinction from his predecessors and competition.[94] In such a case, there are two options. The first is to use your own ingenuity, strength, wit, or some other feature to shore up these weaknesses. Matthew Pustz believes that early Marvel heroes were in this sense sometimes radically individualistic.[95] Certainly, there are myriad instances of this, a trait arguably integral to the genre itself.[96] What sets Marvel apart, however, is that this option is augmented by another, unprecedented in comics before 1961. Simply put, it is that flawed, imperfect people cannot make it in this world alone, another point stressed by all of

90. Merton, *Conjectures*, 174.
91. Ro, *Tales*, 146.
92. See Dr. Strange's origin story in Lee, *Origins*, 227ff.
93. See Lee, *Son of Origins*, 189ff.
94. Poniewozik, "Superhero Nation," 77.
95. Pustz, *Culture*, 50. See also Costello, *Crisis*, 66. However, at least part of this assessment probably owes to the influence of Steve Ditko's Objectivism on Marvel comics.
96. Christopher Peterson and Nansook Park, "The Positive Psychology of Superheroes," in *The Psychology of Superheroes: An Unauthorized Exploration*, ed. Robin S. Rosenberg (Dallas: Benbella, 2008), 13.

our theologians in different ways. Here, then, Lee put reality and relationality together by asserting that incomplete and imperfect heroes, like all of us, need others and, in fact, that we are who we are just in that interdependence, often whether we like it or not. As it does in real life, this was expressed in a number of ways for Marvel characters.

For one, Marvel heroes were not always friendly to each other. Imperfect people inevitably relate to each other . . . imperfectly. This was another key difference between Marvel and DC at the time. In DC crossovers such as the JLA, all the heroes got along and their team-up issues consisted of "square-jawed good citizens, like lodge meetings in tights."[97] Lee made it a point in doing the FF to have the heroes' personalities rub each other the wrong way, so you frequently have scuffles—usually between Reed and Ben or Johnny and Ben. This was really unknown to comics before 1961,[98] with the remarkable exception of the animosity between the original Human Torch and Sub-Mariner of 1940s Timely.[99] Similarly, whenever Lee did a crossover of heroes into each other's storylines, they always fought upon first meeting, mistaking each other's intentions.[100] This theme was important even in more permanent groups like the Avengers, which Daniels affirms is often unstable precisely because of the flawed personalities of Marvel heroes.[101]

Another result of Marvel's focus on vulnerability was that there are not nearly as many Marvel heroes that are orphans as there were in DC's Golden Age. Peter Parker is the most notable. He is an orphan in that his biological parents are dead, but that predicament for him is mitigated by the tender caretaking of his Uncle Ben and Aunt May. Even after Ben's death, Peter's lack of a loving father figure does not drive him to invent his own future. Instead, his regret and humility work as a guide for the moral use of his newfound powers, and his devotion to Aunt May is now even stronger, instilling a deeper sense of responsibility.[102] Moreover, as Danny Fingeroth wisely observes, the orphan fantasy is not everyone's dream, especially for women and those who want families.[103] This stands in great contradiction to the sense of orphanage that characterizes America's national identity and that has been consistently glorified in the various media that propagate the American monomyth.

In their essay "The Fantastic Four as a Family," Chris Ryall and Scott Tipton observe that in most superhero comics, family stands in the background. In the FF, however, and Marvel more generally, the family bonds

97. Raphael and Spurgeon, *Stan Lee*, 117. See also Fingeroth, *Superman*, 104.
98. Lee, *Origins*, 72.
99. Don Thompson, "Axis," 118.
100. Raphael and Spurgeon, *Stan Lee*, 117.
101. Daniels, *Marvel*, 108. See also Fingeroth, *Superman*, 104.
102. See Fingeroth, *Superman*, 74–76.
103. Fingeroth, *Superman*, 78.

are as central as the action.[104] Adopting Aristotle, they understand the ideal family to be "a particularly intimate partnership for living well."[105] Even though the FF argue, battle, and sometimes harbor bitter feelings, their commitment to each other and mutual love supersede any negative dynamics.[106] In addition, they each have their own distinct interests and personalities and are not made to conform to some meritocratic standard.[107]

This familial dynamic is in no way precluded by the fact that the FF is a not a biological family (with the exception of Johnny and Sue, who are brother and sister) to which each member is connected without choice. Ryall and Tipton assert that, even with constructed families, we do not deliberate and then decide to be a family. Rather, "we find each other and then feel a bond. . . . It's more like a mutual affinity than decision and duty."[108]

Fingeroth takes a similar but more psychological approach to superhero families. He agrees that the Marvel teams are more like real families than groups such as the JLA, whom he likens to the real life/television family the Nelsons.[109] Yet, there is a struggle—both for us in mass society and for our superheroes—between the freedom of being an orphan with no commitments and the longing for a family who accepts us.[110] Ultimately, we want to be part of a family of freaks who have been alienated as we have been. The X-Men, then, as genetic mutants, are most like a real family for Fingeroth, in the sense that there is no choice or special achievement needed to enter. They are simply born with an extra quality that differentiates them from normal humans, and this makes them acceptable and accepted into this surrogate family.[111] Roy Thomas, a former X-Men writer, even suggests that a major part of the series' success was the element of community; not just a group, but "the *family* idea."[112]

The redefinition of family beyond two married people and their biological children is also important for Ruether, and we should note that the chief characteristics of the broader idea of family that she promotes are

104. Chris Ryall and Scott Tipton, "The Fantastic Four as a Family: The Strongest Bond of All," in *Superheroes and Philosophy: Truth, Justice, and the Socratic Way*, ed. Tom Morris and Matt Morris (Chicago and La Salle: Open Court, 2005), 118–129. See also Daniels, *Marvel*, 86; Fingeroth, *Superman*, 97–117; Peterson and Park, "Psychology," 11; Robert Genter, "'With Great Power Comes Great Responsibility': Cold War Culture and the Birth of Marvel Comics," *Journal of Popular Culture* 40, no. 6 (December 2007): 956–957.
105. Ryall and Tipton, "Fantastic Four," 123.
106. Fingeroth, *Superman*, 113, 116; Rhoades, *History*, 79; Ryall and Tipton, "Fantastic Four," 124.
107. Genter, "Great Power," 958.
108. Ryall and Tipton, "Fantastic Four," 128.
109. Fingeroth, *Superman*, 104.
110. Ibid., 98.
111. Ibid., 107.
112. DeFalco, *X-Men*, 35. Emphasis in original.

exemplified in both the FF and X-Men: women are equal with men (in general); members share their resources with one another; and they have nurturing friendships outside of their romantic partnerships.[113]

Of course, not all of the Marvel heroes are part of teams that resemble families. Yet, even the lone heroes find themselves embedded in relationships that define and determine their beings. Peter Parker's sense of responsibility and goodness in the face of guilt and suffering stems from his moral upbringing by his aunt and uncle.[114] His priorities are determined not only by his superpowers, but by his love for his friends, romantic interests, and Aunt May. In the famous FF storyline that introduces Galactus and the Silver Surfer,[115] unlike earlier heroes who ride off into the sunset after saving the town, the Surfer is forced by Galactus to stay with those whom he has saved. It is, in fact, the Surfer's encounter with Ben Grimm's blind girlfriend Alicia Masters which convinces him of the beauty of Earth and the dignity of humanity.[116] Even the mighty Thor, suggests Scott Rosen in an essay on Jack Kirby, "exists within the context of community."[117] He is a member both of the superhero team the Avengers and of the pantheon of Asgard, where his father Odin lives, upon whom he occasionally calls. Rosen even concludes that a "corollary truth gleaned from Kirby's work is that evil might best be fought within a context of team effort," and that individual abilities, though great, "will only be successful in defeating powerful enemies when employed within the context of community."[118]

All of this means that Marvel heroes have a commitment to the communities and contexts in which they live, as opposed to the older monomythic formula in which heroes leave town at the end of the story. Part of Marvel's philosophy overall was, in fact, to make their characters "residents instead of visitors," which is why Peter Parker attends (fictional) Empire State University and Dr. Strange spends time in Greenwich Village.[119]

It is not surprising, then, to find a depth of romantic involvement among Marvel characters, another rather noteworthy advance in the superhero genre. The fact that older heroes shunned sexual advances is well known. Lee, though, went decidedly against the grain in writing the Marvel heroes as longing for romantic intimacy. For him this is simply consistent with the desire for reality. In response to a 1970 interview question about sex and

113. Ruether, *Modern Family,* 207–212; Ruether, *New Woman,* 208–210.
114. C. Stephen Evans, "Why Should Superheroes Be Good? Spider-Man, the X-Men, and Kierkegaard's Double Danger," in *Superheroes and Philosophy,* 173.
115. *Fantastic Four* #48–50 (March–May 1966).
116. B. J. Oropeza, "The God-Man Revisited: Christology through the Blank Eyes of the Silver Surfer," in *Gospel According to Superheroes,* 157.
117. Rosen, "Kirby," 119.
118. Ibid., 124.
119. Gary Dauphin, "To Be Young, Superpowered & Black," *The Village Voice,* May 17, 1994, 33.

comics, especially Marvel's difference from DC in this regard, Lee admits that "we certainly have our characters fall in love, have romantic problems. Again, we try to make everything as realistic as possible without offending anyone. . . . We sort of have the idea that our characters are reasonably normal human beings who won't turn the other way if a pretty girl comes by."[120]

Not only do you have heroes falling in love, but in creating the FF, Lee also made it a point to have a pivotal romantic relationship within the team. "The first thing that came to mind was love interest. For the first time we'd have a hero and a heroine who were actually engaged. No more coy suggestions that she'd really dig the guy if only she knew his true identity."[121] This aspect was different not only from what came before, but even from the mood at DC in the 1960s. Mark Best observes that in 1965, only two years after Batman was avoiding Batwoman's advances, Marvel celebrated the marriage of Sue and Reed.[122] Referring to Sue's brother Johnny in 1977, Lee even asks rhetorically, "How many other strips can you remember in those days [early 1960s] that ever hit you with an in-law?"[123]

Reflective of reality as well is the fact that the Marvel heroes do not always end up with the object of their desires. "We tried to do everything else as realistically as possible. For example, if a hero had a super power, we didn't, ergo, just assume that he'd be lucky in love and have all the money in the world and everything would come his way."[124] Aside from outright rejection, one of the ways this loss of love became expressed was in the hero's refusal of romance due to concern for the beloved. This is a standard of the genre now, but it is a far cry from the misogynistic masculine fantasy of self-sufficiency or a general disdain for sexuality. Instead, the hero shuns romantic involvement because he does not want to put those he loves in danger. Should a villain discover those the hero cares about, the villain will no doubt use them as leverage against the hero.

Like Golden Age heroes, then, Marvel heroes' heroic mantle hindered them from pursuing love. However, whereas for earlier heroes this was mostly celebrated, for Marvel heroes it is a cause of suffering.[125] Unlike the male pattern of gynophobia, which both Ruether and Keller critique, Lee's heroes risked themselves for the objects of their vulnerable desire. The Thing slowly and grudgingly accepts the love of the blind Alicia Masters, all the while wondering whether or not she would love him if she could see him. Bruce Banner and Betty Ross portray this perhaps most poignantly. Speaking of writer Peter David's run on the Hulk series (1987–1998), comics

120. Lee, *Conversations*, 28.
121. Lee, *Origins*, 17.
122. Best, "Domesticity," 96.
123. Stan Lee, *The Superhero Women* (New York: Simon and Schuster, 1977), 58.
124. Lee, *Conversations*, 21.
125. Jones, *Men of Tomorrow*, 302.

historian Peter Sanderson describes their relationship as "a strangely moving metaphor for any man and woman reaching out to each other despite their own emotional scars."[126]

The general elevation of the role of romance in comics implies, of course, a shift in comicbook conceptions of women. In this area, Marvel was not nearly as progressive as it could have been, in spite of Lee's claims of equality.[127] The treatment of women characters within the comics is often pejorative and demeaning, highlighting the traditional male perspective that women are impatient, impulsive, and overemotional.[128] Moreover, although Lee chalks the lack of strong solo heroines up to the fact that the audience still consisted mainly of boys,[129] the heroines who were present were usually less powerful than their male colleagues.[130] This was to be expected in an industry still dominated by men, where, as in the Golden Age, women were either damsels or villains, the latter now often portrayed in the context of the women's liberation movement as violent feminists who saw men as sexist pigs.[131]

Nevertheless, Marvel and Lee still made important strides here. For one thing, Lee concedes that for too long the emphasis was on men, while women were relegated only to supporting roles. Even with some of his heroes, such as Thor, this was the case early on, even though he admits that Marvel had no official policy toward women one way or the other.[132]

Even more significant is his conviction that women should be a part of the superhero team and not just girlfriends.[133] The key example is Sue Storm. He not only made her a member of the team, but Reed Richards's fiancée at that.[134] Moreover, he wanted her to be different from the strong Wonder Woman, and more like a mother or caretaking figure.[135] This often comes to expression in Sue calming down the male members of the group when they are angry at each other or about to quit for some other reason. Sometimes, Sue is explicitly self-conscious of this role, in one issue referring to herself as "nursemaid" to the three others.[136] Although in the earliest issues, Reed's patronizing treatment of Sue leaves much to be desired—clearly a reflection of the cultural assumptions associated with the gendered separation of home and work that Ruether critiques[137]—the fact that she is from the beginning

126. Peter Sanderson, *Marvel Universe* (New York: Harry N. Abrams, 1996), 66–67.
127. Lee, *Women*, 12, 71, 234. See also Bradford Wright, *Nation*, 219.
128. For one among many instances, *Amazing Spider-Man* #18 (November 1964).
129. Lee, *Conversations*, 201.
130. Fingeroth, *Superman*, 90.
131. Costello, *Crisis*, 91.
132. Lee, *Women*, 8, 105.
133. Ibid., 57.
134. Lee, *Conversations*, 167; Lee, *Women*, 57–58; Lee and Mair, *Excelsior*, 117.
135. Lee, *Conversations*, 179.
136. *Fantastic Four* #3 (March 1962).
137. Ruether, *New Woman*, 195–197.

a full member of the team (and eventually regarded as the most powerful by none other than Dr. Doom) speaks volumes about both the deviation from sexist conventions and the addition of layers of complexity inaugurated by Lee in the genre.[138]

This was intensified by the 1970s, when, according to Raphael and Spurgeon, the culture had changed enough for Lee to promote women and other minorities as leading characters, something which was more difficult to achieve before then.[139] Like the idea of heroes without costumes, however, Marvel was ahead of its time in this, and promising heroines such as the Cat did not last long, ostensibly because of the conflicting commitments of her writers and artists,[140] but it may also be the case that the predominately male readership was not ready for her.

However, a place where female heroes were able to shine was in the X-Men comics. In an essay on its women characters, Rebecca Housel observes that this series was among the first to maintain female superheroes as leads, adding that "Lee and Kirby cocreated an unprecedented world of gender equality."[141] This was deepened in the renewal of the series by Chris Claremont and Dave Cockrum in 1975, whose new female characters were even more independent than the earlier Jean Grey, created by Lee and Kirby.[142] Richard Reynolds highlights Ororo Munroe/Storm in this regard, an African mutant who can control the weather and who was worshipped as a goddess at the time Charles Xavier recruited her in the Claremont/Cockrum run. Not only has she taken on a significant position of leadership over the years, but she is also "on all occasions an advocate of calm and the healing of divisions."[143] It is largely because of heroes like Storm that the 1970s X-Men comics gained a strong female readership.[144]

Certainly, most female superheroes and villains are still written by men and are, thus, drawn to appeal to the sexual tastes of the dominant heterosexual male readership.[145] Moreover, as Reynolds notes, feminist critics could rightfully propose that these characters rarely offer anything particularly feminine, instead behaving in battle like male heroes.[146] Yet, for just this reason, the exceptions that Marvel has presented over the years stand out all the more. Storm, Sue Storm, the various women in Peter Parker's life, and others, in spite of the occasional stereotyping expressed in their

138. Zimmerman, *Character*, 71.
139. Raphael and Spurgeon, *Stan Lee*, 141. See also Daniels, *Marvel*, 160–161.
140. See Lee, *Women*, 147–170.
141. Rebecca Housel, "X-Women and X-istence," in *X-Men and Philosophy*, ed. Rebecca Housel and J. Jeremy Wisnewski (Hoboken: Wiley, 2009), 85.
142. Ibid., 92.
143. Reynolds, *Super Heroes*, 94.
144. Bradford Wright, *Nation*, 263.
145. Zimmerman, *Character*, 74.
146. Reynolds, *Super Heroes*, 79–80.

characterizations, often behave according to the more communal economy that many women, including Ruether and Keller, commend as an alternative to staunch independence and self-subsistence.

For Lee and others at Marvel in the Silver Age, this became manifested not only for women, but also for men. By writing characters more realistically, Lee unconsciously stumbled on a deep truth about the nature of humanity itself. Ultimately, what we have reflected in the Marvel stories is a primal yearning to be held and to uphold one another—in spite of our differences and flaws—in loving patterns of relatedness that literally define who we are and why we are here. It is, in point of fact, the heroes' faults and failures themselves that call self-sufficiency into question. If one is *not* perfect on one's own, *cannot* guarantee one's own destiny and identity by one's own power, the only two options are that no one can or someone else can. This is a far cry from the rugged independence that characterized both older heroes and traditional American views of the person. This is not simply women's dream, but the human dream and hope.

Not surprisingly, this relational being—or becoming in community—is not lost on those who write about the significance of comics, especially Marvel's turn to reality. Housel, in a different essay on the X-Men, observes that several ancient philosophers—including Plato, the Stoics, and Paul—understood human fulfillment to come about only through solidarity, not individuality.[147] Zimmerman concludes that "we were designed for life together."[148] Philosopher Kevin Kinghorn, writing on the identity of Bruce Banner and the Hulk, insists that "personhood arises through relationships with other people."[149] Ruminating about religious faith in an essay on Daredevil, Tom Morris commends the fact that "ancient religious traditions have a more communitarian view of the human person and our condition . . . in the sense that the individual person and the larger community are understood as existing in deep forms of dynamic interdependence."[150] Comics editor and historian Danny Fingeroth asserts that the "nature of human life is defined by the presence or absence of relationships with others."[151] Comics writer Mark Waid opines that the basic desire to belong "is a fundamental aspect of human nature . . . our need to connect to others is paramount to our wellbeing."[152] Perhaps most germane to our purposes here, comics critic Arthur Berger, with explicit reference to Marvel heroes, suggests that

147. Rebecca Housel, "Myth, Morality, and the Women of the X-Men," in *Superheroes and Philosophy*, 81.
148. Zimmerman, *Character*, 103.
149. Kevin Kinghorn, "Questions of Identity: Is the Hulk the Same Person as Bruce Banner?" in *Superheroes and Philosophy*, 233–234.
150. Tom Morris, "God, the Devil, and Matt Murdock," in *Superheroes and Philosophy*, 57.
151. Fingeroth, *Superman*, 102.
152. Mark Waid, "The Real Truth about Superman: And the Rest of Us, Too," in *Superheroes and Philosophy*, 7–8.

the "old idea of the self-reliant 'individualistic' hero who can do everything on his own, with no help from anyone else . . . has been replaced by a view which sees everything as interrelated and everyone's fate being related to the fate of everyone else."[153]

Only by accentuating our normalcy and frailty did Stan Lee and his colleagues stumble on our relational being, reflected so subtly in the miseries and triumphs of the Marvel heroes. He was also writing in light of the manifold events of the 1960s and 1970s, which were for many a source of anxiety. The Cold War, the Civil Rights movement, women's liberation, social unrest, and personal doubt in the face of disenchantment called into question much of what Americans held to be certain. Not surprisingly, then, Marvel heroes came to doubt both what they knew and who they were.

THE GAMMA CLOUD OF UNKNOWING: MARVEL EPISTEMOLOGY

Arguably, the first casualty of this new uncertainty was the traditional optimistic position toward science. Many have noticed that 1960s Marvel differed from other companies and eras in this way. While DC and the Golden Age in general exalted scientific progress and epistemic certainty, viewing the unknown as something to be overcome, Marvel treated it as best left undisturbed.[154] Their stories reflected the anxiety of the time regarding atomic energy, especially the threat of nuclear war that always lurked in the background of the Cold War.[155]

Accordingly, the origins of most of the Marvel heroes during this time stemmed from Cold War anxiety and scientific progress gone awry. Although there is a sense in which the attitude toward science is ambivalent, especially in the recognition that it has the power to grant superhuman abilities, the overall stance is cautious and sometimes negative.[156] The FF were exposed to the dangerous cosmic rays that gave them their powers because they did not make the adequate preparations to shield themselves.[157] Matt Murdock became blind due to a radioactive substance that splashed into his eyes.[158] Peter Parker was given his powers from the bite of a radioactive spider. Although such events gave rise to Marvel heroes, the anxiety and apprehension came about due to the accidental nature of their transformations. They never asked for these things to happen, unlike the intentional

153. Berger, "Comics," 173.
154. Bradford Wright, *Nation*, 202.
155. This was the case even in Lee and Kirby's monster comics of the 1950s, according to Rhoades, *History*, 77.
156. Rosen, "Kirby," 114–115.
157. *Fantastic Four* #1 (November 1961).
158. *Daredevil* #1 (April 1964).

experimentation that created many Golden Age heroes. The result, Rosen suggests, is that the idea "that all humankind's ills can be cured by the promise and power of science and technology is turned on its head,"[159] an assessment shared by Merton and Cone, as we saw.

More specifically, Marvel challenged the rationality of science by demonstrating the arrogance of misdirected knowledge.[160] The primary chord of disdain was not so much for science as such but rather for science in the hands of those who would use it to destructive ends. Unlike in the Golden Age, though, this meant the military establishment, whose discovery of devastating atomic power was demonstrated in full force to end World War II. Although most Americans saw this conflict as a great moral and patriotic battle, the ensuing power struggle with the Soviet Union gave many pause regarding our predicament. Even World War II itself would eventually influence the rapid decline in faith in science and human progress that had characterized Western culture for the preceding few centuries.

Thus, some Marvel heroes were products of government irresponsibility with science. Bruce Banner became the Hulk by saving a young man from a gamma bomb that the military was testing.[161] The X-Men are still interpreted by some as "products of scientific and moral miscalculation created by the hubris of the military-industrial complexity of the United States government."[162] The revamped Namor/Sub-Mariner of the Silver Age declared war on all humanity because atomic tests had destroyed his undersea kingdom.[163]

This social and political epistemic anxiety grew to become existential as well, since the certitude of past decades was now being called into doubt all around. This is profoundly reflected in the psychological complexity of Lee's heroes, which were the first to really break the mold set by earlier heroes. Michael Lavin says it well: "Super-hero comics of the fifties and early sixties tended to be very formulaic, with noble, unswerving heroes, simplistic conflicts, and often times, gimmicky plot devices and trick endings. Little was seen of the hero's alter ego, except for the obligatory scene where he tried to hide his secret identity from friends and coworkers."[164] In contrast,

159. Rosen, "Kirby," 114.
160. Bainbridge, "Superheroes' Interrogations of Law," 462. See Reynolds, *Super Heroes*, 24.
161. *Incredible Hulk* #1 (May 1962). See also Bradford Wright, *Nation*, 209.
162. Tim Perry, "Mutants That Are All Too Human: The X-Men, Magneto, and Original Sin," in *Gospel According to Superheroes*, 173. See also Trushell, "American Dreams," 153ff.; Andrew Burnett, "Mad Genetics: The Sinister Side of Biological Mastery," in *X-Men and Philosophy*, 55.
163. *Comic Book Superheroes Unmasked*.
164. Michael Lavin, "A Librarian's Guide to Marvel Comics," *Serials Review* 24 (1998): 48; quoted in Perry, "Mutants," 173. See also Michael Chabon's comments in *Comic Book Superheroes Unmasked*.

Silver Age Marvel heroes reflected the times with their feelings of antiestablishmentarianism, alienation, and self-deprecation.

An important device that Lee employed to this end was the extended use of thought balloons in order to portray a character's inner feelings,[165] another change from the Golden Age, which used them primarily to describe the plot. For Spider-Man, he also made use of rooftop speeches. As a medium, Lee finds this to be one of the few advantages that comics have over film, since in the latter, monologues and voiceovers are unconventional. Thought balloons and soliloquies, asserts Lee, "gives the reader a chance to get to know the characters better, and the better you know the characters the more you care for them."[166]

For this reason, Spider-Man, in particular, is considered by some to be the first introspective hero. Fingeroth is quite specific: "The thing that makes Parker so modern—and so human—is not merely the combination of emotions that spur him on, and hence his multiple motivations, but that he . . . is like all of us, capable of encompassing contradictions."[167] Hence, there can even be different opinions about what motivates Peter. It is typically understood that Peter is driven to fight crime by guilt over the death of his Uncle Ben, which he inadvertently helped to bring about.[168] Certainly, his origin story lends to such a reading.[169] Yet Stephen Evans is also correct that guilt as such does not necessarily lead one to strive for the good.[170] Peter could just as easily have been so overcome with guilt that he pursued evil, succumbing to a downward spiral of negative emotions, not controlled but rather expressed in destructive ways. In fact, there are Marvel villains who have responded to their feelings just so.[171] All of this simply illustrates the complex realism that Lee introduced regarding psychological turmoil and ambiguity.

Another chief epistemic dynamic of introspection was self-doubt, which meant that, unlike earlier heroes, Marvel heroes were generally uncertain about the world, and especially of their places in it. This was, of course, the case with Peter Parker, but we might consider a parallel phenomenon that Lee and his colleagues introduced into the genre: the hero as antihero or monster. Probably nowhere are the themes of self-doubt and monstrosity more intertwined than in the character of Ben Grimm/Thing. Fingeroth suggests that he was the first hero who did not like being one.[172] No doubt this is related to the fact that he was basically the first hero who could not

165. On the following, Lee and Mair, *Excelsior*, 128, 135–136.
166. Ibid., 136
167. Fingeroth, *Superman*, 75.
168. Daniels, *Marvel*, 96; Fingeroth, *Superman*, 75.
169. *Amazing Fantasy* #15 (August 1962).
170. Evans, "Superheroes," 173.
171. See Moleman in *Fantastic Four* #1 and Lee's comments in *Origins*, 71.
172. Fingeroth, *Superman*, 122.

change into a normal-looking human at will, like earlier heroes and even his own Marvel cohorts. It is very likely that Thing's popularity among the fans is tied to this fact and its resulting anxiety.[173]

For Ben, this self-consciousness was manifested in two primary areas. The first had to do with romantic partnerships. His nagging doubts about his perceived inability to appeal to the opposite sex are still poignant, even despite the untimely lingo, altogether familiar to those men and women who consider themselves in a similar light. In *Fantastic Four #50* (May 1966), Ben's love interest, Alicia Masters, a blind woman who has become friends with the group, helps the Silver Surfer to see the beauty of humanity and Earth, instigating him to confront his master, Galactus. Upon returning from the encounter, Alicia is so excited to congratulate and encourage the Surfer in her actions that she does not notice Ben at first. Ben backs away, misperceiving the exchange as Alicia expressing romantic interest in the Surfer. Instead of being confident in their own friendship and budding romance, Ben walks away talking to himself: "Anyhow, if I wuz Alicia . . . who would I pick?? A gleamin' gladiator like him . . . or an ape like . . . me? Face it, ugly! It ain't no contest!" He is too far away to hear when Alicia tells the Surfer that she wants to share all that has happened with Ben.

A few pages later we have an example of the second area in which Ben was insecure. Walking down the stairs away from Alicia, he accidentally bumps into a woman on the street. She recognizes him and scurries away in a hurry, visibly scared and revolted, making up an excuse about having to rush to an appointment. Ben reflects to himself that even *he* gets scared of his face, concluding that he will "never be nothin' but . . . the Thing!"

Bradford Wright suggests that Thing was the first hero who was actually alienated from the human race by his powers in this second, more general sense.[174] Prior to the FF, Coogan concurs, "superpowers had consistently been portrayed as an unproblematic blessing."[175] The Marvel hero, according to Lang and Trimble, is thus a compromise between the classical myth of reintegration (as in Campbell) and the American monomyth of separation from community (Lawrence and Jewett). For them, this is because the hero attempts to reenter society by doing a violent act that the people are unable to accomplish themselves, as in the American monomyth. However, in the Marvel mythos, it is an act that the people find abhorrent, with the result that the hero is then considered a menace.[176]

With Ben Grimm and some others, however, it is not primarily the redemptive acts that are frowned on, but the repulsive appearance of the hero himself. Hence, the search for identity, the longing to know oneself,

173. Lee, *Origins*, 17–18.
174. Bradford Wright, *Nation*, 205.
175. Coogan, *Superhero*, 13.
176. Lang and Trimble, "Man of Tomorrow," 166.

was catalyzed for the Marvel heroes by their own unique personalities and features, a phenomenon foreign to the Golden Age and even early Silver Age DC.[177] Yet, the quest, as Lang and Trimble imply was to nevertheless search for identity in community.[178] For the FF and the X-Men, this was at least partially achieved within their own groups, in spite of the alienation that they felt in light of the ostracism endured from the larger culture.[179] For others, however, identity in community has been a more or less futile endeavor, a situation most often portrayed as unfortunate and pitiful by Lee and Marvel, in general.

Probably the most notable example is Hulk, whom Lee explicitly wanted to be a "nice-looking monster, big and brutish enough to make him feared by all who met him and yet with a certain tragic appeal that would make our readers care about him and cheer him on."[180] The notion of making a hero out of a monster had no real precedent before this.[181] Not even Ben Grimm was in quite so dire a straight, for although Ben and Bruce have in common contempt for their alter-egos,[182] Bruce could not control his actions while in his gigantic green form.

What saves Hulk from being a villain, then, is the fact that he simply wants to be left alone. Although at the earliest he was written to be somewhat cunning, Hulk was quickly dumbed down, a move that Daniels thinks made him more attractive.[183] He is just a creature who does not want to be hurt and so acts out of self-preservation, which is why most of his good deeds are inadvertent.[184]

Hulk's chief predator is the U.S. government, especially General Thaddeus "Thunderbolt" Ross, who has demonstrated no less than an obsession with finding and killing him. The irony, however, is that the government's hubris and irresponsibility led to Banner's transformation in the first place. Ross was the commander of the military's gamma bomb project, and Bruce its head scientist. When Bruce ran into the test zone to save an innocent bystander who had strayed there unknowingly, he was exposed to the radiation and became the Hulk.[185] Hence, many commentators suggest that Hulk is a metaphor for the Cold War fear of atomic power and a general warning about the "Enlightenment's misguided faith in the capacity of reason to subdue the excesses of human nature."[186]

177. Bradford Wright, *Nation*, 203.
178. Lang and Trimble, "Man of Tomorrow," 167.
179. Lee and Mair, *Excelsior*, 165–166; Raphael and Spurgeon, *Stan Lee*, 103.
180. Lee, *Origins*, 76.
181. Fingeroth, *Superman*, 123.
182. Daniels, *Marvel*, 89; Raphael and Spurgeon, *Stan Lee*, 99.
183. Daniels, *Marvel*, 91.
184. Coogan, *Superhero*, 41.
185. *Incredible Hulk* #1 (May 1962).
186. Genter, "Great Power," 960. See also *Comic Book Superheroes Unmasked*; Daniels, *Marvel*, 91; Bradford Wright, *Nation*, 209.

In spite of his capacity for destruction, the early and quintessential Hulk is still seen as more of a victim than a threat, a pitiful and misunderstood creature looking for companionship and reflecting an age of growing ambiguity about both national and personal identities.[187] For this reason, the Bruce/Hulk crisis is often seen as a paradigm for our internal struggles. Fingeroth puts it most forcefully:

> When you ask a crying child what is wrong, what is making him or her cry, the answer often is: "I don't know." It's a response frustrating to child and adult alike. It is the existential cry of humankind, the reason even the rich and accomplished suffer angst and depression. Is it biochemical? Is it spiritual? Whatever the reason, something is wrong, something we can't name or define, something that a run in the park or a drink or a visit to a brothel or a house of worship won't cure. It just . . . hurts to be alive.
>
> That's where the primal scream of Hulkdom comes in. At the very least, one can cry out in anger and defiance: *I am here! I hurt! Make it stop!*[188]

For the first time in the superhero genre, then, Lee and Marvel expressed the epistemic anxiety and inner turmoil of the age. Yet in simply being realistic, we may conclude that the complexities, ambiguities, and longings for communion presented in these stories are simply anthropological data with which we must deal. Over 50 years later, we have grown no more confident in our knowledge and no less anxious about the state of the world and our place within it and with those among whom we live, as the fallouts from 9/11 and Hurricane Katrina have amply demonstrated. For this reason, we would do well to bear in mind what Arthur Berger observes in his commendation of Marvel's attitude toward science: "Progress is a function of moral character as well as intelligence."[189]

JUSTICE BELEAGUERED: MARVEL ETHICS

As we discussed in chapter 2, following Eco, Golden Age superhero comics defined evil primarily in terms of threats to private property.[190] This made sense in a social context in which the dominant group was relatively undisturbed and confident in its convictions of superiority, enabled by a perception of government as trustworthy. DC, even into the 1960s, as we

187. Costello, *Crisis*, 92; Lee, *Origins*, 75–76.
188. Fingeroth, *Superman*, 126. Emphasis in original.
189. Berger, "Culture," 175.
190. Eco, "Superman," 123. See also Gabilliet, 203.

saw, reinforced middle-class democratic ideals and white capitalist afflu-ence, while intentionally resisting moral complexity.[191]

Over at Marvel, however, the epistemic anxiety that Lee and his col-leagues presented in their comics brought with it ethical anxiety about the natures of evil and justice and about the right course of action. Again, this was largely a reflection of what was already in the air. In making realism a priority, Lee had to recognize that life was not a matter of black and white in an age of growing disillusionment with the government and more publicized racial and gender tensions.[192] This new acknowledgment had many expres-sions in Marvel comics.

One area in which moral ambiguity arose for Marvel heroes was in a growing attitude of disdain for government. Steve Rogers/Captain America, having been reawakened in 1964,[193] took perhaps the most ironic turn by occasionally challenging the contemporary administration. For a character that was originally created near the beginning of America's entrance into World War II in order to encourage troops on the Western front, Cap had changed quite a bit.

In the 1960s, Cap was not involved with defending America against for-eign enemies, as was the case in the 1940s, but rather with the various cultural issues at home, as well as with his own relevance in a society that was not the one he knew so well.[194] Even during Vietnam, Cap only visited there twice, and only to rescue American soldiers, a far cry from his con-sistent involvement overseas during World War II.[195] As early as 1970, Lee himself admitted, "Captain American can't—although he's considered an establishment figure really—he's beginning to have second thoughts about the whole thing. He realizes he can't really side with the establishment 100 percent."[196] In the 1970s overall, Costello observes, patriotism was hin-dered in Marvel comics, especially Cap stories, by the recognition that it was often distorted into bigotry and arrogance.[197]

After the Watergate scandal of the early 1970s, Steve was so disappointed with the United States that he abandoned the stars and stripes and became the superhero Nomad, "man without a country," for a short time.[198] There

191. Bradford Wright, *Nation*, 75, 184, 224.
192. Lang and Trimble, "Man of Tomorrow," 172.
193. *Avengers* #4 (March 1964).
194. Zimmerman, *Character*, 88–89; Jason Dittmer, "Retconning America: Captain America in the Wake of World War II and the McCarthy Hearings," in *Amazing Transforming Superhero*, 41.
195. Dittmer, "Retconning America," 41.
196. Lee, *Conversations*, 22. See also Mike S. Dubose, "Holding Out for a Hero: Reaganism, Comic Book Vigilantes, and Captain America," *Journal of Popular Culture* 40, no. 6 (December 2007): 928.
197. Costello, *Crisis*, 107.
198. Bob Hulteen, "Of Heroic Proportions: Fifty Years of Captain America," *Sojourners*, August/September 1990, 39.

are several stories from the 1980s as well in which Cap critiqued the reigning political regime.[199] Although his strong moral compass has never disappeared, he has learned that it is not absolute and unchangeable.[200]

Similarly, Tony Stark's attitude toward the conflict in Vietnam changed greatly during the 1960s. His introduction in 1963 reflected a very pro-war position, with Stark gleefully torching his Vietnamese captors.[201] Stark made a dramatic shift after 1968, however. "The symbolic Cold War confrontations that had dominated the series all but disappeared,"[202] and within a few years his company stopped manufacturing weapons.[203] Not only that, but he turned to fighting domestic social problems.[204] Writing in 1975, Lee conceded that the first Iron Man story came "at a time when most of us genuinely felt that the conflict in that tortured land really was a simple matter of good versus evil and that the American military action against the Viet Cong was tantamount to St. George's battle against the dragon."[205]

This attitude reflects another area in which Marvel changed the moral economy of comics. Just as authorities were called into question in the Silver Age, so was war itself. Lee actually admits to hating war—another similarity to our theologians, especially Thomas Merton—which is why Marvel introduced pacifist characters such as the Watcher and the Silver Surfer.[206] Other characters also make very antiwar comments, including Daredevil,[207] Iron Man,[208] and even Galactus, Devourer of Worlds![209] As early as the 1950s, this can be seen in the Marvel comics of Lorna the Jungle Queen. Written by Lee starting in 1954, her stories showed the killing of animals in early issues. Shortly after, that changed and she became more of a conservationist. According to Nicky Wright, Lee did not like killing, and "in this he was a pioneer of sorts."[210] Arguably more significant for our discussion is the fact that the bipolar portrayal of the Cold War ended in Marvel comics long before the actual Cold War did. For instance, between 1971 and 1986, Costello notes, there were only 10 Captain America and Iron Man stories combined that featured Communist villains.[211]

One of the reasons Lee and his characters grew to hate war was because of the conviction that America's enemies might not be all bad. Thus, Marvel

199. Costello, *Crisis*, 137; Hulteen, "Captain America," 39ff.
200. Dubose, "Holding Out," 928. See also MacDonald, "Sold American," 249; Skidmore and Skidmore, "Fantasy, 86.
201. *Tales of Suspense* #39 (April 1963). See also Daniels, *Marvel*, 98.
202. Bradford Wright, *Nation*, 241. See also Daniels, *Marvel*, 98.
203. Skidmore and Skidmore, "Fantasy," 86; Bradford Wright, *Nation*, 242.
204. Costello, *Crisis*, 103; Bradford Wright, *Nation*, 241–243.
205. Lee, *Son of Origins*, 45. See also Daniels, *Marvel*, 101.
206. Lee, *Conversations*, 116.
207. E.g., *Daredevil* #47 (December 1968).
208. E.g., *Invincible Iron Man* #78 (September 1975).
209. E.g., *Fantastic Four* #50 (May 1966).
210. Nicky Wright, *Classic Era*, 167.
211. Costello, *Crisis*, 164.

also challenged moral certainty by calling into question the traditional nature of villains as entirely corrupt and evil. In the monomyth, of course, this was required in order to maintain the purity of the hero and the innocence of the saved community. In the context of the disruptions of the 1960s and 1970s, however, those old clear distinctions were unraveling.

This shift can be seen already in *Fantastic Four* #1. The villain Moleman, who has taken to living underground away from civilization, is threatening the world. When the FF confront him, he laments that he was rejected by people on the surface, forcing him to look for a new world on his own. After sealing him underground, Reed supposes that there is no place for him in the normal world, but hopes that Moleman finds peace where he is. While we may disagree that isolation was actually the best thing for Moleman, his sympathetic treatment in the medium of superhero comics is novel and profound. Lee himself admits that this is how he hoped readers would respond to Moleman.[212] Other examples abound. Both Red Skull (Cap's nemesis) and Dr. Doom (FF's nemesis) see themselves as hideous and worthless;[213] deformed Soviet villain Gargoyle admits that he hates being a monster;[214] and Spider-Man villain Doctor Octopus turned to crime as a result of mistreatment by his parents.[215]

Marvel also highlighted the ambiguity of its villains.[216] Peter Parker's friend Dr. Connors was a good family man, but as the villainous Lizard he was violent and hungry for power.[217] Norman Osborn/Green Goblin is similar. He is the father of Peter's best friend Harry and has also taken Peter under his wing at times.[218] Dr. Strange's nemesis Dormammu has his own code of ethics and is the ruler of a people. When the vicious Mindless Ones break the mystical barrier Dormammu created to keep them out, Dr. Strange agonizes over whether to help him, but ultimately decides that this would be the best thing.[219] The X-Men villain Magneto, although created by Lee and Kirby, was not developed until Chris Claremont rewrote his backstory in the mid-1970s. Claremont decided to make him a Holocaust survivor because it allowed him to portray Magneto as "a tragic figure who wants to save his people. Magneto was defined by all that had happened to him. So I could start from the premise that he was a good and decent man at heart."[220]

212. Lee, *Origins*, 71.
213. Coogan, *Superhero*, 85.
214. *The Incredible Hulk* #1 (May 1962).
215. Coogan, *Superhero*, 94.
216. Lee, *Bad Guys*, 8.
217. Lee, *Origins*, 138.
218. Lee, *Bad Guys*, 157.
219. *Strange Tales* #127 (December 1964).
220. Quoted in Kaplan, "Kings of Comics," part 2. See also Coogan (*Superhero*, 94), who notes that writers after Lee in general used soliloquy to reveal villains' humanity.

Merton, Cone, and Keller also argue against the idea of a purely evil enemy against which America, white people, and men form their identities as superior. Their claim is that of Lee: if you cease to label people as enemies or aliens and see them first as human beings, then you will be more open to seeing how they are like you and perhaps even understand and sympathize with their motivations.

The understanding of villains in terms of motives and personal background, particularly victimhood, was in fact new to the Marvel Age, whereas earlier at DC, villains were defined strictly by their deeds.[221] Lee explicitly prefers a personal relationship between hero and villain—"two human beings in opposition"[222]—which is precisely why Peter Parker, for instance, has had many father figures who turned out to be foes.[223] This complexity and call for understanding with regard to villains is simply an expression of the turn to reality for Lee. In recognizing them first and foremost as persons, and not as generic devices, he and his successors were able to describe them in basically the same way as the heroes. In other words, neither heroes nor villains are simplistic and altogether guilty or innocent. Rather, like all of us, they have strengths and weaknesses, faults and imperfections, and lovable qualities. This is utterly foreign to a mythology or anthropology that draws strict lines of demarcation between persons with regard to ontic status or moral value.

The phenomenon that Lee consistently presents as the reason for our perpetual vilification of others is fear, specifically of that which we do not know and the attendant anxiety that leads us to respond violently to strange others. Early on, of course, Lee maligned America's Communist enemies, even though particular evildoers were portrayed unusually sympathetically. Toward the end of the 1960s, however, even the Communists were shown more humanely, to reflect a more ambiguous time—quite in contrast to contemporary portrayals in other areas of popular culture, it should be noted—and this sentiment has characterized Lee's philosophy ever since.

On the contrary, Lee, like Merton and Shults, has called for the alternative to fear and violence to be found in understanding, compassion, and love. More than any other Marvel character, the Silver Surfer has acted as Lee's mouthpiece in this regard. The Surfer has surveyed humanity and found that fear of others and that which we do not know drives us toward violence, hatred, and oppression. He consistently condemns the will to destructive power, insisting instead "that love is the power supreme."[224] Fear, Lee seems to suggest via the Surfer, is at the root of all the relational

221. Coogan, *Superhero*, 83; Perry, "Mutants," 176.
222. Lee, *Bad Guys*, 160.
223. Donald Palumbo, "The Marvel Comics Group's Spider-Man Is an Existentialist Super-Hero; or 'Life Has No Meaning Without My Latest Marvels!'" *Journal of Popular Culture* 17, no. 2 (Fall 1983): 72.
224. Oropeza, "Silver Surfer," 160.

problems and ethical discord that characterize broken humanity. In this way, Marvel moved past the simplistic notion of the irredeemable villain bent on destroying society and suggested rather that villains, like all of us, are people who respond to their environments, both out of fear of others and in reaction to others' fear of them.[225]

The last point leads naturally to the question of how other marginalized persons were presented in the Silver Age. If the traditional understandings of both villains and evil were found to be limited, what alternative did Marvel offer? A dominant theme in Silver Age Marvel, following concerns in the culture at large, is social justice, particularly the issues of systemic sexism, racism, and classism. Early on, this was very mild, subtly portrayed in the questioning of authority,[226] but later in the 1960s and into the 1970s, the political commentary became broader and more overt.[227]

Lee himself felt that subtlety was the best way to address social issues in comics, as opposed to the explicit messages that came to characterize DC's stories around the turn of the decade, especially the *Green Lantern/ Green Arrow* series.[228] This was congruent with Lee's own political views, which Reynolds describes as a "liberal conservativism" that advocates passive support for the marginalized.[229] Thus, Lee did not believe in completely replacing the traditional hero trope of stopping bad guys with exclusively social concerns; he expressly admits that "by saving the day, you are improving the world."[230]

Nevertheless, Lee and Marvel consistently worked to condemn bigotry, racism, ostracism, and fear of the other in general. One of the ways this happened was in the form of Lee's editorial comments in a section of their comics called Stan's Soapbox.[231] Lee states in an issue from December 1968 that racism and bigotry are "social ills" and "insidious evils."[232] In a later forum, Lee mentions that Marvel's main purpose is to entertain, but also to show the world as it might, could, and should be.[233] Costello opines that this stance "seems to go beyond mere passive liberalism," calling for true tolerance and responsibility.[234]

The other way in which the marginalization of others was criticized was, of course, in the comics themselves. While this was shown with all Marvel heroes at one time or another, the most consistent and provocative messages were found in the X-Men comics. Debuting in *X-Men* #1 (September

225. See Lee, *Bad Guys,* 8; Lee, *Origins,* 71; Perry, "Mutants," 176.
226. Coogan, *Superhero,* 207; Bradford Wright, *Nation,* 219.
227. Costello, *Crisis,* 17; Trushell, "American Dreams," 154–155.
228. Lee, *Conversations,* 37–38.
229. Reynolds, *Super Heroes,* 120.
230. Lee, *Conversations,* 193.
231. Daniels, *Marvel,* 107.
232. Quoted in Costello, *Crisis,* 123–124.
233. Costello, *Crisis,* 124.
234. Ibid.

1963), Lee and Kirby created another Marvel innovation with five teenagers whose superpowers originated in their genes instead of by magic, bestowal, extraterrestriality, or scientific accident.[235] These *mutants,* as they were and continue to be called, were taken in and trained by Professor Charles Xavier to use their abilities for fighting evil.

At first, the theme that was arguably most evident was teenage alienation. Their mutations and feelings of difference acted as points of identification for Marvel's adolescent readers. Fingeroth observes that many stories were about their powers erupting for the first time, sometimes with disastrous consequences.[236] This parallels what many young people feel when their puberty brings about new and awkward experiences.

However, what makes the X-Men ripe for ethical discourse is the additional fact that, because of their uniquenesses, they were marginalized by regular humans. Not only that, but cultural implications were intensified by the presence of two different groups of mutants. On the one side were Xavier's heroes, who sought to protect a human race that feared and hated them.[237] On the other was Magneto, whose Brotherhood of Evil Mutants, as it was first called, tried to take over the world and was frequently opposed by the X-Men.

While Lee and Kirby tried to use this series as a parable for prejudice and intolerance, most critics agree that the full implications for social commentary were not realized until writer Chris Claremont revitalized the X-Men in 1975.[238] For one thing, the original group was all white.[239] Len Wein and then Claremont especially corrected this by creating new mutants from a variety of ethnic and national backgrounds.[240]

Another change Claremont made was to recreate Magneto's Brotherhood as a group of mutant supremacists who would pursue violent revolution if necessary in order to attain their rights and power in the world. Although the peak of the Civil Rights movement was some years past, Claremont and Cockrum made explicit the parallels between Xavier and Martin Luther King, Jr. on the one side, and Magneto and Malcolm X on the other.[241]

In spite of the problems with these particular parallels, the X-Men comics have continued to emphasize two chief points which are of utmost interest to us here. First, that to the extent we must live as outcasts, our only hope is

235. Daniels, *Marvel,* 111.
236. Fingeroth, *Clark Kent,* 116.
237. Daniels, *Marvel,* 172.
238. Fingeroth, *Clark Kent,* 114; Rhoades, *History,* 107; Terrence R. Wandtke, "Introduction: Once Upon a Time Once Again," in *Amazing Transforming Superhero,* 18.
239. Mikhail Lyubansky, "Prejudice Lessons from the Xavier Institute," in *Psychology of Superheroes,* 76.
240. Reynolds, *Super Heroes,* 88.
241. Fingeroth, *Clark Kent,* 121. See also Kaplan, "Kings of Comics," part 2; Trushell, "American Dreams," 154; Zimmerman, *Character,* 80.

to do so together; to seek and find a home not on our own, but within community. Reynolds notes that the X-Men ultimately triumph only through their loyalty to each other.[242] Claremont himself suggests that this notion of family or belonging is responsible for the very success of the series.[243]

Second, that fear and oppression of the other is wrong. Humankind is diverse, and Marvel's decision on this reality has always been that our diversity is to be respected.[244] Significantly, this is not to be a tolerance of distance as it was for Thomas Jefferson, who thought that different groups of people could live in harmony only if they lived apart.[245] Rather, this is an intimate, self-sacrificing tolerance. Yet, since we are all unique, and in this sense other, the result must nevertheless be that not only should the outcasts seek community, but everyone should do so. Lee himself says it best: "The whole underlying message of the X-Men was about 'love thy fellow man'. He may have wings growing out of his back or beams shooting out of his eyes, or he may be a different colour or different race, but he's still your brother."[246]

So far so good when we consider Lee and Marvel's philosophical views, but to what extent did their sentiments come to expression for real-life non-white characters in their comics? When we keep in mind that the majority of comicbook creators are and have always been white and male—the two most notable traits of America's historically dominant group—our hopes in this area may already be hindered. In addition, even with all their personal troubles, the best-known Marvel heroes are still middle class and college-educated.[247] As Zimmerman rightly remarks, within its comics this majority "often doesn't know what to do with anyone else."[248] In some ways, then, Marvel simply followed Golden Age and contemporary examples. In the 1960s, Africans were primarily portrayed as naïvely obedient and superstitious, the Viet Cong were slant-eyed targets of heroic vengeance, and Arabs were pretty much not around at all.[249]

Where Marvel broke new ground, though, was in its representations of African Americans, who at the time were still strangely absent in DC's stories.[250] Although not superpowered, the trumpet-playing Gabe Jones was an equal member of *Sgt. Fury and His Howling Commandos,* a war comic debuting in 1963. What marks his inclusion here as significant is the fact

242. Reynolds, *Super Heroes,* 91–93.
243. DeFalco, *X-Men,* 80.
244. See Cord Scott, "Written," 336.
245. See Onuf, "Jefferson's Thought," 17, 40.
246. DeFalco, *X-Men,* 11. See also Fingeroth, *Clark Kent,* 113, 122; Lyubansky, "Lessons," 77; Zimmerman, *Character,* 78.
247. Geoff Dyer, "American dreams," *New Statesman,* January 12, 2004, 43.
248. Zimmerman, *Character,* 69.
249. Shaheen, "Arab Images," 123. Over the years, both Marvel and DC have sought to correct this, however.
250. See Hulteen, "Captain America," 41; Thompson, "Axis," 128; Bradford Wright, *Nation,* 65, 219, 237.

that the company that separated the colors for printing made Jones pink. Lee had to write a memo telling them that he really was supposed to be black.[251] This is a simple example to demonstrate the difference between the conventions at the time and where Lee wanted to go.

T'Challa/Black Panther is normally considered to be the first black superhero. He was an African chieftain created by Lee and Kirby and introduced in 1966 in *Fantastic Four #52* as a guest star, then got his own series in 1973.[252] Kirby wanted this character because he had many minority readers and some of his friends growing up were black.[253] The young Black Panther movement even inspired Lee and Kirby for the name, something that Jeffrey Brown sees as "a hip reference to the struggles of black American culture."[254]

Another significant black figure was Sam Wilson/The Falcon, created by Stan Lee and artist Gene Colan and debuted in *Captain America #117* (September 1969) as Cap's partner/sidekick. He was a social worker in the ghetto and viewed as an Uncle Tom by more radical African Americans.[255] His precise role is difficult to pinpoint and depends on the perspective from which one is viewing. For his white writers, he was viewed as a partner. For his black readers and Wilson himself, he was a sidekick.[256] Bob Hulteen may be correct that something in the middle is most accurate: not a full partner but still an improvement over earlier characterizations.[257]

We should also consider Luke Cage, a hero with super strength and rock-hard skin who may be the first truly African American superhero. He appeared in 1972 immediately in his own series, *Luke Cage, Hero for Hire,* the first at Marvel to take its title from a black character.[258] Unlike Wilson and most other Marvel heroes, interestingly, Cage was lower class.[259] Although not created by Lee, he was a result of the editorial decisions that Lee helped inaugurate in the Silver Age.

In spite of these new inclusions, much was left to be desired in Marvel's portrayal of black heroes in their comics. First, black heroes were generally not on the same level as their white counterparts with regard to power and abilities.[260] This led, secondly, to the critique that black masculinity was then represented in terms of the binary of "pure body and little mind."[261]

251. Daniels, *Marvel,* 108; Ro, *Tales,* 79.
252. Daniels, *Marvel,* 158; Hulteen, "Captain America," 41.
253. Ro, *Tales,* 98–99, 195.
254. Brown, *Black Superheroes,* 19–20.
255. MacDonald, "Sold American," 251.
256. Brown, *Black Superheroes,* 20; Costello, *Crisis,* 120.
257. Hulteen, "American Dreams," 41.
258. Daniels, *Marvel,* 158.
259. Bradford Wright, *Nation,* 247–248.
260. Rob Lendrum, "The Super Black Macho, One Baaad Mutha: Black Superhero Masculinity in 1970s Mainstream Comic Books," *Extrapolation* 46, no. 3 (Fall 2005): 367.
261. Brown, *Black Superheroes,* 173; Lendrum, "Macho," 367.

Hence, Rob Lendrum can suggest that Black Panther is an example of the noble savage, a key figure in early American literature.[262] Moreover, thirdly, in order to prove himself worthy in the dominant culture of white heroism, the black hero's hypermasculinity came to expression in misogyny. Black women, like the white women of the Golden Age, were primarily damsels or villains.[263] Fourth, it is generally accepted that both DC and Marvel's black heroes grew out of the blaxploitation films of the early 1970s.[264] Not only were these figures stereotypically masculine and patriarchal, but their race was emphasized in a way which was not shared by whites. Accordingly, during the Silver Age they were more stereotypes than persons, "heavy on race and light on individuality."[265] Luke Cage, for instance, is seen by Brown as "the epitome of blaxploitation's angry young black man."[266] As we saw in the previous chapter, Cone and Ruether leveled many of these same critiques against blaxploitation media.

Finally, black hero comics never addressed the systems of oppression that give rise to black crime and violence. Instead, they only affirmed the liberal ethics of their white counterparts.[267] Ultimately, Reynolds suggests, black heroes really only fill a quota.[268] The general attitude was that if change were going to happen, it would have to be on white terms.[269] Even Spider-Man firmly believed that only by working within the system would full acceptance and integration happen.[270] White comics creators saw black nationalism, violence, and extremism as militant and totalitarian.[271] As Mikhail Lyubansky points out in an essay on the X-Men, however, to place the burden of peace and tolerance on the oppressed group is itself a form of oppression.[272] Indeed, Marvel's method was exactly opposite of how Merton and Cone claimed unequal race relations were to be solved. For them, white people, including white liberals, had to listen to blacks and allow them to determine the conditions of their own empowerment and integration.

Nevertheless, for all this, there are a few positive aspects to consider. For one, the black heroes, however imperfectly portrayed, at least acted as points of identification for black readers and opened space for black characters in the genre.[273] Also, it was shown in these comics that black

262. Lendrum, "Macho," 367.
263. Ibid., 364.
264. Brown, *Black Superheroes*, 19; Lendrum, "Macho," 360.
265. Zimmerman, *Character*, 75. See also Brown, *Black Superheroes*, 178; Lendrum, "Macho," 360; Bradford Wright, *Nation*, 249.
266. Brown, *Black Superheroes*, 23.
267. Lendrum, "Macho," 370.
268. Reynolds, *Super Heroes*, 77–79.
269. Costello, *Crisis*, 122.
270. Mondello, "Spider-Man," 236.
271. Costello, *Crisis*, 120–122.
272. Lyubansky, "Lessons," 85.
273. Brown, *Black Superheroes*, 163; Lendrum, "Macho," 371.

heroes were better equipped to help their communities than were white heroes,[274] the opposite of what many other white people said in different media. Finally, in spite of stereotypical representations, it may be a step in the right direction that minorities in general are at least shown to express their own group identities instead of being thrown into a melting pot of the generic nonwhite other.[275]

While the various critiques of Silver Age representations of black *heroes* may be valid, no mention is made therein of other black characters that graced Marvel's pages. While in the Golden Age, and even simultaneously at DC, minorities were hard to find at all, Lee made it a point to include African Americans and other traditionally marginalized people as both supporting and guest characters. Moreover, already in the early 1960s, Marvel started to diversify pedestrians and other background characters.[276] Lee was especially ahead of his time in including other black characters without commenting on their minority status or emphasizing their blackness, as had happened with black heroes.[277] Sometimes black characters were represented according to stereotypes, but many others were unique persons whose color did not determine their cultural identities in a degrading fashion.

A key example is Robbie Robertson, created by Lee and artist John Romita and introduced in *Amazing Spider-Man* #51 (August 1967). Robbie was a friend and confidant to Peter and a supporter of Spider-Man against the delusions of *Daily Bugle* editor J. Jonah Jameson, with whom he closely worked, often acting as Jameson's voice of reason. Lee himself affirms that Robertson was one of the first black characters in comics to have an important and continuous role.[278]

Black characters as guest stars also figured prominently in Lee's comics. He used them not only as counterstereotypes—showing them as unique, diverse, and full members of society (a point that could be viewed negatively as one-sided accommodation)—but also in order to teach ethical lessons. Two examples illustrate this point.

First, *Silver Surfer* #5 (April 1969) features a black man, Al Harper, who rescues the Surfer after the latter falls to earth in a failed attempt to breach the barrier Galactus has set for him. When the Surfer asks why Harper did this, he responds that he knows "how it feels to be pushed around." In a monologue later on, Harper tells himself that he should continue to help the Surfer because he has been treated like an outcast, "just because of the way he looks! Just because he's . . . different! Maybe it takes a guy like me to

274. Lendrum, "Macho," 369.
275. Skidmore and Skidmore, "Fantasy," 88.
276. Zimmerman, *Character*, 75.
277. Significantly, Coogan (*Superhero*, 212) observes that writing blacks as heroes and supporting characters was not common till the 1970s. Lee was doing this already in the 1960s.
278. Lee, *Origins*, 137.

understand!" The story ends when a powerful and malevolent figure known as the Stranger plants a bomb somewhere on earth in order to destroy all life. Harper finds the bomb and deactivates it, knowing that what little gas was released in the process will kill him. The Surfer realizes what has happened and honors Harper with an eternal flame at his grave.

Not only is there a subtle sermon against bigotry, but Harper also contradicts a significant black hero stereotype. As a physicist, he is able to help the Surfer make a device that will allow him to reach space. His intelligence is in antithesis to the binary of pure body and little mind that typically characterizes blaxploitation heroes and the noble savages before them.

Second, we have one of Lee's favorite stories in *Daredevil* #47 (December 1968),[279] in which a blind Vietnam veteran named Willie Lincoln, a black man, is framed for taking a bribe, after which he is suspended from the police force and seeks legal help from Matt Murdock. After Murdock clears his name in the courtroom, the mobsters who framed Lincoln (because he, in fact, would not be bribed) come to his apartment to kill him. Daredevil saves his life and says he will talk to the commissioner about getting Lincoln a new job. In the last frame, Lincoln says to his dog, "Y'know, boy—just a short time ago I thought I'd really hit bottom! But then I found me a friend. . . . Now, even without my eyes—I'm looking forward to tomorrow—for the first time! I feel like I'm part of the human race again! Murdock never made a big deal about it, but . . . maybe that's what brotherhood is all about!"

Ultimately, Lee and his colleagues were perhaps ignorant about the systemic factors of oppression and about how black superheroes should be best portrayed. While they meant well, in Silver Age comics the dominant group of liberal white society was still the standard against which black behavior was measured as either helpful or radical and into which black persons were supposed to be integrated. Nevertheless, Lee was innovative and provocative in his incessant polemics against prejudice, bigotry, racism, and exclusion, which came to expression both metaphorically and literally, as in the examples above. His hope was, and still is, that in spite of our vast differences, we would seek to be brothers and sisters. This duty to care for each other and to include each other is, for Lee, not something superhuman, but something altogether natural and definitive of our species, something to which we are called simply because it is right.

Regardless of whether Marvel has been thoroughly consistent or culturally educated in its treatments of marginalized groups, its moral bedrock rests resolutely on two premises. First, that every individual human being is valuable;[280] and second, that we are responsible for protecting this dignity to the extent that we are capable of doing so. Thus, as may be inferred

279. Lee, *Son of Origins*, 139.
280. See Charles Taliaferro and Craig Lindahl-Urben, "The Power and the Glory," in *Superheroes and Philosophy*, 71.

from all of the above, Silver Age Marvel placed moral action at the center of its new hero mythology. Lee is actually rather critical of the more cynical dark phase of comics from the mid-1980s to 1990s, largely because of its lack of ethical standards. Marvel may have asserted—against DC and the Golden Age—that the right course of action was not always clear, but it did not for that reason simply abandon the concept altogether. Instead, it actually worked to broaden our understanding of moral decision by placing its heroes in real-life contexts, ultimately affirming a relational notion of human behavior: both what we do and what we fail to do have consequences for ourselves and others. The chief mode of discourse in which this conviction was expressed is the binary of power and responsibility.

We know it well by now: with great power comes great responsibility. Such is the wisdom Lee extends to readers in the last panel of the first Spider-Man story.[281] In it, Peter Parker uses his newfound abilities to gain fame and fortune, but lets a thief get away when he could have stopped him. When asked by the pursuing police officer why he let this happen, Peter responds that now—that is, with his new powers—he only looks out for himself. Sometime later, Peter returns home to find that his Uncle Ben has been shot by a burglar, only to discover that the killer was the very thief Peter let escape days before. This definitive example of Marvel's ethical stance is a personalization and maturation far beyond anything produced in the Golden Age, and it has significant implications both for the readers who would follow this mantra and for the American myth system itself.[282]

For one thing, it implies not only that the powerful *should* help the powerless, but also that they are *better equipped* to do so.[283] Even if Lee did not fully see this himself, the logical conclusion is that the dominant cultural group of white men should accommodate the needs of the marginalized, whoever they be, instead of the reverse.

For another, Patterson makes a strong case that responsibility suggests a group to whom we are responsible, something that many ethicists have highlighted following Aristotle. Our "moral compass is not something that is innate within us . . . instead it is something that draws upon the community (or communities) that is (are) most important to us."[284] For this reason, both Peter Parker and the X-Men are driven to moral action not in the abstract, but because of their relations to those who do good and their acceptance into ethical communities.[285] Lee himself admits that he did

281. *Amazing Fantasy* #15 (August 1962). See also Lee, *Origins*, 139ff. Originally, it was the last part of a sentence and reads, "with great power there must also come—great responsibility!"
282. See Raphael and Spurgeon, *Stan Lee*, 101. For other Marvel examples, see Lee, *Origins*, 24, 228ff.; Lee, *Son of Origins*, 199.
283. See Lee, *Conversations*, 195; Pustz, *Culture*, 50; Garrett, *Holy Superheroes*, 60; Roz Kaveney, *Superheroes*, 160.
284. Patterson, "Spider-Man," 138.
285. Evans, "Superheroes," 173.

not want his characters to be heroes inexplicably, but rather to be driven toward heroism.[286] The embrace within a healthy and morally upright context extends inevitably outward. Hence, Trushell can note that the original X-Men "privileged public service over self-gratification."[287]

This means, thirdly, that the American monomythic feature of communal passivity is subverted. The traditional stories "have a tranquilizing effect, repeatedly validating the notion of a spectator democracy and instilling a fantasy of Edenic resolution enacted by superhero redeemers."[288] In such a context, the superhero genre itself becomes "a medium for disempowering ordinary people."[289] Berger contends that with Marvel, however, we have rejected this old model in exchange for a new sense of responsibility. Even the diminished power of these heroes corresponds with a renewed sense of confidence in our own abilities.[290] The conclusion, as Lee readily admits, is that all of us, not just our heroes or governments, are responsible for the promotion of justice and the wellbeing of others.[291]

Fourthly, if this is the case, it calls into question the ontology of violence in which superhero comics and American mythology at large have been steeped. Of course, Marvel heroes still resolve most of their conflicts through violence, as is evident with any cursory reading.[292] However, when it comes to real social problems, Marvel consistently endorses nonviolent solutions.[293] Moreover, by questioning heroic and governmental intervention, they challenge the ideology of power as dominance. This "is a remarkable development for the superhero comic book," say Max and Joey Skidmore. "Mere physical force no longer is able to settle issues and insure that good triumphs over evil."[294]

Finally, Stan Lee did something in comicbook culture that had not yet been done on any consistent level: he introduced the category of sin into the genre. Certainly there was recognition of evil in the Golden Age comics, but for the most part this was limited to damage to private property, as we saw. There was also crime against persons or groups, but this was defined simply over against contemporary cultural mores. Even the frailties and failures of Marvel heroes can be chalked up to their unique personalities and situatedness in the real world. As important as this is, we are still only dealing with the categories of difference and finitude, but this is not sin.

286. Lee, *Conversations*, 168–169. See also Garrett, *Holy Superheroes*, 31.
287. Trushell, "American Dreams," 156.
288. Coogan, *Superhero*, 236. See also Lawrence and Jewett, *Myth*, 24, 349.
289. Coogan, *Superhero*, 238.
290. Berger, "Comics," 173.
291. Lee, *Conversations*, 198. See also ibid., 35 and Lee and Mair, *Excelsior*, 150, for more on Lee's personal views.
292. See Lang and Trimble, "Man of Tomorrow," 166. Lee rationalizes this by making two distinctions: between action and violence (Lee, *Conversations*, 191) and between entertainment and real life (Lee, *Conversations*, 26, 53).
293. Costello, *Crisis*, 124; Bradford Wright, *Nation*, 235.
294. Skidmore and Skidmore, "Fantasy," 88–89.

What Lee did was to go a step further and suggest in profound yet often subtle ways that human behavior can be morally right or wrong in a cosmic sense and does not go without consequence. We are capable of thoughts, words, and actions that are not merely mean or unhealthy, but utterly immoral, metaphysically disjointed. At the same time, there is hope because we are also capable of great love and sacrifice, of coming together and putting an end to the atrocities, oppressions, and exclusions that express our fear of the unknown other. Hence some scholars opine that Marvel, like many ancient philosophers, believes that justice will prevail because "it is built into the fabric of things."[295] This longing, for Lee and Marvel, may not be theologically articulable, but it is a theological hope.

SUMMARY

The Marvel comics of the Silver Age, although in many ways still reflective of American monomythic ideology, nevertheless began to offer a viable and constructive alternative to it.[296] This new model for human persons, as it is for heroes, is for us to be found in ways of being, knowing, and acting in which our quirks and flaws are accepted and tolerated; in which we are still held to accountability and responsibility; and in which the mutual love of family, friends, and neighbors consoles our primal screams and secures us against the anxiety that so often naturally comes in the face of the different and unknown. Although Stan Lee certainly could not have anticipated that his comics would be read in precisely this way, his turn to reality necessarily brought with it a "turn to relationality" and a subtle yet powerful admission that we are not meant to be alone, and that we are, in fact, not alone.

As we did in chapter two, we can again picture our discussion and show relations between the various dimensions of the alternative to monomythic anthropology offered by Marvel:

Recognition of imperfection ↔ longing for intimacy ↔ interdependence ↔ epistemic doubt ↔ wariness of unchecked progress ↔ psychological depth ↔ moral ambiguity ↔ anti-establishmentarian tendencies ↔ accountability ↔ respect for differences ↔ responsibility to others

We now turn to a consideration of the ways in which the Marvel superhero movies of the last fifteen years have both continued the revolutionary insights of Stan Lee and paralleled the philosophical and theological positions of our key thinkers; and, just therein, have also worked to subvert the American monomythic picture of human nature we have been challenging.

295. Taliaferro and Lindahl-Urben, "Power and Glory," 65.
296. Lang and Trimble ("Man of Tomorrow," 169–170) mention explicitly that Lawrence and Jewett fail to see either that myth systems shift along with the culture or that Marvel in particular began to bring an evolution to the superhero.

5 Subverting the Anthropology of the American Monomyth in Marvel Comics Superhero Films (1998–2012)

INTRODUCTION

In this final chapter, we explore the several Marvel movies that have been given wide theatrical release since 1998 as part of their current era of film adaptation. Structurally, we will consider each film or set of films individually (and basically in chronological order of release) as a case study of the convictions and innovations of Stan Lee and his Marvel colleagues and heirs, bearing in mind as well the insights of the theologians discussed in chapter 3, before turning to a final conclusion of constructive anthropological proposals.[1]

In the belief that human life is not so easily separated into discernible moments of being, knowing, and acting, here we break with our three-part heuristic and attend to the films chiefly through consideration of heroic journeys; that is, both through what is actually happening to and with the characters, and in the larger implied consequences of these events. For the sake of space, I will attempt to guide the reader to the most salient points of the narratives that both subvert the American monomythic formula and offer promising points of contact with the convictions of our theologians. As such, it would be of great benefit to view the films before reading the relevant section below. It also means that many of the elements we have discussed throughout the book will be given short shrift, such as villains, violence, and social justice. Moreover, film technical and artistic considerations will fall by the wayside. Indeed, only a handful of these movies have achieved critical acclaim.[2] This point should not blind us, however, to the

1. *The Avengers* (dir. Joss Whedon, 2012) is discussed in parts within the sections where the four main heroes are featured.
2. It should also be noted, though, that the dominant opinion among critics, scholars, filmmakers, and comics writers is that the movies under discussion show either faithful imaginings of their printed progenitors or else valid reinterpretations of them. As far as Stan Lee's thoughts on the matter, a harsh word can hardly, if at all, be found, and in fact his positive comments on the Marvel films abound. See his interview in Leo Partible, "Ordinary Superhero Stan Lee," *Risen Magazine*, July/August/September 2007, 46.

genuine turn taken in the superhero genre exemplified in these cinematic stories, whether seen in slight bends or full revolutions.

We can articulate the centrality of narrative another way by asking what we mean by relational ontology, epistemology, and ethics in the first place. We mean here whatever it is that in these films *happens to* Johnny Storm, Susan Storm, Johnny Blaze, Peter Parker, Wolverine, Storm, Blade, Matt Murdock, Elektra, Ben Grimm, Frank Castle, Bruce Banner, Tony Stark, Thor, and Steve Rogers. For we will indeed see that for all of these heroes, and for many others in their lives as well, what is going on at the end of the journey is not what was going on at the beginning. The greater the difference between end and beginning, the greater the films break with their monomythic heritage and plunge into the vulnerability of relationality—with themselves, with others, and, in some cases explicitly, with the Infinite.

BLADE

Blade (born Eric Brooks) is a vampire hunter, created by writer Marv Wolfman and artist Gene Colan, who first appeared in *Tomb of Dracula* #10 (July 1973).[3] With regard to the three films (all starring Wesley Snipes as the titular hero), we need to direct our attention principally to his subtle shift from aloneness and callousness to community and responsibility.

Several people have commented that in the first movie, *Blade* (dir. Stephen Norrington, 1998), he is an isolated individual who is both "filled with self-loathing and motivated by hatred for those who made him."[4] Screenwriter David Goyer credits this animosity toward vampires to the death of his mother, which follows the comics and is shown in the opening scene. In a line cut from the theatrical release, Blade tells Dr. Karen Jenson (N'Bushe Wright) that he actually remembers "being cut from his mother's womb."[5] Quite opposite from the misogynistic, nearly matricidal traditional male hero that Keller critiques,[6] then, Blade's solitude is a result of pain from being ripped away from his mother and thrown into a world of violence. Far from hiding his feelings "beneath a macho façade," as critic

3. His creation was part of the 1970s black superhero craze, but, like others, he was too often mired in the stereotyped ideas of blackness of the time, according to Terrence R. Wandtke, "Introduction," 10. See also David Hughes, *Comic Book Movies* (London: Virgin, 2003), 159. Although Blade is the only black hero to headline any of our films, Wesley Snipes suggests that his blackness is a rather moot point here. David Goyer and Wesley Snipes, "Commentaries," *Blade,* directed by Stephen Norrington (New Line Home Entertainment, 2001), DVD.
4. David Hughes, *Comic Book Movies,* 158. See also David Goyer and Guillermo Del Toro, "Commentaries," disc 1, *Blade II,* directed by Guillermo del Toro (New Line Home Entertainment, 2002), DVD.
5. David Goyer, "Commentaries," *Blade.*
6. Keller, *Broken Web,* 201, 209; Keller, "Trace," 212, 214.

James Berardinelli views him,[7] his stoic demeanor is better understood as psychological protection from a society he simply does not trust. Roger Ebert is then closer to the mark when he observes that "Snipes . . . makes an effective Blade because he knows that the key ingredient in any interesting superhero is not omnipotence, but vulnerability. . . . By embodying those feelings, Snipes as Blade gives the movie that edge of emotion without which it would simply be special effects."[8] That this vulnerability or "edge of emotion"—played so close to the chest by Snipes—comes as a clear result of separation anxiety is remarkable, especially for a character as dark and gritty as Blade. With him, the first chip of the invincible monomythic hero breaks away.

Blade's restrained affectivity can also be seen in his closeness to his mentor Whistler (Kris Kristofferson) and in his developing connection to Karen. In an important scene, she comes to speak to him while he is sitting alone in his room.

KAREN. Whistler told me what happened. He told me what you are.

BLADE. You don't know me. You don't know anything about me. I'm not human.

KAREN. You look human to me.

BLADE. Humans don't drink blood.

KAREN. That was a long time ago. Maybe you should let that go.

We should notice Karen's attempt to literally re-identify Blade as human instead of vampire. In the mythos of the films, this distinction is not merely a genetic one, but is, more importantly, a moral one. Like many Marvel villains, the chief one here, Deacon Frost (Stephen Dorff), continually boasts of his own group as being superior to humans, as sort of Nietzschean supermen beyond good and evil. Most of the Marvel film antagonists, in fact, see humans as little more than pests to be stepped on, as peons to be ruled, or, in the case of vampires, as food. In the Blade series, contrarily, as Karen implies, to be human is to be in touch with one's emotions and to seek goodness and redemption from one's past sins. For Blade, this means letting go both of hatred over the death of his mother and guilt over his own murderous actions as a vampire.

In *Blade II* (dir. Guillermo del Toro, 2002), we see once again the closeness between Blade and a potential romantic partner who facilitates his

7. James Berardinelli, review of *Blade,* Reelviews, accessed April 17, 2010, http://www.reelviews.net/php_review_template.php?identifier=1442.

8. Roger Ebert, review of *Blade,* rogerebert.com, accessed April 17, 2010, http://rogerebert.suntimes.com/apps/pbcs.dll/article?AID=/19980821/REVIEWS/808210301.

turn to others, this time the vampire Nyssa (Leonor Varela).[9] Their growing chemistry comes to fruition not in an act of intercourse but in a still rather sexual scene in which Blade lets her drink blood from his wrist after she is wounded in an ambush toward the middle of the film. Producer Peter Frankfurt mentions that this is their "love scene"; del Toro adds that they did not have a more traditional one only because he did not feel their relationship justified it.[10] Nevertheless, their encounter becomes quite poignant when we consider Blade's selfless vulnerability, a fact noticed even by the villain Nomak (Luke Goss), who watches the event from a distance, silent and befuddled, "fascinated by Blade's capacity to sacrifice himself."[11]

This is even more indicative of Blade's growth when we juxtapose it with the scene at the end of the first film when Blade drinks blood from Karen in order to restore himself. Although Karen has tried to reach him throughout the film, his actions toward her are consistently harsh and culminate in what some see as essentially a rape scene.[12] By the second film, Blade is beginning to let go of his hatred over his mother and to learn that not all people are dangerous. He is in a place to offer himself to a woman he cares about, even if she is a vampire. In the end, Nyssa dies in Blade's arms as the sun rises. Although he does not weep, the mood and posture clearly show a man who has simply had to get used to great loss; to accept it with dignity instead of lashing out in revenge or even against those who want to help him.

Blade: Trinity (dir. David Goyer, 2004) is the most antimonomythic of the three films, principally because Blade is now made to address his isolation and consider his need of others more robustly. Early on, Whistler uncharacteristically opens up to Blade regarding the attention they are getting from both vampires and human authorities: "You're like a son to me. I'm sorry I got old on you. I see you alone, surrounded by enemies, and it breaks my heart. We can't win this war alone."

Although in many respects Blade still fits the pattern of the loner male hero, it is interesting to consider that the advent of his partners Abigail (Jessica Biel) and King (Ryan Reynolds) into his life happens after his aloneness is established as an unfortunate reality. The attitude of Whistler suggests that it is not simply that Blade needs help because he is outnumbered by many foes, but also and arguably even more importantly because he is in all respects solitary and alone, and just so to be pitied.

This becomes most pronounced in the relationship between Blade and Abigail. Biel observes that Abigail, like Blade, is also a character closed off from her emotions, but one who sees Blade "as a replacement father because

9. In this film Blade allies with vampires against a more dangerous foe, which allows us a glimpse into vampire society as well as the opportunity to see vampires as more complex and ambiguous figures.
10. Guillermo del Toro and Peter Frankfurt, "Commentaries," *Blade II.*
11. Del Toro, "Commentaries," *Blade II.*
12. E.g., Jonathan Gayles, "Black Macho and the Myth of the Superwoman Redux: Masculinity and Misogyny in Blade," *The Journal of Popular Culture* 45, no. 2 (2012): 291.

he's been such a factor in her life."[13] When they find one of her close friends killed, it is Abigail who experiences the gutwrenching pain of death and bears her open wounds, as Blade had done in the first film in a different way. Now, although no less reserved, he is in the role of consoler.

David Goyer, who both wrote and directed the third installment, says that he tried to bookend the three movies. In the first one, Blade has to deal with loss and is emotionally distant, and Karen helps him. In the third movie he has moved on and is at a different place in his journey, but Abigail is where he was in the first film, "trying to find someone to love,"[14] or, just as surely, to be loved by. Blade moves into the role of counselor for Abigail when she has shut down, thus coming full circle. We should consider as well the different roles each woman plays in the three films. Karen is shown to remind him of his mother in the first one; Nyssa is much more of a romantic interest; and, by the end, Abigail is something of a surrogate daughter.

The turn to relationality for Blade is marked, then, not only by a need for others, but also by growing into a place where he himself is needed. In the context of the final film, this latter fact is arguably the one most acknowledged by Blade himself, who only stubbornly accepts the help of his new allies. He realizes, though, that Abigail is a person in pain, and rather than treat her like the solitary figure he pretends to be, his compassion for her, no doubt partly born from his own past, cannot be ignored or suppressed.

THE X-MEN AND WOLVERINE

The X-Men were created by Stan Lee and Jack Kirby and first appeared in *X-Men* #1 (September 1963). The original group consisted of Professor Charles Xavier and five teenagers who were born with special mutations and whom he took under his wing as students: Cyclops, Iceman, Angel, Beast, and Marvel Girl/Jean Grey.[15] When the series was revamped and rebooted in 1975, several other mutants were added to the ranks, including many who appear in the films. Among them was Wolverine, born James Howlett around the turn of the twentieth century. Created by Len Wein and John Romita, Sr., he first appeared in *Incredible Hulk* #180 (October 1974) before joining the X-Men.[16] Since anthropological themes in the X-Men films could take up an entire book on their own, we will address some of the most significant ones by exploring the stories of Storm, Jean Grey, and Wolverine before stepping back to briefly consider more abstractly how the films handle the notions of difference, tolerance, and acceptance, which have been at the heart of the series since its inception in the comics.

13. Jessica Biel, "Special Features," disc 2, *Blade: Trinity*, unrated version DVD, directed by David Goyer (New Line Home Entertainment, 2004).
14. David Goyer, "Commentaries," disc 1, *Blade: Trinity*.
15. Marvel Comics, *The Marvel Encyclopedia*, rev. ed. (New York: DK Publishing, 2009), 378ff.
16. *Marvel Encyclopedia*, 368.

Ororo Munroe/Storm was introduced by Len Wein and Dave Cockrum in 1975 as an African goddess, although in the films her origin is not explored. In the first film, *X-Men* (dir. Bryan Singer, 2000), Storm is shown early on as an integral part of the team and a competent teacher to the students at Xavier's school. She is also in an important position of leadership, just behind Scott Summers/Cyclops (James Marsden) and Xavier (Patrick Stewart) himself. Rebecca Housel rightly offers that Storm "is her own person . . . not the center of a traditional, patriarchal heterosexual matrix."[17]

A key way in which this departure from patriarchy comes to expression for Storm is in her openness to diversity. In *X2: X-Men United* (dir. Bryan Singer, 2003), Housel suggests that she is drawn to the blue-skinned Kurt Wagner/Nightcrawler (Alan Cumming) precisely because he is so utterly different. "This strangeness that strikes fear into the hearts of most people . . . is here presented as the bridge it is capable of being in an individual's trajectory of learning and personal growth."[18] Storm's interest in him demonstrates a healthy willingness to move beyond her range of past experience. This fact itself is significant, because he is not only physically unusual, but approaches the world differently philosophically as well, being a devout Catholic.

Shortly after finding him, Storm asks about the symbols he has etched on his body, which he tells her are angelic. He continues:

NIGHTCRAWLER. You know, outside of the circus, most people were afraid of me. But I didn't hate them. I pitied them. Do you know why? . . . because most people will never know anything beyond what they see with their own two eyes.

STORM. Well, I gave up on pity a long time ago.

NIGHTCRAWLER. Someone so beautiful should not be so angry.

STORM. Sometimes anger can help you survive.

NIGHTCRAWLER. So can faith.

This encounter shows that Storm is a whole and complex person along the lines advanced by Ruether, not a woman molded to gender expectations.[19] She is not simply a sweet, caring woman who naively sees the best in things and just takes care of people; neither is she a villainess or wayward woman in need of masculine salvation. She is imperfect, but, like all of us, capable of being challenged. Nightcrawler's own faith in God and his regard for people who fear him helps to teach her that her one-sided disposition of anger toward the world is not the only option. By the end of *X2*, Singer comments,

17. Rebecca Housel, "Myth," 78.
18. Ibid., 79.
19. See ibid., 80–81.

Nightcrawler has inspired in her the faith she needs to save humans from the machinations of Magneto (Ian McKellen).[20]

In the third movie, *X-Men: The Last Stand* (dir. Brett Ratner, 2006), Storm becomes second in command to Xavier early in the film when Scott is killed, and takes over the school altogether when Xavier is killed. Although she does not get as much screen time as we would like due to all the different subplots and characters, it is significant that even in the midst of the tragedy she is not overwhelmed by the emotion and responsibility of it all, as often happens with fictional women in power. Neither does she go the way of the loner hero and assume a stoic façade of emotional impenetrability. Instead, she takes on the role of leader with dedication and strength, and recognizes both a need for others and the gravity of their situation against Magneto on one side and the mutant "cure" on the other. She is a realistic and emulable depiction not only of a woman in light of being in relation, but of anyone.

The second important female character in the films is Jean Grey (Famke Janssen), whose path unfortunately repeats the problematic trope that Storm's avoided, but which is often associated with the feminine mythologically: the woman with power becomes unstable. Housel is helpful again here. She notes that in the comics, Jean is loyal and intelligent but lacks self-confidence and is overly dependent on the men in her life.[21] In the first film, this timidity is seen in the loss of her audience at the hearing with Senator Kelly (Bruce Davison), who challenges mutant rights in a way to which Jean is not able to respond. In *X2*, she is still taking guidance from the men around her, but starts to evolve toward greater assertiveness, seen sporadically at different points throughout the film.[22]

At the climax of *X2*, Jean takes her boldest step yet when she sacrifices herself to hold back the water so the others can escape. Citing John 15:13 explicitly, Housel suggests that laying one's life down for one's friends "is not the privilege of a man alone. . . . This could be a modern mythic presentation of the ultimately transformative power of love."[23] While people like Stryker (Brian Cox) and Magneto are satisfied to build a world to their own liking with the deaths of others, Roz Kaveney concurs, Jean "is prepared to sacrifice herself."[24] To this extent, Jean also subverts the monomythic set of expectations for women, but in a different way than Storm does. Moreover, this choice is not thrust upon her from the outside like many of her other actions are by the men in her life. It is rather a decision of love for those with whom she has found a home and belonging.

20. Bryan Singer, "Commentaries," *X2: X-Men United*, directed by Bryan Singer (Beverly Hills: Twentieth Century Fox Home Entertainment, 2003), DVD.
21. Housel, "Myth," 83.
22. Ibid., 84.
23. Ibid., 86.
24. Kaveney, *Superheroes*, 260.

In the third film, *X-Men: The Last Stand,* all that had been built up with Jean falls apart. In a storyline taken from the comics, Jean is basically resurrected but with a dual personality similar to that of Jekyll and Hyde and the Hulk. On the one hand, she is the sweet but unconfident Jean we have known in most of the first two films; on the other hand she has released a Dark Phoenix force of incredibly destructive unconscious power. What follows is "unalloyedly [a] parable about women not being able to handle power that the comics version arguably to some extent avoided being."[25]

Shortly after she returns, Xavier tells Logan/Wolverine (Hugh Jackman) that Jean's greater powers are in her unconscious because he has created "psychic barriers" to keep her under control. Logan questions the ethics of treating someone like this, but Xavier says he picked the lesser of two evils, the greater apparently being that, with too much power, Jean would necessarily use it for destructive ends. That these are the only two paths for Jean is an assumption on Xavier's part and a false alternative set before us by the film. Could it not also have been the case that Jean's upbringing within a community of acceptance such as Xavier's school would influence her to use her incredible abilities for good? Certainly our theologians see the real effects of a loving family in this way. In the film, unfortunately, this option is not offered. At the end, then, instead of Jean realizing what she has done or harnessing her powers to benefit others, the decision was made that the only way to stop her was to kill her.

With regard to Wolverine, however, the films are more promising. Les Daniels sets the stage for us perfectly in his description of the character from the comics, which clearly describes that in the films as well. "In essence, Wolverine fits the pattern of the archetypal hero who appears out of nowhere, performs deeds nobody else would dare attempt, and yet by the very nature of those deeds is denied total integration into the community he serves."[26] Such is almost identical to the monomythic hero pattern as defined by Lawrence and Jewett, and it is where we find Wolverine by the beginning of the first X-Men film. We start, however, with the prequel which tells his backstory, *X-Men Origins: Wolverine* (dir. Gavin Hood, 2009).

As with Blade, the question of identity is key for Wolverine. His name itself suggests ambiguity: is he human or animal? The four films present not a genetic difference this time, but a strictly moral and philosophical one. To be an animal here is to be without emotion, to act on instinct, and to do what Wolverine does best, kill, without regard for intimacy, mercy, responsibility, or compassion. To be human, on the contrary, is to be emotional, to need human connection and love, to be thoughtful of one's actions, and to experience the full range of human life.

At the beginning of *Wolverine,* we see Logan (again Jackman) and his brother Victor (Liev Schreiber) sharing life together as runaways, fighting

25. Ibid., 261.
26. Daniels, *Marvel,* 191.

side by side over the decades in a series of wars and ending up in an elite U.S. military unit with other mutants, led by a younger William Stryker (Danny Huston). When innocent people are about to be slaughtered by a now more violent Victor at the command of Stryker, Logan stops him and quits the team, disgusted by the merciless actions of his comrades, brother, and commander.

Years later, Logan is making a life for himself as a lumberjack in the Canadian Rockies, sharing a home with Kayla (Lynn Collins). His old life catches up when Stryker pays him a visit, after which Kayla inquires about why Stryker wants him back. In a famous line from the comics, Logan responds, "Because I'm the best at what I do, and what I do best isn't very nice." In opposition, Kayla affirms what would become Logan's lifelong struggle: "You're not an animal, Logan. What you have is a gift."

When Logan believes Kayla to be dead at the hands of Victor, he agrees to go back to Stryker and have his bones grafted with indestructible adamantium so that he can pursue revenge. In losing Kayla, Hood comments, he not only lost a person, "he lost a future."[27] A different future is offered by Stryker, who tells him, "We're going to make you indestructible, but first we're going to have to destroy you," adding that in order to kill Victor, he will have to "become the animal." For this new life, Logan asks for new dog tags, thus the moniker Wolverine, taken from a story Kayla had told him.

The question of Logan's identity is raised again when he is about to kill Victor. Kayla, whose earlier death was staged, yells, "Logan! You're not an animal." Victor counters, "Oh, yes you are. Do it. Finish it." Logan relents and lets him live, a choice that serves him well when Victor reappears to aid Logan in the final combat against one of Stryker's engineered soldiers. At the very end, Stryker shoots Logan in the head with an adamantium bullet, which does not kill him but erases his memory.

This is where we find him in *X-Men*: a lost past, faint and scattered memories, dog tags with the name Wolverine the only shred of his former life.[28] Back in the Canadian Rockies, his independent and isolated world is shattered when he meets Rogue (Anna Paquin), who clandestinely hitches a ride in the back of his truck. Reluctantly the victim of some deep sense of compassion, he cannot make himself abandon her when he discovers her presence. When they are rescued from Sabretooth, they are taken to Xavier's school for the first time.

Being a powerful telepath, Xavier is able to read something of the hidden thoughts and memories in Logan. When he tells him that he is not as alone as he thinks, he "wants Wolverine to believe that there are people he can

27. Gavin Hood, "Commentaries," disc 1, *X-Men Origins: Wolverine,* special ed. DVD, directed by Gavin Hood (Beverly Hills: Twentieth Century Fox Home Entertainment, 2009).
28. That he retains the name Logan throughout seems to be a matter of inconsistency between the two sets of films.

trust and depend on."[29] Logan has become fearful of others at this point, having lived for several years on his own with no memory of his past. For this reason, he is incredibly slow at trusting the other mutants.

The long process of letting down his guard is facilitated in this film by his brotherly relationship with Rogue. When she herself runs away out of shame and fear of rejection, Logan finds her, gently puts his arm around her, and tells her in a rather revelatory sentiment, "There's not many people that'll understand what you're going through, but I think this guy Xavier's one of them. He seems to genuinely want to help you and that's a rare thing for people like us." In this encounter lies Logan's new hope. He cannot escape the tenderness and affection of a girl who shares his own sense of alienation, who has not learned to suppress the deep desire for belonging over years of callous encounters, and who genuinely needs him.

At the end of the film, Logan touches Rogue in order to heal her, knowing that it will cost him his own strength and life energy, possibly unto death. At this point, the isolated loner Wolverine has found someone unexpectedly lovable and acts accordingly. His macho façade of untouchable, monomythic virility has been exposed as a fraud of self-protection, replaced now by self-giving vulnerability. Indeed, "he sacrifices his own good because he has such strong faith in Rogue's goodness and preciousness."[30]

Although Logan's heart is starting to change, he is still not committed fully to Xavier and his team. At the end of the first movie, he leaves to explore what happened before the loss of his memory. His first appearance in *X2* is at the military facility at Alkali Lake, where he begins to have flashbacks about the procedure done to him there. Upon returning to the Xavier School, his priority is to get Xavier to help him recover his memories, something Xavier insists must come naturally in time. While Logan's heart has begun to open, his next challenge is to let go of his past.

At the end of the movie, Logan confronts Stryker about the experimentations on him. "Who am I?" he demands. Stryker answers, "You are just a failed experiment. . . . People don't change, Wolverine. You were an animal then. You're an animal now. I just gave you claws." Notice again the dichotomy between human and animal, which we saw in the *Wolverine* film. He then tells Logan to abandon his friends and come with him. A little while later, when Logan is about to leave with the others holding one of the rescued mutant children in his arms, Stryker asks, "Who has the answers, Wolverine? Those people? That creature in your arms?" In a moving and symbolic gesture, Logan rips off his Wolverine dog tags and throws them on the ground, responding, "I'll take my chances with him." Singer observes that here Logan is finally severing his ties to his past and his need for Stryker.[31]

29. Katherine E. Kirby, "War and Peace, Power and Faith," in *X-Men and Philosophy*, 219.
30. Ibid., 220.
31. Singer, "Commentaries," *X2*.

This is even more significant when we consider it in light of the openness of the future in the thought of Keller and Shults. For them, to live in genuine relation with both God and others is to be no longer bound by the determinations of the past, but to live in light of the unexpectedness of that which is coming. It is, in short, to really hope, which for both thinkers is deeply connected to beauty, for the sharing of love with uncontrollable others is truly breathtaking. So, whereas Rogue opened his heart to love and goodness, Logan's rejection of Stryker facilitated his turn to hope and beauty. Even the words, "I'll take my chances with him," suggest this, for Logan acknowledges that he does not know how his new life will turn out, but is willing to take the necessary risks anyway.

In the final film, Logan does not have a crisis so much over identity as over commitment. When Jean comes back as Dark Phoenix and joins Magneto, he leaves the mansion yet again to go find her. In an important scene demonstrating also Storm's strength as a leader, she confronts Logan as he is packing. She reminds him that Jean killed Xavier, but Logan insists that she is still good deep inside and that he cannot let her go, because, Storm concludes, he loves her. She continues, "She made her choice. Now it's time we make ours. So if you're with us, then be with us."

Logan persists in leaving, only to come back some time later when he does not succeed at changing Jean. Finally committed to the team at the end, Logan gives a pep talk to the other mutants before they go to face Magneto. Speaking of Xavier and Scott, he urges, "If we don't fight now everything they stood for will die with them. I'm not gonna let that happen. Are you? Then we stand together. X-Men, all of us." In the climax, his loyalty is tested when Jean is destroying nearly everyone in sight, humans and mutants alike. Because of his adamantium frame, he is the only one who can stop her. They have some parting words and he stabs her, letting go of that heartbreaking phase of his life. Although Jean's death is problematic in a number of ways, it signifies yet another sacrifice Logan is now willing to make for his friends and what he perceives as the greater good. His very last scene takes place at the mansion after Xavier's funeral when students are returning to school. He steps outside with a hopeful look and stands on one of the balconies as the camera pans out, then up. He is home at last.

Finally, the X-Men films persistently raise the issues of prejudice, intolerance, acceptance, and difference. The comics were already a parable condemning sundry forms of bigotry, something that carried over into the films in a unique way. Whereas other Marvel movies agree with this philosophy, only the X-Men series has as its entire structure the "mutant problem" and the complexities involved with it, which is why we have decided to address these topics here.

The films are remarkable in highlighting the two negative ways by which difference is approached. One of them is destruction of the other. This is the goal of Stryker in *X2*, of both the Soviet and American military at the end of *X-Men: First Class* (dir. Matthew Vaughn, 2011), and, more implicitly, of

Senator Kelly in *X-Men,* who pushes for mutant registration so that humans will be aware of the abilities and identities of mutants. Notice fear of the unknown at work here. If the authorities can know what they are dealing with, they will have more control and, therefore, be less anxious about the mutant presence. The unspoken in such a situation, though, is the intent to remove those whose presence might pose a threat to humans.[32]

The other negative approach is assimilation. In the first film, Magneto's goal is to make all humans into mutants. In the second and third films, especially, humans are shown to want the same thing. "Have you ever tried *not* being a mutant?" is the question posed to one of Xavier's students in *X2.* For oppressed persons who take this route, the challenge is to "pass" as one of the dominant group by suppressing as much as possible any characteristics which would suggest that one is a mutant, or, so history has gone, gay, black, female, and so on.[33]

This theme is central to *First Class,* especially as it defines the personal struggle of Raven/Mystique (Jennifer Lawrence), who has natural blue skin but who can also change her appearance at will. Even mutants are not agreed on the right course of action, as the question of "passing" is brought up explicitly and creates a tension between those whose mutations are physical and visible, such as Raven's, and those whose are purely mental, such as the naïve and culturally accommodating Charles Xavier (James McAvoy). For the latter, passing as "normal" is not immediately relevant, because they look just like other people. Indeed, Xavier's inability to really empathize with Raven and his discouragement of her revelation as a mutant to the larger world contributes to her ultimately joining Magneto (Michael Fassbender) and his group of more courageous, if ill-willed, mutants.

Cone and Merton are helpful here. For them, as we saw, both destruction and assimilation serve only to deprive minorities of their humanity because both options presuppose that the dominant group is the normal or standard. They suggest instead that the oppressed must affirm their identities by a different reality; in this case, one that is uniquely mutant and not defined by the majority of humans. Yet, in the X-Men universe, the right course is not always so clearly defined, although we can certainly agree with Cone and Merton against forced extermination or assimilation. When it comes to the idea of a "cure" for mutants, most of them are critical of anyone who would volunteer to take it and be rid of their mutant trait. If we read the films as strictly about being black or gay or disabled, we are inclined to agree with Storm's sentiment that there is simply nothing to cure. However, if we read the films on a literal level, we must bear in mind that there is incredible diversity among mutants themselves. The fact that they are more or less forced to work together against shared oppression is *itself* oppressive,

32. See Kirby, "War and Peace," 211..
33. Patrick D. Hopkins, "The Lure of the Normal: Who *Wouldn't Want* to Be a Mutant?" in *X-Men and Philosophy,* 8.

a denial of the vast differences in mutation and of those who have them. Patrick Hopkins may be correct, moreover, that the negative stance toward the "cure" is more easily taken by those who can pass than by those who cannot, since the latter will certainly face more volatile social consequences, at least to the extent that they wish to remain a part of larger society.[34]

In this light, we are much more sympathetic to Rogue, who sees in the new treatment or "cure" in *The Last Stand* a way out of her physical isolation, for she cannot touch anyone without draining their life. Although controversial, a number of writers have agreed with the decision to have Rogue desire the suppression of her mutation, not out of any bigotry, but because of the connective and essential importance of touch, something in which Rogue is hindered. "Imagine a life without touch," Housel implores. "Because of Rogue's limitations, she is isolated and lonely and desperately wants to feel someone's touch."[35] J. Jeremy Wisnewski is even more explicitly anthropological: "Consider this: young human children can actually die from lack of physical contact with other persons. . . . To live Rogue's life is to live a life that is in many ways *not human*."[36]

Rogue's story is an example of the complexity and ambiguity of being an oppressed minority. Not all such persons agree on the best course of action, on the use of violence, on the matter of assimilation, or, arguably in the unique case of mutants, on whether that which makes them different genuinely fosters their wellbeing. On these points, the X-Men series of films ought to be applauded at least for not evading their significance, despite how we may assess their implied conclusions.

Yet the question remains, what is it to be really human? The position that physical contact is not only good for but *constitutive of* humanity is only part of the larger philosophical claim in the Marvel films that we find our beings and identities in relation, specifically in embodied relationships of love, faithfulness, tenderness, acceptance, understanding, sacrifice, hope, responsibility, and mutuality. Several other heroic journeys illustrate the same lessons.

SPIDER-MAN

Peter Parker/Spider-Man is usually considered Marvel's flagship hero and was created by Stan Lee and Steve Ditko for *Amazing Fantasy* #15 (August 1962). The four recent films based on the hero, as well as the essays and reviews commenting upon them, offer an enormous amount of material with regard to our project. For the sake of space, we will concentrate on

34. Ibid., 10.
35. Housel, "X-Women," 94.
36. J. Jeremy Wisnewski, "Mutant Phenomenology," in *X-Men and Philosophy*, 203. Emphasis in original. See also Hopkins, "Lure," 11.

three phenomena: Peter's interrelated dilemmas over ethics and identity, the villains and Peter's relationships with them, and Peter's relationship with his key love interest Mary Jane Watson (or MJ).[37]

The first film, *Spider-Man* (dir. Sam Raimi, 2002), follows closely the origin story of Lee's comicbook version, with one peculiar variation added by Raimi. The "quirk in the story structure," according to Robert Taylor, is that the wrestling promoter jilts Peter, whereas in the comics this is not shown to be the case.[38] In the latter, it is strictly Peter's selfishness that gets in the way; in the former it is his felt right to get back at a man who has wronged him. For Taylor, the filmic version thus takes away the element of guilt, since anyone would have done the same thing. However, that Raimi still judges Peter's action as wrong puts us in a different moral universe and raises the standard of expected behavior: it demands that we love our enemies and not respond to the misdeeds of others with revenge. Hence, Taylor's sense that Peter should not feel guilty is not a logical conclusion but an ethical judgment, one far inferior to that which Raimi has set before us.

It is no surprise, then, that the Spider-Man films present the most human and understandable villains in the Marvel movie corpus. In the first, Peter's best friend Harry's father Norman Osborn (Willem Dafoe) becomes his nemesis after he inhales an experimental formula produced by his company. It results in superhuman strength as well as a psychotic split personality for Norman, the violent face of which is dubbed the Green Goblin.

He is also considered by many to be a surrogate father for Peter, demonstrated in a number of scenes in which their mutual respect is displayed, particularly related to their shared love of science.[39] Dafoe suggests that Norman actually prefers Peter to Harry (James Franco),[40] which is in various places evident in the film, especially in moments where Norman's disappointment in Harry is expressed. When Norman discovers Peter's heroic identity, Raimi even says that he "feels terribly betrayed."[41] In their final battle, Goblin is unmasked and tries to lure Peter close by playing on his filial feelings.

Arguably Peter's most significant relationship, though, is with MJ (Kirsten Dunst) Throughout the first movie, he maintains for the most part a watchful, pining distance, unwilling to express his feelings to her. Nevertheless, they do have some tender, intimate moments in which they share their hearts with each other, helping to establish both that she is just as anxious as Peter

37. The latest film, *The Amazing Spider-Man* (dir. Marc Webb, 2012), repeats all of the themes in Sam Raimi's trilogy which are important for us, so I am not including a separate discussion thereon.
38. Robert B. Taylor, "Raimi vs. Bendis: Reimagining Spider-Man," in *Webslinger*, 41–42.
39. Willem Dafoe and Sam Raimi, "Special Features," disc 2, *Spider-Man*, special ed. DVD, directed by Sam Raimi (Culver City: Columbia TriStar Home Entertainment, 2002).
40. Dafoe, "Special Features," *Spider-Man*.
41. Raimi, "Special Features," *Spider-Man*.

about being loved, and that the Raimi trilogy is about her journey as well as his. When he saves her life from the Goblin, Dunst observes that here, the very moment MJ realizes that Peter loves her for who she is, she is freed:[42] from a past of abuse and neglect by her parents, from a hurtful history with men, and from her own felt inadequacies. Peter's sweet, indomitable desire for her is pure, because it is so genuine: he sees her not as she sees herself, but as altogether beloved. After she confesses her love for him, however, Peter takes the way of the old hero and rejects her advances for fear that she would be hurt.

In the second film, *Spider-Man 2* (dir. Sam Raimi, 2004), Peter encounters another would-be father figure in Dr. Otto Octavius (Alfred Molina), a scientist whose work Peter has read and who spends a day with him discussing different aspects of physics and romance.[43] When Otto's wife sits down with them for a few minutes, it shows Peter a glimpse of something that he could really have: an ordinary life with a regular career and a woman who loves him.[44]

This spawns in Peter what becomes his chief temptation in the film: to quit being Spider-Man for the sake of having what he perceives is a normal life.[45] His loneliness and isolation from others has been established from the beginning through his inability to really connect with his friends and the guilt that keeps him from closeness with Aunt May. We also see him struggling early on with his responsibilities at work and school, setting up the idea that it might just be better if Spider-Man were no more.

This turmoil over his identity comes to expression in a Freudian way when he begins to lose his powers right after he sees MJ kiss her new boyfriend. When he goes to see his doctor about it, he is told that a man needs to know who he is and to have a solid sense of self, suggesting that we are here dealing with a psychological issue of physically manifested unconscious anxiety. When he throws out his suit to become just Peter again, he starts pursuing MJ and also excels in class.

As in the first film, though, it is the wisdom of Aunt May that steers Peter around. When he goes to see her toward the end of the second act, he is asked by the young neighbor boy about what happened to Spider-Man. "He knows a hero when he sees one," May tells Peter. "Too few characters out there, flying around like that, saving old girls like me. And Lord knows kids

42. Mark Cotta Vaz, *Behind the Mask of Spider-Man: The Secrets of the Movie* (New York: Ballantine, 2002), 189.
43. See Kaveney, *Superheroes*, 253; Taylor, "Raimi vs. Bendis," 44.
44. As several in the commentaries point out. Avi Arad, Grant Curtis, Tobey Maguire, Sam Raimi, "Commentaries," disc 1, *Spider-Man 2*, special ed. DVD, directed by Sam Raimi (Culver City: Sony Pictures Home Entertainment, 2004); Alvin Sargent and Laura Ziskin, "Commentary," disc 1, *Spider-Man 2.1*, extended cut DVD, directed by Sam Raimi (Culver City: Sony Pictures Home Entertainment, 2007).
45. See Evans, "Superheroes," 166.

like Henry need a hero. Courageous, self-sacrificing people setting examples for all of us. Everybody loves a hero." When she concludes that the heroes in all of us help us to be noble and proud, even if it means giving up our dreams, Peter is taken aback and goes to reclaim his costume, now willing to sacrifice his own personal desires for a greater good.

In a final confrontation with Doc Ock, Peter is not strong enough to curtail the nuclear effect that is destroying the city, so he takes off his mask in order "to appeal to the man inside," Arad notes.[46] He reminds Ock that intelligence is a gift to be used for the good of mankind and that sometimes we have to give up our dreams. Ock finally realizes the error of his ways, much like Norman came to his senses after it was too late, and sacrifices himself to save the city, declaring, "I will not die a monster."

That Peter treats his opponents as human beings is an important aspect that distinguishes Marvel and Stan Lee from their predecessors, as we saw in chapter 4. It is also a strong conviction of our theologians, especially Merton, Cone, and Ruether. Several of the filmmakers notice this dynamic at the end of the second film. Raimi opines that violence is not the answer to anything, and commends the fact that Peter "awakens the goodness in others."[47] Arad says that they do not want to kill the villain, but to find the man within him so that he will take responsibility for what he has done. At Marvel, he says, there really are "no ultimate villains. Things happen, bad circumstance."[48] Producer Laura Ziskin adds that villains are not black and white, but "people gone wrong because of some other need."[49] While these sentiments in the first two films are already contrary to the ideas of absolute good and evil dominant in the American monomyth, only in the third film do they come to culmination.

After Ock is defeated, Peter returns to his apartment alone, only to be visited by MJ. When he rebuffs her again out of concern for her safety, she asserts—in rejection of his implicit patriarchy, we might add—that she can make her own decisions. "I know there will be risks, but I want to face them with you. . . . I love you. So here I am standing in your doorway. . . . Isn't it about time somebody saved *your* life?" He can no longer escape these redemptive words to his heart. "Thank you, Mary Jane Watson," he replies in resignation. Immediately after they kiss, sirens blare outside and she tells him, "Go get 'em, Tiger," granting her blessing on his role as Spider-Man.

Only now is Peter finally able to overcome the tension between desire for love on the one hand and utilitarian celibacy for the sake of his heroic duty on the other. He transcends the opposition simply by doing both, and by being supported by a woman who knows his secret and still loves him. There is a mutual respect between them for the integrity and wholeness

46. Arad, "Commentaries," *Spider-Man 2*.
47. Raimi, "Commentaries," *Spider-Man 2*.
48. Arad, "Commentaries," *Spider-Man 2*.
49. Ziskin, "Commentary," *Spider-Man 2.1*.

of the other's complex personal uniqueness, which is required for success in any real-life relationship, as Ruether recognizes and commends. Several have commented that MJ is finally challenging everything that Peter thinks about heroism,[50] and, by association, the archaic loner mentality of the old pattern. Mark Cotta Vaz describes the encounter most poetically: "It's a scene in the best movie tradition of the guy and the girl who finally find themselves with no room left to run from each other. In the sweet agony of that precious moment, with the ferocious demands of the world mercifully at bay, MJ and Peter each find the next best thing to peace."[51]

Moreover, we have here perhaps the strongest counterexample in Marvel films of the isolated male ego resistant to sexual vulnerability. At the end of the first film, Peter instantiates the fear of romantic involvement criticized by Ruether and Keller in chapter 3. Even if this was not out of disdain for MJ, the effect was the same. Now, however, after a long and difficult period of realizing how important MJ is to him, and after she herself stands up to his patronizing attempts to keep her from harm, he is finally willing to risk his heart on her, in complete opposition to the hypermasculinity of the monomyth.

In the third film, *Spider-Man 3* (dir. Sam Raimi, 2007), Peter's guilt comes back in full force when the police tell him that the man they originally thought had killed Uncle Ben was only an accomplice. The real killer, they discovered, is Flint Marko (Thomas Haden Church), a recently escaped convict. In great Marvel fashion and in contrast to Peter's assumptions, Marko is then shown sneaking into his house to see his daughter, for whose surgery he had stolen money in desperation. "I'm not a bad person. Just had bad luck," he tells his wife. When the cops are on his tail, he makes his way into a giant hole of sand to hide, but is unaware that it is some kind of testing ground in which he becomes genetically altered. The scene as he arises is the most aesthetic in the film both visually and musically and echoes his own personal sadness. Stephanie Zacharek describes it well: "Eventually, a bigger-than-life creature, an anguished giant, emerges from this hill of sand. He's clutching a locket containing a photo of his little girl, and as he surveys this tiny picture, we know that he's remembering not just the man he used to be, but the man he failed to be."[52]

Peter, though, is not aware of all this, and his vision of Ben's death as a vicious assassination eats away at him and drives him into isolation once more, hurting his relationships with MJ and Aunt May. When he finally comes upon Marko, he is particularly brutal and leaves him for dead, after which he proudly proceeds to tell Aunt May that Spider-Man killed Marko.

50. E.g., Curtis, "Commentaries," *Spider-Man 2*; Kaveney, *Superheroes*, 253–254.
51. Vaz, *Behind the Mask*, 188–189.
52. Stephanie Zacharek, review of *Spider-Man 3*, Salon, accessed June 23, 2010, http://www.salon.com/entertainment/movies/review/2007/05/04/spider_man_3.

Yet she surprises him with her lack of vindictiveness. "I don't think it's for us to say whether a person deserves to live or die. . . . [Revenge is] like a poison. It can take you over. Before you know it, turn us into something ugly."

The film sets up a dialectic between revenge and forgiveness in two other pivotal scenes. In the first, Peter confronts another photographer at the newspaper offices, Eddie Brock (Topher Grace), for a bogus photo of Spider-Man that has landed Brock a coveted staff position. When Brock asks the now more belligerent Peter for a break, Peter replies, "You want forgiveness? Get religion."

The second, cinematically related, involves the growing distance between Peter and MJ. When she tries to intervene in a scuffle between Peter and a bouncer where she works toward the end of the film, he accidentally hits her and knocks her down. "Who are you?" MJ asks. "I don't know," he replies in shock. Immediately, he grasps his chest and feels convicted, then looks up to see the cross atop a church and approaches the church bell, a symbolic contrast to his earlier rebuff of religion and forgiveness.

Realizing that the black alien symbiote Venom is exacerbating his feelings of rage, Peter tries to tear it off. What transpires is an intensely spiritual scene as Peter tries literally and figuratively to rid himself of his sin, vengeance, guilt, and shame. He is next seen showering and by himself, remorseful. When May comes to visit him, Peter expresses confusion about the situation with MJ. Once again the calm voice of wisdom for Peter, May advises, "You start by doing the hardest thing, you forgive yourself."

At the end, Marko confronts Peter and finally brings this part of his journey to a close. He tells Peter what really happened: that he was desperate for money because his daughter was dying and that the gun went off in his hand accidentally. "Did a terrible thing to you and I spend a lot of nights wishing I could take it back. I'm not asking you to forgive me. I just want you to understand." With tears welling up, Peter responds, "I've done terrible things, too." Marko continues, "I didn't choose to be this. The only thing left of me now is my daughter." Then, in three words above and beyond what was asked of him, in total abolition of the entire structure of the monomyth's ethical dualism, Peter concludes: "I forgive you." The absolution is clearly shattering for Marko, who nods gently in recognition, closes his eyes, and wisps himself away peacefully in a cloud of sand. It seems to have been lost on many that this is the only time throughout these three films that a villain lives at the end.

Finally, Peter sees MJ again at the jazz club. She takes his hand and they share a dance together. Their end is left open, but the mood suggests an awareness that whatever love they may have is weathered in a new way and will never be the same, but just for all that will be inevitably more mature and genuine. Perhaps Arad's comment on an earlier scene applies here also: "Still the most important thing in their lives is friendship and trust, and then love will come."[53]

53. Avi Arad, "Commentaries," disc 1, *Spider-Man 3*, special ed. DVD, directed by Sam Raimi (Culver City: Sony Pictures Home Entertainment, 2007).

DAREDEVIL

Daredevil/Matt Murdock was created by Stan Lee and artist Bill Everett and first appeared in *Daredevil* #1 (April 1964).[54] As with Blade, Matt Murdock's story in the film *Daredevil* (dir. Mark Steven Johnson, 2003) takes the form of a journey from isolation to communion, but is much more intense because it is also a tale of redemption from moral apathy and psychological despair. That Matt (Ben Affleck) starts in a dark place is shown early on after he fails to convict an accused rapist in court. Knowing the man to be guilty, he stalks him as Daredevil to a confrontation on a subway platform, which ends with the man being run over by a train. Johnson intends us to see Matt's refusal to save the rapist as an indication that he is "losing his soul."[55] Matt is "on a collision course. He can't keep doing this much longer. He's going to need some form of salvation, whether it be through faith or whether it be through love."[56]

The next day his rescue comes in the person of Elektra (Jennifer Garner). When they kiss for the first time some days later, he hears screams and is about to leave, as per his heroic duty, but she tells him to stay. In a quite significant break with the American mythic tradition, Matt heeds her wish and they make love in his apartment; one of only two sex scenes in any of our movies here considered.[57] Johnson takes this route because he could never accept the scene at the end of *Spider-Man* when Peter denies MJ. "What are you doing?" he thought. "Stay with her. . . . Take your shot at happiness. . . . That's what a person would really do."[58] Moreover, Johnson suggests, Matt's sex with Elektra is "not about . . . banging some chick. It's about exploring each other's scars on their bodies. It's about finding someone that's like him. . . . They really are soulmates. That's the idea of the scene . . . she's like a salve for his wounds."[59]

Unfortunately, their relationship is cut short both by the death of her father and by her own death at the hands of Bullseye (Colin Farrell). Bent on revenge, Matt dispatches him and then goes to face the greater villain Kingpin (Michael Clarke Duncan). After a struggle, Matt is in a perfect spot to kill him, but he spares his life instead, telling him, "I'm not the bad guy."

54. On the following, *Marvel Encyclopedia*, 86.
55. Mark Steven Johnson, "Commentary," *Daredevil*, director's cut DVD, directed by Mark Steven Johnson (Beverly Hills: Twentieth Century Fox Home Entertainment, 2003).
56. Ibid.
57. The other comes near the beginning of *Iron Man* (dir. Jon Favreau, 2008) but is emotionally insignificant.
58. Mark Steven Johnson, "Commentary," disc 1, *Daredevil*, directed by Mark Steven Johnson (Beverly Hills: Twentieth Century Fox Home Entertainment, 2003), DVD. Notice as well Stan Lee's focus on realism illustrated in Johnson's comments.
59. Johnson, "Commentary," *Daredevil*, director's cut.

He has by this time firmly set his sights on defeating Kingpin instead in a court of law. Johnson comments that in this scene Matt has "found his way again. He's learning mercy and compassion, and he's going to try to do the right thing in the courtroom."[60]

Yet, we may be led to ask *why* Matt's attitude shifts by the end of the film. There is no evidence in the narrative to suggest that he has grown conservative ideologically or that he no longer cares for those who are bullied by criminals. Rather, it is simply because the spirit of vengeance has taken a toll on him. "What's most intriguing about this film," Julian Fielding opines, "is that . . . it questions the ethics of 'an eye for an eye; a tooth for a tooth.'"[61] Fielding also notes the words of Father Everett (Derrick O'Connor) to Matt in the confessional early in the film: "Vengeance is a sin. Violence begets violence." Not only is this sentiment a strong example of Stan Lee's ethics, but we find it in our theologians as well, especially Merton and Cone. It is precisely the psychologically debilitating and relationally inhibiting consequences of rage from which Elektra saves Matt, catalyzing the shift toward mercy and compassion to which Johnson refers. She gave Matt a reason to get up every day beyond the drudgery of trying to make some difference in an unjust world. She became his hope, and what she awoke in him also opened his heart toward real friendship and a renewed sense of service, even despite her death. As Matt tells us in a concluding voiceover, "I set out to save the city, but with Elektra's help I saved myself instead. Now I have faith that anything is possible. And some days, faith is all you need."

ELEKTRA

Elektra (same character as above) was created by Frank Miller during his legendary run on the Daredevil comics in the early 1980s and introduced in *Daredevil* #168 (January 1981). Just as Blade is the only black Marvel hero to have his own films, so *Elektra* (dir. Rob Bowman, 2005) is the only of our movies to feature a woman. As with *Daredevil,* hers also is a story of redemptive turning to others from a life of callousness and isolation; "the healing of a woman," Bowman tells us.[62] Her story is significant for us because, while it replicates the male pattern that Ruether, Keller, and Lark Hall criticize, it ultimately offers an alternative to it.

At the beginning, Elektra (again Garner) is shown as an apathetic hired killer, clearly cut off from much of any emotion, let alone compassion and

60. Johnson, "Commentary," *Daredevil.*
61. Julien R. Fielding, review of *Daredevil, Journal of Religion and Film* 7, no. 1 (April 2003), accessed June 24, 2010, http://www.unomaha.edu/jrf/daredevil rev.htm.
62. Rob Bowman, "Commentary," *Elektra,* disc 1, director's cut DVD, directed by Rob Bowman (Beverly Hills: Twentieth Century Fox Home Entertainment, 2005), DVD.

warmth. This is exemplified in her initial distance toward her new neighbors Mark (Goran Visnjic) and his daughter Abby (Kirsten Prout). After Abby persuades Elektra to join them for dinner, however, Elektra begins to feel some innate compassion for the girl, as if unearthed from a deep well, and relents from killing them upon discovering that they are her new targets.

Some critics think that Elektra's brewing softer side, which is absent in the comics, is the film's main failure.[63] However, in addition to the question of whether or not a static figure can ever make a good protagonist, we must also offer that Bowman's decision is more anthropologically realistic and commendable. If our relations with others define us, it is natural that we will respond according to how we are treated. Elektra grew hard and bitter not because she wanted to, but because she grew up with great loss and had met little more than violence and aggression in others' movements toward her. We know that her father was killed in front of her, and we find out in several places in this film that her mother was murdered when she was young.

This was, in fact, the major disruptive event of her life, and oftentimes she flashes back to herself as a little girl reliving the experience of finding her mother dead. In the commentary, Bowman says that some psychologists think that if there is a trauma in childhood, emotional growth will end the day of the trauma. This is why in Elektra's visions her younger self does not age. At the same time, he says, the little girl is "almost the cheerleader for Elektra," encouraging her to "go back to the innocence" before the dreams of childhood were taken from her.[64] So, much like Blade, Elektra's emotional block and isolation are due to suffering from the loss of her mother, not an attempt to escape her. The death of her mother, rather than being a release from responsibility and effeminate bondage, as Keller suggests is the case for the classic hero, is the catalyst for Elektra's despair and emotional paralysis.

By the time she meets Mark and Abby, then, Bowman suggests that she is "haunted. Her past is catching up with her . . . feelings of guilt are starting to . . . fester inside of her."[65] Guilt alone, however, is never enough to engender the intensity of true change or sacrificial love. It may have in some sense provided the occasion for Elektra's compassion, but the narrative suggests that it was the unassuming tenderness of Mark and Abby toward her that spawned something deeper and stronger than guilt. Garner seems to agree, observing that Elektra has "an incredible maternal instinct" that activates when she meets Abby. By risking her own life to save Abby, Elektra thus "finds her own humanity," which had been hidden before.[66]

This new love and awareness for Elektra would come to fruition by the end of the film after Abby is killed by one of the villains. Elektra tries to

63. E.g., Kaveney, *Superheroes*, 265.
64. Bowman, "Commentary."
65. Bowman, "The Making of Elektra," *Elektra*, directed by Rob Bowman (Beverly Hills: Twentieth Century Fox Home Entertainment, 2005), DVD.
66. Garner, "Making of Elektra."

imitate the practice of raising the dead that she had seen her mentor Stick (Terence Stamp) do previously, but it is a sad, awkward scene played well by Garner because, as Bowman notes, she does not really know what she is doing and does not have very much confidence.[67] She lays her head on Abby's chest in tears, having given up, but a few moments later, Abby comes back to life unexpectedly. Bowman offers a brilliant analysis of the scene in alignment with our overall thesis. Elektra "has no idea that because she has become compassionate, and not so selfish and cold-blooded anymore, that she has healed herself . . . in a real way reluctantly . . . she now has the ability to bring back, to give life."[68]

In the end, Elektra treads a new path alone, exemplary of the monomyth we have been critiquing throughout. However, if we think of the female journey in the way that Ruether and Keller suggest, as one from relations of oppression and lack of self to autonomy and fullness of identity, then Elektra has at least begun her healing by having her emotional distance challenged. She has gone from being a woman weighed down with guilt and vengeance, lacking confidence, assurance, closure, and power, to a woman with a new strength, peace, hope, and sense of self. This is a promising example not only for the female hero, but for all of us encumbered with the burdens of grief and loneliness.

THE PUNISHER

Frank Castle/The Punisher was created by writer Gerry Conway and artists John Romita, Sr. and Ross Andru as a lesser Spider-Man villain for *Amazing Spider-Man* #129 (February 1974). Fan reception was better than expected and he kept appearing in other titles until he received his own in the 1980s. Out of all the protagonists considered in this chapter, Frank is the closest to the monomythic male hero. In the first film, *The Punisher* (dir. Jonathan Hensleigh, 2004), for instance, writer and director Hensleigh explicitly intended to make a violent western movie in the spirit of Sam Peckinpah and Sergio Leone,[69] and scholar Lorrie Palmer gives an insightful analysis of the film as a western, observing that in Punisher stories in general certain "codes of the Old West, self-sufficiency and personal action, thread through all these narratives."[70] Consequently, much of what we have found problematic thus far finds perpetuation both here and in the reboot, *Punisher: War Zone* (dir. Lexi Alexander, 2008):[71] the dichotomy of savage and civilized

67. Bowman, "Commentary."
68. Ibid.
69. Jonathan Hensleigh, "Commentary," *The Punisher*, directed by Jonathan Hensleigh (Santa Monica: Lions Gate Entertainment, 2004), DVD.
70. Lorrie Palmer, "'Le Western Noir': *The Punisher* as Revisionist Superhero Western," in *Amazing Transforming Superhero*, 194.
71. Alexander is the only female director in our stable.

bridged by the hero,[72] the insufficiency of government to bring killers to justice,[73] and the ontology of violent exchange in which hero and villains are uncritically steeped.

What is important for us in the first movie, however, is the nature of community and Frank's ambiguous isolationism. Palmer notices three different family dynamics displayed in the film.[74] First, there is the Castle family before they are killed, who share two large meals together and are shown to be happy and optimistic. Hensleigh wanted to emphasize that Frank (Thomas Jane) was a dedicated father and husband who had a conventional life outside of work.[75] Second, there are the villainous Saints, a "decadent amoral family" who are never shown eating together and are given a dark, underworld, imperial feel.[76]

Finally, there is the awkward, unlikely family of Joan (Rebecca Romijn), Bumpo (John Pinette), and Dave (Ben Foster), who live in the apartment building into which Frank moves after recovering from the Saints's attempt on his life. Although these three are present in the comicbook story on which the film is based, Hensleigh gives them a depth and significance absent in the source material.[77] Palmer contends that they occupy the working-class fringe of society and act as a new family for him, as is common in the western genre, providing "a human element to the nearly machine-like Frank."[78] Hensleigh suggests that even the three of them are friends only "because they have no one else, really."[79] However, what distinguishes them and their relationship with Frank from the monomythic scheme is that they are the ones who come to his rescue, instead of the other way around. Palmer calls this a "revision" of the hero myth's preference for self-sufficiency.[80] We will go further: it is nothing short of complete inversion.

Several attempts are made to reach and help Frank on a psychological level. This comes first in the person of Joan, who, after hearing of Frank's family in the news, tells him that she is sorry for what happened. Frank is so shut off that he is almost confused by the statement and asks her if she knew them, adding that he is "over it." She responds, "Don't let your memories kill you." In a later scene she confronts him again, saying, "I know what it's like. I know what it's like to try and make your memories go away. You can make new memories, good ones. Good memories can save your life."

A departure from the tradition also comes in Thomas Jane's ability to make us care about Frank. He is rugged and independent, yes, but in a

72. Palmer, "*Punisher*," 196ff.
73. Ibid., 206; Hensleigh, "Commentary."
74. On the following, Palmer, "*Punisher*," 197–201.
75. Hensleigh, "Commentary."
76. Ibid.
78. Palmer, "*Punisher*," 199.
77. Garth Ennis, Steve Dillon, and Jimmy Palmiotti, *The Punisher: Welcome Back, Frank* (New York: Marvel Comics, 2001).
79. Hensleigh, "Commentary."
80. Palmer, "*Punisher*," 199.

way born more from that familiar wounded melancholy than from pride, suggested also by the music and images of his family that flash in his mind. When he refuses Joan's advances, then, it is not only for the sake of his mission, but also because of his pain and utter inability to give anything else.

Another effort to reach Frank comes in their invitation to join them for dinner. Palmer observes that there are actually two shared meals shown with this new community.[81] In the first, Bumpo and Dave are eating at the counter of the diner where Joan works, the three of them in conversation while Frank sits across the room at a table by himself. In the second, Frank is eating alone when Dave interrupts him and tricks him into coming over to Joan's apartment. As they are eating, Joan suggests that each should share something for which they are thankful. When Frank goes last, all he is able to muster is, "Thanks for dinner." Hensleigh offers that at this point, Frank is simply "incapable of affection and love any longer . . . [he is] shut off emotionally."[82]

The most profound way in which heroic self-subsistence is subverted, though, both mentally and physically, is in Frank's relationship with Dave. Earlier in the film, Joan's abusive ex-boyfriend Mike (Russ Comegys) is pounding on her door late at night. Dave and Bumpo step out of their respective apartments and Dave calmly tells him, "It's kinda late." Mike approaches Dave, pushes him against the wall, and smacks him repeatedly in what is an intense and discomforting encounter. Frank resolves the situation by breaking Mike's nose and telling him to leave.

Shortly thereafter, they have returned to their apartments, except Dave, who is still standing against the wall in shock. Ben Foster plays this moment superbly, suggesting that Dave is not so much scared or relieved as simply baffled. As the camera sits for a moment, Dave says presumably to himself, "No one's ever stood up for me before." The tone of trembling awareness is heartbreaking, because we are convinced that he is absolutely right. Just so, the novelty of Frank's act, entirely unbeknownst to him, creates a hope for Dave that had hitherto been impossible: he now knows that he matters.

In this light, what Dave offers in return takes the form of a seeming paradox. In a scene toward the end of the film, Saint's henchmen have located Frank's abode and have sent a hired killer for him. After a long dual, Frank defeats the intruder but is left wounded and exhausted. When the three neighbors see the goons coming in to finish whatever is left of Frank, they hide him in a hidden compartment beneath his floor.

Saint's second in command, Quentin (Will Patton), who has already been shown as more sadistic than the others, interrogates Dave and Bumpo on the whereabouts of Frank. In a moment taken from the comic origin, Quentin proceeds to remove Dave's several facial piercings with pliers, but Hensleigh animates this with a gravity and brutality lacking in the graphic novel, intensified both by the charged performances of Foster and Patton and by the fact

81. Ibid., 200–201.
82. Hensleigh, "Commentary."

that most of the torture happens off screen, leaving us to hear Dave's moans and screams.

After Frank recovers and arises from below, he says to Dave, "You don't know me. You don't owe me anything. I've brought you nothing but trouble. Why are you ready to die for me?" Here, he demonstrates a bewildered reaction similar to that of Dave in the earlier scene. And Dave's response, pregnant with the uttermost theological urgency, is intoned as though it were pure unarguable fact: "Because you're one of us. You're family."

With that, Frank is offered a new identity and a new being contoured by the replete uncontrollability of altruistic love. By confounding Frank's expectations of what a stranger can or should do, Dave is, in fact, granting him a self-awareness based not on the violent impulses of his grief and formed over against his family's killers, but rather based on the community of the broken, imperfect persons who have reached out to him. Moreover, by connecting his deed explicitly to their own family, Dave enables a way of being for Frank formed just by those relations, subtly subverting the path of the loner and redefining his nature according to their community's redemptive bonds.

What marks the inversion of the monomyth more exactly here is that the act of self-sacrifice so common in the superhero genre does not come from the hero, but from the victim or captive, particularly from one shown previously as quite powerless. Because the hero is mythologically imbued with the physical, moral, and intellectual strength to save us, what is often presented as self-sacrifice is no sacrifice at all, but, rather, the hero doing his job; there is no genuine risk. On the contrary, we do not expect this from someone like Dave, who is clearly portrayed as a weak, passive individual whose personal history of abuse and neglect is continually implied. When Frank defends him from Joan's boyfriend, however, nothing short of a transformation occurs for Dave, allowing him to offer himself freely in gratitude, even to the point of death, not as though imposed on him from the outside.

This clearly echoes Merton's assertion that our sense of value and self-love is mediated by the love of others. When Frank stands up for Dave, it tells Dave that he is worthwhile, which in turn facilitates Dave's new strength and willingness to lay down his life for someone he hardly knows. Only in this way does the film avoid an ethical criticism of the idea of self-sacrifice often raised by the marginalized: that it tends to be encouraged by those in power as an excuse for the perpetuation of oppression. Rather, Dave demonstrates a contrary view: that we cannot presume to dictate to the powerless just for that reason that they should *not* be willing to give their lives for others. If altruistic love is, after all, born from true dignity, it is imperialistic and dehumanizing to declare anyone incapable of it. Certainly, Dave's action is entirely based on a sense of being strong, of knowing he is worthwhile, and of feeling like a somebody for the first time, as Cone might put it. Accordingly, Palmer is correct to conclude, "In their determined silence . . . the makeshift family proves as heroic as any western hero."[83]

83. Palmer, "*Punisher,*" 201.

The effect this has on Frank is to bring him "back from the brink just enough."[84] At the end, after Frank has dispatched all the villains, he shows his appreciation by leaving a huge pile of money for each of his three neighbors. Because of kind people like them, ironically, Frank leaves and becomes driven to punish those who would abuse and hurt others. As he walks out for the last time, he tells Joan that he cannot stay, but that she was right about good memories being able to save one's life. In the end, Frank still feels that this is all he has to give, and so, in monomythic fashion, he continues on alone.

For the most part, *Punisher: War Zone* is similarly reflective of the monomythic hero pattern, especially in its glorification of profuse violence and unquestioned Manichaean ethical dualism. Its one unique trait, however, merits consideration here. Early on, Frank (Ray Stevenson) is invading a criminal stronghold and shoots an undercover detective. Given his guilty reaction, it would seem as if this is the first time he has accidentally killed an innocent, something that strikes one as highly unlikely, since he kills people every day. Nevertheless, it is the only superhero film whose character arc revolves chiefly around this event (and one of a handful to raise it at all), which, in addition, presents a rather realistic tenor in a film genre otherwise unconscious of such collateral damage.[85]

Immediately after the incident, Frank realizes he was a cop and, thus, what he has done. He later goes to the man's funeral and notices that he is survived by a wife, Angela (Julie Benz), and her young daughter Grace (Stephanie Janusauskas), which reminds him of his own murdered family. Suspecting that her husband was the primary earner, he even goes to their house to offer a bag of money to them, but Angela understandably refuses the help.

When the villains come to their house later on, however, Frank and the police rescue them, opening space for her to accept his remorse. Later convinced that the villains will return to harm them, she accepts Frank's offer to shelter and protect them at his place. There is a sweet moment when they are hiding out there and he gives them food. Grace is disgusted and asks what it is, to which Frank responds that they are egg and cheese MREs. "What's an MRE?" she asks. "Meals ready to eat," Frank tells her. "Great for people who can't cook." It is one scene that demonstrates the vast difference in lifestyle between a gun-toting psychotic vigilante and an innocent, unassuming child for whom he feels immense compassion, despite his inability to walk in her world.

Not long after, the villains discover his location, lure him away, and kidnap Angela and Grace. He kills the baddies and rescues them, but not without sacrificing his best friend when forced to choose who will die. When he parts with them—whether for the last time, we do not know—Angela stops him: "Wait. Wait. My husband, Nicky. We talked about you. Argued about you. He said you were one of the good guys." He shows an expression

84. Hensleigh, "Commentary."
85. In the medium of comics, though, Marvel was innovative here.

of relief and looks to Grace, who waves at him. Although Angela's forgiveness of Frank is not explicit, the suggestion is that she has done so, and that this has helped to heal his own heart, not only from the guilt of killing her husband, but also from the pain of his own lost family.

THE FANTASTIC FOUR

The Fantastic Four first appeared in *Fantastic Four* #1 (November 1961) and was the first of Stan Lee and Jack Kirby's new, more realistic heroes to grace the genre and inaugurate the Marvel Age of comics. What we need to focus on in the two film adaptations, *Fantastic Four* (dir. Tim Story, 2005) and *Fantastic Four: Rise of the Silver Surfer* (dir. Tim Story, 2007),[86] are the unique journeys of discovery that each of the four main characters experience as they grow from individuals in different ways isolated from each other into a genuine, if unconventional, family. We begin with Sue Storm (Jessica Alba). Over the course of the first film, she has two primary objectives: to rekindle a love with Reed Richards (Ioan Gruffudd) and to control her newfound powers. In several scenes, these goals are shown to be interrelated; as Sue becomes more vulnerable with Reed and he responds to her in kind, she becomes more in control of her abilities.

In the second film, Sue's struggle is primarily about the tension between being a superhero and public figure, on the one hand, and the desire to settle down quietly with Reed and raise children, on the other. It has often been observed that in the comics Sue is very much the mother figure, especially to Johnny (Chris Evans) and Ben (Michael Chiklis), who in both comics and films are like bickering brothers. This motherly role for the woman hero presents something of a conundrum. On the negative side, it often means that her arc is rather shallow and her character, for that reason, not as interesting. It also potentially raises the feminist critique of Ruether and Keller that the heroine does not gain an autonomous identity, but rather finds her meaning merely in relation to others for whom she is responsible and to whom she attends. On the positive side, however, Sue and others like her are commendable precisely for their faithfulness, responsibility, and tenderness; not because it is the inferior place of a "good woman," but because it is exemplary for what all persons should become. In the final analysis, by giving Sue a personality and a *modus operandi* in each movie, the filmmakers have made her more like the interdependent and mature woman of the alternative mythos preferred by Ruether, Keller, and Lark Hall.

Moreover, Sue provides the strongest moral example of how to treat the neighbor, which becomes the most pivotal factor in the second film. When the four help the military set a trap for the Silver Surfer (Doug Jones/Laurence Fishburne), Sue is the only one who seems genuinely interested in

86. Story is the only African American director in our repertoire.

him as a person. Her treatment of him is also juxtaposed to that by the military, thus offering something of a philosophical critique of the latter. When the army takes him to a special facility for questioning, the first thing the torturer tells the Surfer is that there are certain things he cannot do because of human rights violations, then qualifies it: "Fortunately, you're not human." To the opposite of the army's approach, when Sue sneaks in to see the Surfer the first thing *she* says is, "What's your name?"

Avi Arad, consistently the most reflective of Marvel's executives, offers some rather profound insights about the Surfer's treatment. "We really wanted this [torture] scene so bad, because that's what humanity still does, and I hate to call it humanity. Let's call it people in our world. If something comes here that is misunderstood, the assumption is it's the enemy. Also the assumption is that it's probably not human; therefore, it's impervious to pain. So we can cut it and dissect it and so on."[87] Arad, then, like our theologians, recognizes that the antidote to inhumane treatment of the other starts with acknowledging the other as human.

This is the approach taken by Sue, who, Arad says, can sense that inside, the Surfer is "as human as we are." The Surfer, however, feels like this is his destiny and that all he can do is warn her about the coming fate. "It's very biblical. Like if you find one righteous man would you save the world? And he found a magnificent righteous woman."[88] Sue's compassion for Surfer culminates when she steps in front of a spear thrown at him, wounding her fatally. Arad points out that when she dies a few minutes later, Surfer realizes that he must help these people "who showed him that they're human, and humane even more than human."[89]

Reed, like Sue, is already a fairly mature and stable person. His very blandness, however, might cause us to miss the fact that he is throughout the films quite antithetical to the brazen, hypermasculine monomythic hero. Even one of the screenwriters suggests that we should appreciate Reed's "less flashy values. . . . He's a really moral, grounded, centered guy. Those aren't values that action movie heroes inhabit or frequent a lot."[90] Reed is not given much to do in the first film besides awkwardly pine over Sue and work endlessly to discover a way to reverse their mutations. His role as leader seems to be secured primarily in the fact that he is the genius (quite

87. Avi Arad, Peter S. Elliot, and William Hoy, "Commentaries," *Fantastic Four: Rise of the Silver Surfer,* directed by Tim Story (Beverly Hills: Twentieth Century Fox Home Entertainment, 2007), DVD.
88. Ibid.
89. Ibid.
90. Michael Chiklis, Michael France, and Mark Frost, "Commentaries," disc 1, *Fantastic Four,* extended edition DVD, directed by Tim Story (Beverly Hills: Twentieth Century Fox Home Entertainment, 2007). Some DVD commentaries, such as this one, have several commentators whose voices are difficult to distinguish, even if introduced at the beginning. Hence, the occasional ambiguity evident in my choice of words.

literally) who got them into the mess in the first place. In the final battle with Dr. Doom (Julian McMahon), though, Reed figures out the best way to defeat him and takes charge, garnering the respect of the others.[91]

His arguably more daunting task is to pursue his feelings for Sue. At the beginning of the first film, they have been split up for some undisclosed amount of time and he is clearly holding back from expressing himself, having concluded that the situation between them was too complicated. When they spend time later on, Reed becomes vulnerable, again in anti-monomythic fashion, and confesses that he did not think he was the one she needed. At the end, though, he finally takes the bold step: "No more thinking. No more variables. Sue Storm, will you marry me?" When they finally exchange vows at the end of the second film, it should be noted that this is the only hero wedding in any major superhero movie ever made.

Johnny's story is more sharply defined than Reed or Sue's, primarily because he has further to go, starting out in an almost purely infantile psychological state of hedonism and selfishness. His first response after the accident is simply that they all should embrace their new powers, making them a cause for pomp and celebrity rather than investigation and deep existential consideration, which is what it becomes for the other three, as it would for us. Through a humiliating public experience, Johnny realizes that his newfound powers could be used for more than cheap tricks; that his instant fame is only a façade and has not really brought him the respect he sought from his fans. After returning to the Baxter building with a new-found sense of responsibility and camaraderie, his key moment comes when he saves Sue's and Ben's lives by luring a missile away from them, risking his own life in the process.

In the second movie, Johnny is now very much a part of the team, but experiences growing pains as he learns to trust the others and restrain his selfish impulses, which at one point nearly costs the others their lives. At the end, however, Johnny again realizes the error of his ways. When a disturbance from the Surfer's energy allows them to switch and combine powers, Johnny asks Reed if he can be the one to receive their abilities and go after Doom, who has stolen the Surfer's board and become stronger than them all. When Reed responds that he does not know what effect this would have on Johnny, he replies, "Let's not make this about me." The editors comment that this act "rounds out his character," because he has gone from wanting to be the center of attention to risking his life for the greater good.[92]

And then we come to Ben Grimm, the irreverent, short-tempered Thing with a heart of gold. Unlike the others, Ben cannot use his powers at will, but is stuck with his condition and all that it entails, including his unconventional appearance. That this change has ruined his entire life becomes clear

91. See Michael Chiklis's comments on this scene in "Commentaries," *Fantastic Four.*
92. Peter S. Elliot and William Hoy, "Commentaries," *Silver Surfer.*

in the brief addition of Ben's backstory with a fiancée, through which the screenwriters wanted to show what it would be like "to be totally rejected when you become a monster."[93] In their first public exposure, Ben saves a firetruck from falling off a bridge. A crowd gathers in applause, including his fiancée, who takes off her engagement ring and places it on the ground before walking away. Ben tries to grab it but his fingers are too thick and he is clearly frustrated at not being able to do so. Critic Stephanie Zacharek commends Tim Story for turning what starts as a corny moment into "a stark, simple panel of pure emotion. Ben can't pick up the pieces of his old life—he'll just have to start a new one."[94]

Shortly thereafter, Ben meets a blind woman, Alicia Masters (Kerry Washington), who takes kindly to him and persists in caring for him despite his own inability to see what is worthwhile in himself. Ben's struggle throughout the rest of the first film is whether he will follow Alicia's lead or succumb to his own self-defeating tendencies. Like so many of us, his inability to accept himself runs the risk of sabotaging both his budding romance and his friendship with the others. Nevertheless, as one of the writers observes, Alicia is the one who helps Ben come to terms with what has happened to him; who makes him realize that he need not be like everyone else.[95] When we consider that Alicia is a blind African American woman, the idea of one ostracized person empowering another is quite evident and significant. In being faced with just this one who recognizes the best in him and refuses to believe the lies that brew in his own head, Alicia mediates a redemption for Ben that is unimaginable by his own agency. Like Johnny, Ben realizes that what he has to offer the world as Thing is more important than his own personal wishes; in this case, the desire to look like everyone else. Largely because of Alicia, he is by the end of the first film able to accept himself and is willing to remain in his new condition for the greater good.

Finally, we must briefly consider the Fantastic Four as a family. This is more paramount in the second film, where the question throughout is whether Sue and Reed will leave at the end in order to have an ordinary life. After the villains are dispatched, however, it is Sue who concludes as part of her own arc, "We can't run away from our responsibilities and the people we need to protect. This is who we are." Reed agrees with her and adds that, after all, the team helped save the planet. When Ben asks about their desire to have a normal life and a family, Reed responds, "Who says you have to be normal to have a family?"

Not only is the primacy of the nuclear family displaced, then, but Reed and Sue's romance also becomes one of openness to a diversity of friendships

93. France and Frost, "Commentaries," *Fantastic Four.*
94. Stephanie Zacharek, review of *Fantastic Four,* Salon, accessed May 16, 2010, http://www.salon.com/entertainment/movies/review/2005/07/08/fantastic_four.
95. France and Frost, "Commentaries," *Fantastic Four.*

rather than one of self-enclosure. Only so do the four then become a community of genuine growth for all involved, where someone like Johnny is given space and time to learn from his mistakes, and where Ben learns to see himself as he is seen by those who love him. Their public duty is consequently best understood as an ethical responsibility nurtured within their relations of shared love. This is precisely the kind of communal dynamic proposed by Ruether. Reed and Sue's cohabitation with Ben and Johnny counters the tendency toward isolation characteristic of the nuclear family by the fact that they allow the others to contribute to their wellbeing instead of depending merely on each other. Yet the four are no less a family because of this choice, given Reed's final line above. He acknowledges that although their group may not be normal (i.e., nuclear), it is still a family, thus broadening the definition beyond what is now the common American understanding.

GHOST RIDER

Ghost Rider, introduced in *Marvel Spotlight* #5 (August 1972), was created by writers Roy Thomas and Gary Friedrich and artist Mike Ploog. Marvel had used the name in an earlier series of western comics, but Stan Lee commissioned a new version and created the name Johnny Blaze for the man who would become the Rider.[96] The film *Ghost Rider* (dir. Mark Steven Johnson, 2007) is part origin story and follows the comics closely. Teenage Johnny and his father are stunt motorcyclists, but Johnny wants to run away with his sweetheart Roxanne. Upon learning of his father's terminal cancer, Johnny is approached by Satan (Peter Fonda), who promises to heal his father in exchange for Johnny's soul. He accepts, only for his now-healthy father to perish the next day in a crash.

The adult Johnny (Nicolas Cage) continues to be not only anxious that the Devil will come calling at any time, but is also riddled with guilt over the deal he made. In the extended cut, it is shown more clearly that his original intention was at least as selfish as it was thoughtful; that he wanted his father to be well so he would be free from having to take care of him in his sickness and thus able to be with Roxanne.[97] The result is a mix of remorse over personal culpability and regret over good intentions backfiring. The combination of fear and guilt leaves Johnny generally isolated and hopeless. His only real thrill seems to be his daredevil jumps over cars or helicopters. These are also the only times in which he briefly convinces himself, "You can't live in fear," words made gloomily ironic by the fact that every attempt

96. Roy Thomas, "Sin and Salvation: The Comic Book Origins of Ghost Rider," disc 2, *Ghost Rider*, extended cut DVD, directed by Mark Steven Johnson (Culver City: Sony Pictures Home Entertainment, 2007).
97. Mark Steven Johnson, "Commentaries," disc 1, *Ghost Rider*.

has the appearance of a death wish he cannot fulfill. It is later revealed, and for Johnny only confirmed, that the Devil was keeping him alive during the numerous crashes he has incurred over the years.

Like *Daredevil* and *Elektra*, *Ghost Rider* is also a story about redemption, but is more explicitly theological in the telling. In a moment of vulnerability and self-revelation, Johnny asks a friend if he believes in second chances, wondering if someone who makes a big mistake should have to pay for it every day for the rest of his life. He adds that he is looking for some kind of a sign. Although he does not clarify precisely what such a sign would indicate, the inference is that Johnny is looking for a release from the curse that his past mistake has brought him. The language of second chances and signs implies, of course, that there is someone or something who just might grant these gifts to an embattled and forlorn Johnny Blaze, even if he does not know quite how to ask for them, or from whom.

Like many other Marvel heroes, the sign or second chance that Johnny gets comes in the form of a woman, in this case his old flame Roxanne (Eva Mendes). His attitude immediately begins to change for the better, and even the music reflects his optimism that they will be able to rekindle their relationship. Johnson suggests in the commentary that now Johnny really has a reason to live, because of "the girl that got away . . . he really believes that this is his second chance."[98]

Typical of many hero journeys, Johnny meets a mentor figure in the person of Caretaker (Sam Elliot), the previous Ghost Rider who defected from his duty to the Devil. At first, Johnny is hesitant to embrace what is happening to him and wants to run away. Eventually, though, he starts to listen to Caretaker and practices getting control of his new powers so that he is no longer at the whim of Satan and the rider spirit. When Johnny goes to face the Devil's son Blackheart (Wes Bentley) in the final showdown, he tells Caretaker to trust him; "He may have my soul, but he doesn't have my spirit." Caretaker concludes, "Any man who's got the guts to sell his soul for love, got the power to change the world. You didn't do it for greed. You did it for the right reason. Maybe that puts God on your side. To him that makes you dangerous; makes you unpredictable."

At the end, Johnny defeats Blackheart and, like Caretaker before him, stops obeying the Devil, who refuses to give Johnny back his soul. He must remain with his curse, but, like Peter Parker and others, has learned to accept it for the greater good. Unfortunately, this leads him to once again abandon Roxie, with whom he shares one last moment at their old teenage meeting place before riding off alone.

In the sequel, *Ghost Rider: Spirit of Vengeance* (dir. Mark Neveldine and Brian Taylor, 2012), Johnny is living in Eastern Europe when a member of an esoteric monastic order approaches and offers to lift his curse if Johnny saves a boy who is being hunted by the Devil. Whereas in the

98. Ibid.

first film Johnny began to take control of the spirit inside him, now he is realizing how difficult this task is. We are told that the entity possessing him is the demon Zarathos, an angel sent, presumably by God, to protect human beings, but instead was tricked, brought to hell, driven insane, and subsequently used by the Devil to carry out deeds on earth which he cannot do himself.

In terms of our discussion, Zarathos can be seen as a metaphor for any number of "curses" that we bring upon ourselves because of selfish or impulsive, but ultimately destructive, decisions at points in our past. The fact that Johnny cannot free himself of his burden resonates with those of us who are haunted by such mistakes and feel that our destiny is indissolubly bound to their happening; that is, we live without hope. What marks Johnny Blaze as arguably unique among Marvel movie heroes is that he made a decision to which all of us can relate. Very rarely would anyone find himself in the dramatic and violent situation of Peter Parker before he refused to stop the man who would kill Uncle Ben. Yet who would not "sell his soul" for the opportunity to save his dying father or be with his one true love?

The film is also unique in the answer it presents to Johnny's search for hope and peace: confession. Toward the end of the movie, Moreau (Idris Elba) brings Johnny deep within the caverns of a hidden monastery and tells him that he must confess the one thing that is most difficult for him to discuss. In a retcon of the first film, Johnny explains that he made the deal with the Devil because he wanted his father to live and could not let him go, although his father knew he was ready to die. Immediately, and unexpectedly, Moreau takes a loaf of bread, breaks it, and gives some to Johnny with the words, "this is the lamb of God that takes away all the sin from the world. Happy are those that are called to receive him. You think that you're not worthy to receive him?" "I'm not," Johnny replies. Moreau persists, "Okay, but that's good enough. The Body of Christ."

In the end, Johnny defeats the Devil with the power of Zarathos and he begins to feel his ancient power of good coming through. He rides off on his motorcycle in flames of blue instead of yellow; the demonic Spirit of Vengeance has been replaced by the original, angelic Spirit of Justice. Both Zarathos and Johnny have found salvation.

If LeRon Shults is right that hope for the future is constitutive of what it means to be human, then divine forgiveness as experienced by Johnny is still resolutely anthropological. Caretaker's utterance in the first film suggests a personal origin of Johnny's salvation, one not only unforeseen but also beneficent, offering a new word on his destiny and granting him a second chance. It is precisely this new hope—that what defined Johnny's past need not determine his future—that quite robustly exemplifies and anticipates the inexhaustible personhood for which we long, and which Johnny experiences as a foretaste in the sacraments of confession and Eucharist. That God could turn a servant of Satan against him is not bad theology,

as some suggest,[99] but is a conclusion in perfect logical step for one who forgives sins.

THE HULK

Bruce Banner/Hulk was created by Stan Lee and Jack Kirby as the second Marvel Age hero, first appearing in *Incredible Hulk* #1 (May 1962). The anthropological grandeur of the first film, *Hulk* (dir. Ang Lee, 2003), can be approached by juxtaposing two antithetical forces: those to whom Bruce is an object and those to whom Bruce is beloved. In the form of a chiastic, we begin with the primary among the latter, his mother.

The connection between young Bruce and his mother is established early on in several shots. It is also clear that his father David is typically gone during the day and that his mother is the primary caregiver. When she is killed in front of Bruce, it is so traumatic that he has actually repressed the memory. The adult Bruce only recalls what has happened near the end of the film.

Ang Lee comments that his mother's death is Bruce's "unresolving nightmare" recurring. "Bruce Banner's dream is Hulk's reality . . . Hulk is a representation of our inner aggression, this survival instinct that's animal-like, without the aggression we wouldn't be survival today, but it's so ugly and monstrous and illogical we have to cover up with our consciousness, with logic," that is, by dealing with each other on a civilized level.[100] Lee, then, wanted to establish that it is the deep recesses of paranoia, insanity, fear, and anxiety in Bruce that ignite his anger and, thus, the Hulk, not merely someone pushing him around. "Kind of Freudian," Lee admits.[101]

The mention of Freud in this immediate context, of course, raises the matter of the Oedipus complex: the theory put forth by Freud that boys desire their mothers sexually and see their fathers as threats in this regard. Although Ang Lee himself does not seem to be referring to this aspect of Freud's thought, Erin Runions observes that many critics do argue for such an interpretation of the film. She contends, however, that *Hulk* actually subverts the whole Oedipal notion altogether.[102] It is not so much the impulse to kill the father that stands as the central theme, but rather the "intended sacrifice of the son, forestalled by that of the wife/mother."[103] We should observe, moreover, that the Oedipus complex is still a patriarchal phenomenon in that son competes

99. E.g., James Berardinelli, review of *Ghost Rider*, Reelviews, accessed July 14, 2010, http://www.reelviews.net/php_review_template.php?identifier=550.

100. Ang Lee, "Commentary," disc 1, *Hulk*, special ed. DVD, directed by Ang Lee (Culver City: Universal Studios, 2003). The quotations are correct and betray Lee's broken English.

101. Ibid. See also Kaveney, *Superheroes*, 230.

102. Erin Runions, "Inherited Crypts of the Wife/Mother: Ang Lee's *Hulk* Meets Zechariah 5:5–11 in Contemporary Apocalyptic Discourse," *Biblical Interpretation* 14, no. 1–2 (2006): 129.

103. Ibid., 130.

with father for the right to and control of the mother. Her sacrifice for Bruce as well as this loss as sheer terror for him, as beginning of emotional distance and isolation, subverts the Oedipal scheme because it destroys its misogyny, putting us again on the same level as Blade and Elektra: the loss of the mother leads not to freedom but to death.

The consequences of which death, of course, are psychological turmoil, complexity, and confusion for Bruce, another significant break with the monomyth's shallow hero. The achievements of modern special effects are such that we witness this depth in both Bruce and Hulk, who consistently displays not only anger, but also tenderness, pain, and thought.[104] When Bruce (Eric Bana) tells Betty (Jennifer Connelly) that turning into Hulk is "like a dream" about "rage, power, and freedom," then, we are to understand this not as the maniacal glee of some monstrous caprice, but as the overcompensating explosion of a perennially tormented silence. Hence, Runions concludes that by eventually remembering his mother and working through his pain, Bruce "no longer needs to blow up into a giant green phallus to express himself."[105]

Hence, Bruce's aloneness is differentiated from that of the monomyth in the fact that it is primarily thrust upon him, not chosen out of some rugged autonomy. Berardinelli is correct that everyone wants something from Bruce when Hulk emerges.[106] General Ross (Sam Elliott) is the most ambiguous on this line. At first, he appears to have a personal vendetta against Bruce, based on the work of his father, at one point threatening to put Bruce in prison for life if he goes near Betty again. Later on, Betty confronts her father in the secret military installation where Bruce is being held and pleads for his understanding. "He is a human being," she says. "Well, he is also something else," Ross replies, wondering why Bruce followed the same line of work as his father. Betty asks if he thinks Bruce is "predestined to follow in his father's footsteps." "I was going to say 'damned,'" Ross answers. Eventually, Ross seems to feel some pity for Bruce and is rather upset when his military authority over him is overruled. Still, his attitude toward Bruce is that because he is so dangerous, if he cannot be cured, he must be killed.

The more sinister military figure is the weapons contractor Talbot (Josh Lucas), who offers Betty a job early on because of the work she and her colleagues are doing on genetics. Eventually, we discover his ulterior motive when he tells Bruce that he wants to take his genes out of him and make money off of what he has, presumably by selling it to the government as a weapon, something which Betty at another time admits to knowing.

David (Nick Nolte), now out of prison, has similar but more explicitly devious and psychotic intentions, perhaps a narrative device used to expose

104. Nicholas Schager, review of *Hulk*, *Slant Magazine*, accessed December 19, 2006, http://www.slantmagazine.com/film/film_review.asp?ID=717.
105. Runions, "Inherited Crypts," 141.
106. James Berardinelli, review of *Hulk*, Reelviews, accessed June 22, 2010, http://www.reelviews.net/php_review_template.php?identifier=763.

the real threat of scientific and military power obsessions. Like Talbot, David tells Bruce that he wants to harvest his new mutation. In a conversation with Betty, this becomes connected expressly to ethics. When she tries to reason with him, saying that Bruce is his son, he demurs:

DAVID. And what have I done to my son, Miss Ross? Nothing. I tried to improve on the limits in myself. Myself! Not him! Can you understand? To improve on nature. My nature! Knowledge of oneself! It's the only path to the truth that gives men the power to go beyond God's boundaries.

BETTY. You know what's beyond your boundaries? Other people. All you've given Bruce is fear.

David's arrogance culminates after he gains the ability to absorb any matter and energy with which he comes into contact. In the final battle between father and son, David sucks all of Hulk's energy but then is overcome by it, imploring Bruce to take it back. He is presumably destroyed when Ross drops a nuclear bomb on them. It is poetic justice and a perfect example of the self-destructive tendency of dominating power that has been part of the Marvel philosophy since Stan Lee, and which was insightfully observed and cautioned against by our theologians, Merton most explicitly.

It is interesting to note that David is vehemently against the government and military. Nevertheless, his pomposity is no less dangerous. The result is a condemnation by the film of that for which both he and Talbot stand: an epistemic objectification that treats human persons as tools for experimentation, as fodder for the militaristic game of global dominance, as means for the egoistic exploitation of nature and the usurpation of divine providence, and as pawns, in the American context, of "the will to power that is central to neoconservative thought."[107] And here, beyond all the intrigue and ploys and shifting of secrets and money, beyond the ideology of a rabid, abusive lunacy, stands Bruce, a man torn asunder by them, "a tragic figure trapped by the fate and the hubris of others into showing the inner beast whenever rage overwhelms him."[108]

By what grace, then, comes Betty, the voice of calm, redemptive love. We discover early on that Bruce and Betty have just ended a relationship but must still work together. We do not find out who ended things, but he was being emotionally distant, something in men for which she reveals a penchant. There is a strange flashback sequence when Bruce looks at a picture of himself and Betty and remembers them at a cabin together. In his recollection, Betty tells Bruce of a dream she had recently of when she was a little girl sitting at the army base with her father, who left her there to attend to a military emergency. She is alone, but then the adult Bruce picks up the child Betty and sets her on

107. Runions, "Inherited Crypts," 139. See also Kaveney, *Superheroes*, 230.
108. Berardinelli, review of *Hulk*.

a counter, putting his hand over her face threateningly before she wakes up. This stands in contrast to a real-life sequence later on when Hulk approaches her at the cabin and picks up the adult Betty just like in her dream and sets her on her car. This time, however, he smiles at her and protects her from the mutated dogs his father has sent. It is a not commonly noticed aspect of the film that Bruce is more emotionally present to Betty as Hulk than as a man.

Yet these two scenes with Betty suggest that the narrative is also about her nearly as much as it is about Bruce. She is clearly estranged from her father, as demonstrated in the scene where he invites her to dinner primarily to ask about Bruce. Like David, General Ross was an absentee father who put his work continually before his family. Roger Ebert is quite insightful on this. The movie "is not so much about a green monster as about two wounded adult children of egomaniacs . . . it's touching how in many scenes we are essentially looking at damaged children."[109]

This adds a unique angle to their relationship, something altogether absent from the other films. Betty sees in Bruce not only a man in need, but also the pain of her own childhood. As a man, he consistently shuns her attempts to get close to him, but as Hulk he is vulnerable and tender with her, as much as can be within the intellectual limits of that manifestation. Interestingly, then, he ends up being a source of strength for her, who has lost trust in men despite her yearning for intimacy. Their love is indeed "born from shared tragedy."[110]

Near the end of the film, Betty's longsuffering finally comes to fruition. As he is rampaging in San Francisco avoiding the military, Betty realizes that violence only makes him stronger and angrier, and she convinces her father to let Hulk come to her. Here we see his frailty most profoundly. There are no bombs, no guns, no shouting, only the nearness of one who truly cares for him. As he approaches her, he shrinks back to human size, weak and cold, and she embraces him, weeping.

BRUCE. You found me.

BETTY. You weren't that hard to find.

BRUCE. Yes I was.

This still, small presence brings him to his knees, the gentle answer that turns away wrath and heals open wounds, suggesting, in spite of all forms of pretense to the contrary, that it is for us as it is for Hulk: "Only love seems to appease him."[111]

109. Roger Ebert, review of *Hulk*, rogerebert.com, accessed June 22, 2010, http://rogerebert.suntimes.com/apps/pbcs.dll/article?AID=/20030620/REVIEWS/306200304.
110. Schager, review of *Hulk*.
111. Jay Levitz, review of *Hulk*, Christian Spotlight on the Movies, accessed December 19, 2006, http://www.christiananswers.net/spotlight/movies/2003/thehulk.html.

In *The Incredible Hulk* (dir. Louis Leterrier, 2008), a reboot of the franchise, Bruce (Edward Norton) is much less psychologically burdened than in Ang Lee's rendition. His anxiety stems not from a repressed past but from his condition, which has left him alone and on the run and, hence, desperate for a cure. Nevertheless, there is a definite progression seen in Bruce as the movie unfolds. At first, his whole life is devoted to staying unnoticed and finding a way to reverse what has happened to him. Zacharek may even be right that he hates himself and, as Hulk, believes "that he's a monster unfit to associate with people."[112] There is also a rather touching moment in a deleted scene where Bruce is having dinner with Betty (Liv Tyler) and her new boyfriend Leonard (Ty Burrell) after returning to America. When Leonard tells a funny story about work, Bruce laughs and then immediately begins to cry. "I'm sorry. . . . It's been a long time since I felt light about anything." Betty responds, "You're safe here. You're with friends." Like with many of our heroes, then, the love interest proves to be the healing salve rather than the mere damsel or the temptress as in the Golden Age.

Her treatment of Bruce, as in the first movie, contrasts significantly with that by the military, chiefly this time in General Ross (William Hurt), who wants Bruce alive so he can harvest his genes for weaponization. Whereas Ross is only concerned with the militaristic benefits of the exploitation of nature, Bruce has had to suffer the consequences firsthand and holds a more reverential view. In a deleted scene, Bruce expresses his guilt to Betty over the failed experiment that created Hulk. He observes,

> Nature takes a long time to build us the way that we are. Delicate, wonderfully complicated systems, refined over billions and billions of years, and nobody understood that better than you and me. And so, we did what? We come in here with these big brains of ours and we monkey with things and we think that . . . we're going to do what? Improve it overnight? And then we act surprised when it blows up in our face in some way that we didn't expect.

Such lack of respect for nature becomes expressed as egocentric power primarily through military commando Emil Blonsky/Abomination (Tim Roth), whose destructive tendencies are based on a pure hunger for control and, arguably more originary, his inability to accept his aging. Abomination and Hulk are not altogether different from the men themselves, but rather manifestations of who they are at heart. Bruce is basically a kind, nonviolent man and, thus, so is Hulk. Blonsky is aggressive and controlling, extremely so as Abomination, who explicitly connects human agency to domination when he tells Hulk that he does not "deserve this power"; that is, since Bruce is not using his mutation for selfish and vicious ends, he should not have it at

112. Stephanie Zacharek, review of *The Incredible Hulk,* Salon, accessed June 22, 2010, http://www.salon.com/entertainment/movies/review/2008/06/13/hulk.

all—a Nietzschean refrain implicit in the American monomyth and echoed by most Marvel villains.

Yet, by the end of the film, we are left to wonder if Blonsky's words have had some beneficial effect on Bruce. In an earlier conversation with Betty, Bruce tells her that he does not want to control Hulk, only to get rid of it. After he has defeated Abomination and run off alone again, however, we see Bruce in a cabin practicing meditation when his eyes turn green and he smiles. We are led to think that at this point, like Johnny Blaze, Bruce is embracing his alter ego, presumably for good.

In *The Avengers,* we find Bruce (Mark Ruffalo) in a much more ambiguous place regarding the beast inside him. On the one hand, he is still on the run from military authorities and expressly avoids places with high populations, for fear that "the other guy" might appear and wreak havoc. On the other hand, he manages to remain calm during inordinate stress and he reveals at the end that his secret to keeping Hulk in check is that he is "always angry," by which we are to understand that he can become Hulk at will, suggesting a closer connection between Bruce and Hulk and possibly even a mutual awareness.

Nevertheless, the former attitude is dominant for most of the film until Tony Stark (Robert Downey, Jr.) convinces Bruce to embrace his alter ego. In what is perhaps the most vulnerable exchange of the film, Bruce tells Tony, "You see, I don't get a suit of armor. I'm exposed. Like a nerve. It's a nightmare."

TONY. You know, I've got a cluster of shrapnel, trying every second to crawl its way into my heart. This stops it. This little circle of light. It's part of me now, not just armor. It's a terrible privilege.

BRUCE. But you can control it.

TONY. Because I learned how.

BRUCE. It's different.

TONY. Hey, I read all about your accident. That much gamma exposure should have killed you.

BRUCE. So are you saying that the Hulk, the other guy, saved my life? That's nice. It's a nice sentiment. Saved it for what?

TONY. I guess we'll find out.

At the end, Bruce feels more confident and is able to become Hulk while not turning on his allies and is pivotal in repelling the alien invasion.

The other important point to make about Bruce's progress since the last film is that he is no longer consumed with curing himself. Whedon suggests that he has largely internalized and accepted his condition, even if it remains a burden for him.[113] Thus, he is able to concentrate on helping

113. Joss Whedon, "Commentary," *Marvel's The Avengers,* directed by Joss Whedon (Burbank, CA: Buena Vista Home Entertainment, 2012), DVD.

others, which he does in the form of giving inexpensive medical care to poor people in India (which he also does in South America at the end of Ang Lee's film).

All of this attests to the notion that Bruce is really a compassionate person who simply has to deal with an enormous burden. His narrative arc, like that of Wolverine, suggests that the worst place for him is to be a loner and to struggle against his curse without help from others. Maturity for Bruce, contrary to the monomyth, means letting go of his own concerns and offering what help he can for the good of others, who, we should add, are usually poor people of the third world. By the end of *The Avengers,* even Hulk can be brought under some control and harnessed for the benefit of others.

IRON MAN

Tony Stark/Iron Man was created by Stan Lee, Jack Kirby, artist Don Heck, and writer Larry Lieber (Lee's brother) and first appeared in *Tales of Suspense* #39 (March 1963). The film *Iron Man* is largely an origin story that strays little from that in the comics and echoes the conversion from ignorance and self-centeredness to social awareness that characterizes many Marvel heroes. Tony (Robert Downey, Jr.), having been created by Lee intentionally along the lines of Howard Hughes,[114] is a scientific genius, military industrialist, and playboy who gallivants around the world womanizing and selling weapons to the U.S. military without the least thought of the consequences his career entails for others. When he demonstrates a weapon in Afghanistan, however, he and his escorts are ambushed and Tony is kidnapped. Both this experience itself and his friendship with fellow prisoner Yinsen (Shaun Toub), however, have a profoundly transformative effect on Tony. After having developed a close bond with each other, something that we can tell Tony has never really experienced, a dying Yinsen tells him not to waste his life. As in our other films, we are again looking at a story of change, not so much as psychological redemption from despair as with Johnny Blaze and Matt Murdock, but as moral awakening.

For instance, after escaping back to the States, Tony has a press conference where he becomes uncharacteristically introspective and self-revelatory, expressing his wish that he would have had the chance to ask his father about his business and whether he was conflicted. "I saw young Americans killed by the very weapons I created to defend them and protect them. And I saw that I had become part of a system that is comfortable with zero accountability." He responds to a reporter, saying that he has "more to offer this world than just making things that blow up." He then declares an immediate cessation of the weapons development part of his company.

114. Stan Lee, "Special Features," disc 2, *Iron Man,* ultimate 2-disc ed. DVD, directed by Jon Favreau (Paramount Pictures, 2008).

His second-in-command, Obadiah Stane (Jeff Bridges), confronts Tony later about that announcement, telling him that what they do keeps the world "from falling into chaos." Even his best friend Colonel Rhodes (Terrence Howard) shuns Tony for stopping weapons production, telling him to get his "head on straight." Yet Tony knows that his convictions are based in reality, and he cannot shake them. Berardinelli insightfully notes that the film is in one sense about Tony's "psychological journey from luxurious ignorance to shocked awareness and how, having his eyes opened, he can no longer stand by and do nothing."[115] The key scene in which this is expressed comes soon after Tony learns of his company's contribution to terrorist activities against innocent civilians in the fictional Middle East town of Gulmira. While he is at home watching news footage of the atrocities being committed there, he cannot take it anymore and decides to fly over as Iron Man and help them.

This scene represents an ethically ambiguous dynamic of the film. On the one hand, it seems to repeat a well-known mythic pattern in which helpless dark-skinned foreigners must be rescued by a strong white American, acquiescing to the duality of savage and civilized and to the myth of white superiority.[116] On the other hand, it evidences a profound change in the person of Tony Stark, who in great Marvel fashion recognizes that his powers and resources can be used for the good of those who are not so endowed, and takes responsibility for them. Moreover, Ebert may be right that in the film

> the enemy is not a conspiracy or spy organization. It is instead the reality in our own world today: Armaments are escalating beyond the ability to control them. In most movies in this genre, the goal would be to create bigger and better weapons. How unique that Tony Stark wants to disarm. It makes him a superhero who can think, reason and draw moral conclusions, instead of one who recites platitudes.[117]

In this sense, then, the movie acknowledges the genuine disparity between poor and rich, between those who live under the brutal, selfish whims of others and those who are not so burdened. Its chief moral failure is ultimately its unwillingness to follow Tony's convictions to their logical end and address this reality at a fundamental structural level. It rightly questions the corruptions of war and of the military-industrial complex, but it does not go as far as Merton and challenge the existence of war itself or the very presence of American soldiers and weapons in places such as Afghanistan.

115. James Berardinelli, review of *Iron Man,* Reelviews, accessed June 23, 2010, http://www.reelviews.net/php_review_template.php?identifier=764.
116. Examples are countless, but most recently *Avatar* (dir. James Cameron, 2009).
117. Roger Ebert, review of *Iron Man,* rogerebert.com, accessed June 23, 2010, http://rogerebert.suntimes.com/apps/pbcs.dll/article?AID=/20080601/REVIEWS/467306179.

When Tony realizes that Stane was responsible for his kidnapping, he faces a personal conundrum in addition to his moral one, raising the matter of his relationships, particularly of whom he can trust. As we saw, he starts as a rather isolated person covered over by a charming, confident façade that helps him bed the opposite sex but not experience genuine intimacy. It is the camaraderie and familiarity he has with Stane, Zacharek suggests, that makes his betrayal all the more painful for Tony,[118] and which may be exacerbated also by his otherwise lack of close friendships.

Tony realizes the latter when he returns home from Afghanistan. In a sweet scene with his assistant Pepper Potts (Gwyneth Paltrow), he asks her to help him replace a device for his heart, after which he tells her in all unexpected seriousness, "I don't have anyone but you." Zacharek rightly credits Downey for turning such a simple line "into an expression of yearning and human frailty that soars beyond the simple capabilities of language."[119] Their relationship is some mix of flirtation and professionalism, and just in that moment he reveals his awareness that she really is all he has, the one who knows him better than he knows himself.

Pepper, in turn, cares for Tony, with whom she later shares a kiss, but is hesitant to let herself pursue those emotions because of how he is with other women. It is a fault of Tony Stark in continuity with the monomyth that he is most intimate with a woman with whom he is not having sex. Considering his usual objectification of women, however, it is a step in the right direction to be so close to Pepper, who takes his eccentricities with a grain of salt. Toward the end, he shares more of himself with her in an attempt to enlist her help against Stane. "I shouldn't be alive unless it was for a reason. I'm not crazy, Pepper. I just finally know what I have to do. And I know in my heart that it's right." Touched by his genuineness, she says, "You're all I have, too, you know." By the end, we are left with the assumption that she is now not only his assistant, but also his girlfriend, the one in whom his shallow wanderings may now cease.

The second film, *Iron Man 2* (dir. Jon Favreau, 2010), fails to follow through on the two possibilities opened in the first one: an intimate relationship with Pepper and a bolder statement against militarism. With regard to the former, it is almost as if their relationship has regressed to what it was at the beginning of the first film, a professional partnership with undertones of romantic potential.

As far as the latter, although Tony does not appear to have resumed weapons production, he arrogantly claims to have "privatized world peace" because foreign powers are afraid of Iron Man. Although this may include the refusal of dictators to violently suppress dissent within their own borders, it certainly does not include a criticism of the American military-industrial

118. Stephanie Zacharek, review of *Iron Man*, Salon, accessed June 23, 2010, http://www.salon.com/entertainment/movies/review/2008/05/01/iron_man.
119. Ibid.

complex, as it did in the first movie. Quite the opposite is evident. More-over, as critic William Bradley observes, the movie does not follow through adequately on the claim of the villain Ivan Vanko (Mickey Rourke) that Tony comes "from a family of thieves and butchers," a reference to Tony's industrialist father Howard Stark and his role in the deportation of Vanko's own father back to Russia.[120] It is later clarified that Vanko's father was a spy and that Ivan is, therefore, simply mistaken in his accusation against the Stark family, but given the dramatic nature of the setup, this conclusion feels artificial and inconsistent, not to mention disappointing considering the attitude of the first film.

Nevertheless, where this second installment succeeds is in the psychological growth of Tony Stark, facilitated again by the genius of Downey. Ebert is correct that while Tony appears to be more egotistical than ever, it is really a façade to cover up the fact that he is dying (the palladium that runs the device in his heart is poisoning his blood).[121] This only pushes him further away from Pepper (again Paltrow) and Rhoadie (a better-casted Don Cheadle). At a party that Tony throws for himself, he is at his most irresponsible, donning the Iron Man suit for cheap tricks in the expectation that his last days are upon him. While most of the crowd simply encourages this behavior, Favreau observes that it is his real friends Rhoadie and Pepper who challenge him to stop, which Rhoadie can do only by donning another suit and confronting Tony physically.[122]

This isolation is exacerbated by Tony's failed relationship with his deceased father Howard and the thought that he was never really loved by him. When Tony is met by Nick Fury (Samuel L. Jackson), he gives Tony a series of old videos of Howard and says that the answers he needs are in there. At the end of the final reel, Howard addresses Tony personally and tells him that out of everything he did, Tony is his greatest creation. This message of acceptance from beyond the grave, as it were, is the catalyst Tony needs to embrace his life again, to discover the new element that will not poison his blood, and to be more open and honest with his friends. In the end, only Tony and Rhoadie working together can defeat Vanko, and Tony gives Pepper a more meaningful kiss than before.

In *The Avengers*, it is shown clearly at the beginning that Tony and Pepper are now a couple, a significant change not only for the character, but also for the monomyth; for in only a handful of superhero films, including Marvel ones, does the hero balance a romantic partner with heroic duties. Unfortunately,

120. William Bradley, "*Iron Man*'s Post-Modern Howard Hughes Is Back and Confused," *Huffington Post*, accessed March 4, 2011, http://www.huffingtonpost.com/william-bradley/iiron-manis-post-modern-h_b_575392.html.

121. Roger Ebert, review of *Iron Man 2*, rogerebert.com, accessed March 4, 2011, http://rogerebert.suntimes.com/apps/pbcs.dll/article?AID=/20100505/REVIEWS/100509987.

122. Jon Favreau, "Commentary," *Iron Man 2*, directed by Jon Favreau (Hollywood: Paramount Pictures, 2010), DVD.

Avengers does nothing to address the problems of a bloated American military presence that the first *Iron Man* at least broached. Instead, such presence is assumed and even glorified, even if it is in the form of SHIELD, an apparent arm of Homeland Security, and not the military proper.

Nevertheless, *Avengers* does present a path for Tony's journey that he has not yet taken: self-sacrifice to the point of death. Whereas Tony was the voice of change for Bruce Banner, Steve Rogers/Captain America (Chris Evans) is the one who challenges Tony. For Steve, true heroism includes the willingness to give your life for others, something to which Tony demurs.

STEVE. Big man in a suit of armor. Take that off, what are you?

TONY. Genius, billionaire, playboy, philanthropist.

STEVE. I know guys with none of that worth ten of you. I've seen the footage. The only thing you really fight for is yourself. You're not the guy to make the sacrifice play. To lie down on a wire and let the other guy crawl over you.

TONY. I think I would just cut the wire.

STEVE. Always a way out. You know, you may not be a threat, but you better stop pretending to be a hero.

This exchange is significant because it marks a clear distinction between the American monomyth and Marvel's philosophy regarding power and self-sacrifice. For the former, superhuman power and invulnerability mean that there is no genuine risk when the hero rescues the town in peril. By his or her brawn, brains, speed, or some other heightened quality, the hero saves the day but without any real chance of failure. For the latter, however, the possibility that a hero could die is both real and an extension of their overall vulnerability, physical, emotional, and psychological. Of course, fictional American heroes of all periods tend not to die, at least permanently, but keep surviving or coming back in later issues or movies. The point is that this is not in the first instance a philosophical consequence for Lee's heroes, as it was in the Golden Age and before, but a commercial consequence.

Tony Stark, like the monomythic hero, has not yet learned that not every problem can be solved without sacrifices, or every battle won without casualties. He sees himself as bigger than life and death. Only when a nuclear missile threatens the entire city of New York does Tony finally lie on the wire, as it were, by grabbing the missile and redirecting it into another dimension, expecting that he will not make it back.

THOR

Thor was created by Stan Lee, Jack Kirby, and Larry Lieber, and first appeared in *Journey into Mystery* #83 (August 1962). The film *Thor* (dir. Kenneth Branagh, 2011) is an origin story that alters some details of the

comicbook version in order to save space, but still retains the essential plot and moral theme. What is remarkable for us is not Thor's narrative arc in and of itself, which parallels the shift from arrogance to responsibility found among so many Marvel stories, but that his arc is impossible to understand apart from the political backdrop against which it takes place and, thus, from the social and political messages heavily encoded in the film. This also colors how the movie portrays the villain Loki (Tom Hiddleston), Thor's brother, whose journey is worth some attention, especially because of his role in *The Avengers*.

In the extraterrestrial realm of Asgard, Thor (Chris Hemsworth) is set to ascend to the throne at the bequest of his father Odin (Anthony Hopkins), who has kept their home safe, largely through a treaty with a race of war-mongering Frost Giants. When a few of these people break in to Asgard, Thor responds by leading his friends and brother to the Frost Giant domain of Jotunheim to "teach them a lesson," he says, entirely against the commands of his father. For his impetuousness and callousness, Odin scolds Thor before taking all of his power and banishing him to Earth. Thor must learn humility in order to become worthy of his divinity and the right to rule in Asgard, which he does over time by befriending ordinary people and by sacrificing his life to Loki in exchange for the sparing of his friends.

It is difficult not to consider our contemporary political context when observing the stark contrast of Thor's and Odin's views on the appropriate response to the Frost Giants' actions. While Thor is bent on a full military invasion against Jotunheim, Odin is calm and rational; this was not an act of war, he insists, but the deeds of a few rogue individuals (read "terrorists"). While modern American leaders such as George W. Bush and Barack Obama, heavily influenced by neoconservative political philosophy, believe in punishing the many for the actions of a few, Odin, like Merton and Ruether, is more conscientious and acts on the evidence, which in no way suggests a Jotun invasion. He is also more interested in defense than in militaristic imperialism, telling Thor that they will simply find and shore up the breech that allowed the terrorists access to Asgard.

Thor, on the contrary, jumps to the conclusion that the Frost Giants see Odin as weak and vulnerable, an idea that stems directly from the philosophical presuppositions of the American monomyth and which has been consistently put forward as a major justification for America's invasive foreign policy, especially where military action is involved. After Odin rescues Thor and his friends from imminent death at the hands of an understandably vindictive Laufey (Colm Feore), leader of the Frost Giants, they argue further.

THOR: There won't be a kingdom to protect if you're afraid to act. The Jotuns must learn to fear me just as they once feared you.

ODIN: That's pride and vanity talking, not leadership. You've forgotten everything I've taught you about a warrior's patience.

THOR: While you wait and be patient the nine realms laugh at us. The old ways are done. You'd stand giving speeches while Asgard falls.

ODIN: You are a vain, greedy, cruel boy! Thor Odinson, you have betrayed the express command of your king. Through your arrogance and stupidity you've opened these peaceful realms and innocent lives to the horror and desolation of war. . . . You are unworthy. . . . I now take from you your power!

This exchange illustrates not only the previous points but also the binary of power and responsibility that Lee and our theologians strongly value. Great power is not to be taken for granted or used as a tool for domination or vengeance. Rather, one must become worthy of it by demonstrating patience, awareness, wisdom, peace, reason, and, ultimately, self-sacrifice for the good of others. In contradiction to the monomythic idea of power as "power over," as it were, real power, "power with" or in service to others, must be earned. Odin tells us that the impulsive, inconsiderate, violent power that Thor demonstrates is a sham.

That Odin codes Thor's behavior as not only immoral and arrogant but also stupid is equally significant, something that sets this film off from most others. It echoes Merton's recognition that war is not only wrong, but simply irrational; it makes no sense and accomplishes nothing.[123] This is largely because it only brings destruction on oneself and one's nation, which is part of Odin's point. Thor, like most American politicians, is unable or unwilling to acknowledge that "teaching them a lesson" only invites more violence upon his country.

The other main reason that war is problematic for Merton is because it closes off the possibility that your enemy may one day be your friend. The film is much more vague on this line because although Odin is shown to have spared Laufey's life and offered him a truce long ago, the Frost Giants are clearly shown as a violent, though now-isolated people. It edges dangerously close to Manichaean dualism here in that they are not shown as complex persons or as wanting to seek peace and integration in any way. Loki, however, is treated much more graciously and throughout *Thor* and *The Avengers* given a much more ambiguous personality.

We discover that Loki is the one who manipulatively incited Thor to attack Jotunheim, suspecting that it would lead to Thor's banishment and remove one obstacle to Loki's usurpation of the throne. When Odin falls ill, Loki's plan is complete and he installs himself as ruler of Asgard. While both Thor and Loki lust for power early on, it is from different motivations. For Thor, it seems to stem from his ambitious and arrogant temperament. For Loki, it is rooted in being the second son, the one not to inherit the kingdom, which facilitates the feeling that he is unworthy in Odin's eyes. This is

123. Merton, *Love and Living*, 129–131.

exacerbated when Loki discovers that he was really born a Frost Giant and was adopted by Odin as a baby.

Loki's deceptive ambitions instill a sense of pity in us because we understand that they are born from a genuine desire to be loved and appreciated, a desire for which so many of us overcompensate and overreach in trying to fulfill. This is the express reason that Loki invites Laufey to Asgard to kill Odin, only to turn on Laufey and kill him, so that he may be seen as a hero in Odin's standing. It is one of the more Shakespearean episodes of the film and demonstrates, as the Bard did with many of his characters, Loki's utter desperation. At the same time, Loki's brief rule in Asgard exemplifies the wrong kind of leadership, as Thor's would have had Odin not refused him. Loki rules as if he is bent only on himself and on a taste for power, reveling in his authority and deceiving his friends and family. At the end of *Thor,* he is still too proud or too ashamed to let himself be welcomed back into the fold by Thor and Odin, who are willing to forgive him, a veritable Prodigal Son.

Loki returns as the chief villain in *The Avengers,* having been taken in by a different alien race, the Chitauri, in exchange for his assistance in helping them invade Earth. Being homeless and powerless on his own, Loki is given a scepter by the Chitauri leader Thanos to aid him in conquering and ruling over the people of Earth. Consequently, Loki finds himself basically in the position of a lackey, as it is made clear to him that the Chitauri will hold him accountable should the invasion fail. So again we find Loki in a pitiable position. His lust for power has all the appearances of a façade covering a hidden desire for belonging, which is implied in two scenes where Thor tells him to come home and Loki's face betrays a secret desire to do so.

Nevertheless, Loki is ruthless to human beings, who he thinks are inferior to him. He tells a group of people in Germany, "Kneel! Is not this simpler? Is this not your natural state? It's the unspoken truth of humanity, that you crave subjugation. The bright lure of freedom diminishes your life's joy in a mad scramble for power, for identity. You were made to be ruled. In the end, you will always kneel." This monologue is ironic in two important ways, neither of which is sufficiently explored within the film itself.

First, it exemplifies clearly Loki's own "mad scramble for power" in an act that Freudians would call *projection;* what we might more colloquially refer to as "the pot calling the kettle black." So, in a sense, Loki is right, but only because there are people such as Loki who seek their identities in dominion over others, both politically and personally.

Second, Loki does raise a valid question: considering how humans treat each other, would it be better if we lived under the rule of a leader who denied us our ability to hurt each other at the expense of our freedoms? In other words, ought we to exchange democracy for monarchy or fascism? The irony is that superheroic mythoi are often considered to be fascist in the sense that there are a handful of "supermen" who decide the fate of the masses

of unexceptional people.[124] That the Avengers are a secret, military-endorsed group with enough power to destroy cities in minutes would certainly play into the suspicions of those leery of totalitarianism.

Yet this is where Stan Lee's stories have traditionally attempted to subvert the monomyth's history of superheroic fascism by offering heroes with flaws and often at odds with the ruling establishment. The film text of *The Avengers* clearly suggests this ragtag group as the champion of democracy entirely at odds with the despotism of Loki and the Chitauri. The ironic subtext of fascism, however, should not go unnoticed, especially considering the sanctioning of the Avengers by SHIELD and, apparently, the American government. It remains to be seen how these themes will be approached in sequels.

CAPTAIN AMERICA

Steve Rogers/Captain America was created by Joe Simon and Jack Kirby for *Captain America Comics* #1 (March 1941). The movie *Captain America: The First Avenger* (dir. Joe Johnston, 2011) is the only one of our films to feature a hero created during the Golden Age. In contrast to the Japanese-killing tool of American wartime propaganda, however, the film's presentation of Cap is a result of the changes brought by Stan Lee to the genre and to Cap himself when he was reintroduced in the 1960s.

Like most Marvel heroes, Steve Rogers is rewarded for his selflessness, humility, and courage. Unusually, though, Steve does not begin in a place of arrogance and carelessness like Thor and Tony Stark. He is more like Reed Richards, an already emulable and somewhat ordinary man. What makes Steve remarkable is that he is unconquerably brave, despite his frail stature and physical ailments like asthma. He has been rejected five times from five different recruiting offices from joining the service to fight in World War II because of his condition, risking arrest in the process due to intentional misinformation on his recruitment form.

When Dr. Erskine (Stanley Tucci), the creator of the supersoldier formula, discovers this, he becomes curious about Steve, but must put him to the test. "Do you want to kill Nazis?" he asks. Steve replies, "I don't want to kill anyone. I don't like bullies; I don't care where they're from."

While Erskine is aware that the serum enhances the traits of whoever takes it, which would make Steve a security risk if he were an already violent and aggressive person, Erskine also has moral and philosophical reasons for preferring Steve. He is not looking for a killer or even an expert soldier. After all, the physical effects of the formula will make up for many combat deficiencies. Instead, Erskine is drawn to Steve because he is selfless, determined, honest, courageous, and considerate of the weak. When Steve

124. See Lawrence and Jewett, *Myth*, 24, 349.

asks the night before the procedure why Erskine chose him, he responds, "Because the strong man who has known power all his life may lose respect for that power, but a weak man knows the value of strength and knows compassion. . . . Whatever happens tomorrow you must promise me one thing: that you will stay who you are, not a perfect soldier, but a good man."

Like *Thor*, *Captain America* turns the monomythic understanding of power on its head. It explicitly praises physical and, therefore, cultural weakness and marginality. The critique could be levied that by rewarding Steve with super strength and a hypermasculine physique, his weakness is ultimately passed over and denigrated. However, the film is clear that Steve's virtues, his humility and compassion born from a place of meekness, are both the cause and condition of his role as Captain America. Cap is what he is only because Steve, deep down, is a runt with a heart of gold.

This is just as true in *The Avengers*. What makes Steve a great leader is not his physical abilities or his strategic genius, it is that he treats everyone as an equal, as he would want to be treated himself. He refuses to tolerate bullies, which is why he wants to stop Loki. Just as forcefully, he does not care about the alleged divinity of gods such as Thor or swoon in the face of prima donnas such as Tony Stark. Everyone is on the same playing field for Steve. Everyone, in his estimation, is deserving of life, liberty, and the pursuit of happiness, not some more or less than others.

For our theologians also, genuine power is to identify with those who don't have it and to seek the transformation of social structures for the purpose of communal harmony, giving greater voice in the process to those who have been marginalized. At the same time, the onus is on those with authority to make the sacrifices and listen to the outcast, not on those who have nothing. This can only happen if there is a shared dignity and mutual respect befitting human personhood, whether one understands that as being created in the image of God or simply, like Stan Lee, as living the Golden Rule.

This ideal and pursuit of genuine equality and dignity is what makes Captain America more American than the country he represents and more heroic than the monomythic tradition from which he stems. We can only hope that his future incarnations will push this to its potential, however unpopular it may be with viewers and readers. Steve Rogers, at any rate, would fight for it.

6 Conclusion
Anthropological Proposals

In the previous chapter, we suggested several key resonances between the critical and constructive positions offered by our five theologians on one side, and those of Stan Lee and Marvel on the other, in the context of the Marvel superhero film narratives. In this final chapter, we turn to attend more directly to the major points of contact and also of difference between them in a series of proposals for ways of human being, knowing, and acting alternative to the American monomyth. Just as early American theology and hero mythology were intertwined and shared certain historical and philosophical roots, despite their vast divergences they have rebelled against their foundational assumptions in remarkably similar ways. Consequently, these proposals represent not the awkward mélange of two unrelated phenomena, but the overdue rendezvous of old friends. In the American context, for either superhero creators and filmmakers or professional theologians to think that they should, or even can, proceed in their respective projects entirely without consideration of the other is historical amnesia. To the extent that either of them is genuinely concerned with the stories they tell about humanity and heroism, in a culture that seems to be losing its grasp of both, their communion is needed now more than ever.

TO BE REAL (AND HUMAN) IS TO BE IN RELATION

This must be our principal conviction based on all that has come before. The turn to reality *is* the turn to relationality and vice versa. Whether we articulate this in terms of the law of love (Merton), or of the philosophical preference of relation over substance (Keller, Shults), or of the dismantling of patriarchal and dysfunctional modes of communion and individuality (Ruether, Keller), or of the need for reconciliation between oppressed and oppressor (Cone, Ruether), the ultimate reality of human life over against all pretense spawned by the illusory and isolating opiates of most advertising, religion, commerce, major media, propaganda, politics, and popular culture is that our relations *matter,* and matter *essentially,* constituting the very fiber

of our beings. What follows are three further proposals that merely follow from this first, and reflect not only the convictions of our theologians but also those of Stan Lee.

TO BE HUMAN IS TO BE IN NEED

To need is a key difference between the monomyth and Marvel, shared as well by our theologians. Whereas the old heroes had to be perfect and self-sufficient, Lee wrote his characters with features that made them vulnerable and in need of help, again as in real life. Several dimensions of this stand out.

One of them, as we discussed in chapter 4, is that Lee wanted his heroes to have flaws, which is seen not only in the comics but thoroughly in the films as well (e.g., Ben Grimm's self-loathing, Tony Stark's arrogance, Peter Parker's guilt, Thor's belligerence, Elektra's apathy). Without exception, in these examples and others, such flaws are presented as problematic. At the same time, the value and dignity of these persons are never in question. On the contrary, it is their imperfections that contribute to their unique personalities and offer the occasion for transformation.

Perhaps the theologian most helpful here is Thomas Merton, who, as we saw, criticizes the idea of perfection explicitly, especially to the extent that it is used to gauge human worth. Rather, to be loved by God is to destroy the entire structure of perfection and worth altogether. This is mediated by the love of others in which one's dignity is secured against the world's system of judgment. We are loved, indeed, in spite of everything, including our quirks and frailties.

This is manifested in Marvel chiefly through the self-doubt of so many heroes. For Ben Grimm, Bruce Banner, Johnny Blaze, Peter Parker, and others, the awareness of their frailties and imperfections leads them into isolation. As in Merton and Shults, though, it is the eventual bonds of love that develop—the ultimate recognition of need for others—that serve to guarantee and facilitate their self-knowing against the potentially destructive extremes that anxiety can bring. Freedom from this anxiety is experienced through their communities as a self-transcendence that allows these heroes to accept epistemic ambiguity without falling into despair.

So key is the matter of self-perception in Marvel that the argument can be made that it is itself the determining factor for whether a character becomes a hero or villain. If one is able to accept one's weaknesses and imperfections regardless of the attendant anxiety, one typically becomes a hero and uses one's powers for good. If, on the other hand, one becomes overwhelmed by them and is not able to love oneself, villainy usually results.

For Stan Lee, as for our theologians, the pivotal factor in accepting ourselves is the presence or absence of loving others. Consider Dr. Doom in the Fantastic Four films. Not only does his vanity outweigh his good qualities, making him succumb to the anxiety created by his metallic

appearance, but this process also takes place entirely in isolation from others. Magneto and Loki are similar. Their need to control their circumstances and respond to others based on the fear of not being accepted turns them against the world. Ben Grimm and Peter Parker, on the other hand, are kept from going in this direction because of the presence in their lives of those who love and appreciate them for who they are, regardless of how they view themselves. For Johnny Blaze, it seems to be the love of God directly and the peculiar movement of the Spirit that sustains his sanity and mission. As we saw, it is in fact the love of others that inaugurates a *new* self-esteem for all of them.

Another aspect of need for others has to do with heroic masculinity. The faults of Marvel characters which contribute to their unique natures arose in a cultural and generic context that still held rather tenaciously to a traditional macho conception of manhood. Even today, this is still often the case. Stan Lee's attempt to create heroes that he himself would want to read entailed, to whatever extent he was conscious of it, a criticism of and alternative to this conception. Hence, the journey of Wolverine, among others, bears the marks of a holistic humanity along the lines recommended by Ruether and Keller: not the macho impenetrability of a lone subject, but a vulnerable longing for communion that recognizes genuine need. Several other figures, such as Blade, Elektra, Matt Murdock, Johnny Blaze, Frank Castle, and, arguably, Tony Stark, bear the rough exterior of a hypermasculine ego, but a deeper look reveals this appearance to be an emotionally defensive reaction against intense personal loss. Moreover, a handful of heroes—Reed Richards, Steve Rogers, Nightcrawler, Charles Xavier, and even Bruce Banner and Peter Parker—subtly subvert the rugged male pattern altogether simply by already being honest, kind, and considerate persons in touch with their own imperfections.

Consequently, as we observed, the Marvel hero's desire is not to be cut off from the mother, as Keller notes is the case for classic heroes, but to be reunited with her, or at least to be faced by those who will give what is lacking with the absence of the mother. This is not only the case with Blade, Elektra, and Bruce Banner, whose maternal vacuum has driven them to emotional isolation, but also with Peter Parker. In the Sam Raimi Spider-Man films, it is an encounter with Aunt May, his replacement mother, that spurs Peter to a new realization and affirmation of his heroic identity.

In other areas related to women, however, both Marvel and Christian theology have room to improve. With the former, we would hope to see more films that focus on Marvel's many female heroes and present them in the complex, realistic pattern of Sue Storm, Elektra, and Storm, with just as much diversity of personality. We would also hope that such adaptations would find ways of staying true to the comics without making sex objects of the characters they bring to cinematic life. With the latter, we would hope that the churches that continue to forbid women from positions of influence and leadership, and that continue to hold to patriarchal conceptions, would

consider both the proposals by theologians such as Ruether and Keller and the portrayals of strong female characters like Sue Storm, MJ Watson, Aunt May, Black Widow, and Storm.

Finally on this topic, it is the awareness of our own flaws that enables us to attend to various others as human, even our enemies. All of our theologians attest to this, whether on a national or personal level. Merton says that when we begin to see our enemies as brothers and sisters, they cease to be enemies and may become friends. Ruether and Keller especially note the correlation between the American delusion of innocence and its disparagement of sundry cultural others.

This is another area where we must call for more consistency in Marvel films. Although many of the villains are portrayed humanly and even sympathetically, reconciliation between heroes and villains is scarce, as the superhero genre in all media is still steeped in an ontology of violence and ethical dualism. The persistent friendship between Xavier and Magneto is an exception, but Xavier dies before we get to see how that relationship would have culminated. The real breakthrough is in *Spider-Man 3*, where Peter grants genuine forgiveness to Flint Marko for the death of Uncle Ben. Significantly, Peter only comes to this point when he truly recognizes the mistakes he himself has made. His own need for forgiveness has opened his heart to forgiving others who have hurt him. For as powerful as this moment is, it stands out as a diamond in the rough, even within Marvel films. Perhaps the test will be what becomes of Loki in the upcoming sequel to *Thor*. Having surrendered and been escorted back to Asgard, he will have to face his father Odin for his actions. Will he continue to persist in delusions of superiority and scrambles for power or will he be the prodigal son and let his family welcome him home?

TO BE HUMAN IS TO BE NEEDED

This may seem like an obvious point in the context of superheroes. However, since Marvel heroes diverge from the monomyth in being realistic and not simply a mythic function, the idea of being needed requires a different articulation. In the Marvel films this is true of both heroes and supporting characters. Think of Blade, who takes on a different persona when needed by Abigail; or Elektra, whose hidden capacity to love is awakened by the helplessness of a young girl; or Johnny Storm, who grows up when he finally realizes that his powers can be used for others; or Ben Grimm, who sees his friends in danger and only then willingly embraces his alter-ego; or Peter Parker, who is driven to heroism and sacrifice when May repeatedly reminds him just how important and unique his abilities have made him; or Jean Grey, who gives her life for her friends just at the point when she becomes confident in her powers; or Tony Stark, who realizes what he can offer to the world when he finally sees

how unjust it is. Consider also Dave in *The Punisher,* who lets himself be tortured to save Frank's life only after Frank has stood up for Dave and has thus given his life new meaning.

Merton and Shults have observed that both the giving and receiving of love are constitutive of that dynamic, not the giving alone. If Merton is right that indifference to one is indifference to the other, then both are indispensable. Indeed, for both of them, as well as for Cone, it is the primal love of God that conditions the human gift of love. True love flourishes where it is first received, where it declares to the beloved that who they are and what they have to offer is unique and wonderful and priceless.

In the Marvel movies, this is portrayed not only by the examples above, but also by romantic relationships. On this point, with occasional exceptions such as Ruether and Keller, Christian thought in general must be more progressive in its embrace of sexuality and romantic partnerships, especially as topics for theological reflection. For some of these heroes, to be sure, a love interest does not figure prominently. Where it does, however, it does so crucially. Consider the tender and patient love of Betty Ross for Bruce Banner in both Hulk films, especially the first one. It is only in being wooed out of his isolation through Betty's unfailing love that he is finally found by her. Alicia Masters consistently takes the initiative in redefining Ben Grimm not as the mere Thing but as desirable just as he is. MJ finally challenges Peter Parker to let his guard down and to let himself be loved because he is in fact needed by her, who has felt peace in no other man. Pepper Potts awakens in Tony Stark both an awareness of his own loneliness and a desire, finally, to be with someone who really knows him, after both of them acknowledge that all they have is each other. Even for those heroes who do not end up with their partners at the end, such as Matt Murdock and Johnny Blaze, the love of a woman has brought them out of despair and triggered a new sense of duty and responsibility to the world.

TO BE HUMAN IS TO NEED EACH OTHER

This proposal is implied in the previous ones but here takes on a more mutual and universal scope. To need each other suggests community, particular contours of community at that; a redefinition of family. As we saw with Ruether, the idea of the nuclear family as the standard normative model for human communion is an invention, more insidiously a fabrication created to centralize patriarchal power. This is another area where Ruether and a few other feminist thinkers stand as exceptions to Western assumptions, which in certain conservative circles is explicitly that God has ordained the nuclear family with a male head.

How remarkable, then, that Lee and his colleagues and heirs at Marvel proffer alternative forms of community in many of their stories, which can hardly be read other than as equally legitimate familial bonds. In the

Fantastic Four films, we discussed how this is very much the case when Reed and Sue agree to keep the team together instead of splitting off alone to have children. Frank's makeshift family in *The Punisher* offers him a new community and new memories. Even the Avengers find something of a new communion in their awkward group of outcasts, as the shared meal after the final credits attests. The X-Men films are not only consistent with this, but even entail a subtle critique of the nuclear pattern, particularly in the fact that adolescent mutants are often shunned by their biological relatives.

Yet here we must clarify a pivotal detail. The diversity of communities presented in Marvel films is not meant to criticize nuclear relations per se. Certainly, Reed Richards and Sue Storm are a couple, Sue and Johnny are brother and sister, and Thor and Loki are brothers. Rather, it is to reimagine and widen the idea of family along the lines of mutual love and desire. Both Rogue and Bobby/Iceman (Shawn Ashmore) need a new family in *X2* because, although their blood relatives do not accept them, Xavier and his mutants do. Wolverine finally stays with the X-Men because he is needed. Ben Grimm lets go of his anxiety because he is loved. Frank Castle is continually invited by his new neighbors because he is wanted. In these and other instances, the point is that these persons are desired and beloved by others who *want* them to stay, who *want* them to find their belonging and identity in their new communities, not out of some rebellion against mom and dad.

Moreover, in that these relational bonds are between strangers, the suggestion and implication is that the call to mutual love and need is no less than universal in scope. The X-Men indeed continue to help those who fear and hate them, not out of some love of martyrdom, but in the hopes that those who were once enemies may one day be considered friends. Cone and Ruether argue similarly with regard to the broken bonds between oppressors and oppressed, whether those be based on racism, sexism, classism, nationalism, or any other form of bigotry and alienation. For all of our theologians, the eschatological yearning for infinite peace entails the final reconciliation between all peoples, for which we must now strive if we dare to identify ourselves with the man Jesus, whose very life was a ransom for many and a prayer that just this communion would be realized. That we need each other, then, is simply another way of putting our constitutive and essential interrelatedness. To the extent that we deny this, Keller says, we are deluded.

It is also, in point of fact, another way of subverting the American monomyth, for mutual need, love, knowing, and belonging, especially on a universal scale, is utterly unthinkable if we are individual substances; if we view each other as objects to be used and exploited for selfish gain; if we relate to each other according to the power games of domination and isolation, absorption and abandonment. On the contrary, say Stan Lee and Christian theology, we are made and bound by our relations; we are subjects in need of mutual recognition and respect; and we are all responsible for

turning away from patterns of injustice and toward those of growth, acceptance, purgation, and forgiveness. It remains to be seen if and how Marvel will continue along this path. To the extent that it does so, it anticipates the resurrection life of creation with the man Jesus and his Father in their Spirit, wherein all loneliness and delusion and apathy will be no more, and where we will experience each other as real in a way we can now only imagine . . . and hope for.

Bibliography

Ames, William. *The Marrow of Theology.* Translated by John Dykstra Eusden. Durham: Labyrinth, 1983.

Anderson, Patrick D. "From John Wayne to E.T.: The Hero in Popular American Film." *American Baptist Quarterly* 2, no. 1 (March 1983): 16–31.

Andrae, Thomas. "From Menace to Messiah: The History and Historicity of Superman." In *American Media and Mass Culture: Left Perspectives,* edited by Donald Lazere, 124–138. Berkeley: University of California Press, 1987.

Arad, Avi. "Commentaries." Disc 1. *Spider-Man 3,* special ed. DVD. Directed by Sam Raimi. Culver City: Sony Pictures Home Entertainment, 2007.

Arad, Avi, Grant Curtis, Tobey Maguire, and Sam Raimi. "Commentaries." Disc 1. *Spider-Man 2,* special ed. DVD. Directed by Sam Raimi. Culver City: Sony Pictures Home Entertainment, 2004.

Arad, Avi, Peter S. Elliot, and William Hoy. "Commentary." *Fantastic Four: Rise of the Silver Surfer.* Directed by Tim Story. Beverly Hills: Twentieth Century Fox Home Entertainment, 2007. DVD.

Augustine. "A Treatise on the Merits and Forgiveness of Sins, and on the Baptism of Infants."

Bainbridge, Jason. "'This Is *the Authority.* This Planet Is Under Our Protection'—An Exegesis of Superheroes' Interrogations of Law." *Law, Culture and the Humanities* 3 (2007): 455–476.

Baker, J. Wayne. "Faces of Federalism: From Bullinger to Jefferson." *Publius* 30, no. 4 (Fall 2004): 25–41.

Baskerville, S. K. "Puritans, Revisionists, and the English Revolution." *The Huntington Library Quarterly* 61, no. 2 (2000): 151–171.

Berardinelli, James. Review of *Blade.* Reelviews. Accessed April 17, 2010. http://www.reelviews.net/php_review_template.php?identifier=1442.

———. Review of *Ghost Rider.* Reelviews. Accessed July 14, 2010. http://www.reelviews.net/php_review_template.php?identifier=550.

———. Review of *Hulk.* Reelviews. Accessed June 22, 2010. http://www.reelviews.net/php_review_template.php?identifier=763.

———. Review of *Iron Man.* Reelviews. Accessed June 23, 2010. http://www.reelviews.net/php_review_template.php?identifier=764.

Bercovitch, Sacvan. *The Puritan Origins of the American Self.* New Haven and London: Yale University Press, 1975.

Berger, Arthur. "Comics and Culture." *Journal of Popular Culture* 5, no. 1 (Summer 1971): 164–178.

Beritela, Gerald F. "Super-Girls and Mild Mannered Men: Gender Trouble in Metropolis." In *The Amazing Transforming Superhero!* Edited by Terrence R. Wandtke, 52–69. Jefferson: McFarland, 2007.

Best, Mark. "Domesticity, Homosociality, and Male Power in Superhero Comics of the 1950s." *Iowa Journal of Cultural Studies* 6 (Spring 2005): 80–99.

Biel, Jessica. "Special Features." Disc 2. *Blade: Trinity,* unrated version DVD. Directed by David Goyer. New Line Home Entertainment, 2004.

Boethius. "A Treatise against Eutyches and Nestorius."

Boichel, Bill. "Batman: Commodity as Myth." In *The Many Lives of the Batman,* edited by Roberta E. Pearson and William Uricchio, 4–17. New York: Routledge, 1991.

Bowman, Rob. "Commentary." Disc 1. *Elektra,* director's cut DVD. Directed by Rob Bowman. Beverly Hills: Twentieth Century Fox Home Entertainment, 2005.

Bowman, Rob, and Jennifer Garner. "The Making of *Elektra.*" *Elektra.* Directed by Rob Bowman. Beverly Hills: Twentieth Century Fox Home Entertainment, 2005. DVD.

Bradley, William. "*Iron Man*'s Post-Modern Howard Hughes Is Back and Confused." *Huffington Post.* Accessed March 4, 2011. http://www.huffingtonpost.com/william-bradley/iiron-manis-post-modern-h_b_575392.html.

Brooker, Will. *Batman Unmasked: Analyzing a Cultural Icon.* New York and London: Continuum, 2000.

Bross, Kristina. "Dying Saints, Vanishing Savages: 'Dying Indian Speeches' in Colonial New England Literature." *Early American Literature* 36, no. 3 (2001): 325–352.

Brown, Jeffrey A. *Black Superheroes, Milestone Comics, and Their Fans.* Jackson: University Press of Mississippi, 2001.

Burnett, Andrew. "Mad Genetics: The Sinister Side of Biological Mastery." In *X-Men and Philosophy,* edited by Rebecca Housel and J. Jeremy Wisnewski, 53–65. Hoboken: Wiley, 2009.

Burtt, E. A. *The Metaphysical Foundations of Modern Physical Science.* Garden City: Doubleday, 1932.

Campbell, Joseph. *The Hero with a Thousand Faces.* New York: Bollingen Foundation, 1949.

Carden, Allen. *Puritan Christianity in America: Religion and Life in Seventeenth-Century Massachusetts.* Grand Rapids: Baker, 1990.

Carney, Sean. "The Function of the Superhero at the Present Time." *Iowa Journal of Cultural Studies* 6 (Spring 2005): 100–117.

Chiklis, Michael, Michael France, and Mark Frost. "Commentary." Disc 1. *Fantastic Four,* extended ed. DVD. Directed by Tim Story. Beverly Hills: Twentieth Century Fox Home Entertainment, 2007.

Cohen, Stanley. "Messianic Motifs, American Popular Culture and the Judaeo-Christian Tradition." *Journal of Religious Studies* 8, no. 1 (Spring 1980): 24–34.

Comic Book Confidential. Directed by Ron Mann, 1989. Sphinx Productions, 1988. DVD.

Comic Book Superheroes Unmasked. The History Channel, 2003. A&E Television Networks, 2005. DVD.

Como, David R. "Women, Prophecy, and Authority in Early Stuart Puritanism." *The Huntington Library Quarterly* 61, no. 2 (2000): 203–222.

Cone, James H. "A Black Perspective on America." In *Proclaiming the Acceptable Year,* edited by Justo L. González, 84–95. Valley Forge: Judson, 1982.

———. *A Black Theology of Liberation.* 20th anniversary ed. Maryknoll: Orbis, 1990.

———. *Black Theology and Black Power.* Minneapolis: Seabury, 1969.

———. *For My People: Black Theology and the Black Church.* Maryknoll: Orbis, 1984.

———. *God of the Oppressed.* Rev. ed. Maryknoll: Orbis, 1997.

———. "In Search of a Definition of Violence." *Church & Society* 85, no. 3 (January/February 1995): 5–7.

———. *Martin & Malcolm & America: A Dream or a Nightmare.* Maryknoll: Orbis, 1991.

———. *Speaking the Truth: Ecumenism, Liberation, and Black Theology.* Grand Rapids: Eerdmans, 1986.

Connors, Joanna. "Female Meets Supermale." In *Superman at Fifty! The Persistence of a Legend!* Edited by Dennis Dooley and Gary Engle, 108–115. Cleveland: Octavia, 1987.

Conway, Gerry. "Introduction: Turning Point." In *Webslinger: Unauthorized Essays on Your Friendly Neighborhood Spider-Man,* edited by Gerry Conway, 1–4. Dallas: Benbella, 2006.

Coogan, Peter. *Superhero: The Secret Origin of a Genre.* Austin: MonkeyBrain, 2006.

Costello, Matthew J. *Secret Identity Crisis: Comic Books and the Unmasking of Cold War America.* New York and London: Continuum, 2009.

Cronin, Brian. *Was Superman a Spy?* (New York: Plume, 2009).

Dafoe, Willem, and Sam Raimi. "Special Features." Disc 2. *Spider-Man,* special ed. DVD. Directed by Sam Raimi. Culver City: Columbia TriStar Home Entertainment, 2002.

Daniels, Les. *Batman: The Complete History.* San Francisco: Chronicle, 1999.

———. *DC Comics: Sixty Years of the World's Favorite Comic Book Heroes.* New York: Bulfinch, 1995.

———. *Marvel: Five Fabulous Decades of the World's Greatest Comics.* New York: Abradale, 1991.

———. *Superman: The Complete History.* San Francisco: Chronicle, 1998.

———. *Wonder Woman: The Complete History.* San Francisco: Chronicle, 2000.

Dauphin, Gary. "To Be Young, Superpowered & Black." *The Village Voice,* May 17, 1994, 31–38.

Dawson, Hugh J. "'Christian Charitie' as Colonial Discourse: Rereading Winthrop's Sermon in Its English Context." *Early American Literature* 33, no. 2 (1998): 117–148.

Dean, William. *The American Spiritual Culture: And the Invention of Jazz, Football, and the Movies.* New York and London: Continuum, 2003.

DeFalco, Tom, ed. *Comics Creators on Spider-Man.* London: Titan, 2004.

———, ed. *Comics Creators on X-Men.* London: Titan, 2006.

del Toro, Guillermo, Peter Frankfurt, and David Goyer. "Commentaries." Disc 1. *Blade II.* Directed by Guillermo del Toro. New Line Home Entertainment, 2002. DVD.

DiPaolo, Marc Edward. "Wonder Woman as World War II Veteran, Camp Feminist Icon, and Male Sex Fantasy." In *The Amazing Transforming Superhero!* Edited by Terrence R. Wandtke, 151–173. Jefferson: McFarland, 2007.

Dittmer, Jason. "Retconning America: Captain America in the Wake of World War II and the McCarthy Hearings." In *The Amazing Transforming Superhero!* Edited by Terrence R. Wandtke, 33–51. Jefferson: McFarland, 2007.

Doherty, Brian. "Comics Tragedy: Is the Superhero Invulnerable?" *Reason* 33, no. 1 (May 2001): 49–55.

Dubose, Mike S. "Holding Out for a Hero: Reaganism, Comic Book Vigilantes, and Captain America." *Journal of Popular Culture* 40, no. 6 (December 2007): 915–935.

Dyer, Geoff. "American Dreams." *New Statesman,* January 12, 2004, 42–44.

Eagan, Patrick L. "A Flag with a Human Face." In *Superman at Fifty! The Persistence of a Legend!* Edited by Dennis Dooley and Gary Engle, 88–95. Cleveland: Octavia, 1987.

Ebert, Roger. Review of *Blade*. rogerebert.com, Accessed April 17, 2010. http://rogerebert.suntimes.com/apps/pbcs.dll/article?AID=/19980821/REVIEWS/808210301.

———. Review of *Hulk*. rogerebert.com. Accessed June 22, 2010. http://rogerebert.suntimes.com/apps/pbcs.dll/article?AID=/20030620/REVIEWS/306200304.

———. Review of *Iron Man*. rogerebert.com. Accessed June 23, 2010. http://rogerebert.suntimes.com/apps/pbcs.dll/article?AID=/20080601/REVIEWS/467306179.

———. Review of *Iron Man 2*. rogerebert.com. Accessed March 4, 2011. http://rogerebert.suntimes.com/apps/pbcs.dll/article?AID=/20100505/REVIEWS/100509987.

Eco, Umberto. "The Myth of Superman." In *The Role of the Reader: Explorations in the Semiotics of Texts*, 107–124. Bloomington: Indiana University Press, 1979.

Emad, Mitra C. "Reading Wonder Woman's Body: Mythologies of Gender and Nation." *Journal of Popular Culture* 39, no. 6 (December 2006): 954–984.

Engle, Gary. "What Makes Superman So Darned American?" In *Superman at Fifty! The Persistence of a Legend!* Edited by Dennis Dooley and Gary Engle, 79–87. Cleveland: Octavia, 1987.

Ennis, Garth, Steve Dillon, and Jimmy Palmiotti. *The Punisher: Welcome Back, Frank*. New York: Marvel Comics, 2001.

Eusden, John Dykstra. Introduction to *The Marrow of Theology*, by William Ames. Translated by John Dykstra Eusden. Durham: Labyrinth, 1983.

Evans, C. Stephen. "Why Should Superheroes Be Good? Spider-Man, the X-Men, and Kierkegaard's Double Danger." In *Superheroes and Philosophy: Truth, Justice, and the Socratic Way*, edited by Tom Morris and Matt Morris, 161–176. Chicago and La Salle: Open Court, 2005.

Favreau, Jon. "Commentary." *Iron Man 2*. Directed by Jon Favreau. Hollywood: Paramount Pictures, 2010. DVD.

Feiffer, Jules. *The Great Comic Book Heroes*. Seattle: Fantagraphics, 2003.

Fielding, Julien R. Review of *Daredevil*. *Journal of Religion and Film* 7, no. 1 (April 2003). Accessed June 24, 2010. http://www.unomaha.edu/jrf/daredevilrev.htm.

Fingeroth, Danny. *Disguised as Clark Kent: Jews, Comics, and the Creation of the Superhero*. New York and London: Continuum, 2007.

———. *Superman on the Couch: What Superheroes Really Tell Us about Ourselves and Our Society*. New York and London: Continuum, 2006.

Frahm, Sally. "The Cross and the Compass: Manifest Destiny, Religious Aspects of the Mexican-American War." *Journal of Popular Culture* 35, no. 2 (Fall 2001): 83–99.

Frey, Donald. "Individualist Economic Values and Self-Interest: The Problem in the Puritan Ethic." *Journal of Business Ethics* 17, no. 14 (October 1998): 1573–1580.

Gabilliet, Jean-Paul. "Cultural and Mythical Aspects of a Superhero: The Silver Surfer 1968–1970." *Journal of Popular Culture* 28, no. 2 (Fall 1994): 203–213.

Gamble, Richard M. "Savior Nation: Woodrow Wilson and the Gospel of Service." *Humanitas* 14, no. 1 (2001): 4–22.

Garrett, Greg. *Holy Superheroes! Exploring Faith & Spirituality in Comic Books*. Colorado Springs: Piñon, 2005.

Gayles, Jonathan. "Black Macho and the Myth of the Superwoman Redux: Masculinity and Misogyny in Blade." *The Journal of Popular Culture* 45, no. 2 (2012): 284–300.

Genter, Robert. "'With Great Power Comes Great Responsibility': Cold War Culture and the Birth of Marvel Comics." *Journal of Popular Culture* 40, no. 6 (December 2007): 953–978.

Gillespie, Nick. "William Marston's Secret Identity." *Reason* 33, no. 1 (May 2001): 52–53.

Giordano, Dick. "Introduction: Growing Up with the Greatest." In *The Greatest Batman Stories Ever Told,* by DC Comics, 6–11. New York: Warner, 1988.

Goyer, David, and Guillermo del Torro. "Commentaries." Disc 1. *Blade: Trinity,* unrated version DVD. Directed by David Goyer. New Line Home Entertainment, 2004.

Goyer, David, and Wesley Snipes. "Commentaries." *Blade.* Directed by Stephen Norrington. New Line Home Entertainment, 2001. DVD.

Gunton, Colin. *Enlightenment and Alienation.* Grand Rapids: Eerdmans, 1985.

———. *The One, the Three, and the Many: God, Creation, and the Culture of Modernity.* Cambridge: Cambridge University Press, 1993.

Hall, Lark. "The Other Side of the Coin: Reflections on Women in American Myth and Culture." *American Baptist Quarterly* 2, no. 1 (March 1983): 51–58.

Haller, William. *The Rise of Puritanism.* New York: Harper, 1957.

Harmon, Jim. "A Swell Bunch of Guys." In *All in Color for a Dime,* edited by Dick Lupoff and Don Thompson, 167–190. Iola: Krause, 1997.

Harris, Neil. "Who Own Our Myths? Heroism and Copyright in an Age of Mass Culture." *Social Research* 52, no. 2 (Summer 1985): 241–267.

Hartman, James D. "Providence Tales and the Indian Captivity Narrative: Some Transatlantic Influences on Colonial Puritan Discourse." *Early American Literature* 32, no. 1 (1997): 66–81.

Hatheway, Jay. "The Puritan Covenant II: Anti-Modernism and the 'Contract with America.'" *The Humanist* 55, no. 4 (July 1995): 24–33.

Hensleigh, Jonathan. "Commentary." *The Punisher.* Directed by Jonathan Hensleigh. Santa Monica: Lions Gate Entertainment, 2004. DVD.

Holifield, E. Brooks. *Theology in America: Christian Thought from the Age of the Puritans to the Civil War.* New Haven and London: Yale University Press, 2003.

Hood, Gavin. "Commentaries." Disc 1. *X-Men Origins: Wolverine,* special ed. DVD. Directed by Gavin Hood. Beverly Hills: Twentieth Century Fox Home Entertainment, 2009.

Hopkins, Patrick D. "The Lure of the Normal: Who *Wouldn't Want* to Be a Mutant?" In *X-Men and Philosophy,* edited by Rebecca Housel and J. Jeremy Wisnewski, 5–16. Hoboken: Wiley, 2009.

Housel, Rebecca. "Myth, Morality, and the Women of the X-Men." In *Superheroes and Philosophy: Truth, Justice, and the Socratic Way,* edited by Tom Morris and Matt Morris, 75–88. Chicago and La Salle: Open Court, 2005.

———. "X-Women and X-istence." In *X-Men and Philosophy,* edited by Rebecca Housel and J. Jeremy Wisnewski, 85–98. Hoboken: Wiley, 2009.

Howe, Irving. "Notes on Mass Culture." In *Arguing Comics: Literary Masters on a Popular Medium,* edited by Jeet Heer and Kent Worcester, 43–51. Jackson: University Press of Mississippi, 2004.

Hughes, David. *Comic Book Movies.* London: Virgin, 2003.

Hughes, Richard T. *Myths America Lives By.* Urbana and Chicago: University of Illinois Press, 2003.

Hulteen, Bob. "Of Heroic Proportions: Fifty Years of Captain America." *Sojourners,* August/September 1990.

Jalalzai, Zubeda. "Race and the Puritan Body Politic." *MELUS* 29, nos. 3–4 (Fall/Winter 2004): 259–272.

Jenson, Robert W. *Essays in Theology of Culture.* Grand Rapids: Eerdmans, 1995.

Johnson, Mark Steven. "Commentary." Disc 1. *Daredevil.* Directed by Mark Steven Johnson. Beverly Hills: Twentieth Century Fox Home Entertainment, 2003. DVD.

———. "Commentary." *Daredevil,* director's cut DVD. Directed by Mark Steven Johnson. Beverly Hills: Twentieth Century Fox Home Entertainment, 2003.

————. "Commentaries." Disc 1. *Ghost Rider,* extended cut DVD. Directed by Mark Steven Johnson. Culver City: Sony Pictures Home Entertainment, 2007.

Jones, Gerard. *Men of Tomorrow: Geeks, Gangsters and the Birth of the Comic Book.* New York: Basic, 2004.

Kaplan, Arie. "Kings of Comics, How Jews Created the Comic Book Industry." *Arie Kaplan* (blog). http://www.ariekaplan.com/reform-judaism/.

Kaveney, Roz. *Superheroes! Capes and Crusaders in Comics and Films.* London and New York: I. B. Tauris, 2008.

Keller, Catherine. "Feminism and the Ethic of Inseparability." In *Weaving the Visions: New Patterns in Feminist Spirituality,* edited by Judith Plaskow and Carol P. Christ, 256–265. San Francisco: Harper & Row, 1989.

————. *From a Broken Web: Separation, Sexism, and Self.* Boston: Beacon, 1986.

————. *God and Power: Counter-Apocalyptic Journeys.* Minneapolis: Fortress, 2005.

————. "The Love of Postcolonialism: Theology in the Interstices of Empire." In *Postcolonial Theologies: Divinity and Empire,* edited by Catherine Keller, Michael Nausner, and Mayra Rivera, 221–242. Atlanta: Chalice, 2004.

————. *On the Mystery: Discerning Divinity in Process.* Minneapolis: Fortress, 2008.

————. "Postmodern 'Nature,' Feminism and Community." In *Theology for Earth Community: A Field Guide,* edited by Dieter T. Hessel, 93–102. Maryknoll: Orbis, 1996.

————. "Power Lines." *Theology Today* 52, no. 2 (July 1995): 188–203.

————. "Seeking and Sucking: On Relation and Essence in Feminist Theology." In *Horizons in Feminist Theology: Identity, Tradition, and Norms,* edited by Rebecca S. Chopp and Sheila Greeve Davaney, 54–78. Minneapolis: Fortress, 1997.

————. "Territory, Terror and Torture: Dream-reading the Apocalypse." *Feminist Theology* 14, no. 1 (September 2005): 47–67.

————. "'To Illuminate Your Trace': Self in Late Modern Feminist Theology." *Listening* 25 (Fall 1990): 211–224.

Keller, Catherine, Michael Nausner, and Mayra Rivera. "Introduction: Alien/Nation, Liberation, and the Postcolonial Underground." In *Postcolonial Theologies: Divinity and Empire,* edited by Catherine Keller, Michael Nausner, and Mayra Rivera, 1–19. Atlanta: Chalice, 2004.

Kellner, Douglas. *Media Culture.* New York and London: Routledge, 1995.

Kinghorn, Kevin. "Questions of Identity: Is the Hulk the Same Person as Bruce Banner?" In *Superheroes and Philosophy: Truth, Justice, and the Socratic Way,* edited by Tom Morris and Matt Morris, 223–236. Chicago and La Salle: Open Court, 2005.

Kirby, Katherine, E. "War and Peace, Power and Faith." In *X-Men and Philosophy,* edited by Rebecca Housel and J. Jeremy Wisnewski, 209–222. Hoboken: Wiley, 2009.

Lane, Belden C. "Two Schools of Desire: Nature and Marriage in Seventeenth-Century Puritanism." *Church History* 69, no. 2 (June 2000): 372–402.

Lang, Jeffrey S., and Patrick Trimble. "Whatever Happened to the Man of Tomorrow? An Examination of the American Monomyth and the Comic Book Superhero." *Journal of Popular Culture* 22, no. 3 (Winter 1988): 157–173.

Lavin, Michael. "A Librarian's Guide to Marvel Comics." *Serials Review* 24 (1998): 47–63.

Lawrence, John Shelton, and Robert Jewett. *The Myth of the American Superhero.* Grand Rapids: Eerdmans, 2002.

Ledford, Katherine E. "'Singularly placed in scenes so cultivated': The Frontier, the Myth of Westward Progress, and a Backwoods in the Mountain South." *American Transcendental Quarterly* 18, no. 3 (September 2004): 205–222.

Lee, Ang. "Commentary." Disc 1. *Hulk,* special ed. DVD. Directed by Ang Lee. Culver City: Universal Studios, 2003.

Lee, Stan. *Bring on the Bad Guys.* New York: Simon and Schuster, 1976.

———. Foreword to *Disguised as Clark Kent: Jews, Comics, and the Creation of the Superhero,* by Danny Fingeroth, 9–11. New York and London: Continuum, 2007.

———. Introduction to *Marvel: Five Fabulous Decades of the World's Greatest Comics,* by Les Daniels, 8–12. New York: Abradale, 1991.

———. *Origins of Marvel Comics.* New York: Simon and Schuster, 1974.

———. *Son of Origins of Marvel Comics.* New York: Simon and Schuster, 1975.

———. "Special Features." Disc 2. *Iron Man,* ultimate 2-disc ed. DVD. Directed by Jon Favreau. Paramount Pictures, 2008.

———. *Stan Lee: Conversations.* Edited by Jeff McLaughlin. Jackson: University Press of Mississippi, 2007.

———. *The Superhero Women.* New York: Simon and Schuster, 1977.

Lee, Stan, and George Mair. *Excelsior! The Amazing Life of Stan Lee.* New York: Fireside, 2002.

Legman, Gershon. "From *Love and Death: A Study in Censorship.*" In *Arguing Comics: Literary Masters on a Popular Medium,* edited by Jeet Heer and Kent Worcester, 112–121. Jackson: University Press of Mississippi, 2004.

Lendrum, Rob. "The Super Black Macho, One Baaad Mutha: Black Superhero Masculinity in 1970s Mainstream Comic Books." *Extrapolation* 46, no. 3 (Fall 2005): 360–372.

Levitz, Jay. Review of *Hulk.Christian Spotlight on the Movies.* Accessed December 19, 2006. http://www.christiananswers.net/spotlight/movies/2003/thehulk.html.

Lupoff, Dick. "The Big Red Cheese." In *All in Color for a Dime,* edited by Dick Lupoff and Don Thompson, 59–83. Iola: Krause, 1997.

Lyubansky, Mikhail. "Prejudice Lessons from the Xavier Institute." In *The Psychology of Superheroes: An Unauthorized Exploration,* edited by Robin S. Rosenberg, 75–90. Dallas: Benbella, 2008.

MacCulloch, Diarmaid. "Putting the English Reformation on the Map." *Transactions of the Royal Historical Society* 15 (2005): 75–95.

MacDonald, Andrew and Virginia. "Sold American: The Metamorphosis of Captain America." *Journal of Popular Culture* 10, no. 1 (Summer 1976): 249–258.

Marvel Comics. *The Marvel Encyclopedia.* Rev. ed. New York: DK Publishing, 2009.

Masters, Joshua J. "'Smothered in Bookish Knowledge': Literacy and Epistemology in *The Leatherstocking Tales.*" *The Arizona Quarterly* 61, no. 4 (Winter 2005): 1–30.

McKenna, George. *The Puritan Origins of American Patriotism.* New Haven and London: Yale University Press, 2007.

McNair, Wesley C. "The Secret Identity of Superman: Puritanism and the American Superhero." *American Baptist Quarterly* 2, no. 1 (March 1983): 4–15.

Merton, Thomas. *The Ascent to Truth.* San Diego: Harcourt, 1978.

———. *Conjectures of a Guilty Bystander.* New York: Image, 1965.

———. *Life and Holiness.* New York: Image, 1963.

———. *Love and Living.* Orlando: Harcourt, 1985.

———. *The New Man.* New York: Farrar, Straus and Giroux, 1961.

———. *New Seeds of Contemplation.* New York: New Directions, 2007.

———. *No Man is an Island.* New York: Barnes & Noble, 2003.

———. *Seeds of Destruction.* New York: Farrar, Straus and Giroux, 1965.

Meyer, William E. H., Jr. "The Hypervisual Meaning of the American West." *Philosophy Today* 33, no. 1 (Spring 1989): 28–41.

Millar, William R. "Ronald Reagan and an American Monomyth or, The Lone Ranger Rides Again." *American Baptist Quarterly* 2, no. 1 (March 1983): 32–42.

Miller, Perry. *Errand into the Wilderness.* Cambridge: Harvard University Press, 1964.

————. *The New England Mind: The Seventeenth Century.* New York: MacMillan, 1939.

Mondello, Salvatore. "Spider-Man: Superhero in the Liberal Tradition." *Journal of Popular Culture* X, no. 1 (Summer 1976): 232–238.

Moore, Jesse T. "The Education of Green Lantern: Culture and Ideology." *Journal of American Culture* 26, no. 2 (June 2003): 263–278.

Morris, Tom. "God, the Devil, and Matt Murdock." In *Superheroes and Philosophy: Truth, Justice, and the Socratic Way,* edited by Tom Morris and Matt Morris, 45–61. Chicago and La Salle: Open Court, 2005.

Mosse, Hilde L. "Aggression and Violence in Fantasy and Fact." In "The Psychopathology of Comic Books: A Symposium," by Fredric Wertham, Gershon Legman, Hilde L. Mosse, Paula Elkisch, and Marvin L. Blumberg, 421–426. *American Journal of Psychotherapy* 50, no. 4 (Fall 1996): 417–434.

Noll, Mark. *America's God: From Jonathan Edwards to Abraham Lincoln.* New York: Oxford University Press, 2002.

Nyberg, Amy Kiste. *Seal of Approval: The History of the Comics Code.* Jackson: University Press of Mississippi, 1998.

Ong, Walter. *Orality and Literacy.* London and New York: Routledge, 2002.

Onuf, Peter S. "'To Declare Them A Free and Independent People': Race, Slavery, and National Identity in Jefferson's Thought." *Journal of the Early Republic* 18, no. 1 (Spring 1998): 1–46.

O'Reilly, Julie D. "The Wonder Woman Precedent: Female (Super)Heroism on Trial." *Journal of American Culture* 28, no. 3 (September 2005): 273–283.

Oropeza, B. J. "The God-Man Revisited: Christology through the Blank Eyes of the Silver Surfer." In *The Gospel According to Superheroes: Religion and Popular Culture,* edited by B. J. Oropeza, 155–169. New York: Peter Lang, 2005.

Palmer, Lorrie. "'Le Western Noir': The Punisher as Revisionist Superhero Western." In *The Amazing Transforming Superhero!* Edited by Terrence R. Wandtke, 192–208. Jefferson: McFarland, 2007.

Palumbo, Donald. "The Marvel Comics Group's Spider-Man Is an Existentialist Super-Hero; or 'Life Has No Meaning Without My Latest Marvels!'" *Journal of Popular Culture* 17, no. 2 (Fall 1983): 67–82.

Parnham, David. "The Humbling of 'High Presumption': Tobias Crisp Dismantles the Puritan Ordo Salutis." *Journal of Ecclesiastical History* 56, no. 1 (January 2005): 50–74.

Partible, Leo. "Ordinary Superhero Stan Lee." *Risen Magazine,* July/August/September 2007.

Patterson, Brett Chandler. "Spider-Man No More." In *Webslinger: Unauthorized Essays on Your Friendly Neighborhood Spider-Man,* edited by Gerry Conway, 129–148. Dallas: Benbella, 2006.

Pelikan, Jaroslav. *The Christian Tradition: A History of the Development of Doctrine.* Vol. 4, *Reformation of Church and Dogma (1300–1700).* Chicago: University of Chicago Press, 1984.

Perkins, William. *The Work of William Perkins.* Edited by Ian Breward. Appleford: Sutton Courtenay, 1970.

Perry, Tim. "Mutants That Are All Too Human: The X-Men, Magneto, and Original Sin." In *The Gospel According to Superheroes: Religion and Popular Culture,* edited by B. J. Oropeza, 171–187. New York: Peter Lang, 2005.

Peters, Matthew. "Individual Development and the American Autobiography: Franklin, Thoreau, Adams." *Philological Quarterly* 84, no. 2 (Spring 2005): 241–257.

Peterson, Christopher, and Nansook Park. "The Positive Psychology of Superheroes." In *The Psychology of Superheroes: An Unauthorized Exploration,* edited by Robin S. Rosenberg, 5–18. Dallas: Benbella, 2008.

Pointer, Steve. "Puritan Identity in the Late Elizabethan Church: William Perkins and 'A Powerfull Exhortation to Repentance.'" *Fides et Historia* 33, no. 2 (Summer 2001): 65–71.

Poniewozik, James. "Superhero Nation." *Time*, May 20, 2002, 76–78.

Potter, Tiffany. "Writing Indigenous Femininity: Mary Rowlandson's Narrative of Captivity." *Eighteenth-Century Studies* 36, no. 2 (Winter 2003): 153–167.

Pustz, Matthew. *Comic Book Culture: Fanboys and True Believers*. Jackson: University Press of Mississippi, 1999.

Raphael, Jordan, and Tom Spurgeon. *Stan Lee and the Rise and Fall of the American Comic Book*. Chicago: Chicago Review Press, 2003.

Rasmussen, Barry. "Richard Hooker's Trinitarian Hermeneutic of Grace." *Anglican Theological Review* 84, no. 4 (Fall 2002): 929–941.

Reynolds, Richard. *Super Heroes: A Modern Mythology*. Jackson: University Press of Mississippi, 1992.

Rhoades, Shirrel. *A Complete History of American Comic Books*. New York: Peter Lang, 2008.

Ro, Ronin. *Tales to Astonish: Jack Kirby, Stan Lee, and the American Comic Book Revolution*. New York and London: Bloomsbury.

Robertson, C. K. "The True *Übermensch*: Batman as Humanistic Myth." In *The Gospel According to Superheroes: Religion and Popular Culture*, edited by B. J. Oropeza, 49–65. New York: Peter Lang, 2005.

Roebuck, Lester. "The Good, the Bad and the Oedipal." In *Superman at Fifty! The Persistence of a Legend!* Edited by Dennis Dooley and Gary Engle, 143–152. Cleveland: Octavia, 1987.

Rosen, Scott. "Gods and Fantastic Mortals: The Superheroes of Jack Kirby." In *The Gospel According to Superheroes: Religion and Popular Culture*, edited by B. J. Oropeza, 113–126. New York: Peter Lang, 2005.

Ruether, Rosemary Radford. *America, Amerikkka: Elect Nation and Imperial Violence*. London and Oakville: Equinox, 2007.

———. "The Becoming of Women in Church and Society." *Cross Currents* 17, no. 4 (Fall 1967): 418–426.

———. *Christianity and the Making of the Modern Family*. Boston: Beacon, 2000.

———. "The Development of My Theology." *Religious Studies Review* 15, no. 1 (January 1989): 1–4.

———. *Disputed Questions: On Being a Christian*. Nashville: Abingdon, 1982.

———. "Feminism and Peace." *The Christian Century*, August 31–September 7, 1983, 771–776.

———. "Feminist Metanoia and Soul-Making." *Women & Therapy* 16, nos. 2–3 (1995): 33–44.

———. "Gender and Redemption in Christian Theological History." *Feminist Theology*, no. 21 (May 1999): 98–108.

———. "Gender Equity and Christianity: Premodern Roots, Modern and Postmodern Perspectives." *Union Seminary Quarterly Review* 50, nos. 1–4 (1996): 47–61.

———. "Home and Work: Women's Roles and the Transformation of Values." *Theological Studies* 36, no. 4 (December 1975): 647–659.

———. "*Imago Dei*: Christian Tradition and Feminist Hermeneutics." In *The Image of God: Gender Models in Judaeo-Christian Tradition*, edited by Kari Elisabeth Børresen, 267–291. Minneapolis: Fortress, 1991.

———. *Liberation Theology: Human Hope Confronts Christian History and American Power*. New York: Paulist, 1972.

———. "Male Chauvinist Theology and the Anger of Women." *Cross Currents* 21, no. 2 (Spring 1971): 173–185.

———. *New Woman/New Earth: Sexist Ideologies and Human Liberation.* New York: Seabury, 1975.

———. "The Personalization of Sexuality." In *From Machismo to Mutuality: Essays on Sexism and Woman-Man Liberation,* by Eugene C. Bianchi and Rosemary R. Ruether, 70–86. New York: Paulist, 1976.

———. *The Radical Kingdom: The Western Experience of Messianic Hope.* New York: Harper & Row, 1970.

———. "Re-contextualizing Theology." *Theology Today* 43, no. 1 (April 1986): 22–27.

———. *Sexism and God-Talk: Toward a Feminist Theology.* Boston: Beacon, 1983.

———. "Sexism and the Theology of Liberation: Nature, Fall and Salvation as Seen from the Experience of Women." *The Christian Century,* December 12, 1973, 1224–1229.

———. "Teaching Peace in a Time of War." *Dialog* 42, no. 2 (Summer 2003): 167–169.

Runions, Erin. "Inherited Crypts of the Wife/Mother: Ang Lee's *Hulk* Meets Zechariah 5:5–11 in Contemporary Apocalyptic Discourse." *Biblical Interpretation* 14, nos. 1–2 (2006): 127–142.

Ryall, Chris, and Scott Tipton, "The Fantastic Four as a Family: The Strongest Bond of All." In *Superheroes and Philosophy: Truth, Justice, and the Socratic Way,* edited by Tom Morris and Matt Morris, 118–129. Chicago and La Salle: Open Court, 2005.

Sanderson, Peter. *Marvel Universe.* New York: Harry N. Abrams, 1996.

Sargent, Alvin, and Laura Ziskin. "Commentary." Disc 1. *Spider-Man 2.1,* extended cut DVD. Directed by Sam Raimi. Culver City: Sony Pictures Home Entertainment, 2007.

Saunders, Ben. *Do the Gods Wear Capes? Spirituality, Fantasy, and Superheroes.* London and New York: Continuum, 2011.

Saxton, Martha. "Bearing the Burden? Puritan Wives." *History Today* 44, no. 10 (October 1994): 28–33.

Schager, Nicholas. Review of *Hulk.Slant Magazine.* Accessed December 19, 2006. http://www.slantmagazine.com/film/film_review.asp?ID=717.

Schweitzer, Ivy. "John Winthrop's 'Model' of American Affiliation." *Early American Literature* 40, no. 3 (2005): 441–469.

Scott, Bernard Brandon. *Hollywood Dreams and Biblical Stories.* Minneapolis: Fortress, 1994.

Scott, Cord. "Written in Red, White, and Blue: A Comparison of Comic Book Propaganda from World War II and September 11." *Journal of Popular Culture* 40, no. 2 (April 2007): 325–343.

Shaheen, Jack. "Arab Images in American Comic Books." *Journal of Popular Culture* 28, no. 1 (Summer 1994): 123–133.

Shults, F. LeRon. *Christology and Science.* Grand Rapids: Eerdmans, 2008.

———. "Imago Dei and the Emergence of Sapiential Life." In *Coping with Evil: Perspectives from Science and Theology,* edited by Niels Henrik Gregersen & Christina Hjøllund, 95–117. Aarhus: University of Aarhus Press, 2003.

———. *The Postfoundationalist Task of Theology: Wolfhart Pannenberg and the New Theological Rationality.* Grand Rapids: Eerdmans, 1999.

———. *Reforming Theological Anthropology: After the Philosophical turn to Relationality.* Grand Rapids: Eerdmans, 2003.

———. "Spirit and Spirituality: Philosophical Trends in Late Modern Pneumatology." *Pneuma* 30 (Fall 2008): 271–287.

———. "Tending to the Other in Late Modern Missions and Ecumenism." *Swedish Missiological Themes* 95, no. 4 (2007): 415–434.

————. "That Than Which Nothing More Lovely Can Be Conceived." In *Visions of Agape: Problems and Possibilities in Human and Divine Love*, edited by Craig A. Boyd, 123–134. Aldershot: Ashgate, 2008.

Shults, F. LeRon, and Steven J. Sandage. *The Faces of Forgiveness: Searching for Wholeness and Salvation*. Grand Rapids: Baker, 2003.

————. *Transforming Spirituality: Integrating Theology and Psychology*. Grand Rapids: Baker, 2006.

Singer, Bryan. "Commentaries." *X2: X-Men United*. Directed by Bryan Singer. Beverly Hills: Twentieth Century Fox Home Entertainment, 2003. DVD.

Singer, Marc. "'Black Skins' and White Masks: Comic Books and the Secret of Race." *African American Review* 36, no. 1 (Spring 2002): 107–119.

Skidmore, Max J., and Joey Skidmore. "More Than Mere Fantasy: Political Themes in Contemporary Comic Books." *Journal of Popular Culture* 17, no. 1 (Summer 1983): 83–92.

Slights, Camille Wells. "The Conscience of the King: *Henry V* and the Reformed Conscience." *Philological Quarterly* 80, no. 1 (Winter 2001): 37–55.

Slotkin, Richard. *Gunfighter Nation: The Myth of the Frontier in Twentieth-Century America*. New York: HarperCollins, 1992.

————. *Regeneration through Violence: The Mythology of the American Frontier, 1600–1860*. Middletown: Wesleyan University Press, 1973.

Smedley, Audrey. "'Race' and the Construction of Human Identity." *American Anthropologist* 100, no. 3 (September 1998): 690–702.

Taliaferro, Charles, and Craig Lindahl-Urben. "The Power and the Glory." In *Superheroes and Philosophy: Truth, Justice, and the Socratic Way*, edited by Tom Morris and Matt Morris, 62–74. Chicago and La Salle: Open Court, 2005.

Taylor, Aaron. "'He's Gotta Be Strong, and He's Gotta Be Fast, and He's Gotta Be Larger Than Life': Investigating the Engendered Superhero Body." *Journal of Popular Culture* 40, no. 2 (April 2007): 344–360.

Taylor, Robert B. "Raimi vs. Bendis: Reimagining Spider-Man." In *Webslinger: Unauthorized Essays on Your Friendly Neighborhood Spider-Man*, edited by Gerry Conway, 35–44. Dallas: Benbella, 2006.

Thomas, Roy. "Sin and Salvation: The Comic Book Origins of Ghost Rider." Disc 2. *Ghost Rider*, extended cut DVD. Directed by Mark Steven Johnson. Culver City: Sony Pictures Home Entertainment, 2007.

Thompson, Don. "OK, Axis, Here We Come!" In *All in Color for a Dime*, edited by Dick Lupoff and Don Thompson, 111–129. Iola: Krause, 1997.

Torrance, Thomas F. *Calvin's Doctrine of Man*. London: Lutterworth, 1949.

Trushell, John M. "American Dreams of Mutants: The X-Men—'Pulp' Fiction, Science Fiction, and Superheroes." *Journal of Popular Culture* 38, no. 1 (August 2004): 149–168.

Vaz, Mark Cotta. *Behind the Mask of Spider-Man: The Secrets of the Movie*. New York: Ballantine, 2002.

Waid, Mark. "The Real Truth about Superman: And the Rest of Us, Too." In *Superheroes and Philosophy: Truth, Justice, and the Socratic Way*, edited by Tom Morris and Matt Morris, 3–10. Chicago and La Salle: Open Court, 2005.

Wandtke, Terrence R. "Introduction: Once Upon a Time Once Again." In *The Amazing Transforming Superhero!* Edited by Terrence R. Wandtke, 5–32. Jefferson: McFarland, 2007.

Weber, Max. *The Protestant Ethic and the Spirit of Capitalism*. Translated by Talcott Parsons. New York: Charles Scribner's Sons, 1958.

Wertham, Fredric. "The Curse of the Comic Books." *Religious Education* 46, no. 6 (November 1954): 394–406.

————. *Seduction of the Innocent*. New York: Rinehart, 1954.

Whedon, Joss. "Commentary." *Marvel's The Avengers*. Directed by Joss Whedon. Burbank, CA: Buena Vista Home Entertainment, 2012. DVD.

Wheeler, Charles N. "Fight to disarm his life's work, Henry Ford vows." *Chicago Tribune*, May 25, 1916.

White, Ted. "The Spawn of M. C. Gaines." In *All in Color for a Dime*, edited by Dick Lupoff and Don Thompson, 19–39. Iola: Krause, 1997.

Williams, J. P. "All's Fair in Love and Journalism: Female Rivalry in *Superman*." *Journal of Popular Culture* 24, no. 2 (Fall 1990): 103–112.

Winship, Michael P. "Reconsiderations: Were There Any Puritans in New England?" *The New England Quarterly* 74, no. 1 (March 2001): 118–138.

———. "Weak Christians, Backsliders, and Carnal Gospelers: Assurance of Salvation and the Pastoral Origins of Puritan Practical Divinity in the 1580s." *Church History* 70, no. 3 (September 2001): 462–481.

Wisnewski, J. Jeremy. "Mutant Phenomenology." In *X-Men and Philosophy*, edited by Rebecca Housel and J. Jeremy Wisnewski, 197–208. Hoboken: Wiley, 2009.

Wolf-Meyer, Matthew Joseph. "Batman and Robin in the Nude, Or Class and Its Exceptions." *Extrapolation* 47, no. 2 (Summer 2006): 187–184.

Wood, Timothy L. "Kingdom Expectations: The Native American in the Puritan Missiology of John Winthrop and Roger Williams." *Fides et Historia* 32, no. 1 (Winter 2000): 39–49.

Wright, Bradford. *Comic Book Nation: The Transformation of Youth Culture in America*. Baltimore: Johns Hopkins University Press, 2001.

Wright, Nicky. *The Classic Era of American Comics*. London: Prion, 2000.

Zacharek, Stephanie. Review of *Fantastic Four*. Salon. Accessed May 16, 2010. http://www.salon.com/entertainment/movies/review/2005/07/08/fantastic_four.

———. Review of *The Incredible Hulk*. Salon. Accessed June 22, 2010. http://www.salon.com/entertainment/movies/review/2008/06/13/hulk.

———. Review of *Iron Man*. Salon. Accessed June 23, 2010. http://www.salon.com/entertainment/movies/review/2008/05/01/iron_man.

———. Review of *Spider-Man 3*. Salon. Accessed June 23, 2010. http://www.salon.com/entertainment/movies/review/2007/05/04/spider_man_3.

Zimmerman, David A. *Comic Book Character: Unleashing the Hero in Us All*. Downers Grove: InterVarsity, 2004.

Index